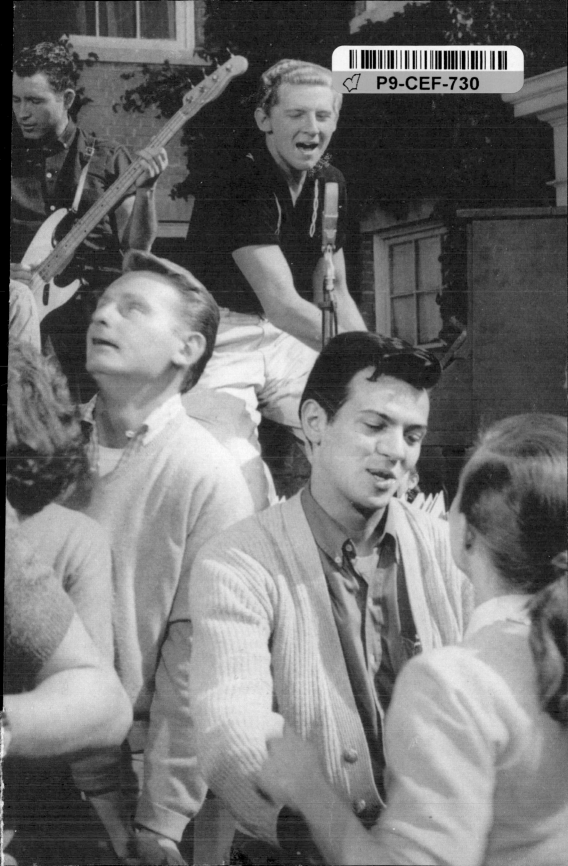

P9-CEF-730

JERRY LEE LEWIS

HIS OWN STORY

ALSO BY RICK BRAGG

All Over but the Shoutin'

Somebody Told Me: The Newspaper Stories of Rick Bragg

Ava's Man

I Am a Soldier, Too: The Jessica Lynch Story

The Prince of Frogtown

The Most They Ever Had

JERRY LEE LEWIS

HIS OWN STORY

RICK BRAGG

An Imprint of HarperCollins*Publishers*

JERRY LEE LEWIS: HIS OWN STORY. Copyright © 2014 by JLL Ferriday, Inc. All rights reserved. Printed in the United States of America. No part of this book may be used or reproduced in any manner whatsoever without written permission except in the case of brief quotations embodied in critical articles and reviews. For information, address HarperCollins Publishers, 195 Broadway, New York, NY 10007.

HarperCollins books may be purchased for educational, business, or sales promotional use. For information, please e-mail the Special Markets Department at SPsales@harpercollins.com.

An extension of this copyright page appears on page 499.

Front endpaper: *High School Confidential*, 1958. Michael Ochs Archives/Getty Images.
Title page: Backstage at the Star-Club, Hamburg, Germany. Redferns/Getty Images.
Back endpaper: Memphis, Tennessee, May 2014. © Ericson Group Inc.

Jerry Lee Lewis Management by:
Greg Ericson, Ericson Group Inc.
www.EricsonGroup.com

FIRST EDITION

Designed by William Ruoto

Library of Congress Cataloging-in-Publication Data has been applied for.

ISBN: 978-0-06-207822-3

14 15 16 17 18 OV/RRD 10 9 8 7 6 5 4 3 2 1

To anyone who ever
danced in their socks

They sow the wind and reap the whirlwind.

—HOSEA 8:7

If I exorcise my devils,
Well, my angels may leave, too.

—TOM WAITS

CONTENTS

JERRY LEE LEWIS

HIS OWN STORY

INTRODUCTION

JOLSON IN THE RIVER

. .

The Black River, and the Mississippi

1 9 4 5

The party boats churned up the big river from New Orleans and down from Memphis and Vicksburg, awash in good liquor and listing with revelers who dined and drank and danced to tied-down pianos and whole brass bands, as their captains skirted Concordia Parish on the way to someplace brighter. The passengers were well-off people, mostly, the officer class home from Europe and the Pacific and tourists from the Peabody, Roosevelt, and Monteleone, clinking glasses with planters and oil men who had always found riches in the dirt the poorer men could not see. Weary of the austerity of war, of rationing and victory gardens, of coastal blackouts and U-boats that hung like sharks at the river mouth, they wanted to raise a racket, spend some money, and light up the river and the entire dull, sleeping land. They floated drunk and singing past sandbars where gentlemen of Natchez once settled affairs of honor with smoothbore pistols and good claret, and around snags and whirlpools where river pirates had lured travelers to their doom.

The country people, in worn-through overalls and faded flour-sack dresses, watched from the banks of the Mississippi and Black

rivers the same way they looked through the windows of a store. In the war years, they had traded the lives of their young men for better times, but they had seen too much bad luck and broke-down history to overcome with just one big war. Reconstruction, the Great Depression, and named storms and unnamed floods had left generations hunched over another man's cotton, and in their faces you could read the one true thing: that sometimes all you could get of a good life was what you could see floating just out of reach, till it disappeared around a bend in the river or vanished behind a veil of flood-ravaged trees. And sometimes, hauntingly, even when a boat had passed them by, they could still hear the music drifting downriver as if there was a song in the water itself, Dixieland or ragtime or, before they turned away to their lives in the colorless mud, a faint, thin scrap of Jolson.

> *Down among the sheltering palms*
> *Oh, honey, wait for me.*

He was still a boy then. One day, when he was nine or ten, he stood on the levee beside his mother and father as one more party boat pushed against the current, well-dressed people laughing on deck. Safe in the middle of the Black River, they raised their glasses in a mocking toast to the family ashore. "They tipped their mint juleps at us, tipped 'em up," he says, and smiles the faintest bit to prove how little it matters to him after so much time. But it mattered to the man and woman beside him. His daddy was indestructible then, gaunt, six foot four, with big, powerful hands that could squeeze weaker men to their knees, and a face that seemed drawn only in straight lines, like Dick Tracy in the funny papers. As the drunken revelers lifted their glasses of bourbon high in the air, Elmo Kidd Lewis pulled the boy to his hip. " 'Don't worry, son,' Daddy told me. 'That'll be you on there someday. That'll be you.' " He does not know if his daddy meant it would be him up there with the

rich folks, the high and mighty, or if it would be his songs they played as the boat passed by. "I think maybe," he says, "it was both."

Elmo knew it the way he knew wading in the river would get him wet. He had seen it, he and his wife, Mamie, when his son was barely five years old, seen a power take over the boy's hands and guide them across a piano he had never studied or played before. For the boy, it was . . . well, he did not truly know. His fingers touched the keys and it was like he had grabbed a naked wire, but as it burned through him, it left him not scorched and scarred but cool, calm, certain. Only God did such as that, his mama said, and his daddy bought a piano for the boy, so the miracle could proceed.

Finally, something worth remembering.

He rests now in the cool dark of his bedroom and lets it draw at the old poisons in him like a poultice. He is a swaggering man by nature, but for a moment there is no strut in him.

"Mama and Daddy," he says, "believed in me."

He tried to pay them back, with houses and land and Cadillacs. " 'Money makes the mare trot,' Mama always said." But the debt will never be settled. The piano, the weight of it, tilted the world. He still has it, that first piano—the wood cracked and buckled, deep grooves worn in its keys—in a dim hallway in a house where gold records and other awards pile like old newspapers or lean against a wall. He pauses before the ruined piano now and then and taps a single key, but what he hears is different from what other people do.

The boat that taunted them is a ghost ship now.

The old songs sank beneath the water.

Elmo's boy, scoured by a worldly hell and toasted by kings, is still here.

In the summers of 2011 and 2012, I listened in the quiet gloom of his bedroom as he told me what was worth remembering. He told me some of the rest of it, too, when he felt like it, for as long as he felt like it. He remembered it as it pleased him. That does not mean he always

remembered it the same way twice, but day after day I was reminded of a line I once read: it was like any life, really, but with the dull parts taken out. It was odd, though, how he could see the boy on that levee so much clearer than he could see all the long life in between, like he was looking across that wide river again, at himself.

Before he rocked them, before the first piano bench went hurtling across the stage and first shock of yellow hair tumbled into his snarling, pretty face and the first spellbound, beautiful girl stared up from the footlights in unmistakable intent, he played Stick McGhee songs for Coca-Cola money from the back of his daddy's beat-up flatbed Ford and sang Hank Williams before he knew what a heartache was.

Before Memphis, before he took them from the VFW and convention halls to a place they'd not been even in a fever dream, before preachers and Parliament damned him for corrupting the youth of their nations, before he made Elvis cry, he listened to the Grand Ole Opry on his mother's radio, the battery she saved all week till Saturday night finally fading to nothing at the end of a Roy Acuff song.

Before bedlam, before he stacked money and hit records to the sun and blazed up, up, to come smoking to earth only to rise and fall and rise and rise again, before he outlasted almost all of his kind and proved on ten thousand stages that no amount of self-destruction could smother his voice or quiet the thunder in his left hand, before John Lennon knelt and kissed his feet, he performed his first solo in the Texas Avenue Assembly of God, then hid under a table in Haney's Big House to see people grind to the gutbucket blues.

Before any of it, before the first needle and first million pills, before the first coffin passed him by, he walked a high bridge rail like a tightrope between the bluffs of Natchez and the Louisiana side, laughing, loving the scare it threw into mortals below. A lifetime later, he rode across the same bridge and looked down to the muddy water of the Mississippi, to barges long as a football field; from up there, they looked like toys in a bathtub.

"I must've been crazy," says Jerry Lee Lewis, but if he was, it was just the beginning.

The weather seems different now from when he was a boy, the air so hot and thick the sky looks almost white. The afternoon thunderstorms that have shaken this land across generations now hang hostage in that cotton-colored sky, leaving the air wet and steaming but the fields dry as parchment for weeks, a thing the old people attribute to the end of days. But the end of days has been coming here for a long, long time.

"I wonder what it's like to die? I guess they give you shots and stuff, to help you with the pain. I don't really know," he says, softly, as Ida Lupino and *Beware, My Lovely* roll across a muted television screen. "Probably, you just drift off to another world. I don't know what that world will be like. I like to think it's Heaven. Can you imagine me in Heaven? Imagine the *orchestra* we'd have." He tosses a macadamia nut in his mouth, unscrews an Oreo, takes a long swig of purple soda, and ponders that. "Oh, man, what a *band*. I'll want to go twenty-four hours a day . . . won't never get tired. Won't never stop."

He has never believed the grave is the end of a man, and that has been his torture. The greater part of a man walks in Glory or burns; there is no real in-between, not in the Assembly of God. Across his life, he has proclaimed on a rolling basis the kind of man he considers himself to be, shifting from world-class sinner to penitent, sometimes in the space of a single song. Now his choice seems finally made. I am warned by members of his family, before I even enter his presence, that he abides no cursing, no blasphemy. He will live the rest of his life, he hopes, without offending God. He tithes. He blesses his food and prays at night the Lord his soul to take. He knows the Holy Ghost is as real as a pillar of fire. He believes, as always, in the God of Texas Avenue, and knows he has sinned greatly, deeply. But his God is a God of miracles and redemption, and in this case that might amount to about the same thing.

"I did a lot of thinkin' about that. . . . Still think about it, real heavy.
I sure don't want to go to Hell. If I had my life to live over, I would
change a lot of things," he says, not for the approval of man, but for the
grace of God. "I believe I would. I'd probably not do a lot of things that
I've done. . . . Jesus says, 'Be thou perfect even as my Father in Heaven
is perfect.' But my Lord, I'm only human. And humans tend to forget. I
don't want to die and my soul go to Hell.

"There *is* a Hell," he says. "The Bible plainly speaks of it, very big-
time. The fire never quenches, the worm never dies. The weeping and
wailing and gnashing of teeth. The lake of fire."

But he can bear that, he believes, better than the rest of it.

"I just want to meet them, meet all my people that I have ever lost, in
the new Jerusalem," he says. "I often wonder about that. God says you
will know as you are known, and if you don't see them there, it will be
as if you never knew them. That's awful. It worries me," the notion that
if he is cast down, it will be—to his people, even his children—as if he
had never lived. "That's heavy, ain't it?"

"The answer is written in the book of life, for me," he says, and the heat
in his eyes tells you this is not mere rhetoric but deadly serious. "Can a man
play rock-and-roll music and go to Heaven? That's the question. It's some-
thing that won't be known . . . that *I* won't know, till I pass away. I think
so, but it don't matter what I think. And I will take all the prayer I can get."

The question almost pulled him apart, as a younger man. Elvis, who
would understand the question perhaps better than any other man, was
haunted by it, too. Jerry Lee would have liked to talk with him about it,
but Elvis hurried away, face white as bone; and then he left this world,
leaving Jerry Lee to grow old with it alone.

The thing he has come to believe, to hope, is that whatever happens
in this life or beyond, it is not purely the music's fault. People blamed
the music for everything.

"It's not the devil's music," he says, sick and tired as he would be of
any pretender, any hanger-on.

He is almost eighty years old now. He knows what he has wrought.

"It's rock and roll."

The devil was no troubadour. The theater of it all, the convenient women and bottomless liquor and jet-plane parties, the whipped-out knives and waistband pistols and bags of blues and yellows, might have drawn the devil like green flies, but the devil never called a tune or found a chord, not even in the nastiest blues or most whiskey-soaked cheatin' songs or any other music that moved a waitress to wiggle her hips or a farm boy to dance in his socks or a notary public to shake the hot rollers out of her head.

"My talent," he says, "comes from God."

Mamie tried to tell them, even as she worried where it would all end.

"I can lift the blues off people," he says.

He did some meanness, God knows he did.

But the music—funny how it turned out—was the purest part.

Mama's cookin' chicken fried in bacon grease

"The only piano player in the world . . ." he says.

Come along boys, just down the road a piece

" . . . to wear out his shoes."

In the twilight of his life, in the late nights of the here-and-now, he sometimes still wonders: "Did I lead them people down the right way?"

But he did not take the people anywhere they were not ready to go. Even in the most barren times, when cigarette smoke hung like tear gas in mean little honky-tonks and he might have missed a step on his way to the stage, he gave them something they were looking for. People say a lot of things about him—"talk about me like a dog," he says—but few

people can say he did not put on a show. They talk about seeing him and grin and shake their heads like they got caught doing something, like someone saw their car parked outside a no-tell motel in the harsh light of day. They grin and talk about it not like a thing they witnessed but like a thing they lived through, a meteorite or a stampede. It usually started without fanfare; he just walked out there, often when the band was in the middle of a song, and took a seat. "Gimme my money and show me the piano," he often said of how the experience would begin. But it ended like an M80 in a mailbox, with such a holy mother of a crack and bang that, fifty years later, an old man in a Kiwanis haircut and an American flag lapel pin will turn red to his ears and say only: "Jerry Lee Lewis? I saw him in Jackson. Whoooooooooo, *boy!*"

Joe Fowlkes, a Tennessee lawyer, likes to tell about the time in the mid-1980s when he heard Jerry Lee do four hours at his piano without a break, after he was already supposed to have been dead at least twice. "We all went to see him at the dance hall at 100 Oaks" in Nashville, he recalls. "They called it a dance hall because it was better than calling it a beer joint." Jerry Lee showed up looking a little worn and pale, and he started off slow—"it was kind of gradual, like watching a jet taking off"—but he played and he played and he played, and it was three o'clock in the morning before he got done. "He kind of got his color back, after a while. By two-thirty in the morning, he was lookin' good. He played every song I'd ever heard in my life, including 'Jingle Bells' and the Easter Bunny song. And it was *July*.

"It was the best concert I'd ever been to. I saw Elvis. I saw James Brown." But Jerry Lee. "He was the best."

"There was rockabilly. There was Elvis. But there was no pure *rock and roll* before Jerry Lee Lewis kicked in the door," says Jerry Lee Lewis. Some historians may debate that, but there was no one like him, just the same; even the ones who claimed to be first, who claimed to be progenitors, borrowed it from some ghost who vanished in the haze of a Delta field or behind the fences of a prison farm. People who played

with him across the years say he can conjure a thousand songs and play each one seven ways. He can make your hi-heel sneakers shake the floor-boards, or lift you over the rainbow, or kneel with you at the old rugged cross. He can holler "Hold on, I'm comin' " or leave you at the house of blue lights. Or he can just be still, his legend, the legend of rock and roll, already cut into history in sharper letters than the story of his life. Sam Phillips of Sun Records, a man who snagged lightning four or five times, called him "the most talented man I ever worked with, black or white . . . one of the most talented human beings to walk God's earth."

"I *was* perfect," he says, "at one time. Once, I was pretty well perfect when I hit that stage." On another man, such a claim would wear like a loud suit. On Jerry Lee Lewis, it sounds almost like understatement. Roland Janes, the great guitar man on so many Sun Records hits, once said that not even Jerry Lee knows how good he is.

He knows. He likes to use the word *stylist* when referring to some of the musical greats who came before: it is his highest compliment. A stylist is a performer—not necessarily a songwriter, yet still a creator—who can take a thing that has been done before and make it new. "*I* am a stylist," he explains. "I can take a song, a song I hear on the radio, and make it *my* song." He can remember the first time he felt that power, too. "I was fifteen years old. Back then I played the piano all day and then at night I'd lay in bed and think about what I'd play the next day. And I see records that was out there, see the way they were going, and I just thought that I could beat it. Back then, I was playing the skating rink in Natchez, on this old upright piano—I remember it wasn't in very good shape—and I played everything. I played Jimmie Rodgers, Hank Williams, boogie-woogie, and I turned it *all* into something else. What did I turn it into? Why, I made it rock and roll."

He made it roll and thump in the spaces between the plaintive lyrics, a thing of rhythm impossible to describe in words. "The girls crowded around me and the boys got all upset and wanted to start a fight, but

before long *ever'body* was lovin' it. I can see 'em now. And it was love. Pure love. I loved it, and they loved it. That don't come around too often, I don't believe. And it wadn't just the song they loved, it was the *way.*" At first he was struck by the power, at the rapt faces, the heaving chests, but did not marvel at it for long. "If you know you can do a thing," he says, "then you ain't never surprised."

He is not, even with the years tearing at him, a soft man. His body has been hammered by hard living, and scoured by chemicals, and pain-racked by arthritis and most of the ailments of Job, but now he is rallying again, with clean living and that mysterious thing he has always had cloaked around him, something beyond science. He is still a good-looking man, his hair faded from gold to silver; he still records and fills concert halls in the United States and Europe, though he admits it is sometimes all he can do to finish a show. Young women still push to the edge of the stage and try to follow him back to his hotel room. Now it is his prerogative to tell them no, because the shows exhaust him. What a sorry thing, a rotten choice for a good lookin' rock-and-roll singer to have to make.

"If I's fifty-one," he says, "they'd have to hide the women."

He lives near the river still, south of Memphis in the low, flat green of north Mississippi on a ranch with a piano-shaped swimming pool, behind a gate with a piano on the wrought-iron bars. Here the living history of rock and roll sits unrepentant to any living man, and even as he tells you his life story, he seems to care little what you think. "I ain't no goody-goody," he says, the Louisiana bottomland still thick on his tongue, "and I ain't no phony. I never pretended to be anything, and anything I ever did, I did it wide-open as a case knife. I've lived my life to the fullest and I had a good time doin' it. And I ain't never wanted to be no teddy bear."

He has been honored by state legislatures and dog-cussed over

clotheslines. He has disowned children and walked away from wives and girlfriends—even in the age of DNA, none has challenged his actions—and does not much care that his life and his choices might not make sense to other people. "I did what I wanted," he says. He lived in the moment, unconcerned what those moments would add up to in the eyes of men. "Other people," he says, "just wished they could have done what I done." He is unconcerned with worldly redemption. He has bigger worries than that.

He has played over seven decades, from pubs to palladiums, from soccer stadiums to Hernando's Hideaway South of Memphis, for thousands, or hundreds, or less, because even when there was no one to play for but a handful of drunks or hangers-on, there was still the talent, and when you have a jewel, you do not hide it in a sock drawer. Raw and wild in the 1950s, almost forgotten in the mid-'60s, a honky-tonk chart-topper by the early '70s, and a Rolls-Royce–wrecking, jet plane–buying crazy man in the late '70s and '80s, he always played. He absorbed scandal—*Rolling Stone* virtually accused him of murder—and played when he could barely stand. He spent two decades wandering the wilderness, overmedicated, set upon by the tax man, divorce lawyers, everything but a rain of toads. There were more fights and pills and liquor and car crashes and women and discharge of firearms—accidental and on purpose—than a mortal man could be expected to survive, but he played.

I approached him with great anticipation—and one reservation, as to getting shot. People told me he was mercurial; some said he was crazy. He shot his bass player, they said. Why not shoot a book writer? Instead, across the days, he was mostly gracious, and asked about my mother. "I hit this one guy in the face with the butt of the microphone stand," he tells me, as he eats a vanilla ice cream float. He actually hit four or five that way. He remains willing to take a swing at a man who offends him and suffer the prospect that some drunk redneck half his age will not care he is living history and knock him slap out. His bedroom door is

reinforced with steel bars. I started to ask about that but decided I did not need to. He still has a loaded long-barreled pistol behind a pillow, a small arsenal in a dresser drawer, and a compact black automatic on a bedside table. Holes in a bedroom wall and an armoire prove that all that has come to claim him in the night, ghosts, bad dreams, or time itself, has been dealt with violently. A bowie knife sticks in one door. A dog sleeps between his feet—a Chihuahua, but it bites.

He has, in old age, a stiff-necked and—all things being relative—sober dignity, but do not say he is growing old gracefully, any more than an old wolf will stop gnawing at his foot in a steel trap. It is harder, even now, to explain what he is than what he is not. He is not wistful, except in the rarest moments, and does not act wounded; he just gets mad. He does not swim in regret, even when he walks between the graves of two sons and most of the people he has ever loved. Six marriages ended in ashes, two of them in coffins. He believes he is due some things but not the right to whine. A man like him forfeits that. A Southern man—a real one, not these modern ones who have never been in a fight with a jealous husband or changed a tire or shot a game of pool outside the church basement—does not whine, anyway. "It didn't bother me none," or "I didn't think much about it," he often says when talking about things that would have torn another man down to his shoes. Then he would physically turn away. In time I came to understand that remembering, if you are him, is like playing catch with broken glass.

His friends and closest kin, most of them, are protective of him now, always polishing his legend. They will fight you if you question his generosity, or the goodness that, they assert, shines just beneath his more public persona. He has played benefit after benefit for charity, even when he himself was busted, or nearly so. That does not mean he does not expect to get his way, almost all the time. "He don't jump on top of the piano anymore," said guitar picker Kenny Lovelace, who played three feet away from him for forty-five years. "But still, he walks out there and sits down, and you know the Killer is here."

"I was born to be on a stage," says the man himself. "I couldn't wait to be on it. I dreamed about it. And I've been on one all my life. That's where I'm the happiest. That's where I'm almost satisfied." He knows that is what musicians say, what a musician, in his twilight, is supposed to say. "I do really love it," he says, in a way that warns you not to doubt him. "You have to give up a lot. It's hard on a family, on your women, on the people that loves you.

"I picked the dream."

Even if it was worn and scarred, or hidden in some raggedy place at the end of a gravel road, or protected by chicken wire, he would drive six hundred miles, even club a man with a microphone, to possess it. And for much of his life he gave his fans more than they paid for, gave it to them slow and soulful and fast and hard, till the police came clawing through the auditorium doors, refusing to relinquish the stage even as other rock-and-roll idols, including the great Chuck Berry, waited helpless and seething in the wings. In Nashville, three hundred frenzied girls in the National Guard Armory tore his clothes off his body, "down to my drawers," and he grumbles about it to this day, about all those crazed, adoring women, because they cut short a song, dragged him off the stage, and cut short the show.

The dream is why, when news of his marriage to his thirteen-year-old cousin, Myra, caused promoters and some fans to turn away and his rocket ship to sputter, when scandal and changing times caused record sales to sag, he filled two Cadillacs with musicians and equipment and went on the road. He played big rooms at first, then dives or beer joints where he had to fight for his money or fight his way out the door. But he played, fueled by Vienna sausages, whiskey, and uppers, and the next day he rolled out of some little motel, said good-bye to women without names, and drove all day and into the night to play again. Others became footnotes, vanished. He fought, tore at it, one motel room, one bottle, one pill, one song at a time. And it is why, in the early days of his stardom, he would come back onstage when the house was dark and the

door chained shut, to play some more. Other musicians on the bill, ones who would be legends, too, trickled back to the stage to sing with him, for that one last encore to the empty seats.

"I want to be remembered as a rock-and-roll idol, in a suit and tie or blue jeans and a ragged shirt, it don't matter, as long as the people get that show. The show, that's what counts," he says. "It covers up everything. Any bad thought anyone ever had about you goes away. 'Is that the one that married that girl? Well, forget about it, let me hear that song.'"

Hank Williams taught him this, and he never even met the man.

"It takes their sorrow, and it takes mine."

He looks across the arc of bad-boy rockers who have come after him and laughs out loud; amateurs, pretenders, and whistle-britches, held together with hair spray. But worse, they were not true musicians, not troubadours, who lived on the road and met the people where they lived. He crashed a dozen Cadillacs in one year *and* played the Apollo. With racial hatred burning in the headlines, the audience danced in the seats to a white boy from the bottomland, backed by pickers who talked like Ernest Tubb. "James Brown kissed me on my cheek," he says. "Top that."

In recent years he has recorded two new albums, both critically acclaimed, and both made the Top 100. He did them between hospital visits: viral pneumonia, a stabbing recurrence of his arthritis (in his back, neck, and shoulders, never in his hands), and broken bones in his leg and hip have left him in pain and unable to travel or even sit for more than a few minutes for much of the past few years. But even at his lowest, of course, Jerry Lee was merely between resurrections. In March 2012 he married for the seventh time, to sixty-two-year-old Judith Brown, a former basketball star who had been married to his former wife's little brother. She had come to help care for him when he was sick. To make the proverbial long story short, he got better. "I didn't mean to fall in love with him," she says, "but . . ." They married

and honeymooned in Natchez, near the bridge he walked as a boy. By late summer 2013, he was back playing gigs in Europe, booking studio time in Los Angeles, buying a new Rolls-Royce and stopping for Sonic cheeseburgers before driving Judith's Buick one hundred miles an hour down Interstate 55. The laws of Tennessee, Mississippi, Louisiana, and the United States of America have never much applied.

Once, while mulling over a difficult question, he muttered, "This feller's about to get shot." And I thought, *Well, I'm dead*. It was only *Gunsmoke* he was watching over my shoulder. He'd seen it all before, and he knew what happened next.

"You know, you can load that .357 with .38 shells," I told him, "and you won't blow such deep holes in . . . things." I waited a few flat, silent seconds, knowing I had wasted my breath.

"Naw," he finally said, "I don't think I'll do that."

One afternoon near the end of it, I told him why I wanted to write his story. I was born in the South in a time of tailfins, when young men with their hair slicked back with Rose hair oil and blast-furnace scars on their necks and arms would thunder down the blacktop with his music pouring from the windows. The great Hank Williams lifted their hearts with "Lovesick Blues" and became a kind of sin eater for their lives and pain. "That's it," says Jerry Lee. "Hank got them up off their knees, and Jerry Lee got them to dancin'." They loved Elvis, too, but there was a softness in him, a kind of beauty the men did not understand. They got Jerry Lee. He was a balled-up fist, a swinging tire iron. My people, aunts and uncles, rode ten to a car to see him in Birmingham's Boutwell Auditorium in 1964. "I was wild as a buck then," said John Couch, who made tires at Goodyear. "And he embarrassed me." His wife, Jo, was scandalized. "They got all over Elvis for shaking one leg. . . . Jerry Lee shook *everything*." Juanita Fair, a bird-like member of the Congregational Holiness Church, remembers just one thing, and has to whisper. "He played piano, with his *rear end*." They drove home to pipe shops, furnaces, and cotton sacks, somehow lighter than

when they left. I told him this one afternoon as heroes sang to their horses and bad men reached for the sky.

"I did it for them people," he says, though a great deal of the time he did it for him, because without the music, I had come to believe, he would just cease to be, like cutting through the drop cord on an electric fan. In the still, awful nothing, he is just like everyone else. But it was still a fine thing to say. The point is, when he talked about lifting the blues off people, I knew it to be true. In the past, in telling his story, he pretty much cussed out the world. It was like the story of his life was a record warped and stuck on the wrong speed, but left on, anyway, to howl, groan, and hiss. He was, he admits, often a little bit drunk or mad in those days, and he put people on, to watch them twitch or swing on the gallows of his temper and moods. Even today, it can seem that the only people he truly trusts with his legacy are the ones who knocked over seats as they lunged to their feet in the city auditorium, who got their money's worth in the Choctaw casino, or who begged him for one last song in some airport hotel lounge. Only they will remember him right. "I look at the faces," he says. "I look out there, and I *know*. I know I've given 'em something, boy, something they did not know was out there in this *world*. And I know. They won't forget me."

In the dark of his room, the rock-and-roll singer watches himself on the big-screen television, watches himself in fifty-year-old black and white do that song about shakin' that conquered the world, watches the power in that young, dangerous man. He sees the man stab the keys and kick away the bench and lift the audience from its seats to come swarming, twisting, jumping onstage, to close in a tight circle around his grand piano, all of them shakin' and twitchin' like he has them on a stick or a string or a jerking rubber band. He sees him vault on his young legs to the lid of the piano as if some outside force just threw him there, as the other young people snatch at him, at his hair, at the hems of his

garments. The boys seem about to lose control of themselves and break something or turn over some cars. The women, jerking and sobbing, seem about to faint, or die, or embarrass their mamas. As he watches, the old man's toes tap, tap, tap in time, and his fingers play the air. "Gr-r-r-r-r-r-r-r-r-r-r," he says, in duet with the young man, and grins wickedly. When the song is over and the young man takes his exaggerated bow, the old man settles back in his pillows, content. Then, from the gloom, barely loud enough to hear, comes a soft "Hee-hee-hee."

Later, on one of those quiet, weary afternoons, I have one more question before we stop for the night.

"Didn't I hear once that you . . ." But he cuts me off.

"Yeah," he says, "I probably did."

1

THE FATHER OF WATERS

. .

Concordia Parish, Louisiana

THE BEGINNING

The water would rise up every few years, wash across the low, flat land, and take everything a poor man had, ruin his cotton and corn and drown his hogs, pour filth and dead fish into his home, even push the coffins from the earth and float his ancestors all the way to Avoyelles. Jerry Lee's sister, Frankie Jean, tells of a day the rains beat down, the rivers rose, and the swelling groundwater shoved the dead from the mud. "Uncle Henry and Aunt Maxine had been nippin', and they went by Uncle Will's grave and saw he'd come partway out of the ground. Uncle Henry said, 'Oh, Lord, Maxine, the Rapture has done come and the Lord has left us here. He tried to take Will and Will just wouldn't go. Oh, God, Maxine, we done been left behind. Oh, God, Maxine, I told you not to buy that whiskey. . . .' " The point is, it takes guts to stay with it when the land you owe the bank for runs liquid between your toes and balls of water moccasins form islands on the rising tide. Water was everywhere, was life, and death. A person could not live here in this low place, Jerry Lee believes, and be afraid of water.

"We were going to the backwater one day, me and Daddy," he says,

traveling as far back as his memory could reach. "I was three years old." It was late summer, the Louisiana sun hot on his blond head. Elmo, singing about trains and untrue women, swung his boy like a knot on the end of a rope. They followed the river to a place where the current slacked and died and pooled in lakes and sloughs, as still as black glass. The air smelled as it has always smelled and smells now, of a thousand years of silt, rot, and mud. His daddy pushed an old boat into the shallows, and they headed to deep water. The boy had never been out so far, never done more than wade close to the bank, toes digging into the silt and sand, his mama and daddy holding his hands. This water had no bottom, let in no light. They drifted a while, just living.

Then his daddy reached for him, lifted him high in his arms, and threw him out of the boat.

The water closed over his head. He thrashed toward the light, sank, and clawed his way up again, in panic. He kicked at it with his legs as if it was filled with devils, all twining around his skinny body, dragging him down. It was not a cruelty, he knows now, it was just his turn. It did no good to wait till a boy was older. The terror only grew with the child. You threw them both in the river and took what came out.

"Get with it, boy!" his daddy yelled.

Jerry Lee drank the water in, breathed it, choked.

"Swim," his daddy yelled, "or float!"

"Help me!" the boy hollered.

But his daddy only knelt in the boat, his arms outstretched.

"Come on, boy!"

"Help me!"

"Come on."

Then he felt iron fingers on his arm and he was lifted up, up, forever out of his fear. He thinks now his daddy would have saved him; surely he would, would have dove into the suffocating black and pulled him free just in time. But what kind of boy would he have held there, squalling? "It wadn't no easy place," he says now. But it was here, at the river,

that his people came to settle, to snatch once more at the good life after the high ground failed them for the last time.

"If you're ashamed of where you're from, then you're ashamed of yourself," he says of the years he lived in overalls, mud-bound. "I ain't never been ashamed. Ferriday, Louisiana, is where I'm from. We lived a while at Black River, and lived a while down at Angola, when Daddy helped build the prison there. Daddy was up at four o'clock, and Mama was up five minutes after. Daddy followed carpentry work, so we moved all the time, moved three times in one week, to old shanty houses, mostly. He farmed cotton, corn, soybeans, split halves with my Uncle Lee, and he made some whiskey. Mama picked cotton. It was a small place, but it never seemed small to me, when I was a boy." It is where his people, all of them, are buried, "so it's home to me." He has never been one of those poor Southern children who claim to have lived in blissful ignorance of their poverty and the life into which they were born; such a thing leaves no room to dream. "It kind of dawns on you after a while. It occurred to me pretty quick." His mama and daddy never owned much of the bottomland when he was a boy, sometimes not enough to fill a teacup, but that only made it more precious. It was their last stand, this Concordia Parish, and even now, as he crosses the bridge from Natchez, he breathes easier, as if someone has lifted a heavy hand off his chest. He has to try to remember the bad of it; the good comes easy, "all good, good singin', good eatin', good—You know that song about the tree?"

> I'm like a tree that's planted by the water.
> I shall not be moved.

People have been dying beside these waters a long time, hoping for a piece of the unsteady ground, hoping to grow something from it. Would he have been the same if he had come from a gentler place? "The talent would have come through," he says, "even if I'd been born

in some big city. But it mighta been . . . different." It might have been, somehow, gentler. "I think my music is like a rattlesnake. It warns you, 'Listen to this. You better listen to this.' " That essence, the toughness and meanness and maybe even a spike of savage beauty, he believes, crawled straight out of this mud.

In *Wicked River: The Mississippi When It Last Ran Wild*, historian Lee Sandlin identifies a quality that seems to have marked Mississippi River people from earliest days: "They all lived for the spontaneous, heedless surge of wild exuberance, the sudden recourse to violence with no provocation—the violence if not of act then of thought and language. They routinely did and said extraordinarily foolish things for no reason other than joie de vivre." One such character was a Bunyanesque scalawag named Mike Fink. "He was a creature of pure impulse—and yet whatever he did, no matter how bizarrely random it might be, he did perfectly. He achieved without effort what nobody else could do in a lifetime of labor. His air of godlike grace, of what in classical literature was called *arete*, transcended everything about his personality—which was in all other ways appalling."

Figures like Mike Fink "had a ritual game they'd play called shout-boasting," Sandlin writes, "the point of which was to make up surreally violent claims about themselves, and then dare to fight anybody who challenged them."

But it is not boasting, as Jerry Lee says, "if you really done it."

The Spaniards came to the river in 1541. Hernando de Soto led men in iron helmets into the malarial jungles in a bloodthirsty search for nonexistent gold and was one of the first white men to die in the heat, damp, and mosquitoes thick as fog; some say his rusty conquistadores still ride in the mist. Pierre Le Moyne d'Iberville et d'Ardillières, knight of the Order of Saint-Louis and founder of the Colony of Louisiana of New France, brought settlement and Bible and sword; soon the indigenous

tribes were extinct. Flags would go up and down as white men fought over it all, till the Old World finally retreated from the yellow fever and floodplain.

In 1803, the Louisiana Purchase gave the mud to a new nation, and Thomas Jefferson sent naturalist William Dunbar to see what all the dying was for. Dunbar explored the Mississippi, Black, and Ouachita rivers by boat and horseback, and in his journals he made the land sound like paradise. "Vegetation is extremely vigorous along the alluvial banks; twining vines entangle the branches of trees [with] the richest and most luxurious festoons." The result was "an impenetrable curtain, variegated and spangled with all possible gradations of color from the splendid orange to the enlivening green down to the purple and blue and interspersed with bright red and russet brown." Dunbar saw endless oak trees, red and black, along with ash, pecan, hickory, elm, and persimmon; the soil was "black marl mixed with sand," the riverbanks "clothed in rich canebreak." The forest along the river would offer "venison, bear, turkey . . . the river fowl and fish . . . [along with] geese and ducks surprisingly fat, and excellent."

And the river itself? Dunbar wrote of its unpredictability and moods, of whirlpools and crosscurrents where, "even in the thread of the stream, we can make no sense of it."

Natchez would become the seat of civilization here, and it was a city of two faces. One was gentility itself, a place of plantations that set a standard for opulence, of cotillions and white columns, of high tea and fine saddle leather, London silver and Parisian gowns, all resting on a foundation of human bondage. On the other face was a leer, a wild gateway to the West peopled by gamblers, whores, pirates, riverboat men, trappers, no-accounts, swindlers, and dope fiends, where keelboats, riverboats, and oceangoing ships lined the docks; the river was so deep that the big merchant ships could creep all the way from the English ports to the whorehouses in Natchez Under the Hill. Sailors from around the world drank, fought, and cursed here in their language

of origin. Beyond the lights, pirates used lanterns and bonfires to lure boats aground, robbed passengers, and rendered their bodies to the catfish.

Across the river, in Concordia Parish, in rich bottomland fed by centuries of flood, the land was hacked and burned into vast, gray-brown fields. Small towns like Vidalia, Waterproof, and St. Joseph bustled with commerce, as great steamboats tied up to take on unending cargoes of cotton and lumber. The *Southern Belle, Princess, Magnolia, Natchez*, and *New Orleans* served meals to rival any restaurant in New Orleans and had staterooms to rival the grandest hotels. The Indians called them "fire canoes," and they routinely burned to the waterline. But every arrival in Natchez or Concordia Parish was a carnival, to see what the river would bring. Their captains became mythical figures, and poets told of them as the Greeks sang of Agamemnon:

> *Say, pilot, can you see that light?*
> *I do—where angels stand.*
> *Well, hold her jackstaff hard on that,*
> *For there I'm going to land.*
> *That looks like death a-hailing me*
> *So ghastly, grim and pale.*
> *I'll toll the bell—I must go in.*
> *I've never missed a hail.*

It took muscle to power it all, and by 1860 there were 12,542 slaves in Concordia Parish alone, compared to 1,242 free whites—a cold-blooded economy wherein many plantations were controlled by absentee owners who saw the fields as a pure business venture. Life expectancy was so poor for slaves here that slave owners in other states used Louisiana plantations as a lash to keep their own slaves in line, saying if they misbehaved, they would be sold south. With populations in such disproportion and order kept by bullwhip and rope, it was a tense and

brittle arrangement, prone to insurrection. One often-told story involves a slave, found guilty of murdering white men and kidnapping white women, who was burned on a pyre, or at least it was planned that way till he pulled his chains free of the post and staggered off—only to be shot dead, disappointing the crowd.

Violence lay thick here, like the air. Duels were so common on the sandbars that they take up fifteen pages in Robert Dabney Calhoun's *History of Concordia Parish*. Democrats shot at Republicans, husbands shot at judges in their wives' divorce claims, and physicians and generals shot at senators, congressmen, and the commanding officer of the Mexican War. In 1827, Dr. Thomas Maddox challenged planter Colonel Samuel Wells to a duel over some forgotten thing. Both men missed their first shot and honor was satisfied, but their seconds decided to settle old scores and opened fire. Two men died. One of the combatants, the planter Jim Bowie—who would go on to die famously at the Alamo—stabbed a man to death with his knife. The two sides did not consider honor satisfied and would argue for years over who among them was the biggest lout, rogue, skunk, and low-bred. Most affairs were not so bloody, as those smoothbore pistols were notoriously inaccurate, and most gentlemen would accept a clean miss as providence and pull a cork. With Concordia Parish in mind, the Constitution of 1845 tried to curtail dueling, warning its practitioners that they risked being "deprived of holding office of trust or profit." (It is lucky, say some, that the practice was outlawed before the arrival of Jerry Lee.)

The war dismantled the old society. Ulysses S. Grant took Vicksburg midway through the war, and Natchez followed. Natchez became a gracious occupied city, while in Concordia slaves walked off the fields and headed to occupied New Orleans, some to fight for the Union, and some to bring their own music to town, where they blended it with local Creole sounds and bent it into a new music called jazz. The bottom land fell hard into a puzzling time when black men wore badges, carried guns, served in the statehouse, and stood in judgment of whites on

juries and from the bench itself. Reconstruction brought carpetbaggers, night riders, and Jim Crow, but it was still cotton that swung fortunes for rich and poor. Poor whites, who survived dysentery and grapeshot and suicide charges against the high ground, came to skin logs out of the woods; ex-slaves came to work the dirt, old stripes on their backs. The twentieth century brought the levees, so tall a man had to walk uphill to drown, but the river was indifferent still, and when hard rains came, it washed over and through and drowned the poor men's dreams anyway, and fish swam in the streets of the river towns.

But it does not take much dry ground to hold up a train track, and that is where a relative prosperity—and for some poor men and women, a promise of salvation—took hold. The Texas & Pacific and Iron Mountain railroads decided they needed a terminal in Concordia Parish to service trains that hauled wood and cotton. It would be a corporate town, drawn up by an investment company on the site of an old plantation and named for the owner of the plantation, J. C. Ferriday. It was incorporated in 1906, and for passersby it was as if a town appeared overnight. Author Elaine Dundy called it "a town with no natives," a wide-open place with a cotton compress mill, a sawmill, a lumberyard, and a large compression plant on the pipeline from the Monroe gas fields to Baton Rouge. By 1920 there were 2,643 whites and almost 10,000 people of color in the parish, and on payday they came to Ferriday to spend their money.

Ferriday, Louisiana, would become known as one of the wickeder places on earth, a place where brothels, gambling dens, and saloons ran around the clock. "Not only a bad town . . . the baddest town," as Dundy wrote in her biography of the place. Men beat each other to death in the street over wives or cards, or even if someone kicked a deer hound. Hogs and cattle roamed Main Street, and in winter, when forage was lean, men knocked the limbs off the trees so livestock could get at the moss. Railroads would come and go, but by the 1930s, as the Depression sucked the life out of much of the country, the Texas & Pa-

cific, the New Orleans & Northwestern, and the Memphis, Helena & Louisiana all made the village a destination. Drummers and gamblers and oil speculators arrived a trainload at a time, bound for the King Hotel, and hoboes came off the boxcars like fleas.

It was busy, and busy meant work.

"The Lewises come from Monroe" to Ferriday, said Jerry Lee, and their history was not always one of cotton sacks and shanty houses. His great-great-grandfather was Thomas C. Lewis, a landowner who became a parish judge in Monroe. His son, John Savory Lewis, Jerry Lee's great-grandfather, was a fearsome, powerful man, a prosperous slave owner, but when the Yankees came, that dynasty fell, too. Some of his children would prosper, but one, Leroy Lewis, Jerry Lee's grandfather, drifted in and out of professions till he settled on farming, for which he had no aptitude. His talents were in making music. He fiddled like a man on fire, fiddled as the old century gave way to the new. He passed that love of music and talent to his children, with a kind of perpetual grin that defied everything the broken South had left him. He was also prone to drink hard and often and then just disappear for a while, leaving his wife, Arilla, to wonder if he was dead. "You drunk, ain't you?" Arilla would ask when he reappeared, wobbling. "No," he would say, "I am intoxicated."

In 1902, a son was born in Mangham, Louisiana. Elmo Kidd Lewis was one of eleven children, a good-looking boy with crow-black hair and that squared-off face and a permanent, inked-on grin. He was what his blood had made him, a man of great physical strength with a lovely voice and flair for music, and the thirst of generations. But there was no cruelty in him for smaller souls, say his son and others who remember him, no meanness for women or children, a lowness other men who liked a drink could not always claim. By the time he was born, there was nothing of the old family left to him but a name, so in daylight he

dragged a cotton sack and swung a hammer, and in the nighttime he picked guitar and sang. He did not fight other men; never had to, just slapped them down to the ground, "quick as nothin'," says his son. He wore that badge of honor Southerners bestow on good men who drink, if they "didn't bother nobody" and "never missed a day of work." To the landowners, he was a cotton-sack-pullin', nail-drivin' machine. Elmo had his dreams, of someday playing music onstage, but there was such a vast distance between that and his waking life, across rows and rows of cotton that wasn't going to pick itself, that he seldom talked about it till he was older and the dream had gone to seed, after which he talked about it all the time. Like many working-class Southerners, he felt something deep inside when he heard Jimmie Rodgers sing of lost love, shantytowns, lonesome whistles, and chain gangs, and could see himself yodeling on the radio like his hero, before tuberculosis choked him to death in a New York hotel at thirty-five.

> *I'm gon' buy me a pistol, just as long as I'm tall*
> *I'm gonna shoot poor Thelma, just to see her jump and fa-all*

The great flood of 1927 drowned the fields and made hard times worse, as powerful men of the state tore apart the levees to flood the land upriver and save New Orleans. It was a bitter time in Louisiana, a historically corrupt place that proudly carried those traditions into the twentieth century. In '28, ragged and angry voters put in power a kind of half-mad puppeteer, a song-leading dictator named Huey P. Long, known as the Kingfish. He swore to redistribute the wealth of giants such as Standard Oil and to make every man a king. He preached reform from the towering state capital, built by poor men on relief, and lived lavishly in a suite in the Roosevelt Hotel in New Orleans. He had ambitions to claim the White House and scared rich people to death. From the eve of the Depression, as governor and senator, he built 111 bridges and thousands of miles of roads, and he promised to end

the plight of hungry children, the soul-killing darkness that enveloped them, if desperate men like Elmo would just give him a little more time.

In the heartbreak of that moment, in Richland Parish, Elmo met a dark-haired girl named Mary Ethel Herron, whom everyone called Mamie. She was a lovely girl, if a little serious, and devout, which scared off the lesser rascals, but good women are naturally drawn to a rogue. She saw in the grinning, rawboned Elmo one of the most striking men she had ever met. On weekends in those days, the country people would congregate at an abandoned house, sprinkle cornmeal on the plank floor to slick it up, and dance. Elmo played his guitar and sang, and won her heart from the lesser rascals. She was a good woman, which in Southern vernacular usually means long-suffering, but Mamie was different. She was gentle on the outside but had iron in her jaw. She understood that all men have in them a certain sorriness, and she was willing to run the train if other hands were unsteady. Elmo and Mamie were married in 1929, when she was seventeen and he was ten years older, as the Depression settled on the land. He farmed other men's dirt, and she picked cotton beside him, when they could find work.

Mamie's mother's people, the Foremans, were prosperous, but her mama, Theresa Lee, married a poor farmer named Will Herron, and the prosperity had died at the bottom of that lover's leap. The only legacy the Foremans passed on was a thing in the blood, a kind of darkness that dropped across the mind and left a person to wander, haunted, till they found a way out. There are names for it now, clinical explanations of dementia and depression, but not so much back then, in the low country. No one—at least no one Jerry Lee can recall—ever refused to pick cotton or frame up a house because they felt depressed; people walked inside it, lived next to it. "I guess I get it from both sides," Jerry Lee says, and he will not talk about it much beyond that. It is just a thing that rides across the generations, landing where and when it chooses, and a man could blame all his actions on it, all his mistakes and miseries, if he chose; he chooses not to do that, any more

than he blames—except in the rarest of circumstances—the whiskey, the drugs, or the devil. He owns his mess.

Elmo's father-in-law, Will, was a hot-tempered, stumpy little man who raised excellent deer dogs and was said to be quick to pull a knife. "Kill you," says Jerry Lee, "at the drop of a hat." When Will and Elmo hunted together and came to a fence line, Elmo would just pick the little man up like a child and set him down on the other side, recalls Jerry Lee. That sometimes made Will Herron so mad he hopped like a small, agitated bear, but it was hard to cut a man like Elmo, who smiled at you without even a trace of fun. Herron was "four-foot-somethin'," says Jerry Lee, but the old man was a crack shot and could bring down deer even from the saddle of a horse. "He'd say to Daddy, 'You don't get none of this deer,'" if he was mad at his son-in-law, but Herron seldom stayed mad for long. Elmo had that gift, too; he was a magnet for forgiveness.

In the evening, after suppers of cornbread and beans, Elmo and Mamie listened to records on a wind-up Victrola, their single luxury, and sang duets from the hymnal. She had a lovely voice too, and they sounded beautiful together, but she would not sing drinking songs or hobo songs, which were sinful. They were poor but had enough to live, to eat, till the fields went fallow in Richland Parish, till there was nothing better than starvation wages. The newlyweds needed a new start, and lately all their kin had been talking about a town in Concordia Parish wedged between the river and railroads. Two of Elmo's sisters had married brothers named Gilley and moved to this place, Ferriday, and another sister, who would marry a man named Swaggart, was thinking on it. But the linchpin of it all was Mamie's lovely older sister, Stella, who had landed the richest man in all Concordia, a speculator in land and people named Lee Calhoun.

Lee was not a big man physically, or particularly handsome, and if you saw him walking down the dirt street in work-stained khakis, you might have thought less of him than he was; people regretted that. He had a voice

bigger than himself, cursed loudly and often, yet built three churches from his own pocket. He came from money, from educated people, but acted like he crawled from under a broke-down Chevrolet. He was smart as to a lot of things, but especially land. He understood that, despite what the scientists said about gravity, what really kept people from drifting off into nothing was the land. The man who controlled it controlled everything worth thinking about.

Lee Calhoun did not farm but owned dirt and seed and mules and the plain, bare houses, did not ranch but owned the grass. He saw liquor as a commodity, not as a thing he took into himself. He hired his kin to make bootleg whiskey in the deep woods, men who would absorb the risk of hard time the way other men absorbed blisters from a hoe handle. "He was the backbone of the family, I believe, Uncle Lee was." If not for him, the clan would likely have scattered, "but he held us together, definitely so." He owned oil wells and knew millionaires, but if you owed him fifteen dollars, he wrote it in a book, and he would come for it the morning it was due. He held no office, but politicians, judges, and sheriffs tipped their hats to him on the street. He rode a big horse around town; any stick he tied it to, he owned it or owned a piece of it. He was the head knocker, plain and simple, and as his wife's relatives trickled in, he put them to work.

"I loved my Uncle Lee. He was kind to us. Uncle Lee was a fine man, a great man. But if you wanted twenty dollars out of him," says Jerry Lee, "you had to get on your knees."

In time, the Lewis-Gilley-Swaggart-Calhoun clan would become a thing of some wonder here, in its personalities and configuration. Cousins and in-laws and other relatives married each other till the clan was entwined like a big, tight ball of rubber bands. Here is just one example: Willie Harry Swaggart, whom everyone called Pa, was married to Elmo's older sister, Ada. Willie Harry's son, Willie Leon, whom everyone called Son, then married Mamie's sister, Minnie Bell, Elmo's sister-in-law and Willie Leon's aunt, which made Willie Leon

into Elmo's brother-in-law and nephew and would make the progeny of Willie Leon and Elmo, when they came, double kin. "Me and Jimmy [Swaggart] are double first cousins," says Jerry Lee, his face deadpan, as if such things happen every day. Other relations were too complex to explain, except to say that future children would have not one relation to the clan but two or more. They were, all of them, singers and guitar pickers and fiddlers and piano players, and some preachers and bootleggers, and some bootleggers one month and preachers the next, or both at the same time, which was not unheard of or even that unusual on both banks of the big river, but especially on the Louisiana side.

Elmo and Mamie were expecting their first child when they arrived in Concordia Parish in time for planting season in '29 and moved onto a farm owned by Lee Calhoun in a place deep in the woods called Turtle Lake. There were 2,500 souls in Ferriday then, most of them descendants of slaves, but the Depression had a way of bleaching everything gray, and Elmo tugged a cotton sack and did any work he could. The house had no electricity, plumbing, or running water. But in a time when every other man was out of work and a place to live, out of hope and time, where loaded-down, raggedy trucks passed them on the dirt roads on the way to some vague promise of a better life a thousand miles west, Ferriday would do.

On November 11, 1929, Mamie gave birth to a golden-haired boy. They named him Elmo Kidd Lewis Jr., and even as a toddler he could sing. He was, the relations say, a beautiful boy, obedient, the good son. His mama and daddy called him Junior, and would talk of their hopes and plans for him—Elmo's dream, really, that the boy might grow up to be a singer on the radio or stage. The boy minded his mama, said sir and ma'am, and *liked* school, *liked* church, and carried around a slate and chalk or a pencil and scrap paper to practice writing and spelling. By the time he was in his first year of elementary school, he was writing songs to sing in front of the congregation.

In 1934 Elmo went to work in one of Lee Calhoun's other enter-

prises. Lee made whiskey for years in a kind of shadow corporation, in a magnificent, glowing, fifty-gallon copper still hidden in the woods not far from Elmo's front door at Turtle Lake. He had made it before Prohibition and would make it after the repeal of the Volstead Act, because such faraway things had little to do with thirst in Concordia Parish or the local law. He never, of course, paid a dime of tax—Lee had a deep disdain for the federal government and most governments and anyone who wanted to boss him the least little bit—so he hired Elmo and his brother-in-law/nephew Willie Leon Swaggart and other kin to increase production, which they did with great success, between frequent testings for quality control. "People said it was good whiskey, the best whiskey," says Jerry Lee. The local law did not care that Lee Calhoun made liquor; the fact that men would drink whether it was legal or not, taxed or not, was just what *was*. Illegal liquor made the church people happy, in a way, because it was like having invisible liquor, until a drunk staggered into the middle of Main Street and urinated in the general direction of Waterproof.

Sometimes Lee would ride to the still to check on things, but he seldom lingered, knowing that the only way the government would successfully link him to the liquor business would be if they caught him standing hip deep in the mash. In winter of '35, Elmo was in the woods with Willie Leon Swaggart and three others, running off a batch, when the trees around them started shaking and a gang of armed men crashed through and pointed shotguns in their faces. They were Treasury agents, the lowest form of life. They took an ax to the beautiful still and let the lovely whiskey flood across the ground. Then they loaded Elmo and the rest in a truck, and with another man holding a shotgun on them, took off down the road.

Then providence intervened, though not so much that it would do Elmo any good. As the truck rattled down a dirt road, it passed a very pregnant Minnie Bell Swaggart laboring along the shoulder. She saw Willie Leon sitting in back of the truck and began to sob and run,

calling his name. When the agent in charge saw the young woman waddling down the road in tears, he told the truck's driver to pull over before she gave birth there in the ditch. He asked the prisoners who she was, and Willie Leon told him. The agent thought on this, and told Willie Leon to get out and go home with his wife. Willie Leon and the pregnant Minnie Bell went down the road, praising His name.

Elmo kept his mouth shut about who owned the still. He knew his family would be cared for, and his crop would be waiting when he got out, because even if he was tighter than Dick's hatband, Lee Calhoun took care of his own, unless they did some dumb thing like talking to the federals. In January of '35 he left in chains for the federal prison in New Orleans, sentenced to a year but knowing he would be home in six months. Other men had books or prayer to pass the days, but he just sang. "Daddy told Mama it was 'nice,' and said he got three good meals a day," Jerry Lee says, and in truth the prison turnips and the beets and white beans flavored with salt pork were better than what a lot of families were subsisting on.

In late spring, he came home to Ferriday more or less untouched and unchanged, at least as far as anybody could tell, and well fed. He went back to work in the fields, but not in the woods at the still; the federals had warned him that if he was caught making or even hauling liquor again, he would do real time. At night, he showed his namesake how to play his old guitar. The three of them, Mamie and her Elmos, would pretend they were on the radio, like the Carter family, to remind themselves that short cotton and chain gangs and a rising river were not all there was. She was expecting again, and the new baby kicked Mamie hard and often.

The state was in mourning as Mamie neared her time. On September 8, 1935, Huey Long had strutted down the hallway of his capitol, intent on pushing through a redistricting plan that would remove from the bench a longtime political enemy, Judge Benjamin Pavy. The judge's son-in-law, a young doctor named Carl Weiss, stepped from the crowd

of onlookers and fired a single shot into Long's body; his bodyguards fired sixty-two rounds into Weiss, most of them after he was dead. Long, the friend of the little man, was laid out in a tuxedo, and two hundred thousand people filed by to see him in repose. One great storm in Louisiana had finally blown itself out; another one, at Turtle Lake, was just beginning.

The new baby came twenty-one days later, on September 29, 1935, after the last of the cotton was in. "Dr. Sebastian was supposed to deliver me," says Jerry Lee, who has heard so many stories of the night of his birthing that it is as if he was up there in the rafters himself, looking down. "At least, he was supposed to. . . . Well, he did make it into the house."

Mamie knew something was horribly wrong that night. The pain was awful, worse, much worse, than she remembered. Elmo went for the doctor, and she prayed.

Dr. Sebastian and Elmo could hear her wail as they neared the house.

"Thank God," Mamie said, as they came into the room.

Dr. Sebastian told her to hush, it wasn't time yet, but to Mamie he seemed a little unsteady on his feet. The doctor had been at home, relaxing with a drink or two.

Elmo offered him a drink of corn whiskey, to be polite. Dr. Sebastian looked at the clear whiskey the way a scientist could. He examined it for trash, and there was none, and for color. It looked like spring water. This was good whiskey. He unscrewed the lid—it smelled strong and rank and hard, which was also the way corn whiskey was supposed to behave—and took one long, slow, big slash, to be polite, and then another.

Sometime later, when she knew it was time, Mamie cried out for them, but found only Elmo at her side.

"Where's Dr. Sebastian?" Mamie croaked.

"Over there," Elmo said.

"What?"

"He's a-layin' over there," Elmo said, and pointed across the room.

Dr. Sebastian was asleep in a chair.

"Wake him up," Mamie said.

Elmo had tried that.

Dr. Sebastian dreamed.

"I can handle this," he told Mamie.

Of course the child would not be born in the usual way. The baby was breached, turned in the womb, and emerged not head- but feetfirst. Elmo did not really understand the perils of that, but Mamie did. Babies strangled this way, died horribly or were damaged for life, and mothers died in agony.

Elmo took hold of the baby's feet and pulled.

"Watch his arm," Mamie said, iron back in her jaw.

Elmo nodded.

"Watch his head," she said, and did not remember much after that.

"Daddy brought me right out," he says now. "I come out jumpin', an' I been jumpin' ever since." He likes to say that, likes the idea of it, as he likes the idea that it was his daddy and mama who brought him into the world without help from outsiders: one more little legend inside the larger one. It was a time rich in babies, and in legends. Over in Tupelo, that January, another poor woman gave birth to a son she named Elvis. In Ferriday, in March, Minnie Bell Swaggart, who had rescued her husband from the prison truck, gave birth to her son, Jimmy. Another of the extended family, Edna Gilley, soon gave birth to another cousin, whom she named Mickey. All of them came in the span of two years, all of them somehow anointed, all of them destined to sing songs and bring their gifts to the multitudes in one way or another, with great success but varying degrees of cost.

Mamie and Elmo named their second son for an actor Mamie sort of remembered, some Jerry-something, and for Lee Calhoun, whose whiskey turned out the lights on Dr. Sebastian, and perhaps a little bit for his grandfather, Leroy Lewis, though family members would argue on whom the boy was named for exactly. It was, regardless, the happiest time of their lives, and it would have stayed that way, if time could have only gone slack, somehow, right then, and pooled deep and still.

2

WHISKEY IN THE DITCHES TWO FEET DEEP

.

Concordia Parish

1938

The serpents balled up in the hot dark over his bed, a whole nest of them tying and untying in knots, scraping quietly across the boards of the attic, eighteen in all. Their rattles sang, but the boy never heard. Odd, how he never heard. But Scripture tells of the slyness of serpents; in the Pentecostal South they slide not only through the still water but across faith and myth. Old men hung serpents on barbed wire to bring the rains, and would not look a serpent in its eyes for fear of being charmed. In the fields of Concordia Parish, old women told of serpents that formed a circle and rolled like a wheel, and re-formed if they were chopped in two. But myth is myth and Scripture is the Word of God, and it tells over and over of the serpents' duplicity and evil and jealousy, in Eden, Egypt, and Canaan, after God reduced it to a thing that crawled on its belly, and decreed, in Isaiah, that dust shall be the serpent's meat. The story of the serpents above little Jerry Lee's bed has endured for seventy years and will endure long after this, as people tell how the rising waters lifted the copperheads and diamondbacks into

trees, barn lofts, and rafters. They talk of how surely the serpents would have come down in the night and coiled in the dark corners and under beds if the boy, in his covers, had not seen a big rattler slide through a knothole in the boards above his head, "stuck his head down, and looked right at me" in the dim lamplight in his room.

"This ain't your bed," the boy called up to it.

The snake hung there, a few feet from his face.

"Daddy," the boy said, quietly.

"Daddy!"

But Scripture says, too, how a man without fear will go among dragons and serpents and, with God's sanction, protect his tribe. People tell how Elmo crawled into the dark of the rafters with a kerosene lantern and piece of hard hickory and, catching them in that writhing knot, beat them to mush against the boards till they stopped singing and there was no sound in that tight space but him, breathing hard.

His daddy could not have been any other kind of man, not weak or goody-goody or ordinary; the boy's memory could not have endured that. He has forgiven him all the rest. "He was a man. He was a magnificent man," he says. His father had almost no schooling, "but he was a smart man," a capable one who could not read a book of literature but could look at a machine and tell you how its pieces fit. In a less desperate place, a more prosperous time, he might have been anything, maybe even been successful, but in the bad years he was what he had to be. It was not a good age for gentle men in Concordia Parish, when men clawed at scraps and fought each other in desperation and drunkenness and sometimes just to prove their worth, when there was no other way it could be. "Daddy didn't walk around no man," says Jerry Lee. "His hands were so big he'd just slap people, just slap 'em about, and he never lost no fights." A lot of people do not see why a man had to fight. "All of that, all that of not being able to do for your family, it'll get to

you, and it got to him. I saw him knock men off the porch," men who
came collecting, or threatening. "He knocked one man off the porch
and he fell so hard he broke his leg, just popped him off like he was
nothin', with his left. Wasn't nothin' could take my daddy down. He
could beat anything, but one thing. He couldn't beat the Depression."

The busy town had proven no great salvation, after all. Jerry Lee was
too small to recall the worst of it, when cotton wasn't worth the muscle
or diesel it took to plow it under, and construction jobs dried up, no
matter how far a man drove or rode a boxcar to chase the work, but
he remembers how his mama and daddy spoke of it, like it was a war.
Elmo could have gone to his brother-in-law, Lee Calhoun, and begged
for a little extra, but that was not in him, so he walked downtown to
the grocery and threatened the storekeeper, backed him up against the
wall. "He demanded food," says Jerry Lee. "He told 'em, 'You got a
store full of food here, man, and my family, my wife, my boys, ain't got
nothin'. And he walked out of there with the food he asked for, and
when he could, when he got money, he'd pay the man back. All I know
is, my daddy never let us go without." His daddy cleared swamps, dug
stumps, and stood in line with other men to do any job that came along,
and their families waited and prayed, even the backsliders, for things to
ease. It had to ease. How could a man's labor be worth so little as this?

There was only one man hiring. After the raid that sent Elmo and
Lee Calhoun's other in-laws to prison, Lee was out of the whiskey busi-
ness . . . for about a week. He found a new place to set up in the trees
and had another still constructed of even newer copper that gleamed
like new money, and in no time his kin were running off good liquor
again, for it was one of the certainties of hard times that a man could
not be so poor he could not find money for liquor. But the consequences
of getting caught were serious now. Elmo and the other in-laws, once
convicted in federal court, had lost all the grace they would receive.
Mamie asked him not to go back to it, but there was no denying that
liquor money was better than the bare subsistence he made in the field,

and they were already beholden to Lee Calhoun, already living in his house on a farm that grew only debt.

Lee was glad to have Elmo back. He was the same kind of whiskey man as he was a carpenter and farmer. He chopped wood like a fiend, cooked whiskey round the clock, ran off hundreds of gallons a week, and hauled it himself around the river parishes in his old truck, under a tarp, taking all the risks, as demand grew and grew and production jumped.

"There was whiskey running in the ditches two feet deep," says Jerry Lee, who grew up on the stories of his uncle's magical still. "I mean, *ever'body* was drunk. It was the best whiskey in Louisiana."

Mamie choked down her fear and went to the store with her head up, because whiskey money was green as any and the only real shame was in standing there in line with no money at all. Then in spring of 1938, Elmo was stopped by federal men at a roadblock. He was not even working that day, not even hauling liquor, but he was guilty nonetheless. "They caught Daddy with a single gallon of whiskey in his truck," says Jerry Lee. "One gallon. He wasn't sellin' nothin'."

He was sentenced to five years. He kissed and hugged his boys—Jerry Lee too small to know what was really happening, and Elmo Jr., going on nine years old, not sure himself—and left for New Orleans in chains, again. Mamie took the boys back to their borrowed house with the same assurances she and her husband had received the last time, that Lee Calhoun would make sure she and her boys lacked nothing, which in an odd way made it easier when Elmo was in prison than when he was out, if you didn't mind the loneliness. People patted her, said they would pray for her.

Having a husband in jail for liquor was almost an honorable thing then, not any more shameful to her neighbors or her kin than digging a ditch. Frank and Jesse James and the Younger boys said the same thing about robbing banks and trains: it was the times that done it. Moonshine was a shadow, a hidden stream that ran through the con-

gregants and piebald sinners alike, and so was insidious and harder to preach against. It was the reason a man could make liquor on Saturday and sing in church on Sunday with head held high, in one of the great contradictions of the age: Pentecostals, working people, desperate now, absorbed the reality of illegal liquor into their houses of worship in a way they would never have tolerated other sins. It was survival, a sin but their sin. They owned it. For men like Lee Calhoun, churches were good for business; they railed against the store-bought liquor and fought to keep things dry, at least as a matter of law, no matter what the federal government did.

As Jerry Lee neared his third birthday, Elmo Jr. was already writing and singing his own songs in church, or in the tent meetings that passed for churches here in those days. It looked more and more to Mamie like her husband's passed-down dream, of one day seeing a Lewis on the stage, was coming true, and it was more than blind love and parental pride. The boy *was* gifted—people with no blood ties to Elmo Jr. swore it, in church and around town—and Mamie knew that such artists made a good living singing about Jesus and did not have to worry at the end of the day about their immortal souls. Her boy would live and sing in a world without jail, without the reek of liquor legal or otherwise, in concert with the Lord, and might even travel the country singing his music in a gilded ministry, with her in the front row. For now, his voice was enough, a balm for the pain and loneliness.

"They say I can't remember him, but I do," says Jerry Lee. "I was in the yard one day, digging in the dirt with a spoon, and I heard my mama call out, 'Junior, you watchin' that baby?' And I heard him say back, 'Yes, Mama, I got my eye right on him.' We'd play under them old houses, me and him. . . . I was in my diapers. Them old houses must have stood six feet off the ground—they built that way, for when the high water came—and we'd play under them old houses, digging in that soft dirt. I can see him, see his blond hair and see his overalls, see him clear, see him just like I'm looking at you right now."

By the time the boy they called Junior was big enough to sing his first solo in church, there was a permanent House of the Living God to sing it in, a thing of boards and blocks instead of brush arbors and ragged canvas. But the church—a simple thing floating above the mud of Texas Avenue on piers of cinder block—might not have ever been built, if not for Mamie's boys and their cousins, all prophesied to become mighty talents. It was built, as people here tell it, because it was ordained by God, Who spoke to two women as they knelt on the floor of a boardinghouse two states away in Mobile, Alabama. He told the women to go to this place called Ferriday and lead a great revival, because it was a wicked place, and there were souls there, jewels in that colorless ground, that needed to be brought to Him.

About the time Elmo was being sent off for the second time, a woman named Leona Sumrall and her mother, whom everyone just called Mother, were planning to go to St. Joseph, Louisiana, to start a church. The Sumralls were Pentecostals, a relatively new sect born in the twentieth century but spreading quickly through desperate work camps and factory towns in the bleak landscape of the Depression. Leona would later describe what happened here in her own book, in great detail. As she prayed in the Mobile boardinghouse, she heard God tell her to abandon her original plans and go instead to this place called Ferriday:

"God spoke to us through prophecy of the Holy Spirit: 'I have valuable treasures in this town. They are hidden from the view of man. These jewels will be carefully shaped by My Spirit. Their dedication will surpass those around them. To salvage this treasure you must dig with caution. Your patience will be tried but I will bring them forth as pure gold. Your lives will display My love and I will draw them to Myself. They will see that your dedication is not shallow and will seek to pattern their lives according to your Christian living.'"

Mother Sumrall in the same instant heard the same words in her head.

"Did God speak to you?" Mother Sumrall asked.

"Yes," her daughter said.

"Is it Ferriday, Louisiana?"

"Yes!"

They arrived in long, white dresses, with no money and no place to stay. Leona, in her teens, was a revival preacher in a time when you did not need much besides a bare spot of earth to get such a thing going. She asked people if they knew of a spot in Ferriday where she could hold revival, and they pointed her to a patch of weeds on Texas Avenue, near the American Legion. They cut and stripped branches from trees and built a brush arbor, and laid boards across stumps for pews, and used donated lumber to build a platform to preach from. The owner of the lot, a Ferriday businessman named Perry Corbett, told them he would donate the land to them in a ninety-nine-year lease if they pushed through with plans to build a more permanent church. In a city with as much sin as Ferriday, people figured, they would take all the religion they could get. "The wives were crying for the Lord, because it was such an evil place," said Gwen Peterson, whose mother, Gay Bradford, grew up in the church.

The Sumralls were Assembly of God missionaries, one of the most demanding of sects. Women wore no makeup, and did not cut their hair, and dressed plainly, in long skirts, without lace at their cuffs or necks. The tenets forbade public swimming, and dancing. The sect denounced gambling, moving pictures, tobacco, and alcohol—though that one was complicated—as sins of the flesh. But the rewards would be great if a person could only last. This was a religion working men and women could wrap their minds around, and their hearts. The Assembly of God believed in healing, in miracles. It was a faith a man could *see*, see it take hold of a person and shake them half to death, and *hear*, in unknown tongues. "God wants to change this town," Leona exulted, and some people wondered if she might be mad. At the end of the day, after walking the streets, she sat on the stoop of her donated room and poured blood from her shoes.

Lee Calhoun, being the head knocker here, met with the women as they readied the bare lot for the first revival. He was not a churchgoing man but was for churches in general. He said hello to the ladies, accepted their invitation to revival, and wished them luck.

That first night, the lot would not hold the people who came, and cars clogged the narrow street. Leona opened her Bible to Revelations. "But the fearful, and unbelieving, and the abominable, and murderers, and whoremongers, and sorcerers, and idolaters, and all liars, shall have their part in the lake which burneth with fire and brimstone: which is the second death." Law-abiding men and women listened with drunkards, gamblers, prostitutes, and thieves, and when she called them to the altar, they came by the dozens, confessing a litany of sins. One of the first to be saved was a Herron, and other kin in the great extended family would follow. Not long after, Lee Calhoun dug in his pocket, and there was a church. "Old man Lee built the church for them, for his kin," said Glen McGlothin, who grew up in that time, witnessed the birth of the church, and later became mayor of Ferriday. "Built three more, I know of."

The extended family would trickle in a few at a time, till it was as much their church as anyone's, and they were there long after the Sumralls moved on. The people of the church would remember Mamie, her face alight, tears flowing down her cheeks, her arms raised to heaven. Son and Minnie Bell Swaggart, and Irene Gilley, others—the ones old enough to comprehend—all lived in the ecstasy of salvation. And through it all, Mamie's boys sat wide-eyed, white shirts buttoned to the neck. People would often claim, writing from outside this faith, that Jerry Lee was tortured by an unfathomable religion, but it was not beyond his understanding, in time. He was raised on the Christian teachings of heaven and hell and particularly in his people's belief in the existence and pervasive power of the Holy Ghost. The presence of the Holy Ghost, living inside of them, sometimes caused them to tremble and shake, or go into a trance and speak in tongues, in old language,

the language of Abraham, which they heard as the voice of God. In their church, it was not a theory or possibility but something as fierce and plain as a burning hill.

"It took hold of them," Jerry Lee says now, "because it *was* real."

The Holy Ghost comes into a person "like a fire," he says.

"*I* took hold of it," he says, "because it *is* real."

That does not mean he would grow up to adhere, to comply, just that he knew in his heart when he did wrong. Preachers at the tiny church came and went, but with one unwavering message, that the wages of sin is death. And while they preached on all sin, on a great, wide world of sin, they preached on no sin like that of woman laying with man. Only in the sanctity of marriage could such a thing be without eternal damnation as its consequence. It seemed even more vile than murder, than stealing, than anything, and preacher after preacher railed against it in the little church, so many and so regularly that it became clear, especially to the young people, that there was sin and then there was *the* sin, that of lust and fornication, and such a sin had to be held down by righteousness and smothered in prayer. The wages of sin is death. The cost of sin was to burn. In Ephesians, the Bible warns: "Be ye therefore followers of God, as dear children; And walk in love, as Christ also hath loved us, and hath given Himself for us . . . but fornication, and all uncleanness, or covetousness, let it not once be named among you. . . ." Little Jerry Lee, sitting between his mother and his big brother, did not understand it at first, all of it, but it sank into his bones.

Lee Calhoun, despite his church-building and his efforts to distance himself from his whiskey business, would face federal charges not long after that, for conspiracy: having failed to catch him making liquor, they got him for thinking about it. Lee was offered a chance to pay $1,500 and avoid prison altogether, in that peculiar way that rich men always have more choices than poor men in situations such as these, but he was unmoved by the offer. "So," he told the court, "I pay you fifteen hundred, or you're gonna feed me and clothe me and give me a bed to

sleep in and a roof over my head for six months, and I don't have to do nothin'? Well, I'll take six months of that," and he headed off to federal prison, joining Elmo on his second stint. Elmo got word to Mamie that he was fine—that he could do his time, again, and they would start over as soon as he got out, again, and that he was done with the liquor business for good. At night, he and the ghost of Jimmie Rodgers sang about the wages of sin and the poor man's burden, with the dope fiends and the perverts shrieking and cursing and crying for release.

In the late summer of '38, when Elmo Jr. was nine and Elmo Sr. was still away, Mamie took the boys to visit her sister, Stella. They talked in the shade of the porch as Jerry Lee dug in the dirt and Elmo Jr. played at the edge of the road with his cousin, Maudine. Traffic was light on the road and drivers knew to slow down as they came through town, and the children knew to stay out of the road. They were walking down the edge of the road, Junior singing a song, when they came to a slow-moving farm truck pulling a trailer. The truck was just merging out onto the highway, and Maudine ran and jumped on back, laughing, to ride a little piece down the road, just as a car came roaring up behind the trailer. The driver of the car was so drunk he did not see the trailer or the girl till he was almost on them. He snatched at the wheel, swerved off the road, and ran down Elmo Jr. in midsong. The car came to a stop, engine screaming, on top of the child, and the man inside was too drunk to know.

The boy was dead when the police got him out from under the car. They brought the drunk driver to stand before Mamie, so the man could see what he had wrought, but the man, a stranger to them, was still too drunk to know where he was or what he had done, too drunk to stand, and he just reeled there, blabbering on and on, held upright by the police. The officers said they would see that justice was done.

"No," Mamie said.

Her iron jaw was locked, and her eyes were dry as stone.

"Ma'am?" one officer asked.

Mamie told the officer that was not their way, that there was a higher justice, a more awful one, than man's.

"God will punish him," she said.

She said the man would pay for his sins, all his sins, and his punishment would be much more terrifying than anything that would happen to him in the hotbox or forced labor of a prison farm. The police took their handcuffs from the man's wrists, and he staggered off, free. It is said that Mamie walked into the yard and wept and screamed. Jerry Lee cannot remember that. If his mama did show weakness, he is sure, it was not for long.

The Lewises, Calhouns, Herrons, Swaggarts, Gilleys, Bateys, and the rest of them assembled in black, most of the men in their one good suit of clothes, some with an ancient suit coat covering their patched and faded overalls. The women carried wildflowers; almost all of them, like Mamie, stood with babies or toddlers on their hips.

The extended family had already all gathered around the grave when the prison truck rolled up and two armed guards helped Elmo out. He was in street clothes, but bound in handcuffs and shackles. They walked him to the graveside, Elmo taking baby steps because of his restraints, and left him with his wife, still in chains. The guards stood just a few feet away, their 12-gauge shotguns pointed at the ground. Elmo tossed a white flower onto the casket of his oldest son and wept. Then, with his second son in his arms, he stood with Mamie and the members of his tribe, and sang of the King of Kings.

> *Will there be any stars, any stars in my crown?*
> *When at evening the sun goeth down*
> *When I wake with the blest in those mansions of rest*
> *Will there be any stars in my crown?*

Then the guards linked Elmo's handcuffs and shackles with a piece of chain, and hustled him into the prison truck and drove off to the federal pen in New Orleans, Mamie begging them to let him stay, just a little bit. And the toughest man in Concordia Parish, the snake killer, went back to the sweltering cells and the dark and dragging days. Mamie's children would sometimes wonder if she let the drunk driver go free because she knew what it was like to live with a man in prison, knew what it was like in the quiet of the nights. Years later she would get a letter from the man, telling her how he had suffered since that day, begging her forgiveness. She threw it in the trash.

The headstone, when it was finished, was a simple one, but Elmo would not see it for some time.

ELMO K. LEWIS, JR.
NOV. 11, 1929
AUG. 6, 1938
Budded on earth to bloom in heaven.

The stone would never tilt, never lean, a rare thing in the unsubstantial dirt of Louisiana.

Lee Calhoun had purchased a place for his people to rest, in a community called Clayton, in one of the most peaceful places on God's earth, under lovely trees, with the fields stretching off in the distance. Clayton was good, high ground, a place where the river could not rise up out of its channel and wash them out of the soil. Home from prison, he paid for everything, even paid for the stone in a time when the babies of other poor families were buried under crossed sticks and rough piles of rock. Death had not much visited the extended family by then, and the grass of the small graveyard was not yet crowded.

The child had been a kind of antidote to the worst of what was out

there, plugging the gap of her missing husband with his voice. It was a family that could almost live on songs. Jerry Lee would carry his one recollection of his big brother around with him all his life, Mamie's call to the boy, and the boy's answer; he always liked that idea, how a brother was watching over him. It is not enough to grieve on, barely enough to hold to, to keep a person from slipping away altogether.

"Sometimes a memory ain't enough," he says, thinking of a song.

Most people have to wait years and years before they can even guess at their purpose in this life; some never do. In 1940, when he was not yet five years old, Jerry Lee found his reason for being born. "I was walkin' through my Aunt Stella's house. I saw it, and I just stopped, cold."

He cannot remember wanting to touch anything so bad. He had studied pianos for quite some time, but only at a distance. He had looked on them in great curiosity, these big wooden boxes so heavy you needed a truck to haul them around, so complicated that if they went out of tune it took a mad scientist to make them right again. He did not even fully understand how they worked, that you tapped a thin key of ivory to make a tiny steel hammer strike a steel wire, sharp and clean, eliciting a sound so sweet and pure and resonant it seemed more magic than machine. He studied them in thrown-together churches and tent revivals where silver-haired old women, hair buns so high and tight it looked like a B-movie spaceship had landed on the top of their heads, banged out "Victory in Jesus" like they were mad at it, stiff fingers jerking, marching across the ivory. He watched fat men in loud suits and dime-store diamond rings slap ham-handed at the ivory as they hollered a jingle for liver tonic or cough medicine that was 90 percent alcohol, till it was clear, from the way they played, they had been having some liver trouble themselves. And he had spied them, just a flash, through the doors of the jukes on Fifth Street, as sharp-dressed black men with cigarillos in their lips pumped the pedals like they were kicking at

the devil himself rising up from beneath their feet, hands moving and crossing in the shadows. What a wonderful box, to hold so much. But you almost never saw one like this, unattended.

That day, he and Elmo and Mamie had come to visit his Uncle Lee and Aunt Stella, to talk of crops and children and other unimportant things, leaving him unsupervised, to roam the big house. "I just kept lookin' at it," he recalls. "I just had to get at it. It was just an ol' upright piano, but I had to get at it."

His fingers closed and unclosed and he made baby steps, sidling and creeping.

"I wasn't hardly even walkin' around too good—I was just a baby," he says. Still, "I kept gettin' closer and closer."

Funny that he did not think he would *try* and play it.

"I knew I had to play it."

In those days, a child, even a treasured and somewhat spoiled one, did not just jump onto a piano in another person's house and play it, any more than he would take out the fine china and start spinning it on a stick. He waited till he could not stand it anymore, as the grow-nups just kept yapping.

"And I reached up and, for one reason or 'nother, it just come to me."

He touched a single key, pushed it sharply down.

Cool fire.

He has always had a hard time describing what happened that day, in that moment, as he heard that music come out of him. He does not want to make too much of it, but at the same time he is not sure he *can* exaggerate it, any more than a man could exaggerate standing under a skinny tree in a lightning storm, at the precise moment the world around him turned a smoking blue.

"I don't know what happened. Somethin' strange. I felt it in my whole body. I *felt* it."

Musicians, great ones, often claim that when they touched an instrument their hands knew where to go. The sound of the first key leaped

into his head, ringing, ringing, and told his fingers which key to hit next, and it just kept happening, a cascade, and before he even knew what he was doing he had played a song, or at least a part of one.

Silent night, holy night

"Can you believe that?" he says now. "For a four-year-old kid, to walk by and just reach up and play it?

"Now I know what it was," he says.

"It was deliverance."

He laughs at himself then, a little self-consciously, at talking this way. "A talent e-merged," he says, his words exaggerated, "and not a bad lookin' kid, either," as if it is too important to him to take seriously for long. But it was the day that changed everything, the day he knew what he had to be. He still remembers, after so much time, how his Aunt Stella looked at him, so oddly. She had always been a smart woman.

"She knew," Jerry Lee believes.

Mamie almost fell out as she heard her son play. She brought her hands together and praised God.

"Oh, Elmo," she said, "we've got ourselves a natural-born pianist."

"Well, Mamie," Elmo said, "we might have a piano *player*."

Jerry Lee smiles at that. "Like there was a difference," he says now.

"He's a prodigy," Mamie said. Such words had rarely even been used.

"Probably is, Mamie," Stella said, that look still on her face. "Probably is."

It must have seemed to Elmo and Mamie like answered prayers. They had lost one prodigy; the good son slept safe in the high ground. But now they had seen delivered unto them another one—more or less.

The wild son, seven or eight years old now, barefoot, dirty faced, and grinning, climbed the iron girders of the Mississippi River bridge till he

stood swaying in the hot wind at the height of the span, then walked it like a circus rope, one step, two steps, more, as the little boys below, cousins and such, stood slack-jawed and trembling at the rail. Jerry Lee had scared them to death, again, and if the yellow-haired imp fell to his doom in the river below, surely their mamas and daddies would find a way to blame all of them and beat them unconscious. He waved at them, taunting, as the wind sucked at his shirt and almost lifted him off the iron beam as the tugboats and great barges passed beneath his feet, as the drivers of the passing cars wondered which asylum had let that boy slip out. He walked the span over and over, skinny arms akimbo, like a crow on a wire, not even looking at his feet but leering, jeering at the boys below and mightily pleased with his little self.

"Are you conquered?" he shouted.

"Please, Jerry Lee," they begged, in a chorus, Jimmy, Mickey, Cecil Harrelson, David Batey, others. "Please get down."

He laughed in their upturned faces.

"Get down!" they wailed.

"Come and get me," he said.

It had started that morning as all mornings started then along the dirt streets of Ferriday, in an ever-swelling migration of scamps and urchins and ne'er-do-wells, aimed at no place in particular but intent on doing no good when they got there. One of their favorite games was called Conquer, which was basically a game of double-dog dares. One boy would do something dangerous or asinine, anything as long as there was at least some chance of bloodletting or broken bones or bug-eating, and the other boys had to do the same or admit they were just big fat sissies and sing out, "I'm conquered." It might be anything from jumping off a railroad trestle into a murky creek to taking a punch to hollering at a big girl, and nobody—nobody—conquered Jerry Lee. "I never was afraid. . . . I don't know why. I just never was scared of nothin'," he said, which is an easy thing to say but hard to live. But his cousins would stand in amazement at the things he did. Cousin Mickey

would say he believed most geniuses were crazy, and his cousin was a genius for sure. But the stunt on the bridge, 150 feet above the big river, was off the scale.

"Are you conquered, or not?" Jerry Lee asked.

The boys looked at the river below. They shook their heads.

"Are you conquered?" he shouted again.

They nodded.

"Say it!" he shouted.

"We're conquered! We're conquered!"

Jerry Lee leaped up, grabbed a crossbeam, and hung there, laughing.

"Oh," he says now, "they begged me to come down, but I didn't pay 'em no mind. I guess I could've fell, but I didn't."

He remembers coming back to earth in triumph.

The little boys crossed their hearts and swore not to tell.

"But somebody told," he says.

His mama had a good cry and wondered what she had done to have God punish her this way.

"I'm gonna have to kill you, boy," Elmo said, then just walked off, shaking his head. Mamie would not let him whip the boy.

The bridge incident was hard to eclipse, but sometime later he tried. One day, as the cadre of boys stood on an overpass, a long freight train appeared in the distance.

"I'm gonna jump on it," Jerry Lee said.

"No you ain't," they said.

"Yes I am," he said.

Jerry Lee climbed up on the rail and crouched there, like a hawk. The train had seemed to be lumbering along, but now, so close, it shook and clanked and rumbled, and the steel wheels moved in a blur. But he'd said he would do it. He picked a boxcar, one with a flat roof.

Well, he thought, *you'll probably make it.*

He leaped into space.

He landed, slid, and came to a stop.

Hah.

Most boys would have let it go at that. But in the cowboy matinees, he had seen the heroes and bad men jump from one boxcar to another on a moving train, and he decided to give that a whirl. Besides, he was not altogether sure where this train was headed or when it might get there, and he might have to jump all the way to the engine, to tell the engineer to Please, sir, my name is Jerry Lee Lewis, and will you please stop this thing and let me off. It already looked like he was halfway to Baton Rouge. The other boys just stood in the far distance, wondering if they would ever see him again, and half hoping the train did not stop till it got to Canada. But then things would sure be dull around here, without Jerry Lee.

He walked to the edge of the boxcar and looked down at the coupling, at the crossties going by faster than he could count. Then he walked to the other end, got a running start, leaped and made the gap, easy, sliding on his belly. But this car had a more rounded roof. It occurred to him, in one sickening second, that there was nothing to hold on to. "I just slid off."

He hit the big gravel at the trackside with an awful *oomph,* and the sound of rending clothes. The other little boys, watching in the distance, ran for home.

"They just left me there, the others, left me laying there like an old shoe," he says. He was bruised all over, and skinned alive, but not broken, at least not that he could see. "I dragged myself up to the road and got a ride home with this rich guy." The man looked him over.

"I slid," Jerry Lee said.

"Oh," the man said.

Mamie was without words. Elmo breathed fire and threatened, but there was nothing he could do. It was Elmo, in that deep backwater, who had taught the boy not to let fear own him. But this boy had no limits. Southern men like to think of people, sometimes, as machines so

they can understand them, and they know that most small engines, like lawnmowers, have a tiny mechanism on them called a governor, a kind of safety device that keeps them from running wide open all the time and burning up. In people, it's fear or common sense that serves as the mechanism. This boy, Elmo quickly figured out, didn't have one. He was buck wild and strutting and had been since he was walking around good, determined to get away with as many transgressions as hours in the day would allow; he would not read a book on a bet and ogled all the pretty girls on the big yellow school bus and pretty women in town when he didn't even know what he was looking at. He put one of his cousins in a cardboard box and set him in the middle of the road, and walked the parish with a perpetual smirk, like he knew even as a boy that he was the stud duck around here and people might as well get used to it.

They might have done more to rein the child in if they had not heard him play and sing.

The first time he really sang, when he was not yet even in school, it struck Elmo and Mamie hard in their hearts, because it was like their lost boy was not lost at all, like he was singing through this second son. Jerry Lee was not the good son, yet he could—if he did not fall to his death or drown in the Blue Hole or disappear on a freight car or get remanded to reform school—be a great one. *He* might be the one. But while this boy loved singing and, more important, *noticed* music, he was not yet a devotee of it, as his brother had been. There was too much of the other life out there to taste and conquer. He was a student of mischief, and even a lifetime later he relishes it almost as much as he relishes the early music, relishes any discomfort or awkwardness or devilment he took part in, the way he remembers the taste of his mama's tomato gravy. Some men outgrow their boyish devilment. Others only polish it.

"Mama would wake me at seven thirty in the morning; school started at eight thirty. And I'd always say, 'All I need is just one more minute,

Mama,' always just one more minute. She would come back in with a cup of cocoa and some vanilla wafers, and I'd eat it there in the bed and she'd sit with me. That was my favorite, that or tomato gravy and biscuits and a Coca-Cola. She was the angel in my life, my mama was. I had the best mama and daddy in the world, and I know everybody says that, but I believe it to be true. I know it is."

The war raged, far off. Franklin Delano Roosevelt, the one Uncle Lee Calhoun considered a sack of hot wind and a socialist, came on the radio after the double-dealing Japanese bushwhacked the sailors at Pearl Harbor, and he vowed, in that highbrow Yankee accent, that there would be a world of hurt in store. The next thing the poor people of Concordia knew, they were at war with Germans; if only Jerry Lee and the boys had paid attention in history, maybe that would have made some sense. But even before the war had reached the boys of Concordia Parish, people were beginning to feel it in their pocketbooks, as work bloomed in munitions plants and even in the fields, as parish cotton was suddenly worth something again.

Uncle Lee Calhoun had so many rental houses he could not collect for all of them in a single day and would have killed a good horse doing it. He made collections now in a raggedy prewar Chevrolet pickup and took off the driver's-side door to save time on collection days. People here laugh about the time he ran a red light and crashed his truck into a man's big Cadillac, how he stood there in his sweat-stained work khakis and told the man, a stranger passing through, how that ol' truck was the only thing he owned in this sorry world and if he had to pay to get the man's car fixed he would be ruined and maybe even have to go to prison, because when he failed to pay the damages and fine, the cold-blooded police would sock him in jail and his poor family would starve. The other man, almost in tears, patted him a little bit and drove away, his ruined car limping slowly along, happy that he had spared a poor man even more pain. The new prosperity made Lee no more generous with his own workers. One day, he promised workers in his fields some

fish for lunch, and they worked all morning with their mouths watering, thinking about fried catfish, till Lee Calhoun showed up at noon with a sack full of sardines and some loose dry crackers.

Other members of the clan began to find a small prosperity of their own. Willie Harry Swaggart, the one called Pa, became chief of police. He was a craggy old man with steel-colored eyes who did not carry a gun, did not need to, because Pa had made his living in Ferriday in the swamps, trapping things that bit. But it was handy, for Jerry Lee and his cousins, to have an inside man in the department. The Gilleys opened small cafés, and others in the extended family put their names on doors and store windows. Elmo and Mamie found work in the war effort as carpentry took off again; munitions plants sprang up, other jobs appeared, and they had a grip on the here and now for the first time in their lives. "Mama sent me to the store," Jerry Lee says, "with money."

For working people, the boom did not extend to new houses or cars; Detroit had stopped producing cars, anyway, to use their assembly lines for planes and tanks. For the people who had been picking cotton or cutting timber, it came in the form of new overalls and food on the table at dinner and supper. His mama had the means, for the first time, to work true magic in the kitchen. "There has never been such a cook," he says, "as my mama. Pork chops and gravy, beans and cornbread, beef, biscuits and gravy, cornbread dressing, okra, squash, tomatoes . . ." It was nothing they hadn't had before, from the ground or the stores, but even such simple things had become so dear in the Depression. "We had hog killings, and we had fresh ham, and those pork chops, and cracklin's." There was money for new records, and for batteries so his mama's radio could keep bringing in those songs by Roy Acuff and Ernest Tubb.

There was even money left over for the matinee. The Arcade Theater was a place of such importance in Ferriday that the movies showed even during great floods, and men rowed their sweethearts to the entrance in canoes and bateaux, to see the outside world flash across the screen.

It gave Jerry Lee's imagination a place to grow, and he wondered, sometimes, what lurked in the dark woods on nights he walked home by himself from the double feature at the Arcade, after he watched Lon Chaney turn into *The Wolfman* one clump of hair at a time. He was not scared, just *almost* scared, "but then my imagination had been whipped up quite a bit." But nothing drew Jerry Lee to the Arcade so relentlessly as a new Western, and no Western pulled him like those of the singing cowboy, Gene Autry. The actor had taken a sabbatical from shooting cap pistols out of outlaws' hands to go fight the real war, in the army air corps, flying the Hump between Burma and China over the dangerous Himalayas. But he had already made so many black-and-white horse operas that there were enough to make do in the war years, and "if Gene Autry was at the Arcade Theater, then Jerry Lee Lewis was the first one in line. I liked the way he fought and I liked the way he shot, but mostly I liked the way he sang."

One day, his cousin Jimmy approached his father and asked if he could take in a movie with his cousins. His father and mother began to cry, in disappointment. The movie theaters, they believed, were the devil's playground, and while Jimmy went into the theater that day, he came right back out again, sobbing, convinced of their wickedness. Jerry Lee did not understand how a man in a white hat, who rarely even kissed the damsel in distress, who championed orphans and puppies, could drag a boy into the depths of hell. So, while Jimmy knelt and asked for forgiveness, Jerry Lee just ate some popcorn and sang *yippy-ti-yi-yay*.

The cost of the war—and of the local economic recovery—would not be known for some time, when the first casualties started appearing in the newspaper. "We had kin lost in the war," Jerry Lee recalls. "Paul Batey got killed. A sniper got him," in the Pacific. "My Aunt Viola never got over that. The war took a whole lot of people from here." But for

the children, safe in the low country, the war was a thing of adventure, where Germans could be killed with slingshots and Japanese fell from paper planes. The river was said to be a thing of great strategic importance, as it had since the Yankees took Vicksburg, but now it was said to be a target for sabotage, because of the freight it carried for the war effort. So the boys watched from the bank for saboteurs and submarines. It was what he did instead of going to school; it was a patriotic duty.

"Mama and Daddy seen their kid had school," he says, but he did not always make it inside the door. He would walk off in that direction, till he was out of sight, then just go wandering, to fish or swim or throw rocks or sit and listen to an old man whup a guitar, because it was so hard to sit there in those little bitty desks and try to learn about fractions and what made the sky blue and the names of all those men in puffy pantaloons, when there was great time wasting to be done, pool halls to sneak into, barbershops to linger by. And so he just did not go often to Ferriday Elementary and hoped the teachers would just pass him through, something teachers have done since the advent of chalk. His daddy made the mistake of buying him an old motor scooter, which only increased his range. "It was a great time," he says. "Every now and then a plane would fly over, and we'd go hide under the bridge."

It was about this time, in the thin shadow of that distant war, he decided his own world was just too small.

"I don't know why I did it. I just wanted to go."

He looks as if he is searching for some kind of understanding of that, which is rare for him.

"Sometimes you just need to go."

He had hitchhiked the dirt roads and blacktop in Concordia Parish and parishes up and down the river since he was old enough to realize what his thumb was for, sometimes just to see where the roads ended, the same way he wondered how deep the Blue Hole was, that place in

the backwater where cold-blooded killers were said to dump the bodies of their victims, wired to a truck part or a cinder block. The world was wide and mysterious and rich and dangerous, and he lived in only a little bitty corner of it. The river only went north and south but roads went everywhere. He had made it as far as Vicksburg, across the dull, flat green and rolling land, had some ice cream and a candy bar, then, his head humming with sugar, hitchhiked home. One day, without a sack lunch or change of clothes or a dime in his pocket, he walked down the road till he was out of sight of his mama and daddy's house, sprinted for the highway, and stuck out his thumb.

"Mama," he says, "would have had a heart attack."

The first car to stop was a '41 Ford. The old man inside looked him up and down.

"How far you goin', boy?"

"New Orleans," he told him.

He made up a plausible, heart-tugging story as to why; it evades him now, but he knows it must have been a good one or he never would have gotten out of Concordia Parish. A few hours and stories later he was standing on Decatur Street, with the Crescent City hunkering at his feet. He looked at the curve of the river, crowded with ferries and tugboats and big freighters, so many vessels he could almost walk from the French Quarter to Algiers, but it was the same brown river he had at home, so he did not waste much time on the docks. He wanted to see a city, see a real one, and all that it implied. "I wanted to go somewhere big," he says, "and New Orleans was the biggest place I could think of."

He walked the traffic-choked, narrow streets in wonder. This was the New Orleans of Tennessee Williams, dark and rich and dangerous. He saw the old iron streetcar, rumbling and clanking and spitting sparks, crowded with people rich and poor. Ladies, some half-dressed, reclined on the balconies, just languidly wasting the day. He passed the grand hotels and the tap dancers who banged against the old bricks with bottle caps on the soles of their shoes, and the mule-drawn carriages with

their velvet-fringed rooftops, and a great, cream-colored church, the one the Catholics called the cathedral of St. Louis. He peeked into cafés where the rich smell of coffee drifted down the streets till it bowed to the stronger scent of a hundred kinds of liquor, pouring from bars already going strong in the stark light of day.

"Well," he said to himself, "this is a place."

But he was also hungry, and beginning to think, at least a little, about the commotion that would arise when suppertime came and his mama and daddy noticed he was gone.

"I wound up in front of this Italian grocery," he says. "I guess I looked lonesome."

The grocer, his accent so thick Jerry Lee could barely understand him, asked the boy who he was and what he was doing there, standing around. He did not look like a New Orleans street urchin; he looked lost.

"I have been kidnapped," Jerry Lee said.

The man just looked at him, sternly.

"And I'm hungry," Jerry Lee said.

He may not be buying this, he thought.

Then a thickset, middle-aged woman came out of the grocery, apparently the man's wife, and said something in Italian that seemed to be laced with smoke and fire, then in English that he could understand told the man that he should be ashamed of himself for leaving this baby to stand in the street. "Give this *bambino* something to eat right now," she said. He ate enough bologna to kill a normal man.

Around one o'clock in the morning, he found himself sitting on a straight-back chair in a New Orleans police station, or perhaps Juvenile Hall; he cannot really say. A police officer, calling every place in Ferriday with a telephone, had finally gotten somebody to fetch Elmo to a phone, so the officer could tell him to, please, sir, come and get his boy, because New Orleans had enough trouble as it was.

"I don't know what's wrong with that boy," Elmo told him.

Mamie was saying "Thank you, Jesus" in the background.

"I don't know, either, sir," the officer said.

"I mean, I got him a motor scooter," Elmo said.

"Just please come and get him, sir," the officer said.

Elmo drove into the night. It was no pleasure trip in those days, on those roads. When he finally got there, he just looked at his son for a moment, his face cloudy with fury, and sighed.

Jerry Lee said he would have been home sooner, but, "Daddy, it's hard for a little boy to get home."

Elmo sighed again and drove his son back to Ferriday.

"There stood Mama," he says, remembering.

She ran to the car and grabbed his shoulders. "Boy," she said, "I should kill you." Then she snatched him to her chest. "I love you so. Come here, baby."

He knew then that he would get away with just about anything.

"They loved their boy," he says, again. "They were just glad to get him back."

He is not certain, anymore, exactly why he left.

"I just knew that a motor scooter was not what I was looking for."

Elmo had long since decided the boy was special and not always in a good way. He knew quickly that he was never going to be a farmer or a carpenter; he refused to pull his own weight around the house and might have been the sorriest cotton picker who ever put on a sack. He not only came in light, he came in almost empty, and he could tear up a tractor in no time, just disappear with it down a road, plowing up the *asphalt*. And he had accepted that the boy was no scholar. He had hoped, at least, to keep his son out of reform school or prison, but even that was looking grim. Before he was able to see over the dashboard, he had stolen Elmo's Ford and gone joyriding down the roads of Ferriday and Black River, whooping. The first time it happened, Elmo had

looked up to see his car rolling out of the driveway, ran up to see who was driving. It appeared to be nobody. Then he caught a brief flash of just the top of a blond head, and cursed, and considered praying. The car went sliding out of the driveway wide-open and roaring down the dirt road, and Elmo watched and listened for the sound of great tragedy. All he heard was the roar of the engine, roaring, roaring. There was something wrong. It finally hit him. "Oh Lord," he said, "the boy ain't changing gears." Jerry Lee must have been pulling about four thousand RPM, the engine smoking, before he finally turned around and headed home.

When he pulled up in the driveway and killed the motor, his daddy was standing there aghast, his big hands on his hips. He could smell gaskets melting, metal smoking.

Jerry Lee decided to act like he was supposed to drive.

They stood there looking at each other.

"Well," Elmo finally asked, "how'd you do, son?"

"I did pretty good, Daddy," said Jerry Lee, "but I couldn't figure out how to get it out of low gear."

Elmo knew he should lock the boy in a pen, but he was one of those animals who would kill himself against the wire.

"Well," he said in defeat, "maybe I better show you."

By the fall of '43, he was becoming more enamored of music, so that a song on the radio, or at a clothesline, or in the fields, could freeze him midstep. Music, black and white, blues and hillbilly, swirled around him, and as he sang it back, his own voice grew richer, till he sounded less like a freckle-faced kid. He knew something about the purity of music, the unvarnished beauty of it. It was among the first sounds he heard as a baby, even before Elmo Jr. was sent to heaven and Elmo Sr. was sent to New Orleans, and it would never desert him. "It was beautiful," he says, "when Mama and Daddy sang their duets. They sang 'I'll

Fly Away,' and 'Will the Circle Be Unbroken?' and 'Old Rugged Cross,' and they sang 'Will There Be Any Stars in My Crown?' " And sometimes when they sang, it looked like their hearts were breaking, but to Jerry Lee then it just sounded like the soul of music itself was laid bare, when he heard them sing the songs from church. "You simply," he says, "cannot beat them old songs."

He would never improve on that beauty; never wanted to sing with more heart. He just wanted to make it move faster, harder, and for that he needed an engine, but the only pianos in his world all belonged to someone else. His daddy had a guitar and encouraged him to play it, but there was just a limit to the thing—he had always despised limits—and it seemed like the strings were designed to hold him, not set him free. "I learned to play guitar, could play it pretty good," he says, but "a guitar just has six strings." He says it like a man would say his dog just has three legs, with dejection and pity. In church he heard the future on those old pianos, battle-scarred from all those crusades against the devil one big tent at a time. But only the rich people had one in their house, or at least, people richer than they were.

He was playing in the yard when he saw his father's old truck lumbering up to their house on Tyler Road. The better times, the carpentry work and cotton prices, had allowed Elmo a little breathing room, and for the first time in his life he had purchased his own land. It was the first dirt he had ever put his name on.

"He had a piano on his truck," he says, "and my eyes almost fell out of my head."

He started hopping, like old man Herron used to hop when Elmo lifted him over a fence.

"I found out later he mortgaged his farm to buy it for me," he says. "I tol' you. I had the best mama and daddy in the world."

Elmo backed the truck up to the porch and undid the ropes. To-
gether, they lifted it into the house.

"There it is," Elmo said. "Now play it."

It was an upright, paneled in dark wood, manufactured by the P. A.
Starck Piano Co., of Chicago, Illinois—a unique manufacture, according
to the advertisements, with a bent acoustic rim that gave it a fuller, richer
tone, more like a grand piano—and "well adapted for concert use."

His daddy bought it in Monroe, Louisiana, for how much he cannot
recall.

It was used, certainly. "It looked new to me," he says now.

He let his fingers run down the keys.

"Thank you, Daddy," he said.

Mamie stood in the doorway. She had never completely forgiven him
for going to prison that second time, leaving her alone with the boys
and her grief. Women can be hard on a man that way.

"You done good," she told him.

"And it wasn't long," he says. "I was playin' piano about as good as
I play now."

You have to forgive him for dismissing a lifetime of influence, of adapta-
tion, of study—not in any traditional sense, like paid-for lessons, but in the
way he learned his art, by simply listening, always listening. He will always
believe that, while he did learn, did soak up the music from the outside
world, the great bulk of his genius came from within, where God placed it.

The piano would come to be called the wisest investment in the
history of rock and roll.

"It's sittin' in there," he says now of his first piano, motioning be-
yond the door to where the old upright leans tiredly against the wall in
the darkened hallway. "I thought it was the greatest thing in the world."

The boy played, played every moment he was not obligated to be some-
where else, and stopped only to bathe and sleep; sometimes he even ate

at the thing, chewing on a sandwich, thinking about melodies, rhythms, songs. It is not like he had anything better to do. He had never seen a great deal of value in school, at least before he discovered girls, and now knew it was totally unnecessary. Now, in the cursed classroom, he would stare at the top of his desk in abject misery and itch to be set free of this foolishness. "I was sittin' on *Ready*," he says, "and pumpin' on *Go*." There was no bell at Ferriday Elementary to mark the end of the school day, but "the band started practicing at three o'clock sharp," and that meant the last period was finally over. He almost turned his desk over getting out, cleared the front steps in one leap, snatched up his bicycle and pedaled home, where he banged through the door and slid onto the piano seat like he was sliding in at home. He played "Blessed Jesus, Hold My Hand" and "He Was Nailed to the Cross for Me" and every other hymn he could think of, all of it by ear; the notes meant nothing to him, and the sheet music and hymnals just a waste of a good tree.

> *I will be a soldier brave and true and firmly take a stand*
> *As I onward go and meet the foe, blessed Jesus, hold my hand*

He disappeared into the piano just as surely as if he had crawled into the cabinet and closed the lid. His cousins came for him, but mostly now he sent them away. This was important. Nothing else was.

Elmo and Mamie encouraged his obsession, but there was a limit.

"Son," Elmo would say, as the hour struck ten, or sometimes eleven, or later. "Son, we got to get some sleep."

"Ten more minutes, Daddy," he said.

"No."

"Five more minutes?"

"No."

Mamie would come in, rubbing her eyes. "Put the lid down, son, and go to bed."

Even though he was a born piano player, he still had to practice and practice to master the more complicated songs. Elmo knew music, knew the science of it, despite his lack of schooling, and sometimes, in the beginning, he would correct his son.

"You missed a minor chord, son," he said, once.

"So I missed one, big deal," he said, then, more sheepish: "What is a minor chord?"

"And then Daddy would sit down and show me," he said, thinking back.

But Elmo had never seen someone so quickly master the instrument, any instrument, or master the nuances of songs.

He would call out a song, "and I'd sit down and play it," says Jerry Lee. Some of those songs would stay with him—and in his stage shows—for a lifetime, like "Waiting for a Train" by Jimmie Rodgers, the story of a penniless man just trying to get home, but thrown off the train by a railroad bull. "Songs that told a story," he says. Others just made you feel good. He played "Mexicali Rose" by Gene Autry—that one made Elmo whoop and grin—and "My Blue Heaven" by Gene Austin, and "In the Mood" by Glenn Miller. He did not know what swing music was, completely, but he knew the feeling even before his feet reached from the piano bench to the floor. He would play "Alabama Jubilee," a song from 1915, and "Silver Threads Among the Gold," an even older song his mama loved. And there were other songs of a newly popular piano style called boogie-woogie—songs like "Down the Road a Piece" and, later, "The House of Blue Lights." He cannot remember where he heard them all, but he knows how he learned to play them. "I just had to hear 'em," sometimes just once.

And yet there was always a difference between a boy and his father. One day, as Jerry Lee was laboring to learn one of the new songs, Elmo sat down at the old piano and played it through himself. But he played it beautifully, flawlessly, and it was so lovely, so impossibly beautiful, that the boy started to cry, in despair. And, seeing that, Elmo never played

another song on the piano in front of his boy again. "Can you imagine that?" Jerry Lee says. "Lovin' a kid that much," to stay away from the piano for a lifetime?

The shocking thing was how quickly he could learn a song, and adapt it into something new. Elmo wired the house for electricity, and got his boy a radio so he could snag what was drifting through the air. He listened to the radio like a man sifting for gold. Some stations came in maddeningly faint, wafting down from Chicago or some other big city, but the best music in the world was being played almost next door, anyway. The Jesuits at Loyola University had fifty thousand watts pushing big band and Dixieland up from New Orleans, and you could hear Sharkey Bonano like he was standing in the hall. In Natchez, WMIS played the blues almost nonstop, from the rusty piano shuffle of Champion Jack Dupree to the citified jump bands of Louis Jordan and Amos Milburn. WSMB in New Orleans piped in hillbilly music from Nashville, and before long KWKH started bringing the Louisiana Hayride in from Shreveport, on a signal that would change his life. He bought records every time a little money came his way, boogie and hillbilly and pop hits, sounds that were obscure only to people with a tin ear, and eavesdropped endlessly in Ferriday's black section to hear the most lowdown blues he could find drifting from the flung-open doorways, always collecting, absorbing. In time, he only had to hear a song once to store it inside his head. Then he would match the words to the rows of black and white, anything from country tunes like "You Are My Sunshine" to the old New Orleans song "Margie" to blues songs and drinking ditties.

It was a grand time in American music, when field hands laid the bedrock of rock and roll, elegant orchestras held sway in hotel ballrooms in New Orleans, jump blues combos toured the South continuously, and country music was maturing from fiddle tunes and cornpone

to something a soldier returning from the war could cleave to, drink to, even dance to, with his baby. New music was busting out all over, but the old music still shined. He feasted on the new, but also listened for Al Jolson, who had never truly gone out of style, and Hoagy Carmichael:

> *Now he's poppin' the piano just to raise the price*
> *Of a ticket to the land of the free*
> *Well they say his home's in Frisco where they ship the rice*
> *But it's really in Tennessee*

On Saturday nights he sat by the radio like it was something he could see into. He listened to the Grand Ole Opry, even bore up to Roy Acuff, who was "the worst singer I ever heard."

"What do you mean you don't like Roy Acuff?" asked his mama.

"Well," he and his daddy would say, almost in concert, "he ain't no Jimmie Rodgers."

The Singing Brakeman lived in their house now the way he had bunked with Elmo in New Orleans. His daddy played his boy the music on the Victrola, and he heard the genius in it, heard the train whistle across the tortured land and heard the blues bleed into this white man's music, the way he heard it in the fields of the parish. Rodgers was the father of country music, but he was also "a natural born blues singer," Jerry Lee says. "I loved his blues." In no time he was singing and playing about hopping freights and getting drunk and the perils of no-account women, and if he was ten years old, it wasn't by much.

> *Oh, my pocketbook is empty and my heart is full of pain*
> *I'm a thousand miles away from home, just waitin' for a train*

Mamie frowned at that, at the little boy singing such raw, secular music, but there was no containing it now. "Mama supported my music" from the beginning, he says, even if she blanched at the words.

When he was fourteen or so, he was moved by a song called "Drinkin' Wine Spo-Dee-O-Dee," which a rhythm-and-blues singer named Stick McGhee had adapted from a nastier, profanity-laced chant he'd learned in the army. Mamie's son worked up a slightly cleaner version of his own, so that she wouldn't faint or fall to praying for his soul or pinch a plug out of his arm, and boogie would echo down Tyler Road . . .

> Way down in New Orleans where everything's fine
> All them cats is just a-drinkin' that wine
> Drinkin' that mess is pure delight
> When they get sloppy drunk they sing all night
> Drinkin' wine spo-dee-o-dee, drinkin' wine
> Drinkin' wine spo-dee-o-dee, drinkin' wine
> Drinkin' wine spo-dee-o-dee
> Won't you pass that bottle to me

. . . then he would do another hymn. His cousins Jimmy and Mickey had also fallen in love with the piano at about the same time, and they would play together, sometimes, the three of them, and the people of the town would wonder at such talent in one bloodline, even if it was dad-gum impossible to figure exactly which lines ran in what direction. "All three played," he recalls. "Me and Jimmy would play together, and you could hear it for three blocks." But there was never any doubt about who was leading that trio. "You think Mickey and Jimmy could have cut it like me, could have cut that Al Jolson like me?" he says, as if daring someone to disagree.

But he did not, even as a child, hear anyone playing exactly like he wanted to play, no one singing precisely as he wanted to sing. Most of the standout artists were guitar men; the piano players still seemed mostly in the background, trapped in one genre or another.

Then he heard a man who defied any one label, a man who looked like a country-and-western piano man and played next to men in rhine

stones and big hats but who played jazz, too, and blues, and anything he damn well pleased, from Cab Calloway to Texas swing. Some people called his music Western swing, others said hillbilly boogie. Jerry Lee just knew it sounded good, like something he could do.

> *Yeah I'm an ol' pipeliner an' I lay my line all day*
> *I got four or five women, waitin' to draw my pay*

Moon Mullican's musical talent had germinated in the church, like his. Mullican learned first on an organ, but he was drawn to the sounds he heard drifting from the fields and chain gangs in Polk County, Texas. His daddy put a strap to him, but it was hard to stop the boy from listening to what drifted in on the Texas wind. He was Scots-Irish and as white as white could get—his grandfather fought for the South at Shiloh—but he would mix blues and big-city jazz into his stage shows between tear-soaked country ballads. The people who paid good money to hear him sometimes didn't know what to think, with him playing that colored music so loud, and disc jockeys didn't know where to play him, and record producers did not know what to do with him, but Jerry Lee listened to him closely, very closely, and heard in the music some of the first heartbeats of what he would one day know as rock and roll. "Moon Mullican knew what to do with a piano." And Jerry Lee was playing it in no time.

He sat at the old piano and mixed and matched and experimented. In a way, it was like the piano was the heart of the old Lewis house, always pumping, pumping. "When it would flood, and Ferriday was under water, Daddy would put my piano on the back of the truck, and haul it out" to safety. It was not a hard decision, what to save and what to leave: the piano was the one good piece of furniture they owned. Then, when the water receded and the house dried out, he would fetch it back, and Mamie would breathe a sigh of relief.

"We gathered around the piano every night, back then, me and her and Daddy," says Jerry Lee. It had always been that way for them,

through poverty and misery and death, and now, again, in hope. It was clear that their boy was going places. It was all a matter of direction.

Mamie laid out his white shirt and bow tie. That was how you knew in the Lewis house that a great day was at hand. They rode to church in Elmo's Ford and parked among the other ragged cars. Here and there, a backslid husband made himself comfortable across a seat, to wait out the preaching and singing and the altar call. Even Lee Calhoun drove up in a battered Chevrolet for the same reason a good poker player never flashed his wad. He had had the house of worship built on blocks, to prevent flooding, but blocks were dear, so it could not be much of a flood. There was electricity wired in the walls but no plumbing beneath the plain wood floors—an outhouse had been dug out back—and there was no stained glass in the windows to filter and soften the Louisiana sun. A rusted potbellied stove, the only heat in winter, sat in a corner. But inside, on a Sunday morning, there was no question whose house this was, and it was not Lee Calhoun's.

It was a hothouse in summer; it seems it was always summer. The parishioners threw open the windows and installed two massive box fans on opposite sides of the building to draw the rising heat and expel it outdoors. It drew with it the sounds of the church, and created a phenomenon on Texas Avenue that people could not recall seeing anywhere else. The Assembly of God was an all-white church, but black neighbors would come by on Sundays and sit under trees to hear the music that poured from the place. People parked their cars and rolled down windows or opened doors to listen. The austerity of the Pentecostal sect did not extend to its music, even before Jerry Lee Lewis and the other boys put their stamp on it, and you could hear the piano on Main Street. Elmo whupped guitar, Mamie sang, Son Swaggart sawed his fiddle and the rest of the family joined in. In time, there would be drums, steel guitar, bass, accordion, and more, the place literally shak-

ing. "It was lively," says Gay Bradford, who was born in 1931 and went to church with Jerry Lee.

This Sunday his kin filed in a carload at a time—they were almost all kin, in here—and took seats in the simple, dark-wood pews: tall, angular Swaggarts, the smaller, good-looking Gilleys, the fiery Herrons, the wild Beatty boys, his pretty Aunt Stella and his rumpled Uncle Lee, and all the rest. Mamie and Elmo had a baby daughter now: Frankie Jean, born on October 27, 1944. She would be an annoyance for her brother but an ally in the long life to come. Mamie held the child in her arms, rocking her gently in the pew as the service began. The congregation prayed for strength, for the courage to be a warrior for Christ, for deliverance from all sin, and for life everlasting at the foot of His throne. Then there was a song. Here, pure genetics made the place different. There was no robed choir. The whole place, front to back, was choir.

Then Jerry Lee, his hair slicked down with hair oil, slid out of the rough pew and walked to the front of the church. It was not a long walk, so why did it seem like he was walking through a vast cathedral? He faced the congregation, about forty people that Sunday, but it looked like a lot more then. They waited politely for him to begin . . . and waited, and waited.

Jerry Lee took a deep breath, spun on his heel and walked, a hundred miles at least, back to his family's pew.

"Mama," he whispered.

"Yes, son," Mamie said.

"What song was it I's supposed to play?"

" 'What Will My Answer Be?' " she said.

He nodded.

"People just busted out laughin'."

He marched back to the front of the church.

What will my answer be, what can I say
When Jesus beckons me home?

"It was the first song I ever sang in church."

Everything he has sung or played since rests on the pillars of that day, that church, and that song. He sees no irony in it, asks no questions, abides none: "The music comes from God."

Other styles of music would augment and color and shade his development, but it was all built on the grace and beauty and meaning in that old church music, no matter how far he may have strayed from the stories they told. Without it, he believes, all the other styles and achievements would have been somehow less than they were, as if they had been built on sand. He concedes that he did shake that foundation all he could, as did—to a lesser degree—Jimmy and Mickey and other piano players in the family. "If I'm not mistaken," recalls Gay Bradford, "they had to call someone and put some new ivory on the keys."

If there was one thing he was serious about, it was the piano, and he committed himself to it single-mindedly—but that didn't mean he listened to anyone else about it.

"I had a piano lesson just once, just one time, when I was twelve years old. It was Mr. Griffin. He wanted to teach me how to play by note, from this little ol' book he had, stuff for kids. But I played it the way I wanted to play it—played it that boogie-woogie style." The teacher slapped him. "He popped my jaws a little bit, yeah. 'You'll never do that again,' he told me," and Jerry Lee smiles at that.

What he was lacking was a piano-playing role model, a performer of the kind he envisioned himself becoming onstage. Hank Williams and Jimmie Rodgers were guitar players. Moon Mullican, pasty and round-faced, could play it all, but he was nobody's idea of a commanding personality—and Jerry Lee never saw him onstage, anyway. To find one, he had to look only as far as Pine Bluff, Arkansas, in his own family.

Carl Everett Glasscock McVoy was a cousin, the son of Aunt Fannie Sue Herron Glasscock and a few years older than Jerry Lee, Jimmy

Lee, and Mickey. In cousin Carl's good looks and in his piano style, Jerry Lee saw everything he wanted to be, or at least the beginning of things. Carl's father was an evangelist who traveled the country, and on a stay in New York, Carl was exposed to big-city boogie-woogie piano, and he showed Jerry Lee some licks when he came to visit relatives in Concordia Parish. "He was a genius," says Jerry Lee. "I saw him playin' piano at Uncle Son and Aunt Minnie's place, Jimmy's mama and daddy. He played the piano and sang, and I said, 'Man!' And he was such a good-*lookin'* guy. Aw, he was *handsome.* And I said, 'Boy, if I could do what he's doin', that'd be something else.' "

McVoy wasn't a star, of course. He worked construction in the daylight and played piano at night. Years later, after his nephew had made it big, he made some records, too, including a swinging version of "You Are My Sunshine" that became the first single on Hi Records. His small stardom did not swell or last, but in his charismatic looks and thumping piano style, he had already given Jerry Lee a taste of the future.

Still, Elmo's boy knew his music wasn't everything it could be, not yet. "Something *was* missin'," he says, something that went beyond style—some element of edge, or grit. Even as a boy he knew that the music around him, that gospel and country and old-time music, wasn't digging far enough into the deep blue state of man.

For that, he would have to put aside his hymnal and follow another kind of tumult and shouting all the way across town.

3

THE BIG HOUSE

....................

Ferriday

1945

The church ladies walked faster in the 500 block of Fourth Street. They did not want the sun to set on them there. The conflict, as old as Eden, had been burning on the black side of Ferriday since the first guitar man jumped from a freight and played for his liquor between Maryland and Carolina avenues. Now and then, a few brave preachers, washed in the blood and bulletproof, would set up near the nightclubs and hold church in the twilight. They warned that Satan lurked in the drink and lewdness and would come among them, to sift them as if wheat. But the pull of sin was strong, and people swarmed to Fourth Street after dark. They stepped out in spats and pearls from big Packards and rattling Model As, or stumbled from a Trailways bus, searching for this one place where the brimstone smelled a lot like good barbecue, where the shrieking and wailing had a rhythm to it, and a wild kind of joy. Here, young men played the blues with tiny bags of graveyard dirt tucked into the bodies of their guitars, and fine women moved in a way the human backbone should not allow. The best of the clubs here, or the worst, depending on your affiliation, was a place called Haney's Big House, one

of the biggest venues for blues and R&B between Memphis and New Orleans, and when preachers railed against the devil's music, this was precisely what they were talking about.

But Haney's was no mean little juke with a tub of iced-down beer and a few Mason jars of home brew. This was a place where four hundred people squeezed in on weekend nights—the entire population of Ferriday was less than four thousand—to dance, drink, gamble, fight, and cut, all of it washing onto a dirt street where a rattling old tour bus idled in the weeds. Slot machines spat out a hundred nickels at a time, and floorwalkers kept the peace with brass knuckles, clubbing a pistol out of a man's hand or cracking his head before he did something stupid and violent enough to bring in the white police. It was a club where roofing knives routinely shook loose on the dance floor and women toted straight razors in their underwear, so it was for good reason that the boss tried to keep things as calm as possible.

The big man here was no flashy kingpin but a serious-minded African American businessman named Will Haney, who reigned over not only this den of iniquity but also a motel, laundry, and a modest fortune in rented shotgun houses and even sold insurance on the side. He was said to be a decent man and slow to anger, despite being in league with the devil. But Haney knew rough music was money, knew the power of the blues the same way the sponsors of the Grand Ole Opry understood the appeal of lovelorn ballads and cheatin' songs—knew how the blues could bite down hard on people like a big snapping turtle and not turn loose till lightning burned the earth.

"It's where I got my juice," says Jerry Lee, and he has to think back almost seven decades to taste that first night again, to find the guitar slingers and harp blowers and piano men, young scorchers and scarred old relics in rumpled, sweat-stained, pin-striped suits and two-tone patent-leather shoes, playing boogie like it was their last night on earth. They played in the styles of Kansas City, St. Louis, New York, and the

Oakland clubs, though he did not know them then. Their names are lost to him now, too, if he ever knew them at all; nor can he recall any one piano player, any one style or trick that he tried to emulate, specifically. It was more the feel of it, the rawness, the pounding rhythm that struck him, slapped him, as if the music there had blown open a rift into a whole other dimension. "I fell right in," he says.

The white people called it Bucktown. "They said if you were ever black for one night down there, that you would never want to be white no more," said Doris Poole, who worked the counter at the dime store on Saturday nights back then. "Women used to come in there and buy those slate knives, those knives that would fold . . . put it down in their bosoms before they went out on Saturday night." One thing is sure. The first time little Jerry Lee climbed to the window to look inside, to see what the shouting was about, he knew he belonged there too, no matter how golden his hair, and he would never really make it back to the other side.

You can take me, pretty mama,
Jump me in your big brass bed.

He is asked, again, about the luck of it. Would his music have had the gut and grit and power if he had been born someplace else, someplace more peaceful, instead of smack-dab in the convergence of these two cultures living in uneasy and brittle peace, where people, black and white, all had someone's boot on their neck. Would he have been the musician he became? "*If* is the biggest word in the English language," he says, and his pride will not let him concede that his light might not have shone out the same way from any place, any time. Still, there was a reason he shuffled down Fourth Street so often as a boy, humming church music and cowboy songs, while on the other side of a thin wooden wall, the greatest names in blues were waiting for him to figure a way in. There was no pretense here. Here big-city blues stalwarts like

Big Joe Turner or rising stars like young Riley King would check their pomade in a backstage mirror and go on to shout the blues.

> *You can rock me, baby,*
> *Till my face turn cherry red.*

Will Haney is important to the legacy of rock and roll because of the house he built, and he did not build it for white folks. He was a man above foolishness, who ran a dance club and did not dance, who rarely drank but when he did, did with grim purpose. He was just short of six feet and short of two hundred pounds, moonfaced, with a permanent serious look, like he always had something better to do. In a black-and-white studio photograph taken in the 1940s, he poses in a chair against a fake garden window; he looks supremely unhappy, like a man waiting to be shot out of a cannon. He built a small empire in the Jim Crow South, in a town where the Klan burned a good friend to death in his own store. He had served his country in France in the stench and poison of the trenches, doing soul-killing servant's work, and came home to sell insurance for Peoples Life Insurance of New Orleans, collecting on policies that cost pocket change and paid out barely enough for a pine coffin. But when the floods came to Concordia Parish, he traveled to New Orleans to stop the company from canceling his customers' insurance.

In the mid-1930s, he took the money he made and procured a patch of dirt on Fourth Street, which gradually grew into an iconic nightclub that closed only once, the day his mama died. It sold hot links and pork shoulder and fine fried chicken, and white beans and a chunk of cornbread. "A full-course meal," said Hezekiah Early, who built his first guitar out of a cheese box and grew up with the legend of the place, and went on to play in Haney's house band in later years. Haney arranged to have the bus stop situated at the restaurant's front door. It had fifty tables, as well as pool tables, poker tables, and slot machines, for when

gambling was legal—and when it was not. It was bigger than anything, black or white, so they called it the Big House.

"Back in those days, a white man could always go where he wanted, but white people never came down to Haney's," said YZ Ealey, a guitar man from Sibley, Mississippi, who played with Big Mama Thornton and L. C. "Good Rockin'" Robinson, and played three years in the house band at Haney's. "Haney's was strictly a black thing," and if you wanted to drink, gamble, and hear live music, you paid Haney a dollar at the door. And when you walked into the Big House on a hot Louisiana night, into the screaming laughter and thumping drums and the roiling smoke, you could almost believe all that stuff the church folks were always going on about. You knew, one step in, that you had crossed over, say the musicians who played there. The hot-grease spat at you from the smoking iron skillets, and in the pit, flames licked at the sizzling meat. The air had a tang of snuff in it, and a funk of frying fish, and a cloying sweetness of gin and menthol. One-armed bandits lined a wall, clanking, ringing, the devil shaking hands on every pull. Sharks circled the pool tables, men who came in on sleeping cars but would leave running alongside the tracks, reaching for a cattle car, because Ferriday had some sharks itself. In the back rooms, men in good suits with good cigars in their gold teeth sat behind piles of money, bodyguards standing stone-faced behind them. But nobody stole at Haney's. The games lasted all day and well into the night, drawing gamblers from Houston, New Orleans, and West Memphis, and before the sun rose, there would be wedding rings and bills of sale in the pot, but no IOUs. The house took a cut of everything. "Everybody got a talent," said Ealey, "and Haney's was running a nightclub." At about nine o'clock, after the clientele was pretty well lubricated, the live music would commence with a hellish crackling as the musicians jacked their jerry-rigged, hollow-bodied guitars into big amplifiers. The stage was five feet high and ten feet deep and ran the length of one whole wall; it had to be that way, to hold all the wickedness that would be set loose into the night. It could

hold an orchestra or just an old man by himself on a stool playing a mail-order guitar.

Haney called them "dances," which was less likely to offend church people or scare the white folk, and cars lined up on the river bridge from Natchez, headlights making a glowworm a mile or more long. The dances were announced in a *Concordia Sentinel* column called *Among the Colored*. "You couldn't walk in the place . . . it would be jammed, packed," said Early, whose Hezekiah and the House Rockers played for years at the Big House. "Haney had his floorwalkers, but there would still be some hellish fights, but there wouldn't be no shootin'." There were black professionals here, people who, like Haney, operated solely on one side of the color line, morticians and doctors sharing space with barbers, sawmill hands, cooks and maids, track layers, and icehouse workers. The musicians called it the Chitlin' Circuit, all-black clubs throughout the segregated Deep South where a man or woman with talent could leave with a wad of twenties and still have to sleep in the car. But if you played at Haney's, you slept on clean sheets in Haney's Motel, ate Haney's ham and eggs, and drank Haney's liquor, and if the police pulled you over, you said the magic word. "The sheriff pulled me over many times," said Early. " 'Where you goin'? What you got in there?' I'd say, 'Mr. Haney gave us this liquor.' I never went to jail."

If you were anybody in blues, shoutin' blues, rhythm and blues, any blues, you played the Big House.

Jerry Lee used to stand in the weeds and broken glass and watch the bluesmen disembark from their trucks and buses, "when I wasn't old enough to go in," and not yet desperate enough to sneak in. They had slept in their suits, often, big city suits, from Beale Street in Memphis and as far away as Chicago, and covered their chemically straightened and sculpted hair with kerchiefs, like a woman, till showtime. The guitar men and saxophone wailers, even the famous ones, carried battered cases inside, because no one toted another man's baby. "Ever'body played Haney's, big bands, horns and everything," recalls Jerry Lee.

Haney brought in Papa George Lightfoot, the harp man who would cross over and play some of the white honky-tonks in his old age, and trombonist Leon "Pee Wee" Whittaker, who could almost remember the Creation, who had played with the old Rabbit's Foot Minstrels when the century was new.

Over the years, say the musicians who played in the house bands, the Big House hosted Charles Brown, the smooth Texan, and the elegant Roy Milton and his Solid Senders, who scored nineteen Top 10 R&B records, and Fats Domino, before "Ain't That a Shame" and "Blueberry Hill." He brought in the Slims—Memphis Slim and the House Rockers and Sunnyland Slim. A blind piano player named Ray Charles played here, and guitarist Little Milton, and singer Bobby "Blue" Bland; so did Junior Parker, a skinny black hillbilly named Chuck Berry, and a young Irma Thomas. Haney's hosted young performers like Percy Mayfield, the gentle vocalist and songwriter who begged "Please Send Me Someone to Love," and big stars of the previous generation like whiskey-voiced Tampa Red and his sometime partner, Atlanta piano man Big Maceo Merriweather, who reminded them, with every downward stroke, what they had endured and were enduring still.

> *So take these stripes from around me*
> *Take these chains from around my leg*

Freedom, sang Maceo, was no easy thing, either, and Tampa Red moaned, "Mmmmmm-hhhhmmmm." And if ever a thing of nails and wood had a life, a beating heart of its own, it was this place, where even in the hungover early morning, you might hear a single old guitar man tuning, messing, searching for a sound among the empty tables and chairs.

"Haney never did close the doors," Early said.

Jerry Lee had lived in the hot shadow of the blues all his life. The blues traveled on the wind through the low country of Louisiana, and all he had to do was stand still in one place a little while to hear it. Three out of every four people in Ferriday were people of color, and the black man's blues poured from passing cars and transistor radios and jukeboxes. But he had never heard it—really heard it—till he heard it pour from the Big House. Even before he was tall enough to see inside the place, he would climb to a window or get someone to boost him up, for just a glimpse, for a raw second. It was never enough, and it went on that way, unconsummated, for years.

He dragged his cousin Jimmy with him, tried to coerce him into sneaking in with him. "Jimmy wouldn't do it. I just couldn't get him in there. . . . He was scared to go in there." Jimmy knew the beast when he saw it, "called it the devil's music," recalls Jerry Lee, and, after untold pleadings, Jimmy left his wild cousin to his own destruction. Besides, Jimmy told him, if his mama and daddy found out he was sneaking into Haney's Big House, they would beat him until he did not know his own name. "Mama might not kill me," he told Jerry Lee, "but Daddy will."

"Well, I ain't scared of mine," Jerry Lee told him.

"Never could get Jimmy to go in there with me," he says, thinking back. "He was scared of it." But for him, it was a good time to get out of the house; he might not even be missed, at least for an hour or two. Mamie had recently given birth to a second daughter, another dark-haired girl, named Linda Gail. Mamie and Elmo were distracted, still making a fuss over the new baby. But he truly did not much care if he was found out or not. They did not beat him, only threatened a lot. Besides, some things were worth a good beating, he surmised.

He had long suspected there was something in black music he wanted and needed, but he could not figure out exactly how to get to hear it. He scouted the problem over and over; Haney's was an easy walk from his house, even if he had to swing by after a trip to the Arcade to catch another Western or maybe *Frankenstein*. Over the years,

several people would claim it was they who gave him access to the forbidden nightclub, who hoisted him to an open window or left a locked door unlocked so the boy could creep in. The truth is, one day he just couldn't stand it anymore, the itch, and walked alone to one of the two front doors that faced Fourth Street. It was a Sunday night, and he was AWOL from Texas Street. At Haney's he saw a raggedy bus outside, which meant a traveling band and maybe even a bluesman of some renown; the nightclub was already bulging with people, the red sun not yet fully down. He would not be missed for hours. "Ever'body else was in church," he recalls. The Assembly of God met twice on Sunday, morning and evening; the devil never took a day off.

He waited for his chance, till Haney and the money-takers were looking the other way, and darted into the smoke and noise. He searched around, frantic, for a hiding place, but there was none he could see. "So I got in under a table," he says, just slid underneath smooth and slick and unseen—or at least that was what he told himself—till he was safe in the dark among the patent-leather shoes and the high heels.

I'm in, Jerry Lee kept telling himself. *I'm in Haney's.* In that place that threatened his immortal soul.

And it was worth it. "I could see *everything*," he remembers, though it is unclear if he is talking about the club or something more. Above him, people swayed in rickety chairs, drank, and laughed. On the dance floor, men and women came together in a grind, legs locked inside legs, so tight that if you cut one, the other one would bleed. "Couldn't have been a better place for me," says Jerry Lee. "I got right *with* it."

> *The blues starts rollin'*
> *And they stopped in front of my door*

The guitar man onstage sang with a voice filled with all the suffering in the wide, flat, dusty world. In his voice is the sound of clanking leg irons. In his music is a daddy who grows smaller, less distinct, as a

battered pickup pulls away on a bleak Delta road, and a mule that drags him over a million miles of dirt. His guitar wailed like a witness, too, to every mile and every slur and every pain. The man, his head cocked to one shoulder like it was nailed on at a cant, moved nothing but his thick fingers, fluttering around the frets like a hummingbird, and sweat poured down his face. "I just sat there and thought, *Man, look at him pick.* He was playing all over that guitar," recalls Jerry Lee. In this man's hands, it did not seem so much an inferior instrument. "And I tell you, he was singing some songs."

The applause was still slapping, people even stomping the floor, when the guitar man lit into some stomping blues and snatched the people still sitting out of their seats. "Them cats could dance," Jerry Lee says. Men leaped into the air, impossibly high, like they were flying. Women shook things he had believed were bolted down; some jumped onto the tables and danced up there. "They was throwin' each other over their shoulders, throwin' each other over their heads. And I was in seventh heaven." This, he knew, was what had been missing. This was the spice, the soul he'd been looking for.

> *Woke up this morning,*
> *My baby was gone . . .*

He was already thinking how he would play it, how he would mix it with what he knew. But mostly he just let it fill him up, sink in, become part of him. "I just introduced myself to the atmosphere," he says.

Please, God, don't let Haney catch me now, he thought—and just then a big hand closed around the nape of his neck and lifted him like a doll from under the table and then high, high up off the floor, till he was looking Will Haney in one red, angry eye.

"Jerry Lee?"

He just dangled. Everyone in Ferriday knew the boy. Most little boys, born to overalls, did not strut around like him, like they owned

every mile of dirt they walked. But Haney also knew his Uncle Lee and his Aunt Stella, and had business with them.

"What you doin' in here, white boy?" Haney asked.

"I'm *tryin'* to listen to some blues," he said.

"You ain't supposed to be in here."

"I know. But I am."

Jerry Lee tried to sound brave, but in his mind was thinking, *Haney is big as a door.*

"I'm tryin' to hear some music," he said, "if you don't mind."

Haney was breathing fire and seemed genuinely worried. This was a social breach, and a dangerous one. "Your Uncle Lee will destroy me for this," Haney said.

Jerry Lee dangled.

"If your mama caught you here, she'd kill me! And your Uncle Lee will shoot me. And your Aunt Stella? She would—they would—have a heart attack."

The music had not stopped; you could have dragged a bull alligator and a rusted washing machine through the joint when the music was going good. Haney hustled him to the door. The boy did not have to be dragged, but he did not act contrite, either. "And don't come back," Haney said from the door. Jerry Lee started walking in the direction of home, but as soon as Haney turned his back, he doubled back and crept through the dark to the band's old bus. "I had to get on that bus," he says. "I sat down in a chair, and I thought, *I bet this is where he sat.*" He sat there for a long time, dreaming, the music fainter now. Finally, banned for life, he walked home, the rhythm and the blues thumping inside his head.

A few days later, one of the customers called Haney over to him. "They's a white boy under my table," he said.

At least when Haney dragged him out, it was the same one. He could not have stood an epidemic. He threatened and pleaded with him again. "I came back," Jerry Lee says, grinning, "for years." He checked

the "Among the Colored" column in the *Sentinel*, to find out when the big acts were in town. He always got in somehow, till it became ritual. He would slide under a table, and a customer would nudge him with a toe. "Is that you, Jerry Lee?"

"It's me."

He went back over and over and over and over. But the image that stuck in his mind was that of a young B. B. King, the "Beale Street Blues Boy," who would one day run back into a burning juke joint in Twist, Arkansas, to save his guitar after two fighting drunks knocked over a garbage can filled with burning kerosene. Like his primary influence, T-Bone Walker, he sang the blues for a line or two, then answered with his guitar; as he bent the strings it sounded like the thing was talking back, like there was two men up there instead of one, telling the news.

It had a lot of names, then, that music: the blues, R&B, others less savory. But Jerry Lee knew what it was.

"They was playin' rock and roll," he says.

"They *was*."

It was hard, after he had seen the Big House bulge with such raw, grand music, to get real excited about seventh grade. Still, he did his best to stay in it, even if it meant choking a man, which in this case it did.

This takes a little explaining. The sixth grade had not gone all that well for Jerry Lee. First, there had been a grade-switching scheme. "I changed all my F grades to A," he says. "Only real whipping I ever got." Mamie turned her back as Elmo pulled off his belt and beat the boy like a one-crop mule, beat him till Mamie pleaded with him to stop "before you beat my baby to death." It wasn't that the boy couldn't do the work; it was just that it was almost impossible to learn much about Paul Revere's ride or Isaac Newton's apple while you were at the pool hall. If you ask him today if he minded school, he will say no, he did

not mind it much, because some days—many days, really—he never got within a mile of it. He ate his vanilla wafers and marched off to school like a little man, but if there was a jukebox playing somewhere for the early-morning drunks, it shook him off his stride, or if there was just a lonely street corner somewhere, he felt compelled to lean on a power pole to keep it all company, and if the weather was hot, he just went swimming in the river or Lake Concordia, or lay in the sun and thought about songs and girls or girls and songs. He worked hard on his music because it mattered, because any nitwit could see that it was his ticket out, and let the rest slide because it did not. He watched a lot of boats churn past the levee and knocked a lot of balls across the green felt and heard a lot of Moon Mullican on the jukebox, while other boys suffered through the *Niña*, the *Pinta*, and the *Santa María*, and the square root of some silly thing.

He showed up for the beginning of the seventh grade, only to find out he was not in it. He decided to take a seat anyway. He had already figured out that a person, if they were special enough, if they had something uncommon to offer, could live by a set of rules separate from those set down for dull, regular people. The way to accomplish this was to make it too much effort for people to try to bend him to their regular-people rules. "So I picked me out a seat . . . think I took Bill Herron's seat, and I sat down," he said. "Mr. Lancaster was the teacher and the football coach. He told me I had failed my class and said I had to go back to the sixth grade. I told him, 'Look, if you want me to go to school, I'm going to school in the seventh grade. This is my seat right here.' I told him. He told me to shut up, and nobody tells me to shut up. I couldn't take that. He was a big man, and picked me up out of that seat, and we commenced to fightin'."

Mr. Lancaster had it in his mind that he would just bodily carry Jerry Lee to the sixth grade, but it was hard to get a good grip on the boy. Jerry Lee was bobbing and weaving and gouging and twisting as

the other students watched in amazement, because nothing this exciting had happened in homeroom since a boy named Otto soiled himself during a too-long assembly in second grade and had to be sent home in a secondhand sailor suit.

The coach, red-faced and muttering, finally got a grip on him, and that's when Jerry Lee saw the man's necktie flutter past his face. He grabbed it with both hands and just *pulled*.

"I was hangin' him," he says. "I had him, boy. I was swinging on that necktie, and I was choking him to death."

Mr. Lancaster gave a single, mighty gasp and began to stagger around the room, Jerry Lee swinging from the necktie like a clapper on a bell. The man's face went bloodred and his breath was coming in tiny little *wheeeee*s; some of the little girls began to whimper and scrunch their faces up, about to bawl. "Then two of his football players come in," says Jerry Lee, "and drug me off him."

He was transported, still kicking, to the principal's office and deposited in a chair.

Another boy, Cecil Harrelson, sat across the room, looking glum.

"What you in for?" Jerry Lee asked him.

"I's fightin' Mr. Dickie French," the boy told him.

That impressed Jerry Lee. Mr. French, who taught history, was a navy man.

"Then Mr. Bateman, the principal, come in, and asked me what had happened, and I told him," and he even managed to make himself seem almost noble. "I said, 'Mr. Bateman, they tried to make me go back to the sixth grade but I didn't want to go back to the sixth grade and I wanted to stay in the seventh grade,' and he said, 'Son, I don't blame you a bit, but I got to suspend you for two weeks, because we can't have you killing teachers.'" Jerry told him, "Well, okay," but what he was thinking was more like, *Please, Mr. Fox, don't throw me in that briar patch*.

"I think he give Cecil two weeks, too."

The two boys walked together through the gate.

"Well," said Cecil, as they turned to go their separate ways, "see ya later, Killer."

"And I been the Killer ever since," says Jerry Lee. Most people think he got the nickname because of his wild stage show or his reputation offstage or worse, but it had nothing to do with any of that.

"I named him. I did," recalled Cecil Harrelson, who would go on to be Jerry Lee's road manager and his friend through good and awful times, who would hold men while Jerry Lee hit them, as they played and fought their way across the country and back again. "It's funny. You pass through this life and you wake up one morning, and it's about all behind you," Cecil said shortly before his death, "but you never forget that about being boys. It's the first thing you think of."

Jerry Lee continued to educate himself, one genre and influence at a time. Sometimes a hit song came over him like a fever, and he quit whatever he was doing, left people standing slack-jawed, to go and play it himself and adapt it, in a matter of minutes, to his style. One day, it happened to him while he was on a date at the Arcade Theater. "I'd go see Gene Autry," he recalls, "and just before the movie come on they'd take fifteen minutes and play Al Jolson songs on those 78 records. I was sittin' there and I was listenin'. I had a girlfriend with me."

Then something happened that got his attention. "Al Jolson come on, and he's singin' this song—I think it was 'Toot, Toot, Tootsie, Goodbye.' And back then I could listen to a song an', if I liked it, automatically I adapted that song into my mind. . . . I knew it word for word, melody for melody. I *knew* it. And I told my girlfriend, I says, 'I gotta go use the restroom. I'll be right back.' And I left. I got on my bicycle and went home.

"I sat down at the piano and played that song—played it for two, three times, got it just like I wanted. I got back on my bicycle, went back to the theater, parked my bike, went inside, set down by Faye—

her name was Faye, Faye Bryant. And she said, 'You . . . you was gone quite a while, wasn't you?' I said, 'Naw, I just went to use the restroom. Picked up some popcorn.'

"It's unbelievable. But it happened."

Other musical lessons took longer to sink in. It was about this time that Jerry Lee Lewis first heard the words and music of a painfully thin, sallow, brilliant man from the great state of Alabama. His mama loved Hank Williams, this man they called the Hillbilly Shakespeare, because he sang straight at her, the way he did every man and woman who had ever gone to bed unsure of what the new morning would bring.

Jerry Lee did not actually know it was genius, not quite yet. "I'll be honest with you. I didn't particularly care for him myself," he says. "I didn't think he could sing that good." But in time, he began to listen closer, "and I was really wrong about that. It flowed out, that real stylist talent," and suddenly it was like the man was singing right at him, too, even when the radio was off or when he was out of nickels at the jukebox and only static hissed from the spinning record.

He had practically been weaned on Jimmie Rodgers, but when he heard Hank Williams wail for his attention—really heard him—it was like he was hearing his own future sung to him. Williams had started singing on WSFA in Montgomery, with a voice that was so forlorn, it seemed trapped halfway between this and the other side. He had written songs on café napkins and scrap paper about the things that mattered—about women who did not love you back, and sons who called another man Daddy, and being so lonesome in the night that you wished you would die—and it wasn't so awful somehow, to those cotton mill workers, pulpwooders, coal miners, sharecroppers, sweatshop workers, and the women who wiped the tables in the truck stops, when he sang their pain on the air. Then he made them laugh out loud,

singing about wooden Indians that never got a kiss, and a beer bucket with a hole in it, and how that little dog better scoot on over because the big dog's movin' in. He could not read music or think of a song in notes but never had to, being a genius. He drank and took morphine and gobbled painkillers to smother the agony in a twisted back and a pressing darkness; he sang drunk onstage and sometimes did not show up at all, and people loved him anyway, because he belonged to them, broken whiskey bottles and littered pill bottles and needles and all, because when he sang, you could forget for a while the stabbing, slashing machines that took their fingers, and the rich man's courts that sent them to rot in Atmore, Parchman, and Brushy Mountain.

Like Jimmie Rodgers, Hank was not afraid to yodel, even though the moneymen had told him that a yodel record would not sell in the modern age of American music, and certainly not sell outside the peckerwoods. He told them to go to hell. After a few smaller records he wrote himself, he finally found the song that would carry him to glory. "I can throw my hat onto the stage after I sing 'Lovesick Blues,'" he said, "and my hat will get three encores." And he was right.

Hank Williams did not write "Lovesick Blues"—it was an old Tin Pan Alley song, written in '22 by Clifford Friend and Irving Mills—but he made it his song forever, made his voice and his sound the only ones that would matter, forever and ever. That was what being a stylist was all about. When the Opry put him on the big stage at the Ryman Auditorium to sing it, the song rocketed outward from Nashville across the entire country. Fishermen in the Pacific Northwest heard . . .

> I got a feeling called the blu-ues, oh Lawd,
> Since my baby said good-bye

. . . and liked it.

But the man from Alabama led an uneasy life, and soon his career and his ways were locked in near-constant battle. The men who domi-

nated the bluegrass and commercial country music broadcast from the Ryman Auditorium, some of them about as country as a subway if you knocked the cowboy hats off their heads, were fearful of this young man with the dark circles under his eyes. WSFA fired him for habitual drunkenness, and before long the Opry wouldn't have him either. When Jerry Lee first heard him, it was by way of Shreveport, just 180 miles away from Ferriday, on the Louisiana Hayride, the weekly radio show he played when the Opry wouldn't have him.

After "Lovesick Blues," the wayward yodeler followed up with a string of hits he wrote himself—"I Can't Help It," "Cold, Cold Heart," "Hey, Good Lookin'," "Long Gone Lonesome Blues"—and Jerry Lee loved them all. But that was not the only reason he cleaved to Hank Williams. As much as anything, it was the fact that Hank was also a man raised in faith but pulled and torn by sin, a man who lived with one foot hot and one foot cool, straddling the worlds of sacred music and secular music with a kind of tortured beauty. He would have the crowds tapping their toes in the auditoriums to some hillbilly swing, then mumble, "Neighbors, we've got a little sacred song y'all might want to hear, a little song I wrote. . . ."

> *I wandered so aimless, my life filled with sin*
> *I wouldn't let my dear Savior in*

Jerry Lee knew he was bound to this man somehow. "I think me and Mr. Williams were a lot alike," he says now. He leaned on the jukebox and listened to "Your Cheatin' Heart." He studied the words to "You Win Again" and sensed the unbearable humiliation there.

"I *felt* something when I listened to that man," he says. "I felt something different."

He rarely calls him Hank. It is "Mr. Williams."

"I listened to Mr. Williams, and I listened real close. I listened to hear a sharp note, or a flat note. And you know what? I'm still listening."

There was no television, no video, so he could not really see what the man looked like, how he moved or carried himself. There were only the records to go by, and the occasional poster or flyer of an almost emaciated young man who stood a little knock-kneed onstage, but elegant, somehow, in his white suits and big white Stetson; he was elegant to the end, even after Nashville got to him and he started wearing buckskin fringe and big musical notes on his suits and lined his coat sleeves and pants legs with rhinestones and glitter and whatnot, like a dime store blew up all over him. The Opry hired him back and fired him again, but he always reappeared somewhere, saying, "Neighbors, I'm so happy to be back, and I got a purty little song. . . ."

Jerry Lee played the songs over and over. He did the same with other songs, like Ernest Tubb's "Walking the Floor Over You" and a hundred more, but there was just something different in Mr. Williams's music, the way some paintings are more vivid, more real than others, and he dreamed about meeting the man and telling him how much he liked his songs. But there was no rush. Jerry Lee was just barely a teenager, and Hank Williams was only in his late twenties, and he'd promised, over the radio, that if the Lord was willing and the creek stayed level he'd be in his town real soon.

It was about this time that Jerry Lee first started to challenge Elmo's supremacy in the home. Elmo could abide most things, but not sass, and Jerry Lee was born to sass. He came off the bottle smarting off, and as he became a teenager, he figured he could stand up to his father, could defy his orders as a man would defy another man. It was funny when he was a boy, but when he was big enough, he knew he would have to back it up with his fists. "I figured I would try it one day," he says. He can't recall exactly what sparked it—maybe the old man had finally gotten old after all—but inevitably that one day came.

"He reached his hand around my head and picked me up by the

nape of my neck, and I was looking right into his face." The last time
that had happened he had been a little boy, in Haney's Big House. This
was different. His daddy's eyes were calm, flat.

He remembers one blow, maybe two, then his mother's voice.

"Don't hit him again! Don't hit my baby again."

"I remember he picked me up like I was a straw, and I knew that I
had been conquered."

The year 1948 began with a crime wave in Concordia Parish, or at least
as close to such as anyone there could recall. All kinds of things were
turning up missing, including some items that left police bewildered as
to why anyone would want them. It was just Jerry Lee and his cousin
Jimmy, who had temporarily backslid, creeping around at night, steal-
ing scrap iron from their Uncle Lee and selling it back to him the next
morning, and breaking into warehouses that held things most people
would not take on a scavenger hunt. Jimmy, in his own biography, wrote
that the cousins stole a roll of barbed wire; they did not need a roll of
barbed wire, and Jerry Lee was against taking it, but Jimmy figured if
they were going so far as to break and enter, they dang sure were going
to leave with something. He left carrying a roll of wire, but it got heavy,
so he threw it in a ditch. The boys had better luck with stores, and by
the summer of '48 they had a nice pile of loot. "It's a whole gang," said
Chief Swaggart, when asked about the rash of thefts, but the crime
wave mysteriously flattened to nothing when Jimmy rededicated him-
self to the Lord and Jerry Lee, his family, and his piano vanished on
the two-lane to Angola, where Elmo had found construction work on a
hospital for the infamous prison there.

Home to some of the worst human-rights abuses in American penal
history, Angola was a for-profit prison in its beginning, where men and
women could be leased from the state, whipped and worked to death,
then replaced like parts on a car. They worked the cotton fields and

endured systematic torture, rape, and murder. The state took it over in the twentieth century, but not much changed, and inmates just vanished, buried in unmarked graves or sunk into the river, which formed a great crescent around the prison. In that year of 1948, Governor Jimmie Davis promised to make Angola humane, and his reforms created the new construction that brought Elmo and his family here. But it was not his reforms that got Davis elected; one does not get elected in the South by promising to make prison *nicer*. Davis, a country singer in the Jimmie Rodgers vein, had had a country hit a few years before with a song called "You Are My Sunshine," and he sent out campaign trucks rigged with loudspeakers, blasting the song even in places where only the armadillos were likely to hear it. Sometimes, surreally, the speaker trucks would get stuck behind the truck carrying the state's electric chair, which was hauled around the state so people could execute their condemned right close by. And the trucks rolled on, in a macabre caravan.

> *You are my sunshine, my only sunshine.*
> *You make me happy, when skies are gray.*

In this haunted place, Jerry Lee fell in love, or something like it. The Lewis family moved into a workers' camp outside the prison, and Jerry Lee went to the public school. He even went to class, because he had discovered football. He was skinny but fast, and he could catch a football and run like a water bug, and he made the girls act all gushy when he pulled off his helmet and slicked back his hair, which he knew to do a lot. But then a tackler the size of an International Harvester combine hit him low and separated his thighbone from the rest of his body, leaving him in a cast from his navel to his big toe. So he went back to being a piano player.

The girls, he quickly discovered, liked a good-lookin' piano player even more than a football hero. He started caring about his clothes,

hair, and the kind of car he could get to date in, though he was still only thirteen. Driver's licenses, like most other forms of government interference, had nothing to do with him, and he had already discovered that many people were foolish enough to leave keys in their cars, so they could be borrowed.

As for girls, "I could take 'em or leave 'em," he says. "Take 'em, mostly."

Then he saw her.

She had a lovely name, a name from the Bible.

"Ruth," says Jerry Lee.

She was slim, with dark brown hair, and prettier than string music.

"I think about her, a good bit."

The problem with being Jerry Lee Lewis is all the sharp edges on things in his memories. In the Tennessee Williams play *Cat on a Hot Tin Roof*, the domineering family patriarch describes his own life in similar terms: "All of my life I been like a doubled-up fist. . . . Poundin', smashin', drivin'!" You leave a lot of splintered and broken things, a lot of jagged things, in a life like that.

"But sometimes," Jerry Lee says, "there ain't no sharp edges." It is that way, just like that, when he thinks about Ruth. This was back when only Cecil Harrelson called him the Killer, not yet the whole wide world. He was not a gentle boy and never had been but was gentler around her then, and as he thinks about her now. Not even Jerry Lee Lewis could be a driving fist all the time.

"Now I'm going to loosen these doubled-up hands," Tennessee Williams also wrote, "and touch things *easy* with them."

He already had one girlfriend, of course—a lovely girl back in Ferriday named Elizabeth. "A brunette doll," he says. "I thought I loved her, a little bit. I loved the way she walked, the way she talked. Took her to her prom in a '49 Chevrolet. A *doll*. Her ol' mama stood on the porch

and just watched us, watched us leave and watched us come in, and I didn't care, I kissed her anyway. But then we moved out to Angola, and I got with Ruth."

She was working behind the counter in a little store. "I was still thirteen, and she was sixteen, a good-lookin' girl, and filled out, reasonably well. I said, 'How much is this candy bar?' and she just gave it to me. Next thing I knew, we was laying in the sun on the banks of the ol' Mississippi."

Jerry Lee knew about romance. He had heard it in songs. But he could have been smoother, he concedes now. They lay by the river for hours at a time, just talking.

"Look at those clouds," she would say. "Are they telling you something?"

"Naw," he said. "You can make anything out of clouds you want."

She found all manner of things there, ships and houses and islands in the sky.

"I don't know," said Jerry Lee. "They just look like clouds to me."

He lets his mind drift a bit, quiet for a while.

"She was a sweet girl."

He was still in his cast when they first started seeing each other. When he was finally free of it, he and Ruth danced in her room to the record player. "We danced, and we cut up. One day her daddy caught us, but we wasn't doin' nothing. He whipped her pretty good. We just kept right on. Then she heard me play on the piano, and it was just over. She was in love.

"I had been a man for quite some time," he says, by way of explanation. "Been driving since I was nine."

She seemed content to just curl up with him, in the shade, by the river, or on a couch when her mama and daddy were away. "But I never was much of a cuddler," he says. One day, they found a secluded spot on the bank and put out a blanket. "Right there on the sandy banks of Little Creek. Couldn't have been a more perfect spot. . . . You know,

you spend a lot of time in your life seeking some kind of perfection, but we're a long way from gettin' there. But this seemed like it, that there. I had spent a lot of time, thinking about things like this."

They kissed, and Jerry Lee started asking.

"No," she said.

He asked some more.

"No," she said, but weaker.

He talked her into it; he had talked himself into it, he believed, already.

"I had been fighting it for a while," he says, because of his raising. But he kept on. "I finally talked her into it—gettin' on with the program, so to speak."

Then there she was, naked, and it was as perfect, that moment, as he thought it might be.

"I'm ready," she said.

"And, uh, we got down to the nitty-gritty," he says, thinking back. "And . . . I slowly approached the situation."

But at the last second, he hesitated.

He could hear Scripture in the air.

He heard his mama.

He looked up at the sky, for lightning, for the accusation.

"Help me, Lord."

Ruth looked at him, puzzled.

She waited.

"I can't do this," he said.

"What?" she said.

"I won't."

"It was you," she reminded him, "got me naked."

"I thought I was willing," Jerry Lee told her.

"You mean you got me like this, and you ain't . . . ? You can't do this to me, baby. You know what I want, and I know what you want. You ain't foolin' me."

"No," he said. "It wouldn't be right."

She was hurt, and mad, and embarrassed, and mightily confused.

"I was wanting to . . . but I just wasn't taught this way. I'm doing you a favor," said Jerry Lee, and pulled on his clothes.

"I was scared to," he says, so many years later. "I heard the sermon, and I was scared to death. I heard my mama. I thought there would be lightning flashing and everything else, and I just knew that it was wrong. And I never went with a woman, till I got married."

He knew, even then, what was at stake. "It wouldn't have worked. I wanted to be a star. I wanted to play that piano. Sometimes you have to pick, and I picked the dream. I was not gonna let that dream go by. I hear she married a nice man. Probably had a whole stack of kids. They moved away. But I do think about her, quite a bit. Put that in there, in the book. I want her to know that."

The work ran out in Angola, and the family moved home to Concordia Parish, to a house in Black River. He looked up Elizabeth, but pretty girls do not linger for long in small Southern towns; they slip away, quickly, lightly. But then women were not his first love, anyway.

He had been dreaming since he was nine of being a real musician, and though he knew a hundred songs, no one had ever paid him a dime to sing one till the summer of '49. It was the year Ford Motor Co., in Detroit, Michigan, made a car that will always be beautiful to Jerry Lee, because it was there, against those bulbous fenders, that his future began to take shape. The Ford cost only $1,624, and it had a flathead V8 and three on the tree, and a hood ornament fashioned from a seventeenth-century European crest of lions or something; it was hard to tell. But that flathead was about the meanest thing on the blacktop in '49, and the bootleggers bought a lot of them. Unfortunately, so did the government, so the whiskey men and G-men were in a dead heat. But regardless of your affiliation, you could get your hands on one at Babin-

Paul Ford Motor Co. in Ferriday that summer, and people came to see it, and hear a hillbilly band play "Walking the Floor Over You" from a stage hammered together from plywood and two-by-fours.

By afternoon a small crowd had gathered—farmers, barbers, store clerks, insurance men, and tired women dragging children around by sticky hands—to peer under the hood and to hear Loy Gordon and his Pleasant Valley Boys play "Wildwood Flower."

Elmo, Mamie, Jerry Lee, and his Aunt Eva were looking on, listening to the free show. "My boy can do better'n that," Elmo suddenly said, and took off for the stage, with purpose, and told the organizers of this hootenanny that the *real* talent was standing down there in the crowd popping his bubblegum. The car dealers did not see what harm it would do, and Jerry Lee was welcomed onstage to polite applause. People thought it was cute, letting this boy sit in, and the piano player relinquished his old upright. Jerry Lee took a breath. They were expecting something country, something gospel, and he looked out across the crowd and hollered "Wine Spo-dee-o-dee!" so loud it made Mamie blanch and Elmo grin like a loon.

Now I got a nickel if you got a dime.
Let's get together and buy some wine.
Wine over here, wine over there,
Drinkin' that mess everywhere

The crowd at first did not know what to think about this kid banging that piano like a crazy man and hollering that "nigra music." But the sunburned men tapped their Lehigh work boots in time to Stick McGhee, and people were grinning and looking downright foolish.

"The boy's doing pretty good," said Aunt Eva. "Maybe we ought to take up a collection."

"Money makes the mare trot," Mamie said.

They passed a hat. When it came back around, it sagged with silver.

"I think I made about fourteen dollars," says Jerry Lee.

He was a professional at last.

"I was paid to sing and play the piano."

He walked in the clouds for a little bit after that. He quit school, just saw no future in it. He and Elmo heaved the piano on back of the Ford, and they went on the road, making a little money here and there, Jerry Lee singing and playing gospel and hillbilly and blues and even that Al Jolson, and in time he was taking home trophies from talent shows and doing regular spots on nearby radio stations. "I had my own show," a fifteen-minute spot on WNAT out of Natchez sponsored by a Ferriday grocery store. "People started to hear about me, started to say, 'Hey, who is this kid down there?'" It was mostly gospel, and some country; he couldn't cut loose—not yet—and do the kind of music he wanted.

His cousins did similar gigs, spreading their own talent through the bottomland, though Jimmy still worried that singing and playing boogie-woogie was sending them all to hell on a handcar. Jerry Lee sometimes worried the same—every Sunday in church reminded him of the danger of such intense secular pleasure—but not as deeply or as often. "I wanted to be a star. Knew I could be, if . . ." If the starmakers in Memphis or Nashville would listen to him, really listen, and hear in his piano and voice that he was the only one like him in the ever-lovin' world.

Impatient as he was, he knew his music was wasted if the people couldn't hear it, and for that he needed a bigger stage. What he wanted was a honky-tonk, and that troubled his mama. Mamie would have loved to see her son in the ministry, would have loved to see him onstage in a white suit singing only sacred songs, but to say that she castigated her boy for his secular music would be to exaggerate things, her son says. "Mama didn't like some of it," said Jerry Lee, "but Mama was *with* me," no matter what came, and he knew it then, and he believes it now.

He tested that tolerance and allegiance across the river in Natchez. The rough nightclubs there were the only place he knew in his small

world where musicians could make a living, or at least a little piece of one. But ten dollars or so a night was more than he would make picking cotton, which he wasn't going to do anyway, even at gunpoint. So while he was still living under his daddy's roof, he snuck off to the clubs in Natchez to ask for steady work. The no-nonsense club owners, men who had seen it all, started to smile when the boy walked in. The smile slipped off their faces when they heard him play the boogie and the hillbilly music and even Gene Autry. He told them he was looking for work as a piano man, mostly, but could beat the drums, too, if there was cash money in it.

"I was thirteen the first time I left home to play, soon as I was big enough," he remembers. "I was sittin' on a piano stool where my feet weren't even touchin' the floor. That's how young I was. This was the Blue Cat Club, down Under-the-Hill, the old Natchez," a riverfront neighborhood that had been a warren of iniquity and villainy for more than two hundred years but a gold mine for musical style. Here a musician had to know *everything*. A request was not always a suggestion, not from a man who cut pulpwood for a living and drank his whiskey by the shot. Jerry Lee played hillbilly. He played "Release Me," and "Goodnight, Irene," and even Glenn Miller. "I learned to play everything as long as I could get a tip out of it"—and learned to get down low when the bottles started flying. After a while, he says, "I'd get homesick and tell 'em, 'I got to go home and see Mama.' " But he kept coming back.

At those clubs in Natchez Under-the-Hill, he played with six or seven watches dangling from each skinny arm, put there by customers who figured they'd be safe on the arms of a boy if there happened to be a raid—which happened frequently at the Blue Cat Club. "The owner's name was Charlie. He says, 'Now, if the cops come by and ask you how old you are, you tell 'em you're twenty-one.' I said, 'Oh, sure.' "

The police, at least, had a sense of humor.

"How old are you, boy?" they always asked.

"I'm twenty-one," he lied.

"Well," they always said, laughing, "that sounds about right."

"I have been twenty-one," said Jerry Lee, unwilling to let a good lie go, "for some time."

For the next few years, the clubs would nurture Jerry Lee's music, as much as any place can when the owner walks around with a big .44 sagging his slacks and women routinely have their wigs slapped off their heads by other women. He walked to his car past whorehouses and heroin fiends. Nellie Jackson ran a famous cathouse in Natchez in those days, where you might run into a high official with his suspenders down, but Jerry Lee says he was not a customer. "I walked up to the front door one time, and I turned around and left," he says. He had no business there.

His mama worried and would stay up all night sometimes, till she heard her son's car pull up in the yard, sometimes in the dawn. It went on and on, night after night, till he was fourteen, fifteen, and there were moments of great doubt, moments when, looking at her tired face, he wondered if he could somehow have it all, if he could tame that boogie and bend it to the Lord, tame his lusts and get himself a white suit and a tent and use his burgeoning talents for the church. But he was surviving by playing music. By fall of '51, he was going on sixteen, "and was already a man and acted like one," and past ready to find a wife and marry, at least by the standards of his people. But he worked in a bar, and he knew that a man—a smart one, anyway—does not find a wife in a bar. Such a union is well and truly doomed, built in the quicksands of sin. A man, a wise man, found his wife in church.

He saw the girl and made a covenant with his eyes. "I was playing 'Peace in the Valley' when I saw her. She was sitting in the front row. What a beauty. A woman, really. And I really blew my cool, man. I got it right between the eyes."

It was 1951. Her name was Dorothy, and she was seventeen. Her father

was the Reverend Jewell Barton, a traveling evangelist from up around
Monroe who came to Ferriday to save the wicked and brought his beau-
tiful daughter with him. He was not worried about exposing her to the
sin of this place, to the temptations of the road. Dorothy, whose hair fell
in dark, lustrous waves, was a devout girl, and the reverend knew he had
to go into the wilderness to do his job, had to venture to places like this
railroad town of Ferriday, which had been drawing men like him since
its beginning. He was a warrior for Christ and needed weapons. He hired
Jerry Lee to play piano, to pack 'em in. The boy's reputation as a piano
player had spread. It was a good revival, with good preaching and singing
and music, but Jerry Lee did not see or hear much of it, truthfully, after
he saw the dark-haired girl. He was fixed on her.

"I'd just turned sixteen, and she set my world afire. I mean, I was in
a fever. That's right, a *fever*. And I knew I would do anything, promise
anything, anything I had to do."

He even shared his dreams, told her he wanted to hear his songs
on the radio, maybe even be a big star someday. "She told me, 'Maybe
you can have your name on one of those records with the big hole in
the middle,' and I said, 'You're crazy, a record has a little-bitty hole in
it.' I thought she was making fun of me. But she was just talkin' about
a 45."

They started dating, and "smooching in the car," in '51. He knows it
was '51 because he had a '41 Ford, and like many Southerners, he keeps
track of time and events through the lineage of his cars. "Uncle Lee had
loaned me the money" for the car, he recalls. "I had to go through my
Aunt Stella to get him to do it, but he left me a check laying on the table.
It was white, with whitewall tires and fender skirts. John Frank Edward
wrecked it, in 1958." They spent long, frustrating hours in that car, he
and Dorothy, parked in the pines.

"We both believed it was sin, to do anything more," he says now,
but after three torturous months, he wanted more, needed more, and
used all his charm to get it. She told him he could just stop it right

there, till he walked her down the aisle or at least through the courthouse door.

They were in love, Jerry Lee told her. They had professed it.

"But I'm saving myself for my husband," she said.

"Well," said Jerry Lee, "that ain't no problem at all."

It was not the most romantic proposal, but it got the job done.

"She was a fine woman, a fine and beautiful woman," he says, but his mama and daddy knew the boy was a long way from being ready to start a family; sometimes they were just grateful he was not yet in Angola. "If I had just listened to mama and daddy, . . ." he laments. "But I insisted on gettin' married. Daddy said, 'Mamie, you know how hard headed the boy is,' and then he threw the car keys at me and said, 'Here, go on, and learn for yourself.' "

They set the wedding for February of '52. "Uncle Lee got us the license," says Jerry Lee, who did not then and would never see much need for paperwork when he was in a marrying mood. He wrote on the form that he was a twenty-year-old farmer. The family members who came to the small ceremony said they could not remember a time when two such beautiful people, one fair and one dark, had found each other and were joined in the light of the true gospel, and how lovely their children would be. A photographer came from the *Concordia Sentinel* and took their picture for the social page. Their honeymoon was one night in a hotel on Main Street in Ferriday, across from the Ford dealership where Jerry Lee had first squeezed silver from the crowd. "It's an old folks' home now," he says, and smiles.

He had dreamed of that night, daydreamed of it, and schemed for it. They were both bashful, though, and for hours they just sat and talked, till she asked him if they should make love and Jerry Lee, smooth, said he thought that was why they had gotten married in the first place, "wasn't it?" and by the light of the Babin-Paul Ford Motor Co., consummated their marriage in the sanctity of their faith. But after all that denial and all that conflict with the faith he had been raised within, "It

wasn't what I thought it should be. I thought it should be more." He woke up the next morning and sat on the edge of the bed with his head in his hands. He looked over at the beautiful girl, sleeping.

This is not right.

"It took me about thirty minutes to figure out I had made a mistake, that I had got married too young," for the most dirt-common reason people do such a thing. "*Man,* I told myself, *I have fouled up.* It had nothin' to do with her. She kept her end of the bargain." What was missing was missing from within him.

In that special hell reserved for young people who marry in the heat of a moment, Dorothy started to plan their life together just as he started to scheme for their life apart. "She didn't think there was anything happening that wasn't supposed to be happening. She was in love." He had only whatever you have when love burns quickly out, and no plan at all for how to live it out. She moved in with the Lewis family as though there was still some future there. For about two months, Jerry Lee tried to be a dutiful husband, at least on the outside, working as a truck driver and a carpenter's helper, playing his piano in the service of the Lord. He even tried to preach. Two months of that nonstop goodness almost killed him.

"She was a good girl, a pure girl," he says. In a way, she was just too good. One night, about two months after they said "I do," he came out the front door of the house at Black River wearing a white sport coat.

"Where you going?" she asked.

"Me and Cecil Harrelson's goin' coon hunting."

He had no ready explanation as to why anyone would go coon hunting in a white sport coat.

Mamie liked Dorothy and, like all smart mamas, had feared this.

"You ain't going nowhere," she told him.

He talked back, and she slapped him. "Boy," she told him, "you *married* this girl. You come here and take care of her."

He walked into the yard with his wife calling to him, and his mother's anger cutting at his back.

"I love you," Dorothy cried. "Please don't go."

He headed out with Cecil, and left his wife with his mama.

He and Cecil were going to a bar, to hear music and play music and perhaps consort with women; his reluctance to do such outside the conventions of the church was breaking down. "It seemed like women fell out of the trees," he says, women his age and older, all beautiful, all willing. Across the river in the honky-tonks, they waited for him in great variety. "Playing in the clubs . . . you just do it. They just lay it on you. It was just about impossible to resist. And I just had to pick one out. It just kind of seemed like a dream. It just seemed like 'The Impossible Dream,' as Elvis would say. I'd see these girls walking by the bandstand, mouthing 'I love you,' and I'm sixteen, seventeen, and I see these girls, and I just try to turn my head and do my songs and get off the stage," but he did not try all that hard. "And, son, it was good. As long as I wanted them."

After a while, Dorothy went home to Monroe, heartbroken. "And me and Cecil went to New Orleans."

Once, if you really wanted to hear a piano ring, you went to Storyville, where the ladies of the evening waved languidly from the balconies, half-stoned, sugar cubes in their teeth and absinthe on their breath. Jelly Roll Morton worked here, and King Oliver, playing in the brothels while the gentlemen waited or made up their minds. A music called jazz took hold here, between the hot pillow joints and vaudeville acts and streetcars on the Desire line, but by the early 1950s the whorehouses had moved more deeply into the constant shadows of New Orleans, and the noise had shifted to Bourbon Street. Here the sidewalks throbbed with light, liquor, sex, and music, with more than fifty burlesque shows, striptease acts, and other distractions between Canal Street and Esplanade, most of them clustered in about five city blocks. Vice had a grandeur to it then. The nightclubs featured everything from the dance of the seven veils to slapstick to a man who could scratch the top of his

head with his big toe, all to live music, one band bleeding onto the
street and into another band, and another, and so on, till it was all just
a kind of mad cacophony. Here, men lined up for a city block outside
the Casino Royale, Sho Bar, and 500 Club to see Wildcat Frenchie, Lilly
Christine the Cat Girl, Alouette LeBlanc the Tassel Twirler, Kalantan
the Heavenly Body, Linda Brigette the Cupid Doll, Tee Tee Red, Blaze
Starr (who kept company with the somewhat peculiar Governor Earl
Long), and Evangeline the Oyster Girl, who rose from a shell the size
of a sedan and danced with a strategically placed giant pearl. Soldiers
hooted, bouncers slapped them silly, and the Mob took a little piece
of every dollar. The liquor was overpriced and watered down and the
pimps and the pickpockets and dope addicts moved through the ciga-
rette smoke like wolves, and ten hard-earned dollars would not buy you
a meal at Galatoire's but might be just enough to get you killed. And it
was all kind of wonderful, in a way, if all you were doing was passing
through on the way to someplace that still made a little bit of sense.

Jerry Lee Lewis and Cecil Harrelson, sixteen years old, walked un-
afraid. Cecil, though smaller than Jerry Lee, was the perfect accomplice
for such an adventure. He was tough and quick and capable, and he
knew how to talk to people, how to sell his friend's talent. They had
become fast friends since that day when they both tried to murder their
homeroom teachers at Ferriday High School. "Cecil was bad to use a
knife," said Jerry Lee. "*He* was the Killer."

They walked past the barkers and painted girls till they saw a place
that looked likely, and ducked inside. They never had to worry about
being underage; unless you were pushed inside in a pram, the New Or-
leans bartenders would serve you liquor here, and tell you where to buy
some dope, and let you see a woman dance with a snake.

"I seen things I never seen," Cecil recalled, actually giggling.

"We never bought a drink," says Jerry.

Cecil would ask to see "the boss man of this here establishment."
When the man arrived, Cecil made his simple pitch. "I got a boy here,"

he said, "who can play the piano better'n anybody you ever saw, and I was wondering if you'd let him play a tune."

"And some of them just looked at me like I was crazy," said Cecil, thinking back. "But once they heard him play, even a little bit, that was all it took."

Jerry Lee sat down and did a hillbilly jump tune called the "Hadacol Boogie," named for a booze-laden tonic—played it hot—and in the chorus the drunken throng sang it with him like they'd all gotten together that morning and planned it out.

> *Standin' on the corner with the bottle in my hand*
> *And up steps my mama with the Hadacol man*
> *She done the Hadacol boogie*

"They were pouring us liquor, double shots, just like in the movies. And we just moved on down Bourbon Street, club to club. They even started hearing about me, started hearing about that wild boy that played the boogie-woogies on the piano. And the more we went the drunker we got. . . . By the time the night was over, we was so drunk we couldn't see. Caked in vomit. Couldn't stand up. My first real drunk." They were fortunate to get out of the Crescent City alive, he realizes now. But he had tasted the apple, and he liked it.

He'd been needing to cut loose a little bit, needed it for some time; he was starting to understand that a man just has to cut loose now and then, unless he's scared of the world or scared of his woman. Still, somewhere during that debauched trip to New Orleans, he managed to create some musical history. At the J&M studio, where Fats Domino had been making hits for a few years now, he cut what is believed to be his first recording. Two songs: a Lefty Frizzell ballad called "Don't Stay Away (Till Love Grows Cold)," which he sang high and plaintive, and a stomping boogie that showed off all he knew. Cecil would hold on to that record into his old age.

He was done with marriage, he knew that much, and through with Dorothy. He told himself he was single in his own mind, and that should have been enough, but the State of Louisiana insisted on paperwork or resolutions or such as that. He had always hated forms and formality, hated tedium, hated the rules the other people lived by, so he did nothing, just kept on living within the rules he laid down for himself. A lot of rich men do that, and it's easy to pull off if you're a Kennedy or Lee Calhoun, but it takes guts to try it if you're a poor man. "I just done what I wanted," he says. He says it a lot.

It is why, when he walked past a car lot after closing time and saw a good-looking automobile, he saw no reason not to borrow the car for a little while, at least until morning. In the rules of regular people, that was called grand theft auto, and a felony. In such a small town, though, security on the lots was lax. "I guarantee you, if I walked by a car lot and saw one with the keys in it back then, I was gone. I just said, 'Well, looka here.' I drove it all over the country. But I took it back. I always took 'em back. I got all kinds of car, and parked 'em right where I had borrowed 'em from. Last one was a '50 Chevrolet." In a way, he treated some people that same way. He rarely speaks with regret about anyone, but he does when he talks about Dorothy. "Dorothy told me I was the only man she had ever been with, and I know that was true. . . . I left her cryin' on my mama's doorstep. 'Son, you're wrong,' she told me. I'm ashamed it happened. If I had it to do over, I wouldn't have done it."

He made one more attempt at a holy life, in part because he wanted to ease his mother's mind. Or at least he went to a place where doing right was the general idea. He might have even made it—probably not, but maybe—if someone had just had the good sense to lock up the piano.

The student body waited respectfully in the pews, not one painted fingernail or undone button among them, some five hundred souls hum-

ming, but quietly so, with school spirit, and alight in the love of the true gospel. The male students at Southwestern Bible Institute wore coats and ties and starched shirts to class, and the women wore long skirts and did not cut their hair, some for so long that it swung against the backs of their legs when they walked across campus in their flat-heeled shoes. Makeup was forbidden; lipstick was contraband. The young women were required to wear stockings at all times, but fall came late to East Texas that season and it was too hot to breathe, so some of the coeds drew a line down the back of their bare legs with black shoe polish, for relief. That was the year the editor of the yearbook cropped the pictures of the students so tightly that all you could see was a circle of their faces, because some of the young women had sinned against God and styled their hair. When one of the boys, Billy Paul Branham, went walking through campus after dark one evening, eating an ice cream cone and lustily singing "The Old Rugged Cross," the dean of men gave him ten demerits.

It was not a place that rewarded individuality. "Apparently not," says Jerry Lee.

The school offered courses in church business, missionary organization, Bible study, and of course, Pentecostal history and prophets. But there was not a lot of shouting here in the chapel on Sunday mornings, in a sanctuary sealed tight in stained glass, and no one got happy, very much, in the middle of a song. Just off campus, Victorian mansions and gingerbread architecture fronted clean, quiet streets, with not a mudhole or a black racer or an armadillo anywhere in sight. Here in this unforgiving place, Jerry Lee sat at his piano, looked over the student body, and decided it was time for a change.

The boy had always had the power to win people over, had a personality like an industrial magnet. He would be a formidable evangelist. Still married to a young woman he had no intention of keeping, he finally bowed to his mother's wishes and decided to use his God-given talents as a singer and piano player to bring people to the Lord. He

enrolled at a place called Southwestern Bible Institute in Waxahachie, Texas. The name of the town means "cow creek" or "buffalo creek" or "fat wildcat," depending on which linguist you believe. Waxahachie was a 380-mile, dusty bus ride from Ferriday. He chose the school there in part because it had a junior college division that was content to overlook small matters such as prerequisites and even high school diplomas. Aunt Stella and Uncle Lee helped with the tuition and bus fare, thinking he might make a preacher after all but certain he needed to get out of Ferriday before a jealous boyfriend or irate daddy caught him from behind with a pine knot or a pipe wrench—or before some car dealer had him arrested or shot him from the dark. Mamie kissed him good-bye and told him she was so proud of him, and cried a little. Elmo shook his hand like a man, and as the big Trailways pulled out from Ferriday, it carried a whole busload of unreasonable expectation.

"I really could preach," he says, and he did plan on giving the place a solid try, at least at first. Almost immediately, however, he was stultified. The classes were as dull and irrelevant to his life as the ones he had dodged before. He did not see the point, in a school in which he was purportedly readying himself to be a preacher, of immersing himself in a library of thick, dusty books. The Bible was the Word of God, the Rock, the Great Speckled Bird, and a man preached from it, period. The Bible was all a man needs to *know*, he says even now. The rest was just fluttering paper and wind.

So he dodged these classes too, and crawled from his window late at night to go carouse. But the problem with playing hooky from Southwestern Bible Institute in Waxahachie, Texas, was that when you got over the wall you were still in Waxahachie, Texas. So he caught a ride to Dallas, a half hour or so up the road. Dallas, with its bars and big-haired women, was a whole other temptation, and he even found some boogie-woogie there. But he almost always made it to supper in the college dining hall, and he became popular at the school, especially with young women, who liked the haystack of wavy blond hair on his

head and liked the way he could sing and how he was not afraid to sing anytime he felt like it, whether it was sanctioned by the school or not, as though demerits just rolled off his back. After singing in the Blue Cat Club, where men went after each other with the jagged ends of broken beer bottles, a demerit did not exactly send him aquiver.

"Me and Joey Walden and two or three other guys, we'd just start singing together," a cappella in the dinner line, says Jerry Lee. "We done it all the time," so often that it became a ritual for the students in the cafeteria.

"We all tried to get there in the dining hall when they got there because we enjoyed their singing," said Pearry Lee Green, who started at Southwestern the same year as Jerry Lee and would go on to be the pastor of the Tucson Tabernacle. "They sang hymns. You didn't sing anything that wasn't a hymn, then." To Jerry Lee, it was just natural; in the Assembly of God you were supposed to sing and sing loud, and send the ascending devil skulking and beaten back down into the netherworld with the power and exultation of your voice. Jerry Lee also made sure that the trio sang as the young ladies descended a double stairway into the dining hall, so he could get a good look at them. "Dorothy came to see me up there," he says, "and that did not go over well." He was still married to her but had long since stopped acting like he was.

He was three months into his fall semester when the Institute put on a "singspiration," a kind of assembly and talent show that gathered the school's musicians and singers for a night of religion-themed entertainment. The emcee would be Pearry Lee Green, who led a prayer group for postwar Japan, was business manager of the college yearbook, a member of the student council, president of the Texas Club, and president of the Governor's Club, and had a loose affiliation with the Future Business Leaders of America. Jerry Lee was invited to play a piano solo. One of the students who had heard him play, who knew Jerry Lee's style on the piano, warned Pearry Lee that the boy was "different," maybe even "too different."

"Look," Jerry Lee told them all when they voiced their concerns, "you want this to go over right, don't you?"

As Pearry Lee remembers, Coleman McDuff, who would go on to become a stalwart singer in the Assembly of God ministries, opened the program by singing "The Lord's Prayer" in a lilting tenor. Some of the students had tears in their eyes. "I mean, Coleman was a singer," said Green. "He could break a glass with his voice."

Then he walked out to introduce Jerry Lee Lewis of Ferriday, Louisiana, who would perform the Assembly of God standard, "My God Is Real."

"I understand," he told the crowd, "we're going to have a change in tempo."

Jerry Lee looked out over the student body, still in the peaceful glow of Coleman McDuff.

He stabbed one key, drove it home like a claw hammer coming down on a bell, and launched into "My God Is Real." It was so hot and fast, Green thought it was "When the Saints Go Marching In."

"It was up-tempo, a little bit," concedes Jerry Lee.

It was rolling, thumping, rollicking. So much so that at first the young people, all raised in the church but not in the church on Texas Street, did not know what to think. Even the ones from the smaller, rawer, more distant Assembly of God churches, where people spoke in tongues and wept and danced in the pews, had never seen it done like this, because it had never been done like this. Only the words were familiar.

> My God is real, He's real in my soul.
> For He has washed and made me whole.

"People were shocked," said Pearry Lee.

It would only get better, or worse, depending on your affiliation.

"Up-tempo, *spiritual*," is how Jerry Lee describes it now.

Then he unleashed the boogie. He was true to the song, but he was also true to what was in his heart in that moment, and that ripped and roared through the chapel. He stuck that leg out toward the audience and shifted around so he could see them twitch and suffer, and all that hair tumbled into his eyes as he hammered out:

> *His love for me, His precious love, is like pure gold.*
> *My God is real, for I can feel him in my soul.*

The students, the ones who were not paralyzed by this point, started to move. They started rocking in their seats, and tapping their feet in time, and then some of them even started waving their arms in the air. A few of them came up out of their seats and even did a little dance, right there in the pews. *Now we're gettin' somewheres*, Jerry Lee thought, and he pushed it harder. He raked the keys like he was wringing out the last bit of boogie they had in them, and by the time he was done, he was sweating. "I always knew when I started sweatin'," he says, "I had it knocked."

But the crowd was still moving.

"They were screaming, howling," he says.

The applause boomed inside the chapel, went on and on. It was the most applause, the loudest, he had ever had.

"It scared me, a little bit," he says. "I said, What's going on here?"

They wanted more.

He was willing but saw the dean coming toward him.

"He crooked his finger at me," he remembers. "He was a little bit upset."

"Do you see what you've done to all these young people? You've driven these young people *crazy*." He said the word *crazy* like he was dragging it down a cabbage grater.

Jerry Lee told him he didn't mean to.

"You've ruined a great Christian college."

He told Jerry Lee he was history at Southwestern Bible Institute in Waxahachie, Texas. But when the other students heard that, some of them chanted in support, and shouted that "if he goes, we go."

Why, the dean must have wondered, *couldn't everyone be like Coleman McDuff?*

One of the students let out a holler.

"Look," the dean said to Jerry Lee, "what you have done."

The next day, Pearry Lee Green was called to the president's office. When he arrived, "Jerry Lee was there." The president told Jerry Lee that he had wantonly solicited an impure response from the entire student body of the college by playing reckless and prurient music, and the president and deans gave him the left foot of fellowship and told him not to let the door hit him in his behind on the way out. Jerry Lee, who never lacked gall, told the deans and the president that he would not accept their expulsion.

"I'll just go home for two weeks, but I'm comin' back," he said. He had no intention of coming back, not even if they were handing out free doughnuts and pony rides, but he wanted them to watch the gate every day to see if he was.

Then the school officials turned their wrath on Pearry Lee. Such a break of decency in a schoolwide event had to be a plot, a conspiracy. "They asked me, 'Why did you let Jerry Lee Lewis play the piano?' I told them, 'Well, I didn't know him from anybody else. And they told me he played the piano, and I'd heard him sing.' They expelled us both. They told us they wouldn't put up with that kind of music. They told us to pack up our books and get our clothes off of the campus. 'You are no longer welcome here,' they said. As we both started out the door of the president's office, Jerry Lee turned around and said, 'I want you men to know Pearry Lee had nothing to do with this. He didn't know what I was going to do.' They reversed my expulsion, and I didn't have to leave. Jerry Lee stood up for me."

Some of the students waved as he walked away, headed for the bus station and Ferriday.

"I think sincerely, in his heart, he wanted to be a preacher," says Pearry Lee.

Jerry Lee did not need college or the process of ordination to preach, and he did not immediately give up on it. He felt what he felt, and he preached on it, preached as the sinner he was. Small churches in and around the river parishes welcomed him, "and I preached up a storm on the Holy Ghost." He will not talk about it much—it is one of those things he finds too private, too *real*, in a way, to talk about. But the people who would say he had no right to preach as a sinner, that he should not have been allowed, know nothing of the faith in which he was raised, and besides, if only men of perfection preached, there would be scarce preaching at all. It was stories of failure the people tended to cleave to, because without failure there could be no redemption. Those without sin walked a lonely road, echoing and empty. The funny thing was, the red-hot music that Jerry Lee played in Waxahachie would come to be welcomed and encouraged and even commonplace in the Assembly of God, as it already was on Texas Avenue and churches like it throughout the rougher South.

But Jerry Lee did not preach for long. He went back to the clubs in Natchez and Monroe and elsewhere, but despite some rare nights when he hit it big with tips, the money was still not a real living, so he went looking for day work again. He again tried manual labor, only to rediscover that it required manual labor.

At one point, considering his powerful and winning personality, he thought he might have some luck as a door-to-door salesman. So he took a job on commission with the Atlas Sewing Machine Company. The company sold their sewing machines on an installment plan; the hook was that it required no money up front, just a signed contract committing to a small payment every month. With his partner, Jerry

Lee prowled the river parishes in a '47 Pontiac, lifting the sales model in and out of the car with every call. They discovered quickly that if the people of Louisiana did need a new sewing machine, they were not going to buy one from the trunk of a Pontiac.

"Then," Jerry Lee says, "I figured out a way to really sell sewing machines."

He knocked on the door of the wood-frame houses and mobile homes and garage apartments and said, "Good afternoon, ma'am, my name is Jerry Lee Lewis and I am from the Atlas Sewing Machine Company of Baton Rouge, Louisiana, . . . a *great* sewing machine. Congratulations, ma'am, you have won a sewing machine." Then he collected ten dollars, check or cash, "for the tax," and had them sign an innocuous-looking piece of paper—"which was a contract"—and told them he hoped they enjoyed their sewing machine and the many happy hours it would bring. Then he and his partner took off down the road a piece and split the cash. "The bill come later," Jerry Lee says.

They sold them as fast as they could load them in the Pontiac, "sold more than fifty of 'em in one day," says Jerry Lee. He ordered more sewing machines from the company, to keep the scam going. "They told me I was the biggest sewing machine salesman in the world, the biggest of all time."

When the bill came, people just ignored it, assuming it was a mistake, and when the company contacted them, the people said they were not going to make payments on a sewing machine they already owned free and clear, like that nice young man done tol' 'em they did, and then they told the latest representative from the Atlas Sewing Machine Company, of Baton Rouge, Louisiana, to get off their porch before they got the gun or put the dogs on them. So the poor people got to keep their machines, and the company decided it needed some new salesmen in that part of Louisiana and Mississippi. By then Jerry Lee had already made about twelve hundred dollars on the great sewing machine sweepstakes of 1953.

He varied his spiel, telling some women they had won fifty dollars off, and offered to drive others to the grocery store to cash a check.

"But I was wrong," he later told an interviewer. "I wasn't wrong for selling sewing machines. I was wrong for sellin' 'em the way I did." Then he broke into song:

> Be sure
> You're gonna pay
> For your wrongdoin',
> Jerry Lee,
> But I'll never
> Make the same
> Mistake again.

"Next time," he said, "I won't leave the contract."

One day, in the midst of this new crime wave, he and his partner stopped by a country store to gas up and drink a Coke and limber up their legs, and he saw a big, blue-barreled pistol in a glass case at the counter. "I guess I thought I was Jesse James," he says. "I come back that night and I stole it. . . . I guess it's all right to admit that, now. Got caught with it about two weeks later," as he sat with it in his lap in a parked car as a parish sheriff rolled up behind him. The sheriff put both men in the wretched jail in St. Francisville. He called his Uncle Lee, the only man he knew who could make his bond, and Lee Calhoun said he would be by, "d'rectly."

"It was awful, man," recalls Jerry Lee. "The cell wasn't as big as nothin', and it was crowded with some rough ol' boys—I mean some *rough* ol' boys—but me and my partner stuck together. The food was terrible, this stew that was just slop. And there weren't no women."

After three days, Lee Calhoun finally showed up.

"He didn't have to wait that long," says Jerry Lee.

They went before the judge.

"Well," the judge said, "I'll tell you what I'm gonna do. I'm gonna give you three years in Angola."

Jerry Lee's heart flipped. People joke about that, but he felt it.

"God," he said.

"But seeing as how this is your first offense," the judge said, "I'll make it three years' probation, instead."

Jerry Lee laughs off most near-disasters, but he knows how close he came, in that courtroom, to descending into the very real hell of Angola Prison. "After that, my buddy stole one of them big ol' truck batteries, and they sent him off," says Jerry Lee. He walked a tighter line, on probation, knowing that Angola was the dream killer. It did not last long, that caution, but it lasted long enough to get him past his probation. If the judge had known about his sewing machine racket, of course, he would have certainly done time for theft and embezzlement—unless, of course, his Uncle Lee could have fixed that, too. He can smile about it now, for whatever the statute of limitations is on a sewing machine scam, it is probably shorter than sixty years. It makes him kind of happy, though, knowing that a whole lot of people in the backwoods and bayous of Louisiana got a free sewing machine, which makes him almost like Robin Hood, taking from the rich and giving to the poor and all, except of course for that twelve hundred he made off the top.

He went back across the river and started playing the boogie again for about ten dollars a night. On some slow nights in the clubs, he played the piano with his right hand and drums with his left, till the club's owner, Julio May, told him that might not be a good idea. He told me, 'These people come in here expecting to see a whole band, and when they see's it's one man, they get strange.' "

Rules, always these rules.

"I did what I had to do," Jerry Lee says now, "to get a tip."

Why could there not be a different set of rules, for him?

"Sometimes, when I know it's right, I call it wrong, and sometimes when I know it's wrong I call it right," he says, and shrugs. It might make life confusing sometimes, he says now, but not dull. Dull is the real dream killer. "And it will eat you alive, if you let it."

4

MR. PAUL

.

Natchez

1952

The stage was about sixteen inches high and had a rail across the front to keep drunks from staggering into the bandstand and getting electrocuted in the extension cords. The cigarette smoke roiled in a blue fog and the air smelled of yesterday's beer and perfume you bought by the jug. The Wagon Wheel was like the Swan Club before it, and the Blue Cat, and the Hilltop, and other beer joints where blues and hillbilly music would collide, a place to fight over a good woman or sorry man and knock back brown liquor by the shot till you were numb or just not particular, where a wedding vow was more a suggestion, and truck drivers tipped the band in little white pills. "Country people, big shots and low shots," says Jerry Lee, who kept time to this melee with a pair of drumsticks, and loved it all.

Only the music was extraordinary, and what made it that way, before he finally took over the old upright and stole the show, was a fifty-year-old piano player from Meadville, Mississippi, named Paul Whitehead. "Mr. Paul," says Jerry Lee, "and he knew every song in the world. And we played 'em all." To lift the sound of his instrument above the hard-

packed crowd, Mr. Paul jerry-rigged his old piano to an amplifier, elec-
trifying its eighty-eight steel strings till they would ring out even over
the crack of a .22 pistol. He pumped the keys to get a rich, rolling
sound, slapped them like he expected them to give up some secret,
some music never heard in a place such as this. Sound was what he
had. He could play juke-joint blues or "San Antonio Rose," squeeze an
electric accordion till it spat out a marching band, fiddle up a redneck
storm, and blow a trumpet like he was trying to bring down a wall. He
did it all while staring off into the distance, as if he was playing not in
a tin-roofed den of iniquity but someplace fine, as if he could somehow
see how far a man might fly from here with just the right song.

"Pure talent," says Jerry Lee, "was what it was." The music washed
out in all directions, smoked through the blades of a big electric fan
and poured through the propped-open door, across the gravel and the
Johnson grass and out to the blacktop, luring in the Hudson Hornets
and two-tone Fords and other hunks of big Detroit steel. Young men
in penny loafers and snap-pearl-button shirts checked their shine in the
gleam of a baby moon hubcap and steered women with big hair and low
expectations toward the disturbance within, at no cover charge. Now
and then, at the end of a set, a pretty girl would approach the stage to
make a request or just to tell the silver-haired piano man how much she
loved his songs, and Mr. Paul, suddenly gentle, would bow low, smile,
and say, "Thank you, miss." For Mr. Paul Whitehead was blind, and in
the darkness where he lived, they were all pretty girls.

He'd been born with sight, but when he was three years old he got
measles and lesions in his eyes, and the world went black. "Put a light-
bulb in front of my face," he said, "and I can't tell if it's off or on." But
he could tell where he was on a lonely highway by tilting his face to a
window. "Well, we're passing through Roxie. I smell the sawmill." He
knew, rolling up Highway 51, when he neared McComb. "I smell fresh-
cut hay."

Sometimes at the Wagon Wheel, he would reach out to where a

young woman's voice told him her face would be. "Can I touch your hair, miss?" he would ask, and the girl almost always told him, "Why, yes, of course." After prying hands off her posterior all night and entertaining offers from men whose smoothest line was, "Hey, baby, wanna go wit' me," it was nice to talk to a gentleman. He would take a strand of her hair and feel it between his thumb and forefinger, for just a second or so, never more. "You're a redhead, miss," he would say, and he was right every time. The peroxide blondes tried to fool him, but he could tell them what they were and what they used to be. The young women would waste a smile on the hard, smoked glass that covered his eyes, then rush back to tables knocked together from scrap wood and old doors to tell their girlfriends of the magic powers of Mr. Paul.

But it was his musical memory, unlimited and forever, that was the real trick here.

He gave them Hank Thompson . . .

> *I didn't know God made honky-tonk angels.*
> *I might have known you'd never make a wife.*

. . . and Joe Turner, and Bob Wills and the Texas Playboys, and even "Stardust," sweet as any dream.

The early days of rock and roll are thick in myth, but Paul White-head's place in the greater legend is faded and paper-thin. He has been largely forgotten beyond a sentence or so, a footnote to a legend, but he deserved better than that, says Jerry Lee. He is fiercely proud of his own technique, of being self-taught, of being the one and blessed only, but concedes that he studied the blind man, as he learned the words, learned to read and even take control of a crowd, as he waited for that last element, that one, final, missing thing. "I was gettin' my sound right," he says, and Mr. Paul loved sound like few men he had ever seen. He was the rarest of performers, a pure musician, unpolluted by worldly

things, yet he and Jerry Lee, who was a tar baby for temptation and a walking catastrophe in the realm of regular people, were in one way the same. The stage was the light. Sixteen inches down there was only the black nothing, for both of them.

"Paul Whitehead done a lot. His lesson was worth a billion dollars to me. I guess he was like a father to me," an influence, certainly, and a teacher, but more. He showed Jerry Lee that there was a kind of peace in it all, in the middle of the chaos and fighting and drunkards. There was life in it, in it alone.

Paul Whitehead learned the music not from lessons or travel but from the air, from the Blue Room in New Orleans and big bands in Manhattan; he learned Cajun from the Atchafalaya, and every hillbilly song the Louisiana Hayride or the Opry ever broadcast on a dust-covered radio. But that pumping sound in his piano was pure juke joint; Jerry Lee knew it from those days he was routinely thrown out of Haney's by a man the size of a Frigidaire. Mr. Paul found it not in a club but tapping down a sidewalk in Meadville, listening. He could tell when he passed the color line in a town by pausing a second on the concrete.

In the late '40s he had played with a picker named Gray Montgomery, from Security, Louisiana. Gray had a white Gibson guitar and a French harp, and could play drums with his feet. For years, he and Mr. Paul toured the South, playing honky-tonks. "The girls would come in the clubs, waitresses who worked the cafés," Montgomery recalled. "They'd ask if we knew so-and-so, and they'd write down the words for us. . . . That's how we got our songs, from waitresses.

"There wasn't no rock and roll, but people were tired of the slow songs. We'd take an old country song, and I'd say, 'Paul, I think the people want to jump a little bit.' And we'd watch the crowd, and if you hit some jagged notes they liked and they stomped the floor, you knew to just keep goin'. We didn't know that was rock and roll." Montgomery even played briefly with Mr. Paul and Jerry Lee together. He never hit it big himself but will never forget seeing the silver-haired man and the

golden-haired one together onstage at the birth of a music, like a man watching a comet. Who gets to say they saw something like that?

Outside the clubs, Mr. Paul was all but invisible, living quietly in a small house in Natchez, dressing neat but plain. Jerry Lee would take him home after the gigs and watch him walk unerring down the path to his door, counting his steps. He was resistant to the vices that swirled around musicians. He did not drink or smoke or jazz himself with pills or avail himself of loose women. He drank milk in the fifteen-minute breaks; bartenders kept a glass bottle of it behind the bar. Sometimes, after a show, he would get a ride to a late-night place called Joe's Eats on Route 61 and order a bowl of chili. He would not eat it unless it was scorching hot, and stuck his right index finger in the bowl to make sure. He wanted the first bite to be perfect. Then, alone, he ate carefully till it was gone, and waited, silent, for a ride home. "Same thing, every night," says Jerry Lee. "Chili and a cold glass of milk."

Mr. Paul did not talk much for a man who worshipped sound, as if what came out of people's mouths, absent melody, was grating some-how. But he talked to Jerry Lee. They were often seen hunched over a piano or a song. People, wanting to believe in myth, said it was because he heard the future in him, that he would be the one to take the music to that fine place, a place he would have taken it himself if only he could have found his way alone out of that coiled nest of spitting cords. But people say a lot of things.

"He was just happy to play," says Jerry Lee. "He taught me. I'd sit beside him, and say, 'Mr. Paul, can you show me exactly how you do that?'" recalls Jerry Lee, in one of those moments when he was not himself, when bravado sloughs away and you see the ghost of a desper-ate, searching young man. "Mr. Paul was good to me."

To Paul Whitehead, dull music was just one more place to sit in the dark. "He'd wedge that violin in place with two pieces of pasteboard,"

so it would hold still as he tried to saw it in two, and Jerry Lee beat the drums or the piano like it stole something, and they made people stomp and howl. Some nights it seemed like Mr. Paul, his scarred and clouded eyes hidden by round tortoiseshell sunglasses, was wired into their very bones, and he would play hotter and quicker to make people move faster, faster, and stomp the boards harder, harder. He could tell when it happened through the soles of his shoes. What power, in a man who had to be led to the bathroom and back out again. "And I liked his style," says Jerry Lee.

"Looka here," Mr. Paul would say, then run his thumb all the way down the keyboard, in that waterfall sound, and play Hoagy Carmichael in a redneck bar.

Ah, but that was long ago.
Now my consolation is in the stardust of a song.

"Then he'd say, 'Let's do "Jealous Heart." ' I mean, we covered *everything.*"

Some people, numbskulled, thought he was deaf and would yell a request into his ear. He always recoiled, as if they had shouted into his ear through an electric bullhorn. Some people would say that was myth, too, that a blind man's other senses are not so heightened, but then Mr. Paul could tell you how high the cotton was from the rising dust, the far-off drone of crop dusters, or the lingering bite of cotton poison. He could tell if a club owner shorted him, too, by the feel of the fabric of the bills—people try to pull a lot of things on a blind man. "I told him once, 'Mr. Paul, I hear you used to be pretty tough in a fight," says Jerry Lee. "He told me, 'Yeah, but I've tried to forget those days.' They say he swung at where he *thought* they was. 'But I don't do that fightin' no more,' he told me. 'Those days are gone. I just play, now.' "

Jerry Lee beat the drums and spelled Mr. Paul on piano when he played trumpet or accordion, and never missed a thing. He spent every

minute he could with the older man, and over time he became protective of him. Once a man named O. Z. Maples led Paul to the bathroom and came back without him. "Where's Paul?" Jerry Lee asked.

"I left him in there," the man said.

Jerry Lee told him to go back and get him, now.

"Oh, he's all right in there," O. Z. said. "I asked him if he wanted me to turn the light on for him."

"Gonna be kinda hard for me to play piano around this place, after hearing you," he told Jerry Lee. "You tickle that ivory real nice, son."

Once, in that odd calm after a blistering set, he said quietly: "You gonna be a big star, Mister Jerry."

"He didn't have a jealous bone in his body," says Jerry Lee now. "He was my true friend." He was a witness, night by night, as the boy's talent tumbled into alignment, as old music was remade in those hot, heaving little clubs. It was like waiting for a storm to build, but slower, over months, then years, but he heard it coming. He never claimed he showed the boy a thing, but he always, always reminded the boy that big things were coming, 'cause he heard the lightning building and heard it better than anyone.

It is romantic to believe that Mr. Paul really did somehow foresee it all, really did see Jerry Lee's future and the future of rock and roll entwined. Jerry Lee only knows what he was told. Mr. Paul told the boy he was a natural-born blues crier and a genuine honky-tonk man, and that was just the start of things. He said he would have loved to have seen him, just once, seen that golden hair and ferocious face the people talked about, the women crowded up close, to touch. But in a way he did see it, every time Jerry Lee cut loose with the blues and out poured something raw and wild.

But it was his piano that moved Paul Whitehead the most. He knew the boy had been playing in front of crowds since he was nine, and

there was a lot of church in the boy's music still; some bar owners did not want a piano player whose songs made your wedding ring glow hot on your hand as you danced with a waitress. Mr. Paul heard the genius in it and told the boy to "go 'head on, son." Most right-handed piano men really just played one-handed, keeping rhythm with the left hand while finding the melody with the right, but Jerry Lee had mastered that kid stuff on a thousand late nights on his old upright and moved on to something different. His left hand was sure and deft, and his right hand was controlled chaos, wildly searching for new sounds across the keys till it almost seemed he could play two melodies at once, like there was someone or something else there beside him on that piano bench, something spooky. To Mr. Paul, who was pretty good himself, who knew the limits of the instrument, it was lovely. He knew Beethoven and Brahms, and three-fingered juke men, and every piano man living or dead who ever drifted down from an antenna, and in that boy's piano he heard it all and none of it. The boy was a species unto himself, and he was still learning.

By summer of '52, Jerry Lee had given up on the straight world completely. He had tried manual labor again, tried to shovel gravel and push a wheelbarrow in Ferriday. "I told the boss man, Mr. Durant, to put me on the sand pile or on the rock pile. . . . I was just a kid, trying to pour that cement, pushing them wheelbarrows beside them big men. Then I told Mr. Durant I didn't want to do that no more. He told me, 'Well, if you ain't gonna be no bull, you shouldn't have bellowed.' I told him, 'Well, you won't see me no more around here,' and they cut me my check for half a day's work—half a day—and I went to the house."

He cast around for anything he could. "I tried construction, tried driving a truck, tried being a carpenter's helper . . . didn't last at that too long." The bald, hard truth is, the things a body was supposed to do and expected to do and required to do in this life, if you were anybody

else in this universe besides him, had never lined up exactly tongue-in-groove with the way he went about living. The thing is, he tried, till he did not try anymore. His daddy had been a great carpenter and fine farmer, yet he dreamed the whole time of singing "Mexicali Rose" at the Grand Ole Opry. Jerry Lee saw no reason to labor in a long life of that, on a treadmill of hoping, dreaming, wanting, and not to cut right to the dream. "I couldn't," he says.

The churches of home had acknowledged and welcomed his gift. But the churches and revivals and camp meetings did not pay well; mostly did not pay at all. He was like a tick on a leather sofa; it feels like home, but there just isn't much profit in it. His cousin Jimmy had devoted himself full-time to the Lord. He had seen a red-eyed demon outside his trailer and was flung into the ministry like a human cannon-ball, but Jerry Lee was not called that way.

That pretty much left the beer joints. Week after week, six days a week, he played with bands that tore up the night, serenading the fallen, the drunken, and the lonely, and a growing number of people who were just on fire with this new music, this music that did not even have a name. "Singing and piano playing . . . and women. That's all I ever needed," he says. Some nights, some glorious nights, he made a hundred, even two hundred, from the tip jar, but most nights he made walking-around money, hamburger money, and even on the fattest nights, he was still stuck fast in small time.

He remembers, on one long-ago gig, an empty tip jar.

"Not a resounding success," said his beloved Aunt Stella, worried for the boy.

"Not resounding," Jerry Lee said.

But even as a boy he knew, if you were ever going to be hit by light-ning, you had to stand under a tree. The Wagon Wheel and places like it scattered around the South were where the music was in great dis-turbance, right here in his own dirt. Why, Memphis itself was a fast car ride away, and Memphis was where the whole world was changing,

even if it seemed a distant universe. In the small clubs, people wanted that hillbilly music, and the old, raw, bloody blues, and they wanted it shouted loud, to make the hot divorcée in the corner forget her sorry husband and shake something. Jerry Lee was born to do it. He had heard it all before, had heard it all at Haney's, and he was out from under the table now. "Wasn't nobody gonna throw me out."

> *She roll her belly*
> *Like she roll her biscuit dough*

But instead of parroting a black bluesman, he almost yodeled on the higher, bleaker notes, in a rolling, keening exultation of pain and suffering and lust, something from the other side of town or way out in the lonesome pines, but a place as rough, hard, and mean. His people pulled the cotton sack, too, and walked a chain gang, and sat in the hot dark of the federal prison in New Orleans. To understand it, to see the way it was, you have to think of it in the box it came in, the smoke and cave dark, for discretion, where a hundred people jammed jaw to jaw to medicate themselves, overalls and bow ties and strapless dresses lined up at the bar, all there to fight and cuss and rave and cheat, and some to just get lost in the liquor and the rhythms for a few hours; no one was asking for anything more. But they got Paul, his eyes hidden behind dark glasses, his benign face unchanging, the accordion around his neck and the trumpet at his lips and the fiddle at his right hand, and no one would know, as he sipped his milk, if it was a good day or the deepest, darkest night of his soul. And they got Jerry Lee, whip thin, hair in his eyes, intent on the music, the keyboard. He was not the showman then he would become in just a few years. The hard shell of the Pentecostals had not shattered, but it was beginning to vibrate, and if you listened close enough you could hear it crack. More and more he was replacing Mr. Paul on piano now, and he played rough with it and howled the blues. But for now, he did it all sitting down. Like Mr. Paul,

he was unconcerned with the louts and loud talkers, the knife fighters and dustups and drunken husbands. "People was always pullin' guns and knives," he says. "Didn't amount to nothin' . . . I carried a pistol myself," in case a blind-drunk farm boy got crazy over his girlfriend's wandering gaze.

He played from late in the evening until two, three, even four in the morning, sometimes till the last drunk had tumbled to the floor. He never got tired, or at least his body never told his mind that it was running on fumes. The truck drivers tipped him with Benzedrine. "They'd give me a whole bag of 'em, if I'd play 'em a song. I'd flip one into my mouth and just keep on playin'," he says, "and never even miss a lick." And the crowd ate it up like peach ice cream.

It didn't hurt that he was tall and handsome and had eyes like the sun shining through a jar of dark honey, and that he carried himself like the King of England. And then there was that hair. "That hair, it used to be just waves, just lay in waves," said Doris Poole, who was born in '34 and lived in Ferriday when Jerry Lee was a boy. "He looked *so* good." And when it fell into his face, it made the women like him some good bit better, so of course he shook it and made it do that right off.

He did not have to *act* dangerous; he was. He did not have to *act* a little bit crazy; he was. He did not have to act like he would steal your wives and daughters; he would, in front of you, because he had a good taste for it now and it was like trying to keep a bull out of the dairy lot when the fence was down. He might have been a little rough, a little coarse, but he could *get* smooth if he ever wanted to, and the smooth guys would never have the grit and the menace of Jerry Lee. And no matter how many women say to their husbands and other nice men that they want no part of such a man, the truth is . . . well, the truth.

He was getting a name, a persona, in the flat country and the piney woods. "I went up and played the Atlas Bar in Monroe. They let me play a few tunes, put a jar up there for tips. Before I knew it, I was mak-

ing two hundred dollars a week, playing my piano, singing my songs."
But the good money never lasted. Since the days when he'd played the
talent shows and car lots and played on the back of his daddy's truck,
people had been talking about how he would hit it big someday—just
never the right people. Someday seemed to stretch on forever, like those
endless brown fields that surrounded him. To sustain this life—and,
more important, to survive it and push beyond it—he knew he had to
have a record, and if it was to carry him out of here, it had to be a big
one. "I knew once I had my record, I was off to the races . . . knew there
wouldn't be stoppin' me. It all tied together. I noticed the girls right off,
knew they liked my playin' and singin', knew they liked *me* . . . that they
looked at me and they saw something different." But the record men up
north hadn't yet noticed, did not yet seem to care.

This life was not what Mamie had dreamed of for their son. But she
and Elmo came to see him, and dreamed still.

"You sweat too much," Mamie told him.

Well, let me tell ya somethin'—what I'm talkin' 'bout.

When Elmo walked into the smoke-filled room the first time, he
knew that he was home, here with the music and the dancing and the
pretty women and the smell of legal whiskey in the air.

I'll bet my bottom dollar, ain't a cherry in this house.

Mamie stood with her purse in front of her like a shield.

"Why you sweatin' so much?" his mama asked.

She had never refused him anything, but this . . .

"You gonna have a heart attack," she warned.

Mamie worried, yes, but she also knew that the world is hard and it's
harder if you're broke, so she told him she was with him, as she would
always be with him, and made sure he had an ironed shirt. The young

girls, these new brides, forgot such as that sometimes. If you're going to toil in Sodom, be neat about it.

In '53, on a late-night trip to Natchez radio station WNAT, Jerry Lee met another lovely brunette—he was developing a taste for them— named Jane Mitcham, and when a protesting boyfriend told him to "Hold on now, hoss, that's my girlfriend," he answered with a line he would use all his life.

"Naw," Jerry Lee said, "she *used to* be your girlfriend."

Jane was seventeen and different. She was not a trembling flower. She would also soon be pregnant. Jerry Lee told her he would like to do the right thing, but he was still married to Dorothy, who was currently re-siding in Monroe. Jane went home to Natchez and told her family about her situation and about Jerry Lee's refusal to wed. Not long after that, the male members of Jane's family showed up in Ferriday with horsewhips and pistols and a duck gun. Jerry Lee did not think much of the marriage law, but he did not think much of threatening relatives either. He down-plays any actual danger to his person, but people here still say, only half joking, that it all came down to whether the boy wanted to be a bigamist or a dead man. Not all of Jane's family wanted her to marry; some just wanted him to be dead, and it is believed his Uncle Lee Calhoun stepped in to negotiate. The result was that Jerry Lee did not die but instead got two wives, though because one of those wives was in far-off Monroe, this was acceptable. He married Jane two weeks before he was divorced from Dorothy. "I was bad to get married," he says. "Never let it be said that Jerry Lee Lewis turned a lady down." But Jerry Lee secretly knew he had won. He had lied on his first marriage license, claiming to be a twenty-year-old farmer, and his second was null and void because of the preexisting marriage. "So, see, if you think about it, I ain't never really been married," he says, at least to that point.

Jane believed she was married, and she expected Jerry Lee to act

like he was, too. In the span of a year, Jerry Lee went from a preacher-in-training who was acting single to a man with a baby on the way and a wife who hollered at him and could curse like a man and who insisted he give up his dreams and those Natchez clubs and go make a living. They fought, and fought hard and ugly. "Man, Jane could fight. She hit like a man. She knocked me down the stairs, one time."

They moved into a garage apartment on Louisiana Avenue, and people would marvel at the hail of projectiles that would follow Jerry Lee as he emerged, hollering, from the apartment door, and at how the projectiles—some of which looked like Santa Claus figurines—rained down on him as he descended the steps and flew in great arcs at him as he slid behind the wheel of his car or jumped into the car of someone giving him a ride to work, cars that sometimes barely slowed down because you never knew when something heavy would come winging out of the dark.

"She loved them Santa Claus figurines," says Jerry Lee, but not as much as she hated him, in the moment.

Once he was getting into his car when a bottle shattered against the windshield.

"You gonna regret you did that," he hollered at her, but she didn't.

"That woman was hard on a windshield," he says.

He half wished things would calm down, half wished they wouldn't.

"We fought every night. Why? Because it was somethin' to do."

They had almost no money. He rode to work in a 1940 Plymouth, "six cylinders, but only hittin' on five. Used oil. Used a lot of oil." He drove it till it slung a rod, then found another car, another windshield for Jane to go at with a claw hammer or a high-heeled shoe.

"It was like living in the Twilight Zone," he says.

But the storm abated in November 1953, when Jerry Lee Lewis Jr. was born. Jerry Lee held him and just looked at him for a long time, and saw his own face. He was born into a people who didn't believe a family had to be perfect. Families fought, men drank, women hollered,

and in the middle of it all, babies got born and held and marveled over, and on and on it went, until the grave. "I was raised to believe it, that if a man ain't got a family, then he ain't got nothin'." So he held his son, between storms. "I loved my boy. He was the apple of my eye. So you see, somethin' good came out of all that."

Trying to get fatter and steadier paychecks, he drove up to Shreveport to audition for the Louisiana Hayride, which had given Hank Williams his launching pad. Jerry Lee auditioned for Slim Whitman, who had a villain's pencil-thin mustache straight out of a Saturday matinee, and a yodel so high that Hollywood would one day use it in the spaceman parody *Mars Attacks!* as a weapon that could knock spaceships from the sky. Jerry Lee met Whitman at KWKH Studios and recorded two sides—a Hank Snow song, "It Don't Hurt Anymore," and "If I Ever Needed You (I Need You Now)," a song recorded by Joni James. No matter what happened next, he was living one of his dreams, recording a song with genuine country-music stars looking at him through the glass. Elvis Presley had worked on the Hayride, says Jerry Lee, "so I thought I had a chance." But he let a little too much boogie-woogie creep into his piano playing, and the engineers and Slim Whitman rolled their eyes.

"They looked at me like I was crazy," Jerry Lee says.

Slim sidled over.

"Well," he said, "I just don't think we can use a piano player."

The Hayride's piano player was Floyd Cramer, who would become one of the most famous pure instrumentalists in country music and whose elegant "Last Date" would become a romantic standard.

Jerry Lee told him he would be as close as Ferriday if they needed him.

"Don't call us," Whitman told him. "We'll call you."

On New Year's Eve 1952, Hank Williams slept in the backseat of a powder-blue Cadillac, riding through the rain and sleet of Alabama and Tennessee, sick and weak, on his way to holiday shows in Ohio and West Virginia. He would have said to hell with all of it if they had not been big sellouts, and if the promoters had not made him sign a thousand-dollar penalty clause. Rotten weather had grounded his plane, so he hired a college student from Alabama Polytechnic for four hundred dollars to drive him up from Montgomery, about six hundred miles. He was mildly drunk from a pint of whiskey, and vaguely sick, and exhausted; the boy had to stop on the road to get Hank a couple of shots, B_6 and B_{12} laced with morphine. They had stopped off at the old Redmont Hotel in Birmingham to get a good night's rest, but two lovely fans of Hank's had made it impossible to get any sleep, so he had just tried to eat a few bites of food and take a little nap. But he got sick and fell on the floor. He'd been delivered to the Cadillac in a wheelchair, and now, in the big backseat, he tried to rest. He finally drifted off to sleep, and the miles stretched ahead. The West Virginia show had been canceled, but the Canton sellout was still on, and there might be time to make it, if the weather allowed. Outside Bristol, Tennessee, the boy at the wheel noticed that Hank's blanket had slipped partly off him, and he reached back with one hand to cover him. He touched Hank's hand, and it was ice cold. He could not even tell the police where Hank Williams died, for sure, as if they were all living out some song Hank wrote, like that one about the lost highway.

In Canton, in the packed auditorium, the announcer stepped to the microphone. "This morning," he said, "on the way to Canton to do this show, Hank Williams died in his car." Some people laughed, thinking it might be a joke, since Hank had used up every excuse for a no-show but this one. "This is no joke, ladies and gentlemen," the announcer said. "Hank Williams is dead." People began to cry, and the man working the spotlight threw a yellow circle of light on the stage, where Hank would have stood. Don Helms, Hank's friend and steel guitar player, started to play, and the audience sang his words.

I saw the light, I saw the light,
No more darkness, no more night.

Even as a raw boy, Jerry Lee enjoyed the notion of the troubadour, always liked it, the idea of a man just traveling, talking poetry, singing songs. He did not know the origins of the word or the history of the composers and poets who flourished in the High Middle Ages and spread throughout Europe before fading out about the time of the Black Death. But he knew it meant a singer of songs and a wandering man, and Hank Williams was that, just that, and the fact that he traveled in a Cadillac and was born in Mount Olive, Alabama, ought not to make him any less of one, and if Hank was a troubadour, then young Jerry Lee was a troubadour, too. Hank Williams was twenty-nine years old when he died, but look what he did, look at all the people he touched in that life, says Jerry Lee. He and his daddy would have driven to Texas, to Tennessee, anywhere, to see him sing, if they had only known, but they figured, with such a young man, even a tragic young man, there was time. Now suddenly there was a dull, empty place on the radio, even when someone else was trying to sing, a dead place, the way it gets when you drive through the tunnel over in Mobile or down in a holler so deep the airwaves just fly over your head.

Just a deck of cards and a jug of wine
And a woman's lies make a life like mine.

"I would have liked to have met the man," he says, maybe even showed him what he had done with his songs, especially with his version of the great, heartbreaking "You Win Again." He got a gold record later for that Hank Williams song. "I changed it up, some," he says, "but I think he would have liked it." Many years after the man's death, he would place a simple black-and-white photograph of Hank Williams on his dresser, the frame draped in a black ribbon, and the thin man has

remained there throughout the years, looking down on him. Sometimes he likes to think Mr. Williams somehow knows of his great respect for him, a respect he has granted to so few, and that Mr. Williams knows that he is still here, carrying on his music, music as good as maybe there ever has been. "It's nice," he says, "to think that. You see, you can't fake feelin'. Hank Williams delivered a sermon in a song, and nobody else could do that, nobody else could touch it. He was like a preacher, that way. He could make you glad, and he could make you cry. I would have liked to have seen him. I hate that I didn't."

Turned down, turned away, and his hero dead, he arrived back in Black River and went back to work at the Wagon Wheel. He and the blind man played into the night, sometimes into the dawn. All his life, he would be cast as a wild creature careening from one crisis to the next, succeeding on raw talent and surviving on gall and guts and luck, with a dose of what country people called the "just don't cares," and by God that was just about right, wasn't it? Life outside the clubs had always been not just a runaway train but a runaway train hauling dynamite on fire on a hairpin curve. But as hopeless as it seemed even inside the clubs, as dead-end dangerous, he was creating his sound and his moves and his look and his thing, and even when he stumbled out the door into the rising sun, he knew someday people would buy his records instead of trying to charge him three dollars to record one, the way studio men in Memphis did with other dreamers. The Lewises did not let anything run over them, and certainly not fate or destiny or any other sissy-sounding thing, not the Yankee War that took their gilded past or the federal men who locked his male relatives away in the dark heart of the Depression when all they were trying to do was make a dollar selling liquor. "I didn't give up hope, not ever," he says, his chin in the air. "I wasn't raised that way." How could it begin bright and shining, with talk of miracles, of prodigy, and get

lost somehow in a whiskey-and-Benzedrine blur in a mean little beer joint on Highway 61?

He told his mama it was just a matter of time, and when he hit it big, he would buy her a new house with hot and cold running water and a television set, and buy Elmo a farm, and buy them both Cadillacs and Lincolns till there wasn't room to park them in the yard, and she would never have to worry about money again, as she had worried about it almost every day of her life. It would be music that did it, or nothing. "I'm gonna enjoy this ride," he told himself. "No use in even going, if you don't enjoy the ride." He had seen what life did to men who didn't. He saw them, fresh-scrubbed and upstanding on the outside but dead inside, like an old cornstalk or a burned sugarcane field. "I'm not much on being careful," he says. "I don't even know what that means. When I was a little boy, Daddy would say, 'Be careful, son, and I said, 'Well, I'll try.' "

It is hard, in talking with him now, to elicit any admission of weakness, even disappointment; every crushing setback was a stubbed toe, a pothole, little more. "I don't know how to quit," he says, in a low growl. If the Louisiana Hayride would not have him, if its promoters had so little vision, he would reach even higher, further. If he was too edgy for Slim Whitman, then he would go to the mountaintop. He scraped together some traveling money and drove to Nashville.

By the 1950s, Music City had been country music's holy grail a decade or more, a place where countless country boys and girls had seen their dreams of stardom come apart outside the cold red bricks of the Ryman Auditorium, home since 1943 to the most vaunted country music attraction in the city of Nashville and therefore in the entire world. The Grand Ole Opry had been begun in 1925 by radio station WSM, as the WSM Barn Dance, mostly as a venue for hillbilly pickers, cloggers, old-time fiddlers, and a kind of cornpone slapstick, vaudeville

in overalls. It featured such musical sophisticates as the Gully Jump-
ers, Fruit Jar Drinkers, Binkley Brothers' Dixie Clodhoppers, Possum
Hunters, and a sour, hawk-faced man in a white Stetson and business
suit named Bill Monroe, and people throughout the land loved it. In
the years to come, it would make stars of Monroe, Roy Acuff, Webb
Pierce, Faron Young, and later Patsy Cline. Minnie Pearl, the sales tag
from her atrocious hat dangling in front of her face, came onstage with
a raucous "How*deeee!*" She told one story a thousand times, about kin
who picked up a still-hot horseshoe and dropped it quick, and when
asked if it was hot replied, "No . . . jes' don't take me long to look at
a horseshoe." Grandpa Jones played the banjo in hip waders. The fea-
tured singers sported hand-tooled cowboy boots, big hats, and glittery
suits emblazoned with rhinestone cactus and wagon wheels.

They acted like royalty, some of them, because they were: if you
played the Ryman, you were *somebody* in country music, and the pro-
moters treated it like a private club. You were not hired to play the
Opry; you became part of its membership, as long as you behaved.
They were high and mighty enough to kick even Hank Williams out for
drunkenness, and when Elvis Presley auditioned for them a few years
later, he was told by the Opry management to go back to Memphis and
try to get back his old truck-driving job.

Jerry Lee had no invitation, not even a ticket, unless you count nerve.
He walked the streets and sat down on every empty piano stool he saw
and finally once talked his way backstage at the Ryman, but the men in
big hats looked right through him, and the rhinestones hurt his eyes. "I
never did like them rhinestones," he says. The tall, thin men "looked
like they had been there one hundred years, and maybe they had," he
says. "They kept telling me I needed to play the guitar. They said, 'Hey,
boy, you might be somebody if you'd learn to play the guitar.' I said I
can play the guitar, but I'm a piano man."

"I did try to tone it down a little," he says, but it was impossible in
the end. "There's just soul in a piano," he says, and it just had to come

out. In the end, he knew he had no place on a billing where Ernest Tubb could do "Walkin' the Floor Over You" and get only polite applause.

"Elvis, at the Opry, didn't even get any applause. Elvis wasn't ready."

Jerry Lee auditioned at RCA, thinking maybe the record men would have a more open mind.

"Son," the man told him, "you need to pick a guitar."

Jerry Lee was even beginning to hate the word, the way they said it. GIT-tar.

He took work at a club in downtown Nashville owned by Roy Hall, a piano player himself. At Hall's club, Jerry Lee played for some of the Opry's greats, who came there to unwind—people like Webb Pierce, Red Foley, and others—but none of them reached out to him or offered to help in any way. He played sometimes till dawn, till the people at the tables were too drunk to stand.

"Roy Acuff walked up to the bandstand one night. He told me, 'Son, I don't know who you are, or when, or how, but one day you're gonna be a big star.' And I said, 'Well, here I am, wide open to it . . . but I could sure use a little help.' But he just passed on by. Him and others said later on that didn't happen, but it did. Said they sure didn't remember me, but they did."

The one Opry regular who was good to him was a piano player herself, a Nashville native named Del Wood—her real name was Adelaide Hazelwood, but that was too big a mouthful for most people—who had a big hit on both the country and pop charts with an instrumental called "Down Yonder," which sold more than a million copies. She played, too, with a raw, thumping style, almost lusty, and she saw a kind of kinship in the young man from Louisiana. She did her best to help him, introduced him to some of the stars, told them he could play, but no one was willing to give the boy a try, even then. "She was the one who was good to me," he says now. "She was a fine lady, and I never forgot that—and what a piano player." He swore then that if he ever made it big, he would try to pay her back somehow.

"Nashville is *good* at country," he says, thinking back to those days, trying to be charitable, "and my stuff went either way. But it was daylight and dark." In the end, he came to see those rhinestone suits as hard, empty shells with no real life in them. He was making ten dollars a night at Hall's bar then, and as soon as he saved up enough for a car, he bought a '39 Ford and pointed it toward Concordia Parish. "Nawwwwww, never did like it much," he says of Nashville now. "I did some good country records. Some I'm real proud of. But they were the kind of songs that Hank Williams might have made, or Jimmie Rodgers. Jimmie Rodgers was a straight-up man. . . . Hank Williams was a man." They were flesh and blood, flawed and human, and that was what made them great, as much as any lyric, any melody, he believes. But Nashville was selling proper, well-behaved Middle Americans a myth of what country was.

When he got home, in a dark mood, he coaxed a few lines out of his memory and wrote himself a rare song.

> *The way is dark*
> *The night is long*
> *I don't care if I never get home*
> *I'm waitin' at the end of the road*

By the fall of '55, when he was going on twenty, he was still playing five and six nights a week in clubs, raising a family on wadded-up one-dollar bills and a few fives and tens. But even then, he swears now, he knew. "I knew I was going to be the greatest thing. . . . I just needed a *song*."

On the radio, he heard what that one perfect song could do to a musician's life, how it could lift a man out of the dust itself.

"I think it was maybe about then. I went to get Daddy from work. . . . He was workin' on Ferriday High School. A song come on the radio, 'Blue

Moon of Kentucky.' Elvis. I said, 'What do you think about that, Daddy? Looks like somebody done opened the door.' And Daddy said, 'Well, I hope they shut it quick.' Daddy didn't think much of it."

But his son heard the promise in it, the promise in Elvis and maybe even himself.

He heard it elsewhere that year, too: In Fats Domino, the great New Orleans piano man, and in the magnificent screamer Little Richard, and in the first strains of the song that lifted Charles Edward Anderson Berry from club gigs to the lip of rock-and-roll stardom, to number 1 on Billboard's rhythm and blues chart in '55: "Oh, Maybellene, why can't you be true . . . ?" In Berry, as with other great musicians he studied then, he heard what he could be, "heard it on the radio, and knew I could *beat it*."

But Chuck, Fats, Richard—even that new boy, Elvis—had what he needed.

"A *hit*."

"I was running late that night."

Things at home were not good, had never been, really. Jane was still throwing St. Nicholas at him every other night. She had a better arm than most people would have believed and a seemingly endless supply—he had not known there were that many Santa Clauses in the whole world— and they hurt a good bit if she caught him flush. She was also prone to go at him with a high-heeled shoe. But she could not keep him out of the clubs no matter what weapon she employed. He pulled into the sanctuary of the Wagon Wheel parking lot just as a mindless series of twangs and chirps spilled from the joint. The boys were coming back from a break, finding a chord, tuning up. *Must be a new song*, thought Jerry Lee.

The new music had a name now. It was burning up the airwaves in Memphis and even down here in Natchez, like fire leaping from treetop to treetop in a pine barren. The black man had been doing it for years, of course, but the harsh and irrefutable truth was, it took a little touch

of hillbilly to make it slide down easy for most white audiences, like a chunk of busted-up peppermint in a glass of home brew. You fooled children that way, in the Deep South, to get them to take their cough medicine, and you could fool the whole world just that easy and give them their rock and roll.

It was about this time that Jerry Lee and Paul Whitehead came together in a new band with a Johnny Littlejohn, a slim, razor-sharp young man who played bass and worked days as a disc jockey at WNAT. People said he was a better disc jockey than he was a singer, but he bought his clothes at Lansky's in Memphis, the same place Elvis shopped, and wore black-and-white, two-tone shoes. The girls loved it, the way he dressed, the way he carried himself, and Jerry Lee studied that, too. As he played the bass, he swung that thing around in a rhythmic arc, and acted like he was somebody. "Johnny Littlejohn was a good-lookin' man, tall, dark, had his hair slicked back good," says Jerry Lee. "He had a thing. I was jealous of him, a little bit. Had a nice wife, too."

Jerry Lee was still searching for his last element. The other boy, the one from Tupelo, had found his, and now he lived on the air. He drove to work in a '51 Ford, one hand on the radio dial, spinning, spinning, looking for Chuck Berry, for Little Richard going wild, for the Platters, Fats Domino, and he would find this boy Elvis on the colored stations, too, crossing over the other way. The white citizens' councils would quake and fret and condemn it all as miscegenation, but in the clubs of Natchez, it was hardly any revolution at all; the crowds there had been digging juke music along with cowboy tunes since before the Korean War. Even under the white sheets—the Klan was big here on both sides of the Mississippi—you might catch some redneck peckerwood tapping his toe.

"I walked in the door," says Jerry Lee, "just as they kicked it off."

Paul Whitehead was playing that electrified upright like he was whacking a bell, on a tune that had all the subtleties of a dog bite.

"Man," he said to himself, "I like that lick. I *like* it."
Then Johnny Littlejohn jumped in.

> *Come on over, baby.*
> *Whole lotta shakin' goin' on.*

That quick, he knew.
"That's my song."

> *Yeah, I said come on over, baby.*
> *Baby, you can't go wrong.*
> *We ain't fakin'.*
> *Whole lotta shakin' goin' on.*

"I got to have that song."

> *I said come on over, baby.*
> *We got chicken in the barn.*
> *Come on over, baby.*
> *We got the bull by the horns.*

Littlejohn was singing his heart out, because if you did not sing tough on this song, did not sing wild, it would sound silly, sound like a prissy man trying to act tough in a cowboy bar. The song—written at a fish camp on Lake Okeechobee, some say, in between milking rattlesnakes, drunk—required that. This was a song without a speck of nice in it.

> *Yeah, we ain't fakin'.*
> *Whole lotta shakin' goin' on.*

The origin of the song is cloudy at best. Roy Hall, the Nashville musician and bar owner who briefly employed Jerry Lee, later said he

wrote the song with a black musician named Dave "Curlee" Williams while they were in the Florida swamps milking poisonous snakes and drinking heavily, two things that do not usually mix well. But Williams said he wrote the song himself, leading some to wonder if Hall perhaps bought a piece of the song, as was common then.

Hall recorded the song for Decca—that record lists Williams alone as the songwriter—but it had never been a hit for him, nor for Big Maybelle, who cut the first version, with Quincy Jones leading the band, nor for anyone else who ever tried. But no matter its credits, it does seem to have been born in a state of blissful sorriness, a thing not blues and not hillbilly but with all the baser elements of both, not as raunchy as some dirty songs but maybe just raunchy enough to thrill people and still, if the preachers weren't listening too closely, get played on the radio, trembling somewhere between glorious entertainment and a greased rail straight to hell.

Jerry Lee knew nothing about any of that, not yet, and if he had, he would not have cared even a little bit. He was already singing it in his head, his fingers already twitching in the air. His gaze was fixed on the stage, but from the corners of his eyes he could see the women start to sway and move, even the ones sitting down. "They didn't even know what they were tappin' up to," he says. Then Littlejohn launched into the part that seemed taken straight from under the circus tent at a hootchie coo, from the strip clubs in downtown Atlanta, from the watered-down, two-drink minimum, broken backroom promises of Bourbon Street.

Well, I said shake, baby, shake.

"It was meant for me," says Jerry Lee. "It was *written* for me."

I said shake, baby, shake now.

He did not have to write the lyrics down. The ones he forgot, he re-

placed with others he just made up. It wasn't Tennyson. But the rhythm, the feel, bored into him.

"It was stamped on my mind, right then."

I said shake it, baby, shake it.

"No, it was burned," he says.

We ain't fakin'.
Whole lot of shakin' goin' on.

It ended in a roar.

He walked up to the bandstand, like a boy with a stolen comic book stuffed down his pants.

"You a little bit late, ain't you?" said Littlejohn, when he approached the stage.

"No," Jerry Lee said, "I'm right on time."

"And I took that song home with me."

It played through his pillow, and hummed in his ear.

The next night, he asked—no, he insisted—that Littlejohn let him sing it.

He knew every word, every gesture the singer had made.

"I done it just like Johnny done it," he said. "Maybe I should have felt guilty about that."

Mr. Paul moved to his squeezebox, without ego, just changing gears.

Come on over, baby.

But it was not the same. He rewrote the lyrics in his head as he went along and felt like shouting them, and *was* shouting

before he was through, till it was no longer Curlee Williams's song or Roy Hall's song or Johnny Littlejohn's song but his, just his. It was stronger, rawer, more dangerous. There was a buck-naked joy in it as he pumped the piano hard from the first lick, beat it sore, and the crowd knew it.

But mostly, of course, Jerry Lee noticed the women, moving in their seats at the tables, gyrating at the bar. "They looked at me different, and I looked at them different," he says, "than I ever had before." They pushed up to that rickety rail and heaved and squirmed and "just moved, man," moved everything but their eyes. He can't really explain it, even now, but they just looked different. "They looked better."

They did not all look back at him in exactly the same way—that only happens in the movies and the funny papers and maybe in some really good dreams—but the ones who crowded to the front of that little stage, right up to that deadly coil of extension cords, did. They left their men standing open-fisted, and their eyes drilled at him, offered him everything. "They took their dresses in their hands, and swung them around," like they wanted to do more, needed to do more, right then and there. "And I knew," he says now, "I was doing somethin' different."

It was a dancing song, and the women who didn't crowd the stage dragged their men out on the floor with them—drillers and wrench slingers and insurance men, men who thought dancing was a Texas two-step or a sock hop or a vague, grandma-haunted memory of a Virginia reel. Now they just hung onto their partners' hips with both hands, and if they had possessed any sense, they would have seen that the blond-haired boy was doing them a favor.

The song even had a little talking part in the middle, the way these boys played it, a place where the singer could cheer the dancers on; it was the kind of thing piano players had been doing since Pine Top Smith made the very first boogie-woogie record in 1928. But in Jerry Lee's hands it became something else entirely.

"Johnnie Littlejohn did a little bit of the talkin' part, and that's where I picked it up. But I redone it. Rewrote it all," in his head.

"Easy now," he told the boys, lowering his hand.

> *Shake it! Ahhhhhhh, shake it, babe!*
> *Yeah, shake it one time for me.*

"I saw my Aunt Eva out there dancin' with some young man, so I knew she was gettin' *on* with it."

> *Now let's get real low one time.*
> *Shake, baby, shake.*
> *Shake, baby, shake.*

Then he slowly raised one hand up high, where he and the crowd could see it.

> *All you got to do is stand in one spot*

He pointed one finger and rotated it in the air.

> *And wiggle it around just a little bit.*
> *That's when you got something.*

The young girls screamed.

He had heard them scream during a raw, nasty blues number, but not like that.

The boys and the husbands, some of them, got to lookin' mean.

He liked that, too.

"It was wonderful."

> *Now's let's go one time. . . .*

Mr. Paul pumped his squeezebox, and he knew.

It was the beginning and the end of everything.

Jerry Lee left the Natchez clubs not long after that night. He did not take that song right then and ride it like a rocket, though that would have made a fine movie or a very fine lie. Instead, he tucked it away in his vast catalog of songs, the way a gambler slides a jack or a queen up his sleeve to pull out when he needed it, when the time seemed right, or when he was down to his last scrap of luck. But he could feel it. He knew he had his missing piece. "I knew exactly what it would be," he says, fifty-seven years after that night. "I knew it was on its way to the moon," and someday he would ride it into the stars. It may sound like fiction, but he knew it was one of those forever songs, knew that some-one a hundred years from now would pluck it off a wireless signal or a moonbeam, shout "Shake it, baby, shake it," and dance in their socks.

"They say radio waves bounce," he says. "Well, I reckon so."

It pleases him, as an old man, to think of it like that, out there in space, looping through the universe between the stars, never ending.

And it makes him a little sad.

The song is forever.

Mr. Paul played the clubs for years. He lived long enough to see country music become so banal and plastic he could not feel it in his heart. He saw the blues go out of style, saw it replaced on the airwaves by some-thing called disco and then slip deeper, further into a kind of empty posturing known as hip-hop, which did not seem like something, any of it, that a grown man would do. The few old men who remember him recall a genuine music man in a great, glorious time. Sometimes people leave this world just when they should.

Mr. Paul's sound mostly died with him. The Wagon Wheel closed

and returned to the weeds. The blind man never made a commercially viable record of his own, as far as anyone knows. But there is, if you look for it, a ghost of his piano still. After Jerry Lee left for Sun Studio, Mr. Paul's old bandmate, the guitar picker Gray Montgomery, tried to sell Sam Phillips a song called "Right Now." It was a swinging little guitar-driven song that was rich with rockabilly and featured a lovely piano solo by Paul Whitehead. Phillips said he liked the song fine, but he wanted to replace the piano with a saxophone. Saxophones were getting to be pretty big in redneck music. Besides, he had already locked up the most sensational, wildly wicked piano man in the whole known universe, maybe the most wild and wicked who had ever been, and he needed another piano record like he needed a cement lawn monkey. Montgomery, unwilling to change it, walked away and took the song to a small label instead. The song got jukebox play in and around Natchez, but it faded and all but vanished, as even some good songs are destined to do. But if you search for it on the new lightning of the Internet, on a little label called Beagle Records, you can find it, still, find Paul Whitehead, his piano solo ringing out so lovely, lovelier than can be described with black ink on white paper. It lasts just a few seconds, but it will be forever, too.

5

SUN

.....................

Highway 61

1956

The blacktop runs straight as a hypodermic across the great, flat, brown nothing, stabbing through the heart of the Delta for 323 miles, dreams and failed ambition piled like old bones in the ditches on either side. What waited on the other end of Highway 61, past the crossroad where Robert Johnson cut his deal with the devil and past a huge graveyard of lesser bargains, was the solution Jerry Lee Lewis was looking for. But he knew in his guts that his chances were running out. He stood in the middle of a cornfield near his mama and daddy's house in Louisiana and watched his daddy work, watched him move like a machine down rows of dead stalks and knew he did not want to travel that haunted road to Memphis alone.

It was one of the few times in his life he felt that way, he concedes now. "I wanted my daddy with me," he says. "I wasn't going to Memphis on my own. That road, man, it got a lot of 'em, got a lot of us. . . . It ain't just I wanted Daddy with me, I *insisted*."

But it took some doing. "I was pulling corn with Daddy," he remembers. "He did four rows to every two I did." It was shell corn, late in the

season, the ears gone hard on the stalk. It would be feed for cattle and hogs or ground up for meal or soaked in lye to slough away the hull for hominy. The husks were paper-dry and rustling and the silk as brittle as a dead man's beard. The dust off the stalks and husks was stifling, floating in the sunlight, stirred up as the two men crashed through the crop. His heart was not in pulling corn any more than it was in chopping cotton or pushing a wheelbarrow, but he had a favor to ask his daddy and it was hard to catch the old man when he was just sitting in the shade, and it is insulting, in a way that is hard to explain, for one Southern man to watch another one work.

"Daddy," he said, when he met Elmo coming the other way through the corn, "I been readin' in this magazine about this man in Memphis named Sam Phillips. This magazine told about how he helped Elvis be a star."

"Uh-huh," his daddy said, and kept pulling.

"I want to go to Memphis. I want to show them what I can do."

His daddy straightened up.

"Well, I don't blame you son. I would, too."

But Elmo was between construction jobs and there were debts to pay, and it took a whole tank of gas just to get to Memphis, and they would need hotel money, too. Neither one of them knew how long it would take to get these Memphis moneymen to hear them out, or even if they would let them in the door. But for Elmo, saying no would have been like seeing his own dream go dry on the stalk for a second time.

"I need to see that man," said Jerry Lee. "I want to see if he can do for me what he done for Elvis. I want to see if he can make me a star."

He had been shown the door in Shreveport and ignored in Nashville by men who thought music was a product you stamped out on a press, like car parts. He needed a risk taker, a rebel, and he believed—at least he believed it then—that Sam Phillips of Sun Records was that man. He could have gone on his own to audition for Sun, could have lived on saltine crackers and pork and beans and slept in the car, but he knew

this was his best and maybe only chance to play and sing for people who knew what chance taking was about, who had already taken one flying leap into the unknown with the boy from Tupelo and found gold.

Elmo stood in the rising dust, thinking. From a distance, seeing the two men there in the field, their heads bowed, it might have looked like they were praying. After a while, they came up with the answer.

"We went out in the henhouse and we gathered eggs, and we saved 'em up, day by day, and it took us a while to do it, but we eventually gathered up thirty-nine dozen. We took 'em to town and sold 'em to Nelson's Supermarket. And then we took that money and we headed to Memphis in a '56 Ford."

Jerry Lee spun the radio as they drove, looking for gold. As they passed into northern Mississippi, he found WHBQ from Memphis, found a young man named Dewey Phillips, who sounded wired on speed and certainly was, a kind of hillbilly hepcat who did not care what color the music was as long as it cooked. He played Hank Williams and Muddy Waters cheek by jowl, and Hank Snow next to Elmore James. He played Sister Rosetta Tharpe, picking on that white electric guitar and swinging her hips around, singing how "there's strange things happenin' every day." Then Wynonie Harris did "Good Rockin' Tonight," the Soul Stirrers sang "Jesus Gave Me Water," and Piano Red shouted, "If you can't boogie, I'll show you how." And of course, he played Elvis, who stitched it all together, whose music was so far beyond category that Dewey had to ask him where he went to school so that everyone in segregated Memphis would pick up that he was a white boy who only sang colored. Dewey was sponsored by Champagne Velvet beer— "Yes, sir, CV for you and CV for me"—and yakked crazily even in the middle of the songs about a letter from his grandma, hollering, "Does anybody wanna buy a *mule*?" He exhorted musicians on the records to play faster, hotter, like they were sitting there in the studio with him, shouting "Awwwwww, sit on it, boy. If you can't sit on it, play it," to invisible piano players. You were nobody in Memphis music till Dewey

Phillips played your records on the radio, and as Jerry Lee and Elmo neared the bright lights, he talked them in, frantically piecing together a patchwork quilt of blues, country, and gospel for an audience that had come to reject dull, bland music the way people in New Orleans would not eat bad food.

Jerry Lee looked out the window at the city and felt like a bird on a wire, felt like his old self. He could fly anywhere from here. "And I knew we didn't sell them thirty-nine dozen for nothin'."

"We got us a hotel, right close to Sun Studios," he says. "The hotel had a sink in it, with running water. First time we'd been in a place like that." They just stood for a minute and looked at it.

Before he started his own record company, Sam Phillips had been recording the voices of southern men and women, in moments of ecstasy and agony, for nearly a decade. He recorded big band music, but also church and funeral services, a thousand long good-byes: if you wanted your bereavement preserved, he would rig a microphone right in the eucalyptus at Idlewild Presbyterian and catch every sob. He would do the same with a big wedding in Chickasaw Gardens, an inauguration, or a speech to the Junior League, anything with sound. It was all part of his Memphis Recording Service, a little operation housed at 706 Union Avenue, hard against an upholstery shop.

His real calling, he would tell anyone who listened, was to record music—especially the voices of the blues singers of the Delta region, seasoned performers like John Estes and Howlin' Wolf, and younger men like Junior Parker, Ike Turner, and others who would go on to mean something in the blues. In 1952, after a few of the recordings he made for other companies became solid regional hits, he launched his own label. He called it Sun Records, and turned on the big neon sign in his window, and let the world know he was open for business. He wore good, dark suits with good ties and a gold tie clip, and he had a thick,

full head of dark hair and good teeth—a respectable-looking man, the kind who could sell you the shoes you came in with and leave you feeling grateful. But his love for music was a real, consuming passion, and the kind he loved the most did not even really exist yet, at least not exactly as he dreamed it.

Sam Phillips was self-made if ever anyone has been. Like many of the musicians he would record, black and white, his people worked the land—tenant farmers, in his case, near Florence, Alabama. He was a white man who loved black music, and had since he picked cotton beside his mama and daddy and listened to the music in the fields. He wanted to be a big-shot criminal lawyer, but when his daddy died during the Depression, it left his family hurting for money, so he went to work in a grocery store, then a funeral parlor, and finally as a disc jockey at WLAY in Muscle Shoals, spinning both white and black records, like Dewey Phillips, who was no relation but a kindred spirit. Later he landed in Memphis, at WREC, broadcasting shows from the swank Peabody Hotel, where big bands played dance music for some of the richest people in the South. Sam was exposed to all kinds of music—swing, gospel, hillbilly—but there was just something about that blues, man, that lit him up. He would say blues was about how hard life was but it was also about why people bothered to go on living, and that made it a kind of perfect form. He would say that if he could ever find a white singer with a black soul, he would conquer the world or get rich trying. What he was hoping for was rock and roll.

His Sun Records would become a portal for it, built on a bedrock of blues. People in rock and roll are always going on about the birth of this or that, but if you had walked into the little studio on Union Avenue on March 3, 1951, you would have heard history being laid down, heard what many music historians consider the first rock-and-roll record ever pressed.

You women have heard of jalopies, heard the noise they make,
But let me introduce my new Rocket 88.

A love song to an Oldsmobile, it was credited to Jackie Brenston
and His Delta Cats, but such a band did not actually exist; it was just
the name Sam put on the label, hoping it would stick. Brenston was a
saxophone player in Ike Turner's Kings of Rhythm, which had been
playing the song at a club in Clarksdale, Mississippi. Turner, Brenston,
and the Kings of Rhythm drove up to Sun Records to cut the tune,
giving it a rolling rhythm with a steady backbeat and a unique, fuzzed-
out guitar riff, one of the first distorted guitar sounds ever laid down
on tape. The band's guitar amplifier was broken—one band member
would say it fell from the top of the car and busted on Highway 61 on
the way from Clarksdale—so the amp box was stuffed with wadded
newspaper to hold the vibrating cone in place, making it sound fuzzy.
"Leave it in," Sam Phillips said, when someone asked if he should try to
recut the record. The thing that made music work, he always said, was
spontaneity: what happened in that one imperfect moment, *that* was the
perfect thing.

Phillips would record Brenston, Little Milton, Rufus Thomas, Ros-
coe Gordon, and many others, some famous and some who would never
be heard from on this earth again. As Chicago and other northern cities
began to siphon the talent and business away from the South, the actual
cradle of the blues, Phillips recorded some more hillbilly music, includ-
ing the beautifully named Ripley Cotton Choppers. But he finally found
what he was searching for not in some lonesome backwoods but in a
Memphis housing project, in a boy who made a *C* in music at Humes
High, who just walked in the door at Sun Records one day and told his
assistant, Marion Keisker, "I don't sound like nobody."

Elvis changed the world, but Phillips, living in the real one, sold the last
year of his star performer's contract to RCA Victor for $35,000, money he
would use to run his business and promote new talent. And talent was one

thing that kept coming, sure as funeral money. He had Carl Perkins, who gave him a monster hit with "Blue Suede Shoes," and a moody pill popper named Johnny Cash, whose "I Walk the Line" and "Folsom Prison Blues" were pulling hard at country audiences, and Roy Orbison, who wasn't much to look at but had a voice like sounding bells. They all helped spread this new music around the country, one American Legion, city auditorium, and jukebox at a time. But they were not Elvis, and while they made history of their own on the stage they did not make people lose all reason and want to crawl up on it, thrashing and screaming. Phillips had good music to promote still, but he had sold away the beating heart of rock and roll, its excitement. And he was hoping every day that another miracle would just saunter in his door.

In the motel, Jerry Lee and Elmo took one more splash in the miraculous fountain of indoor plumbing and headed for the Sun studio, only to find that the keeper of dreams was nowhere to be found. Sally Wilbourn, Sun's secretary, told Jerry Lee and his daddy that Mr. Phillips was out of town, but they were welcome to try back later, just like that, like people could come and go any time they wanted, like people had money for such as that. Jerry Lee told her he was not leaving until someone paid him some attention.

"Somebody," he says, "was gonna hear me."

The engineer—what would now be called a producer—was an ex-marine named Jack Clement, who would come to be known as Cowboy Jack and would see his name attached to some of Sun's most enduring records. He looked up to see Sally Wilbourn lead two men back into the studio, saying that the young one claimed he could play piano as strong as Chet Atkins could pick a guitar, or something like that. Clement said he had to see that for himself.

"You think you're that good?" he asked the boy.

"I'm better'n that," said Jerry Lee.

Clement showed him to the piano; this was all he had been asking for, all along. "I knew what I could do, and I knew that if somebody could help me, and put me a record out, I was going to be a big hit. I *knew* that. But convincing other people about it was like crammin' a wet noodle up a wildcat's nose. It just don't work, you know?"

He sat down to show the man what he could do, sure of himself, but when his daddy leaned against the piano, to show he was with him, tight, he was glad. He played for hours, three at least, played "Seasons of the Heart," and messed around with other songs, mostly country standards and music from his memories, like "Wildwood Flower."

"And my daddy was standin' there. I said, 'I think I oughta do "Crazy Arms," put it down on tape so Sam can hear it when he comes back from vacation in Florida.' I said, 'Whether he does or not, I'm gon' be sittin' down on his doorstep, waitin' for him.'"

"'Crazy Arms,'" he says now, "is strictly blues." It had been a big country hit for Ray Price earlier that year, so it wasn't exactly new—but these were days when plenty of different artists would record versions of a hit song, so that record buyers and disc jockeys might have four or five different versions to choose from. Clement just let the tape run. There was something in the boy he liked. Country music wasn't moving then, had just gone stale. But he let the tape run, let the boy go and go.

"I played it on that old spinet," Jerry Lee said, "with Daddy leaning on it, looking right at me."

> *Now blue ain't the word for the way that I feel*
> *There's a storm brewin' in this heart of mine*

His daddy closed his eyes.

He's dreamed of this, of doing what I'm doing, Jerry Lee thought.

"I just took one take on it, just playin' around, you know." He says now that he was never nervous about playing in the studio in front of the engineer, but he was nervous playing in front of Elmo. "I was

a little afraid Daddy would say, right in the middle, 'You missed a minor chord there, son.' But I played it perfect, and I made that song my own."

> *This ain't no crazy dream, I know that it's real*
> *You're someone else's love now, you're not mine*

He hit the last key and looked up. "And all Daddy said was, 'Well, we got to go pretty quick.'"

But not before Clement made him a promise: "Well, I'll see, Jerry Lee, that he hears it."

Clement played the tape for Sam Phillips when he returned.

"Who *is* this cat?" Phillips said. "Get him down here."

"It was about then that J. W. Brown walked up to me down in Ferriday and introduced himself as my cousin," says Jerry Lee, who did not know the man that well. J. W. was the child of Elmo's sister, Jane, but had not grown up with Jerry Lee and the Ferriday cousins. He would later say that Jane had been forced to marry an outsider, a man from Franklin Parish named Henry Brown, because the world had temporarily run out of eligible Gilleys and Swaggarts.

J. W. used to work days as a lineman for the electric company, but he'd recently been shocked off a tall pole by a naked wire, and he was in no hurry to handle blue lightning again. Instead he thought he would like to try his hand at being a musician, which is why he came looking for Jerry Lee. He was pushing thirty, with a wife and two children at home in Coro Lake, in northern Mississippi, but he had tried the music business once before and had never gotten that sweet promise out of his mouth. In the early 1950s, he'd spent some time picking guitar with the owner of a bar in Mangham named Big Red. Once, while they were onstage, a boy with no etiquette whatsoever walked

up to the jukebox and punched in a song. Red shot his own jukebox with a .45, and the boy went back and quietly finished his beer.

Figuring he needed a better ending for his musical story than that, J. W. ordered a Silvertone guitar from Sears and Roebuck and went looking for the cousin he had heard so much about. His timing was dead-on. Jerry Lee was waiting for Sam Phillips to call him back to Memphis anyway. "J. W. said, 'You got to come to my house,'" and invited Jerry Lee to stay with him and his family at Coro Lake, where he could be close to 706 Union Avenue and close to his dreams. He had seen the boy play piano like a crazy genius on the stage and in church, and in a world of strummers and pretenders who could sing through their nose and even shake their leg a little bit, Cousin Jerry Lee seemed something else entirely. He took Jerry Lee and introduced him to his wife, Lois, and son, Rusty, who was just a toddler then, and to his lovely twelve-year-old daughter, Myra. It was not, as some have said, love at first sight. "I did notice," Jerry Lee says now, "that she wadn't no kid." Jerry Lee bunked on the couch, and with his pretty twelve-year-old cousin flouncing around, prepared to conquer the world.

His first real recording session—the first one with an eye toward cutting a real record—came on November 14, 1956. He was playing with true recording professionals, with drummer J. M. "Jimmy" Van Eaton and guitarist Roland Janes, two musicians who would be as much a part of Sun in its early days as the ugly green paint and nicotine-stained acoustic tiles and the slapback echo that appeared, almost like a ghost, on the studio's early records.

Janes and Van Eaton never went on to illustrious careers, at least as far as money and marquees go, but they are synonymous with Sun and with Memphis music and so are at the very nut of rock and roll. They were extraordinary musicians; people who really love the music can pick their styles out of the crowds of lesser ones who played before

and after. Not just anyone could keep up with Jerry Lee Lewis; he has kicked musicians off the stage who could not stay with his tempo, could not blend in with his sound. Roland and Jimmy did that and more.

Janes was a marine during the Korean war, the son of a Pentecostal preacher and lumberman from Clay County, Arkansas. He could play mountain mandolin and had grown up with gospel; he had a light, sinuous tone that made itself known around the edges of a song just as much as it did during one of his indelible solos. He would go on to be an engineer and producer and part of the Memphis sound for another fifty years. Sometimes when people realized that the man they were talking to had been the guitarist on those great early hits, they would hand him a guitar and ask to hear him play. He would tell them simply, they done had. Jerry Lee gives him only the highest praise you can give a guitar man: "He could pick."

Van Eaton was just a kid then, but like Janes he would leave his mark on an entire genre. His beat was subtler that that of most of the early rock-and-roll drummers, influenced by swing, adding crisp punctuation to the swampy Sun sound. He had grown up with Dewey Phillips and Memphis radio, and in the '50s he became *the* creative drummer in Memphis, as Jerry Lee would say.

Jerry Lee respected both men, and enjoyed playing with them, but he would not form the bonds with them that he later would with his road bands, who fought drunks with him and chased women with him and survived each trip as though it was some kind of tour of duty. Roland and Jimmy tried that, but not for long. "They played with me just a very little bit. . . . I don't think they liked being away from their spouses," he says, and laughs. "We had a little problem with that." (Van Eaton would say he did not mind jumping off a roof into a swimming pool now and then, but that touring with Jerry Lee was downright life-threatening.)

Also in the studio that day was guitarist Billy Lee Riley, who would go on to have a small hit with "Flying Saucer Rock and Roll" and a bigger one with a cover of Billy "The Kid" Emerson's Sun hit "Red Hot."

Riley's records also featured Roland and Jimmy—and Jerry Lee Lewis, making a little side money on piano. Sun called them Billy Lee Riley and the Little Green Men, to capitalize on the flying saucer fad of the time.

They all had more experience in a recording studio than Jerry Lee, but to him it appeared a little slipshod, the way his first real session went down. The studio's electrical system was less than reliable, circuit breakers always flipping, the place going dark or silent, and people came and went in the studio even during the course of a song. But later, the musicians involved would agree that little mattered that day except the rolling, pumping, boogie-woogie piano and the boy's strong, plaintive voice, which made all the other sounds in that drab, green little room obsolete. He played his own song, "End of the Road," and some Gene Autry, "You're the Only Star in My Blue Heaven." Finally, he did "Crazy Arms," just him and the drummer Van Eaton, mostly. Roland Janes left and came back, even picked up a standup bass and strummed it a bit, more or less in time, but he was mostly fooling around and off microphone anyway. At the end of the song, Billy Riley came in from the bathroom and, not knowing there was serious work being done there, hit one big, loud, ugly chord right at the end; it remains on that original recording. "He made ten dollars, for just sittin'," says Jerry Lee. "It kind of made me mad."

It was clear from the beginning that Jerry Lee, despite being brand-new at this, could not be led or prodded into playing a song any way other than the way he felt like playing it at the time; it would be like that all his life. Janes and Van Eaton would learn almost to sense the way he was going on a song and follow accordingly. The engineers often just put the tape on and let it run till some kind of imperfect perfection ensued. There was no dubbing, nothing manufactured; there was hardly the technology for that, anyway. "It was art," Jerry Lee says. "I played it like I felt it, man."

But he still had not met Sam Phillips.

Later Phillips listened to just a few seconds of "Crazy Arms."

"I can sell that," he said.

A few days later, Jack Clement introduced them.

"This is Jerry Lewis," he told Phillips.

"Jerry *Lee* Lewis," said Jerry Lee.

He might have tried to be modest, but he truly did not know how.

"He was kinda stone-faced," Jerry Lee says of Phillips, "till he got to talkin' about money. And when he started talkin' about money, all he would talk about was money," and then he had the white smile of a shark.

"I just got one question for you, Jerry Lee," he said. "Tell me what you're going to do with all this money you're gonna make."

Phillips asked the boy what he considered to be a good payday.

"Well," he said, "one hundred dollars a night would be conquering the world."

"You'll do better'n that," Phillips said. "You won't be able to fit it in your pockets."

He might as well have taken a jug of kerosene and upended it on a railroad flare.

Jerry Lee thought for a minute.

"Well?" Phillips said. "What you gonna do with it?"

"I'm gonna spend it," said Jerry Lee.

"On what?"

"On Cadillacs."

Before he reached the door, a box of records under his arm, Phillips stopped him. "Son?" he said.

"Yes, sir?"

"I'm gonna make you a star."

Later, when asked about his first impression of Jerry Lee Lewis, Sam Phillips would say, "I knew that if he could do anything at all, even

toot a mouth organ, I had me my next new star. He looked like a born performer." All Jerry Lee knows is that Mr. Phillips backed up his big talk: he took a copy of the raw record to Dewey Phillips, who listened to it, "just like he done with Elvis." And another piece of his dream clicked into place.

"WHBQ," recites Jerry Lee. "Everybody listened to *Red, Hot & Blue.*" He had reason to be hopeful: "I thought a lot of Dewey Phillips. He was one of a kind . . . wild as the West Texas wind." And one thing was certain: "You were a hit if he played your record."

But just because a disc jockey agreed to hear a record did not mean he would play it; they were the gatekeepers of early rock and roll. All Jerry Lee could do was wait.

"I went home with that box of records, and I went straight to the back forty where Daddy was working."

"Daddy, I want to play you this record," he said.

"Okay, son," Elmo said. "Let's go hear it."

They put the record on and listened standing up as the needle brought that Memphis moment into the little living room in Concordia Parish. Jerry Lee watched his daddy's face, unreadable, as the circle of music grew smaller and smaller, till his own voice finally vanished into static.

"Yeah," Elmo said, "that's good."

But it was all he said. Somehow his daddy didn't seem moved, didn't seem all that impressed by what his boy had done. It may be that Elmo was a little bit jealous, Jerry thinks now, enough to stifle his enthusiasm for his son. When you dream about something for as long as Elmo had dreamed about playing onstage and making a record, it must have been hard to see that dream draped like a fine suit of clothes on another man, even his own boy.

Jerry Lee has thought a lot about that day, but he owes his daddy

too much to feel any anger; what he feels is disappointment, the lasting kind.

"He didn't make much of it. I don't know why. But he didn't. It kind of got to me, I guess.

"But ain't that the way the real world works?"

Jerry Lee went back to Memphis to be close to the music. One night he was watching television with J. W., Lois, and the family when the phone rang. J. W. came back in the room and said, "Dewey Phillips is fixin' to play your record."

Jerry Lee told him he was a liar.

"You listen. Dewey Phillips is about to play it on the radio."

"Nawwwww," Jerry Lee said.

They turned on the radio, and there he was, talking so fast you could barely make out what he meant: ". . . and this is Daddy-O Dewey Phillips, just fixin' to bring you the hottest thing in the country, *Red, Hot & Blue*, comin' to you from WHBQ in Memphis, Tennessee. . . . Here he is, here's a new guy that Sam Phillips has got. Jerry Lee Lewis. And here he is, doin' 'Crazy Arms.' "

"And I couldn't *believe* it. That's the first time that I ever heard my record on the radio. An' I said, '*Man*, listen to that.' "

The air over Memphis and the dark Delta filled with his voice.

"I looked over," Jerry Lee says, "and there was Myra, jumping up and down."

At WHBQ, Dewey Phillips and the engineers took call after call from listeners who said they liked that boy from Louisiana, liked him better than Ray Price, liked him the way they liked Elvis. To make sure that Jerry Lee did not wander away from Memphis, Sam Phillips spread the word that there was a hot piano player in town, and Jerry Lee started

doing club dates in the Mid-South—nothing too glamorous, some downright dangerous. Roland Janes liked to tell people of a night, not far from Memphis, when a big peckerwood started yelling at Jerry Lee, "Blondie? Heeeeeyyyyy, Blondie?" till Jerry Lee walked over, smiling, and punched the man in the nose, punched him so hard he knocked him across the floor. Then he went back to his piano and played a song. A lot of musicians pretended to be tough, pretended to be about a half bubble off plumb, but Jerry Lee really was, tough and a little bit crazy when it suited him, Janes would say, and he was willing, always willing, to defend the dignity of the stage. On it, he could do anything, perform any antic he wanted, but if you impugned his stage, you insulted him down where it mattered, and he was coming for you every time.

The specter of Elvis was never very far away, in those days. It was Elvis, speaking to Jerry Lee through the radio, who had convinced him it was all possible, but he still was invisible to this man who had had such an impact on his life. As he went to work in Memphis on his own career, he wondered if he would ever even meet the man. He had already met Carl Perkins and Johnny Cash, and while he knew they were successes and even stars, they did not have the luster of Elvis. Elvis was said to visit Sun Records still, now and then, and Jerry Lee hoped and waited to see him there, not as a googly-eyed fan but as one professional to another.

Late in 1956, toward Christmastime, Phillips asked him in to help out Carl Perkins, who was coming in to cut the old country blues "Matchbox" and an original tune called "Your True Love." Jerry Lee was reluctant to play behind Perkins. "Carl was doing a session, and I was just kinda hanging around," recalls Jerry Lee. Perkins was backed by his band—brothers Jay and Clayton and drummer W. S. "Fluke" Holland—but for this record they wanted piano, and that meant Jerry Lee.

He is slow to talk about doing session work now, as if such a thing was somehow beneath him, but in Carl Perkins he recognized a mu-

sician who knew how to get the sound he wanted in a studio. Perkins then was a slim man with dark, oiled-back, curly hair and a big jaw, a snazzy dresser who liked to do a little Chuck Berry duckwalk in his black-and-white two-tone shoes, but in the studio he was all business. "Sam wanted to know if I would play behind the boy, and I said, 'Well, I don't know.' I said, 'I'll do the best I can, but Carl does most of the playin' himself, you know? He says, 'Yeah, but I want you to take lead on the piano.' I said, 'I don't think so. I don't think that would really do very good.' And I don't remember if he took the lead on it or not. [But] you could hear it. You could tell who was playin' the piano. And that's what they wanted."

Oh, let me be your little dog
Till your big dog comes

After a take or two, Jerry Lee looked up to see Sam Phillips walking toward him.

"You gonna be around a while?" he asked.

"Sure," he said. "Why?"

"Elvis called. He said he'd be by in a while and wanted to meet you."

Jerry Lee told him he reckoned he could hang around a little bit more.

6

"I BEEN WANTIN' TO MEET THAT PIANO PLAYER"

........................

Memphis

1 9 5 6

He was the most famous man in the world, at that moment. He pulled up to Sun Records in a white and brown Lincoln Continental convertible, slid out of the new leather, and glided into the lobby with a brunette chorus girl from Las Vegas on one arm of his chocolate-colored sport jacket. Her name was Marilyn Evans, and she was almost as pretty as he was.

Elvis said his hellos, then came straight over to Jerry Lee and shook his hand.

"I been wantin' to meet that piano player," he said.

He did not act like the king of rock and roll. He acted like a good boy, with not one speck of ugliness in him. He even hugged Jerry Lee's neck, as a brother would do.

"That your car in front?" he asked Jerry Lee. Jerry Lee had taken his first modest check for his recording of "Crazy Arms" and put it down on a red Cadillac convertible with white leather interior.

"It is," Jerry Lee said, like he was born in a Cadillac.

"Man, that's a beautiful car," Elvis said.

"Well," Jerry Lee said, "I try to keep a good car."

It was a Tuesday, December 4, 1956. Much, much later, when the other boy's body was dead but not his name, never his name, the writer Peter Guralnick would tell of this brief and shining time, and the way it never seemed to fit quite right inside the boy's head: "It was all like a dream from which he was afraid he might one day awaken. It seemed sometimes like it was happening to someone else, and when he spoke of it, it was often with a quality of wonderment likely to strike doubt not so much in his listener's mind as in his own."

Elvis strolled into the studio itself, to say hey to the others, to old friends, and to talk about old times and new records and this desert oasis called Las Vegas. Elvis listened to the tape of Carl's new record and told all the boys, "Yeah, I like that." Later, he wandered to the old studio piano. Just goofing, he sat down and ran his fingers across the keys.

"Everybody ought to play a piano," Elvis said.

"We got to laughing, joking, jamming," says Jerry Lee. He and Carl joined Elvis at the piano, and with Elvis playing somewhat less than expertly, started singing a hodgepodge of whatever came to mind. Perkins's band joined in, one by one, and no one noticed, at first, that Phillips was no longer in the room. He had darted into the control room to put on a tape, telling Jack Clement that such a moment might never happen again, then dashed to the office and made two fast phone calls, one to Johnny Cash, asking him if he would mind getting in his car and get down here *right now*, and one to Bob Johnson, a columnist at the *Memphis Press-Scimitar*. Johnson arrived in just minutes, with a wire service reporter and a photographer, George Pierce. Meanwhile, Elvis was singing a half-joking imitation of Hank Snow. The boys did some Chuck Berry, who they all pretty much thought was a genius, singing "Brown Eyed Handsome Man" or at least as much of it as they could remember among them. It would become one of those rare days in the history of American music, trumpeted by Sam Phillips as a purely ac-

cidental, spontaneous gathering of four of the true greats in the early
history of rock and roll, even though the truth was that he had ginned
it all up himself, sensing its potential, manipulating the proceedings,
arranging to have it all covered and photographed and, of course, re-
corded. But it didn't matter. It was a good day, just the same.

The columnist Johnson would later write that he had never seen the
hometown star more relaxed or more likable. Elvis told them all a story
about a singer in Vegas who put him to shame: "There was this guy in
Las Vegas. Billy Ward and His Dominoes . . . doing this thing on me,
'Don't Be Cruel.' He tried so hard until he got much better, boy, much
better than that record of mine." When voices chimed in to protest, he
said, "No, no, wait, wait, wait, now. . . . He was real slender. He was a
colored guy." (It was Jackie Wilson, one of the Dominoes, though that
meant nothing to them at the time.) And after getting someone to re-
mind him of the proper key, he gave a demonstration for Sam and Carl
and Jerry Lee and everyone else in that little room—sang it not like
himself but like that other singer, pretending to be him.

> *If you can't come around*
> *At least please . . . tel-e-phone!*

"Tel-E-phone," Elvis said, to laughter. "He was hittin' it, boy.
Grabbed that microphone and on that last note he went all the way
down to the *floor*, man. . . . I went back four nights straight. Man, he
sung the hell out of that song. I was under the table. 'Get him off! Get
him off!' "

Johnny Cash arrived, saying he was just happening by on the way to
do some Christmas shopping, and the four of them—or at least three;
there is some debate about how long Johnny stayed—harmonized on
some songs from home and church. Elvis was playing piano, Jerry Lee
standing beside him, aching to play it. "But we blended pretty good,"
says Jerry Lee. "I knew there was something special going on here.

But me and Elvis just kind of took over. . . . Johnny didn't know the words, him being a Baptist," and Carl wasn't much better. "But they done pretty good, I guess, for Baptists." As they sang, a photographer snapped one iconic photograph of the four young men. "Elvis's girl kept trying to get in the picture," recalls Jerry Lee. "That's when I noticed that she's not even looking at Elvis. She's looking at me."

Finally, Jerry Lee sat down at the piano beside Elvis, and started to play.

Elvis shook his head. "Looks to me like the wrong feller's been sittin' at this piano," he said.

"Well," Jerry Lee said, "I been wanting to tell you that. Scoot over!"

Elvis made a little more room, but did not get up.

They started to harmonize on old songs, like the song Jerry Lee had loved since childhood, "I Shall Not Be Moved." Elvis or Carl would sing a line and Jerry Lee would echo it, call-and-response style:

> *Well, Lordy, I shall not be*
> *(I shall not be moved)*
> *I shall not be*
> *(Well, I shall not be—mmmm . . .)*
> *Just like a tree that's growing in the meadow*
> *(down by the water!)*
> *I shall not be moved*
> *(Yeeeeahhhh . . .)*

Jerry Lee was not bashful or deferential; by the end of the song he had taken the lead, exuberant with the thrill of the moment. They went on to do "Just a Little Talk with Jesus," and "Walk That Lonesome Valley," and "Farther Along." The reporter, Johnson, who had failed to notice Phillips and Clement changing the thirty-minute tape in the control room, expressed the obvious: "If Sam Phillips had been on his toes," he wrote, "he'd have turned the recorder on when that very un-

rehearsed but talented bunch got to cutting up. That quartet could sell a million," and that is how Elvis's visit came to be known as the Million Dollar Quartet session.

In one of the breaks between songs, Johnson asked Elvis what he thought of Jerry Lee.

"That boy can go," Elvis replied. "I think he has a great future ahead of him. He has a different style, and the way he plays piano just gets inside me."

"He was nice to me," says Jerry Lee now. "I was impressed."

Word trickled out onto Union Avenue that something special was going on at Sun, and people came by all afternoon, joining in, fading out. After an hour or so, Johnny Cash left to go shopping with his wife, without ever getting on tape, and Carl drifted away a little later.

Soon it was just him and Elvis there on the piano bench, "singing all them songs we had sung as little boys," even the ones they'd learned from the picture show, when Gene Autry was the biggest thing around. Jerry Lee would play a memory, and Elvis would join in or just listen:

> *You're the only star in my blue heaven,*
> *And you're shining just for me.*

"That's why I hate to get started in these jam sessions," Elvis told Jerry Lee. "I'm always the last to leave."

Jerry Lee was in no hurry either. He ran through both sides of his first record, "Crazy Arms" and "End of the Road," and improvised a little boogie that someone would later label "Black Bottom Stomp," though they could have called it anything and been right.

"Jerry Lee, it was good to have met you," Elvis finally told him. "You got to come out to the house."

Jerry said he would do that, and for just a second the two young men just looked at each other. Maybe it was nothing, but Jerry Lee saw the

future in it, or at least what might come to be. "Sometimes I think he was a little afraid of me," says Jerry Lee. "I mean, he was number one. He was sitting right in the throne I was headed for. And I thought, I might have to go through him. I think he knew that, somehow. And I did a pretty good job going through him."

It would have been against his nature to walk away from that day feeling any other way.

"I'm a Lewis," he said, repeating a mantra he returns to often, "and if you want something, you take it. You can ask for it first, but you take it."

"It was comin' together," says Jerry Lee. "I sang in the clubs and cut my records. I cut 'em like I felt 'em. And it was all comin' together the way it was supposed to. There was some hard work still I had to do. Sure I did. But I think all of 'em—Beethoven, and Brahms, and all of 'em—felt it when it was comin' together."

Billboard, in its reviews of new country music, seemed to agree, calling his new "Crazy Arms" single "exceptionally strong" and "flavor-packed," with "a powerful feeling for country blues." The song he wrote himself, "End of the Road," was "another honey, right in the rhythm groove and abetted by the same piano beat. Distinctly smart wax." It is a senseless thing to ask him if he is ever surprised by any of it. He finds such a thing to be a questioning of his abilities, and mildly insulting. "Yeah, I thought it would happen. I think I always knew it would happen. That was my goal, to be on top of the world."

The day the *Billboard* review came out, just before Christmas, Jerry Lee sauntered over to Sun to see Sam Phillips. He had a good car, and some good rock-and-roll clothes to play in, but no big money yet. He had no intention of letting another Christmas pass him by as a poor man. "I just wanted to show my family a nice Christmas," he says.

"Sally," he told the secretary, "I need to talk to Sam."

"What about?" she asked.

"I need to borrow three hundred dollars," he said.

"No, no," she said. "Don't do that. He'll have a heart attack."

"Sam was tight as bark on a tree," recalls Jerry Lee.

He finally cornered the man in his office. "I think you can afford to loan me three hundred dollars," he told him, "so I can go home for Christmas."

Phillips looked at him a moment and nodded his head. He would later say he understood Jerry Lee better than most people. But he certainly knew, if you promise a boy like Jerry Lee you are going to make him a star, you had better do it quickly or at least be willing to advance him $300 on the future you predicted. "Sam knew," says Jerry Lee. "He knew I was a money-making venture."

With that piddling amount of money, Sam Phillips bought a little patience from a consummately impatient man, not just then but for years and years to come. In that moment, $300 meant the world to Jerry Lee. He could take it and show his mama and daddy and his people that he had hit the big time at last. The money to come, checks with so many zeroes he could barely comprehend, would, in an odd sort of way, mean less.

He drove home the hero, with Dewey Phillips shouting in his ear and spinning his record.

"Did I turn it up?" he says. "Of course I did."

The car rode low on its springs down 61, from all that Christmas shopping. "I spent one hundred and fifty dollars just on groceries, on turkeys, on all kinds of stuff. I bought presents. I bought the girls something pretty. I bought Daddy something, and Mama. Mama was glad to see me." The family drew names to buy each other presents, but it was rock-and-roll money that bought them. His mama took a breath, for the first time in a long time where her boy was concerned. He was somebody, and he had proved it. He was earning a living—not in a tabernacle, but not in Sodom, either—and so she took a breath. She could live with auditoriums, with VFWs, and American Legions, much easier

than she could live with beer joints and honky-tonks. Her boy had sung with Elvis, and showed him how to play a piano, properly.

His daddy shook his hand and held it.

"I never was the man you are. I only wanted to be," he told his son.

Jerry Lee just looked away. "No, Daddy, I never will be the man you are."

Decades later, as he talks of dirty dealings and unreleased records and unpaid royalties, he is disarmed a bit by the memory of that measly wad of twenty-dollar bills pressed into his palm by a man he needed to trust.

He could spend money, but he had no interest in counting it. "It's expected," Jerry Lee says of the record business, "to be cheated a little bit."

Phillips failed him later, he believes, but he did not fail him then.

"December twenty-second, nineteen fifty-six," he says now, "the best investment in the history of rock and roll," with the possible exception of his daddy's purchase of a secondhand upright piano.

"I loved ol' Sam. He was my friend."

Years later, Sam Phillips would say that he and only he ever really understood Jerry Lee.

"I could look in that boy's eyes," he said, "and see his soul."

Jerry Lee discovered that much had happened while he was gone. Frankie Jean, who had turned twelve, was getting married. A few relatives said it was a bit early for the child to be wed, but others said it was nothing new, nothing even out of the ordinary in the family history or in the traditions and practices of the community, so the wedding was eventually blessed all around, and everyone went and had some turkey and cornbread dressing, and hot biscuits, and mashed potatoes running with butter, and when they prayed, they thanked God for the good fortune that had found their boy, who had sense enough to know that

if you're going to be hit by a train, you have to go stand on the tracks in Memphis, Tennessee. Amen.

In 1957, Elvis, with a two-year head start, was playing the last of three shows on his fifty-thousand-dollar Ed Sullivan contract. Jerry Lee went on the road, chasing, always chasing. Sometimes he played package tours in front of a few thousand paid customers; sometimes he played gigs not much bigger than the clubs he had played at home. He played auditoriums, true, but also played an electronics store, and a tomato festival, and in bars where the take-home was less than a hundred a night for the whole band. Success was coming, but it was taking its time. He played Little Rock, Monroe, Jackson, Odessa, Texas, and Sheffield, Alabama. In late spring he played the venerated Big D Jamboree in front of six thousand people in the Sportatorium in Dallas, playing with Sid King and the Five Strings. It was his biggest show so far, to a crowd mostly accustomed to Hank Snow, Webb Pierce, Janis Martin and the Marteens, and Leon Payne and His Lone Star Buddies. Billy Walker played there, wore a mask like the Lone Ranger and called himself the Traveling Texan. But radio station KRLD, with fifty thousand watts, carried the show live, and the CBS radio network broadcast it nationwide. Elvis had played here, as did Johnny and Carl and other, less traditional artists. He would be called back for another Saturday night, and then a third, and people reached out to grab his hand as he tried to leave the stage to tell him how ol' Ray Price didn't do that "Crazy Arms" nothin' like he did, how even Hank would have been proud to hear his music sung so well.

Between gigs, he returned again and again to the studio to find a follow-up record that could be his breakthrough hit. He tried old, old American standards, songs he had played as a child like "Silver Threads Among the Gold" and country ballads like "I'm Throwing Rice," "I Love You So Much It Hurts," and "I Love You Because."

He ran through a few country blues tunes, like "The Crawdad Song," "Deep Elem Blues," and Joe Turner's Kansas City rhythm-and-blues hit "Honey, Hush." He did the dark folk ballad "Goodnight, Irene," Western swing tunes like "Shame on You," and the R&B ballad "Tomorrow Night." He did "Dixie." He did the "Marines' Hymn." He went back to Gene Autry for "My Old Pal of Yesterday" and to Hank Williams for "I Can't Help It" and "Cold, Cold Heart." He even cut a couple of attempts at a theme song—a misfire called "Pumpin' Piano Rock," and a simpler, more powerful song he called the "Lewis Boogie":

> *It's called the Lewis Boogie—Lewis way.*
> *I do my little boogie-woogie every day.*

These were the first—or at least among the first—recordings in which he refers to himself in the lyrics, something he would do onstage and in the studio for half a century.

He would burn a few days in Memphis, and then head back out on the road. "I missed it," he says. That year, he played the Rebel Room in Osceola, Arkansas, a place with chicken wire across the stage to protect the band from flying beer bottles. The wire always offended him—"I didn't want nothin' between me and the audience"—but it was a place where bottles were prone to come winging at the singers' heads. The police came in twice that night, to quell riots and thwart attempted murder, and it was past midnight before the crowd, some too drunk to move, settled down even the slightest bit and actually listened.

Some say it was there in Osceola that it happened for the first time. Some say it was at another raggedy little bar over in Blytheville. Jerry Lee knows only what happened inside. He was getting a little sick of trying to sing to drunks who thought music was just a soundtrack for fighting or falling down or throwing up; sometimes he was not really, truly heard. That was when Jerry Lee uncorked his lightning and hit those bleary-eyed drunks and big-haired women right between the

eyes with a hot poker of rock and roll. He started rolling out that two-handed boogie intro he had heard in the Wagon Wheel years before, and snatched them up on their unsteady feet. He brought the women right up to the edge of the stage, breathing so hard their blouse buttons were hanging on for dear life. But it was different now. He was not some kid feeling his way through a song, like he'd been in the Wagon Wheel. He was a real live man.

Whose barn? What barn? My barn!

And when the song was over, the crowd screamed and screamed and demanded that they play it again. So they did, and then played it again. Jerry Lee looked back at J. W. Brown, who was playing bass for him on the road, and at his drummer, Russ Smith.

"Well, there it goes, J. W.," Jerry Lee said. "Think we got a hit?"

"Whole Lotta Shakin' Goin' On" remained his pocket ace, a live music phenomenon, a song people talked about from town to town and came to ask for, but it had no radio play to keep it alive. Jerry Lee, as proud as he was of "Crazy Arms," knew that his first record hadn't been the push he needed and would not carry him where he hungered to go, not onto national television and nationwide play on radio, not to Hollywood, not across the seas. "I just couldn't throw that knockout punch," he says.

So he went to Sam Phillips and pulled out his hole card, only to find that the poker players at Sun Records were suddenly playing checkers like tired old men. Suddenly, the label that had taken that flying leap into the unknown with Elvis Presley was too squeamish for real rock and roll. Jack Clement believed that Elvis had left no room for another Southern white boy singing and playing rebel rock and roll.

"He told me, 'Elvis done drove that into the ground and broke it off,'" recalls Jerry Lee.

Not only did Sam Phillips not much want to record it, he seemed

downright afraid of it. "Awwww, no, that's too vulgar, much too risqué. It'll never go. No way," Sam told Jerry Lee.

"It's a *hit record*," Jerry Lee argued.

Others say Sam must have had more enthusiasm for the song than that, though probably not as much as Jerry Lee. For Sam, good music was both passion and business—and, even if he loved it, this song was a business risk.

To hedge his bets, Phillips told Clement to write a new song for him, and the result was a song with perhaps the most ignoble beginnings any song could have. The story goes that Clement was in the bathroom, thinking about a breakup with his girlfriend and, for some reason, reincarnation, and how funny it would be if he came back as something floating in the bowl and if, when his girlfriend looked down, there he'd be, winking at her. He could not write that, of course, but it was inspiration:

> *If you see a head a-peepin' from a crawdad hole,*
> *If you see somebody climbin' up a telephone pole—it'll be me!*

This was the song Sun Records picked as the A side of Jerry Lee's next recording, the song Sam picked to propel him into stardom. Jerry Lee went back into the studio, and gave it all he had.

He knew, heartsick, it would never fly. "I said, 'Awww, that'll never be a hit, by itself.' "

Jerry knew he had to take a stand. He made it clear that he intended on recording "Shakin' " *somewhere*, and Phillips finally agreed to make it the B side of "It'll Be Me." Phillips would say later that he did it only to placate Jerry Lee, who knew what he wanted even before he had any real clout. He took a few early stabs at recording "Shakin' " in the studio, but they were dry runs at best, never capturing the spirit of the live shows; it was hard to know whether that was even possible.

It was sometime in February 1957 when Jerry Lee finally went back

into the studio with Roland Janes and Jimmy Van Eaton to try it again. They had done five passable takes of "It'll Be Me" when Clement put on enough tape for just one take of the Shakin' song. Phillips had told him not to waste a great deal of time on it, and time was money. This time, Jerry Lee pumped the piano the way he remembered it from the Wagon Wheel, and Janes infused the record with his high, keening guitar, unleashing licks and fills that would be copied by other guitarists for decades. That day, in the studio that had given birth to the sound of Elvis, to "Blue Suede Shoes" and "I Walk the Line" and so much more, Jerry Lee ignored the acoustic tiles and the glass window and the machines and sang it like he would have done it for real people, like he sang it in an Arkansas beer joint and a tight little auditorium in Billings, Montana, and he played it wild and rough and perfect enough. And when he was done, exactly two minutes and fifty-two seconds later, the three young men in the studio just sat there, kind of still, because every one of them *knew*.

"One take . . . and silence," recalls Jerry Lee. "It never had been silent in there before."

And that was that. "Well, then we went over to Miss Taylor's Restaurant—it was right close by—and had some country fried steak and rice and gravy and some turnip greens." Later, Clement would say that the people who came by the studio almost wore out the tape, listening to it, the only tape of the only take. "Only time I did a song that way," says Jerry Lee, as if there was some fate in it, or maybe even the hand of God, after all.

Sam Phillips listened to it and liked the song—it was hard not to like the song—but it did not matter that he liked it as a piece of music, any more than a man who bets on horses can make a living off a horse that only runs across a potato field. "The disc jockeys will not play it," he said, so how would they ever get anyone to hear it? "It'll bomb. 'It'll Be Me' will be the record.'"

Forget television, he said. With visuals, it was even worse.

"That was the problem, see," says Jerry Lee, "when I would sing . . .

All you gotta do, honey, is stand that thing in one little ol' spot
An' wiggle it around just a little bit.

". . . I'd take my index finger and point it in the air, and wiggle it."

To demonstrate, he sticks that finger in the air and rotates it around and around. Without the music, it looks precisely like what it is, what the twenty-one-year-old boy wanted it to look like for all those crazed fans. It did not matter that no one could actually see him do it on the record, if the song made it onto the radio or a jukebox. When he sang it, you could imagine it just fine, and some of the young women, well, could almost feel it.

When Elvis shook his leg, preachers throughout the land may have pretended it was the end of civilization as they knew it, but the sky did not fall, and the Mississippi did not run backward. Jerry Lee intended to follow suit. With his sure-thing hit record on tape but not yet in stores, not on the air, Jerry Lee took to the road again, to play it loud in one auditorium and VFW after another. He did not need to polish the song—that would be like stroking a mean cat—but he needed to get the people talking, get them all whipped up from the Great Lakes to the Gulf of Mexico. Then maybe, even if the police did storm the stage or blockade the convention halls, the disc jockeys would notice, and he would live on the air next to Elvis, or beyond him.

He did not know where he was, precisely, just somewhere in Canada. The caravan thundered down highways that were barely there, the roadbed eaten by permafrost, the gravel flying like buckshot against the bottoms of the big cars. There was a long Lincoln Continental, a Fleetwood Cadillac, a mean-looking Hudson Hornet, and a brand-new Buick Supreme; it was new for only a thousand miles or so, till the

potholes got it. The big sedans might have been different colors, once, but now they were all a uniform gray, the color of the blowing dust. Jerry Lee rode in the passenger seat of the Buick, sick of this great distance between crowds and applause, six hundred, seven hundred miles a day. "I didn't drive. . . . I was paid to play piano and sing. Stars don't drive." Instead, he read *Superman*, or used a cigarette lighter to fire up one cherry bomb after another and flung them out the half window to explode under the trailing cars.

"That first tour was me, Johnny, and Carl, and Sonny James, Marvin Rainwater, Wanda Jackson. We put eighty, ninety thousand miles on that Buick, across Canada, across everywhere . . . throwing cherry bombs the whole way." Sometimes he missed high and the cherry bombs exploded against windshields or on the hoods, and Johnny and Carl would curse him mightily, curse unheard, but one time he misjudged and the cherry bomb bounced off a window frame and into J. W.'s lap, and J. W.'s screams echoed inside the Buick for a good long while, longer than was seemly for a man. They could have used a chaperone, all of them, or a warden. The lead car was jammed with drum kits, guitar cases, and sharp-cut jackets and two-tone shoes. The only other provisions they packed were whiskey, cherry bombs, and comic books.

He cannot really remember all the little cities and towns they traveled through, not even the names on the road signs, only the vast, empty spaces in between. They would go two hundred miles or more and not see a café or a motel. "We'd stop at a store and get some Vienna sausages and bologna and bread and pickles and mustard, and pull over to the side of the road and have a picnic. . . . Calgary, that was one of the places. Quebec. They went crazy in Quebec. Pulled their dresses up."

To the owners of the motels and truck stops, it must have seemed like the lunatics had wandered off the path, had stolen some good cars, and were terrorizing the countryside. "Johnny came in my room and saw this little bitty television in there, and he said, 'You know, my wife's

always wanted one of them.' And I told him, 'Fine, go steal one from your own room.'" And it went that way, eight hundred, nine hundred miles a day, half drunk, pill crazy, larcenous, and destructive and beset by loose women and fits of temper, and it was perfect.

"We had some good fights," says Jerry Lee. "A good fight just cleared the air."

Carl Perkins and Johnny Cash had begun the tour as headliners. They were still the big names at Sun then and, Sam Phillips believed, his best moneymaking ventures. The problem was this newcomer, this blond-haired kid, who did not know his place and had no governor on his mouth, and in such close proximity, they could not tune him out and could not run away and could not kill him, either, though they considered it. He even had the gall to suggest, as the days wore on, he should close the shows, him with just two records cut and shipped and not even one yet on the charts. Who, they wondered aloud, did that Louisiana pissant think he was?

They were starting to call the music "rockabilly" now, but the kid refused to label himself as that, to endorse any kinship with that hillbilly-heavy blues that sold so well in any town with a tractor dealership on its main drag. To Jerry Lee, the word was denigrating, something imposed on these country boys and their music by the outside world. "I wasn't no rockabilly," he says, "I was rock and *roll*." Carl was pure rockabilly— "Blue Suede Shoes" was the music's anthem—and Johnny, the story-teller, was more country than most young rock and rollers aspired to be, though his "Get Rhythm" rocked out good and strong, as Jerry Lee recalls. The audience loved all of it, bought tickets by the handful and just moved to it, man, because it made old, traditional country music seem like the record player was too slow, and in town after town they lined up, hungry. But increasingly, as his stage presence swelled and swelled, it was Jerry Lee who created the excitement, who got them dancing, and so he demanded more and more of the spotlight. It was, he believed, only his due.

More than one music fan, more than one historian of rock and roll, have wished for a time machine, just so they could travel back to this one time, this one tour, to wedge into those packed auditoriums on the vast plains and in the Canadian Rockies, to see it all happen the way it did, to see Jerry Lee Lewis and Johnny Cash and Carl Perkins, young and raw and wild, singing into big Art Deco microphones that looked like something that shook loose off the hood of an Oldsmobile, on stages scarred by a million metal folding chairs, in auditoriums where next week the featured attraction would be a high school production of *The Merchant of Venice*.

"And now, ladies and gentlemen, from Maud, Oklahoma, it's the Queen of Rockabilly, Wanda . . ." And before the announcer could even get it out, the crowd was hollering and hooting—with here and there a wolf whistle or two—as Wanda Jackson came out from the wings in high, high heels, hips swinging free and easy like she walked that way going to the mailbox. She had not a made a sound yet, and already the loggers, drillers, and insurance men were beginning to sweat. This was no cowgirl. Her dresses were fringed, to accentuate her flying hips, and low-cut, to accentuate something else, and her legs were slim and perfect and her waist was so tiny a big man could encircle it with his two big hands. Her big hair was dark brown and flowing, and her big eyes were framed by a starlet's arched eyebrows; she was a goddess with a voice like a beast, and she growled as she sang that a hardheaded woman is a thorn in the side of a man.

That was hard to follow. But here came Sonny James of Hackleburg, Alabama, striding out in his Western suit, a thin, dark-haired man who had survived the Korean War, singing a love song of the ages. "Young Love" was the song, and it wasn't the words that made it lovely but how he did it, like smoke on velvet.

Next came that good-looking Marvin Rainwater, who wore a fringed

buckskin shirt and a headband onstage, because he was one-quarter Cherokee. He sang in deep baritone about how he was "gonna find him a bluebird, let it sing all night long." He was a mellow singer, a ballad-eer, and smoothed out the crowd before the real headliners came on, the boys from the land of the rising Sun.

First came Carl Perkins, in his too-tight pants and pointy sideburns, and he let it rip:

> Well, it's one for the money
> Two for the show . . .

Through force of will, Jerry Lee had climbed up the bill and over and straight through Carl, till now there was only Johnny Cash, in his elegant, somber black, hovering just above him on the marquee. That night, there had been the usual argument over who would close the show. Johnny, with the bigger name and a song on the charts, had the promoters on his side: he got top billing, which meant he had to follow Jerry Lee. But first Jerry Lee had to surrender the stage.

The stage had become a kind of laboratory for Jerry Lee, and he was the mad scientist. Onstage he mixed and matched songs and versions of songs, stitched together some parts and discarded others; because he was Jerry Lee, he did what he felt like in the moment, in a set that was supposed to be four or so songs, but he ignored that, too. He gave them "Crazy Arms" one minute and "Big-Legged Woman" the next, and they clapped to one and stomped and howled to the other. His show got wilder and increasingly wicked on that tour, and the audiences bellowed for encores. He had heard that Canadians were earnest, reserved people, but he must have heard wrong. More and more he was beginning to un-derstand that, while the music was at the core, that was just the start of it. Putting on a show was like flipping the switch on Frankenstein's monster, then watching it show the first twitching signs of life. "You got to dress right, act right, carry yourself right; it all had to come together."

The good-looking part, well, God had handled that. But you had to use it. His hair, by now, had become almost like another instrument. Under the lights, it really did shine like burnished gold, and at the beginning of a show it was oiled down and slicked back, and he looked respectable, like a tricked-out frat boy or preacher's kid. But on the rocking songs, he slung his head around like a wild man, and that hair came unbound; it hung down across his face, and that just did something to the women—and their screams did something to the crowd, and things just got kind of squirrely. As it came unbound, the waves turned into tangled curls and ringlets, and it seemed to have a life of its own, a wicked thing, like Medusa herself. Sometimes he would whip out a comb onstage and try to comb it back under control, but it was too wild to tame. "I was the first one in rock and roll to have long hair," he says, thinking back to that night, "and I *did* shake it."

These were the biggest crowds he had seen or heard, and he can see and hear them still.

"More!"

"More!"

"More!"

He did one encore, then two, and at the end he did "Shakin'," in pandemonium.

"They wouldn't let me off the stage."

By the time he finished, the people were out of their seats and the constables were looking antsy. Jerry Lee swaggered off the stage, one arm held stiffly in the air, a salute more than a wave. "And I left 'em wondering who that wild boy was."

Johnny Cash stood there, sweating and almost white, as the crowd screamed for more. As Jerry Lee remembers it, "he was like a statue. He never said a word."

In the auditorium, a woman had fainted in the aisle.

Jerry Lee walked right on by Johnny. "Nobody follows the Killer," he said over his shoulder.

The crowd was still yelling "Jerry Lee! Jerry Lee!" as Johnny came out onstage.

They quieted, respectfully, as he sang "I Walk the Line."

I keep a close watch on this heart of mine.
I keep my eyes wide open all the time.

They loved Johnny in Canada, but it was like a lull after the storm. "Johnny wouldn't follow me after that, said he wouldn't never follow me again," says Jerry Lee. "He said, 'When he's through, it's done.' Can't *nobody* follow me." That night, after the show, the girls came by not one or two at a time but in a crowd. "It was unavoidable, too," says Jerry Lee. "The girls come by in the evening, even before the shows sometimes, when the sun went down. And I just told 'em to go on," and then he smiles at that, at even the possibility of such a thing happening, of his sending away a beautiful girl.

"My gosh, what a time."

Some legends begin like that, in great drama, and others are purely accidental. Somewhere on the road, in another place he cannot really recall, he got sick and tired of playing sitting down while everybody else in the place was on their feet, so he just rose up to play standing. He loved the piano, but it did anchor a man and give him feet of clay. But as he rose, the piano bench was in the way. "So I decided I would just take the heel of my boot and push the piano bench back just a little bit, to make some room, but my boot got caught and I gave the bench a flip across the stage, and man, it tore that audience up. And I said, 'Well, so this is what they want.'" If they liked it when he just tumped it over, what would they do if he hauled off and kicked it across the stage? So he did, and they howled and hooted and the women screamed, so he had to do it every time now, every blessed time.

"Oh, yeah," says Jerry Lee, "I was a little bit out of control."

Performers came and went on the tour, but Jerry Lee spent most

of his time with Johnny and Carl despite the tension between him and the other two. It seems almost sweet now, to think of them as a fraternity of young men playing jokes and scuffling in the dirt and acting like spoiled children on the road, as they hammered out their craft. But the road was a good bit darker than that. Everyone was addicted to something. Carl drank hard, most nights and some days, and Johnny was hopelessly hooked on pills, always talking about deep things like man's inhumanity to man, and prisons, and whether or not pigs could see the wind. And there was Jerry Lee, flying high on all of it and running hot.

"I liked Carl," says Jerry Lee. "He became my friend. He was a great talent. He could sing, had a real good voice, and he could play that guitar. He could play *all over* that guitar." His feelings about Cash are more complicated. "Johnny, well, I just didn't think he could sing. Wrote some real good songs . . . but let's just say he wasn't no troubadour." He and Cash would be friends off and on and even record together as older men, but in the cold northern spring of '57, the man in black was one more obstacle in his way.

Oddly enough, when things finally boiled over, it was not Cash he had to fight. One night, in a town he cannot really recall, he and Carl Perkins sat in some lounge chairs outside a small motel, just cooling it in the chill air. Springtime temperatures in the Canadian mountains were about zero some days, but they hated being cooped up in the tiny hotel rooms. At some point in the evening, there had been a quart bottle of brown liquor in their proximity, but no one could remember exactly where it went.

"Carl was pretty well drunk," recalls Jerry Lee, "and I was just drinking, a little bit."

That night, Perkins was wearing a fancy shirt from Lansky's in Memphis, where Elvis got his clothes. "Does this shirt look good?" he asked Jerry Lee.

Jerry Lee did not care if Carl was wearing a burlap sack tied together

with fishing line. He only cared what *he* looked like, and he knew he would be elegant standing in a mudhole.

"Don't I look good?" Carl asked.

Jerry Lee felt like spitting. He snarled, "You an' Elvis, always walking around in these fancy clothes, always worried about how you look . . ."

Jerry Lee may have been slightly more drunk than he recalled. "Carl come out of that chair ready to fight, and the next thing I knew we were fighting across the trunk of that Buick." It was not, he says now, an epic battle. "I wasn't throwing no good punches, and Carl wasn't, either." He does remember getting in one good backhand, and then it was over, and they were friends again, but the jealousy would continue. "It was unavoidable. I would get encores in front of twelve thousand people, two encores, three encores. . . . They knew. They knew, even then, they were seeing the greatest thing."

He played one stage that was built on a giant turntable that spun slowly around as he played. "I didn't like that. I liked to stay in one spot, so I could keep my eye on certain people." He would lose sight of a pretty girl, he said, if he was spinning, spinning. "And then I just had to get my eye on 'em all over again. I could always spot my girl then. Wasn't no problem, finding a beautiful girl. *Look*, I'd say to myself, *there's a couple*. I'd say, *Look, there in the third row.*" In Quebec, he almost fell in love. "They pulled them dresses up, and I hollered, 'Pull it up a little bit higher, baby,' and they did. Man, they just laid it on you. And they kept on just layin' it on you, night after night, city after city."

He was still married, of course, to the volatile Jane, who was still in Ferriday with his son and his parents' family, but the truth is that he tried not to think about her that much, anymore. It had been a marriage of necessity, and it seemed less necessary two thousand miles away. "I was living the dream," he said, even if the reality it was based on was, for the time being, more than a little thin.

They drove on for nearly two months, doubling back for even more shows in more remote places, wide-open during the day, wide-open at night, smelling of sweat and whiskey and gunpowder. He was off his leash completely now and, it seemed to some people, almost a little out of his mind. He had taken to playing the piano sometimes with his feet, his size 9½ loafers, and the crowd roared for that, too. "I played it with my feet, in key. It can be done, if you know what you're doing. It wasn't just no stunt. I *played* it." He was showing off and showing people up, and the crowd was in love with all of it, and by late spring his lightning was bouncing around the airwaves, just weaker and more distant than he would have preferred.

The musicians who played with him remember any encounter with him as a kind of validation, a kind of certificate of authenticity. Guitarist Buzz Cason would later write how he walked out of a theater in Richmond and saw Jerry Lee, the great Roland Janes, and Russ Smith, his pint-size touring drummer, dancing after a show on the roof of a '58 Buick, just dancing, because the time onstage was never quite long enough. He remembers traveling with Jerry Lee to Buffalo, and that Jerry Lee wanted to make a side trip to Niagara Falls. He stood on a wall overlooking the great cascade, his blond hair whipping in the wind, and stared down into the abyss for maybe thirty seconds, then jumped to the ground. "Jerry Lee Lewis has seen the Niag-uh Falls. Now let's go home, boys."

Once on a swing through Texas, he saw two singular-looking individuals sitting at a table in a big nightclub. One was his onetime piano hero, Moon Mullican. The other was the homely but melodic Roy Orbison, another Sun artist. "It was in Odessa, Roy Orbison's hometown. Roy, his point was, he wanted to borrow fifty dollars from me, so he could get out of that town. . . . He said he knew he could cut a hit record if he could ever get out of that town. And I said, 'Well, I'll be glad to loan you fifty dollars.'" Orbison quickly grew jealous of Jerry Lee at Sun, believing that Sam Phillips was devoting too much of the label's

energy to one man. It wouldn't be the last time that happened. "He got a little upset," says Jerry Lee, but at least he got out of Odessa.

"Whole Lotta Shakin' Goin' On" was finally on the radio, not just in Memphis but nationwide, and according to *Billboard*, "taking off like wildfire" in country, rhythm and blues, and pop. By the time he got back to the South, it had become a constant on Memphis radio. "They were playin' it in all the hamburger joints," he says, and he would ride down the streets of Memphis in his red Cadillac with the top down and hear his own genius wash all around him and into the almost liquid air that is Memphis in summer. Sometimes he'd take his cousin Myra, who made goo-goo eyes at him under her dark-brown bangs.

Earlier that year, Elvis had reported to Kennedy Veterans Hospital in Memphis for a preinduction physical to see if he was fit to serve his country if he was drafted, though of course there was no war anymore, and surely they wouldn't take the monarch of rock and roll. He went straight from there to catch a train to New York for his final appearance on *The Ed Sullivan Show*, where the cameramen were directed to show him only from the waist up. Knowing that some Americans still were scandalized by his lewd behavior, Sullivan took Elvis by the arm, looked directly into the eye of the camera and the conscience of the nation, and called Elvis "a real decent, fine boy." Then Elvis left for home, where Colonel Tom Parker, his manager, presented him with a suit made of gold lamé, but Elvis kept dropping to his knees onstage and wearing off the gold, which was expensive, so Parker told him not to do that no more. Elvis stopped wearing the pants. He went out to Hollywood and made four movies in two years, one called *Jailhouse Rock*, and recorded more songs in a Hollywood studio than he could even remember. When he came home to Memphis, he moved his mama and daddy into a white mansion called Graceland, which had walls and high gates to keep out the fans who had taken to sleeping on his mama's lawn back on Audubon Avenue. Chuck

Berry, who had been there at the beginning of everything, had written the Bible of rock and roll almost single-handed, but by the spring of '57, the white boy from a shotgun house in Tupelo had ascended high above everyone else in music, so that when people thought of rock and roll, they thought of him and only him.

Some have suggested that there was malice in Jerry Lee's heart where Elvis was concerned, but there was none, not then especially. He would say, well into old age, that he worshipped Elvis as a teenager and as a young man had become his friend. But it would be a lie to say he did not want what Elvis had, and there would be nothing sneaky or underhanded about him when he came for it.

Elvis had many friends but few, Jerry Lee says, whom he had not bought and paid for, fewer he could truly identify with. In those early years, they became close friends. He played the piano for hours—Elvis liked to hear the gospel standards, mostly—and it has been rumored that they caroused around Memphis in those days in various stages of craziness. They both owned big Harley motorcycles and tooled around town side by side. The most outrageous story was that he and Elvis once went riding around town buck naked, a story Jerry Lee refuses to confirm—or deny.

"I knew you's goin' to say that," he says now. "I'd just rather not get into that. I don't think Elvis would appreciate that," and he laughs. "And he's not here to defend himself."

One day, soon after he released a blistering remake of one of Elvis's movie songs, "Mean Woman Blues," he ran into Elvis on the streets of Memphis—almost literally.

"He had a black Eldorado, a fifty-six. I had a white Eldorado, fifty-six. I was comin' up to Sun Records and he was comin' down the street." Suddenly Elvis swerved into his lane. "He was goin' to hit me head-on. And I stopped, and I said, 'What the hell are you doin', boy?'"

"I'm gon' sue you."

"For what?"

"For 'Mean Woman Blues.' "

He laughs about it now. "Them were good days. He didn't have a jealous bone in his body. With me, he didn't."

On a trip home to Concordia Parish, the blond-haired boy had received a notice much like the one Elvis had, telling him to report for his medical exam. "It said on it I was to report to my recruiting officer," said Jerry Lee. "I wadded it up and threw it in the Black River." Then he got back in his Cadillac and screamed up Highway 61 toward Memphis. There, in his V8 chariot, he circled and circled the throne with his hit song, his lightning, like a javelin in his hand, and waited for the power in it to build and build, to crackle and spit deadly fire, waited till the King turned to face him man to man, because when he took his crown, he wanted him to know who was taking it.

He did not need a song to make him inappropriate. Jerry Lee had always been inappropriate, and being a little bit famous did not change it; you can paint a barn white a thousand times, but that won't make it a house. It wasn't just what words he sang; it was *how*. Anybody can sing about sinning, but when he sang, it sounded like he knew what he was talking about and would show you if he had a minute. Pat Boone did Little Richard's "Tutti Frutti" and incited not one riot, even among the Presbyterians.

"Them days are gone, have disappeared," says Jerry Lee, "but I had a *real* good time."

For a thin slice of spring and summer, he and his hit song smoked across the airwaves, first in Memphis but spreading fast across the country, and Dewey Phillips even had him on *Red, Hot & Blue*, talking like the words were burning his mouth. "Whole Lotta Shakin' Goin' On" sold more than one hundred thousand records by midsummer, five thousand in a single day.

And teenage kids weren't the only ones who noticed the new talent. So did songwriters.

"Fella named Otis Blackwell, fella said he wrote songs, said he wanted to write me a song, and he'd write Elvis a song, then write me a song," said Jerry Lee. Blackwell, a black songwriter from New York, was a hot ticket—the man who wrote "Don't Be Cruel" and "All Shook Up" for Elvis.

"'Surely you ain't a white boy,' he said to me, the first time he ever saw me, and I said to him, 'Why, yes, sir, I am white.'"

That alone worried people a great deal. Elvis had fooled them for a while, had them guessing, and when they found out he was a white man, some of the moral gatekeepers cried blasphemy, and when their daughters wept and screamed and drooled over him, the preachers and politicians railed anew against rock and roll. When Elvis went on *The Steve Allen Show*, the producers put him in a tuxedo, then had him sing "Hound Dog" to a trembling, unhappy basset hound. But Elvis, being a good boy, petted it and even smooched the dog a time or two, and young Jerry Lee watched it all with that half snarl, thinking to himself, *If y'all think that's dangerous, wait till you get a load o' me.*

He had been dangerous before, but now, with a hit, he was armed. "'Whole Lotta Shakin'' was on its way to the moon," says Jerry Lee. "From that first time I heard it, I knew it was more than just a good record. I knew it was unstoppable. I just knew it. Wasn't nothin' they could do to stop it."

"And then they banned it."

Sam Phillips sat behind the cold glass at Sun, morosely correct. It had to happen. Banning rock-and-roll records had become almost a national sport, from Boston to Biloxi, a kind of chicken-and-egg game among pandering politicians, rock-ribbed preachers, advertisers, government regulatory agencies, and radio station owners, and history was not on Jerry Lee's side. They all fed on each other, growing larger and louder, not just in the so-called backward South but even in the Northeast, as if the whole country had taken on the guise of a crew-cut daddy

slipping off his belt as he entered the room of his teenager, saying, "You will not play that nigger music in my house."

In 1954, a Michigan congresswoman had introduced a House bill to prohibit the mailing of any "pornographic" recording, like rock and roll. In Memphis, police confiscated the Drifters' "Honey Love" before it could be loaded into jukeboxes. In 1955, in Mobile, WABB received fifteen thousand letters of complaint about dirty records. In Bridgeport, Connecticut, police canceled a performance by Fats Domino at the Ritz Ballroom, afraid that dancing might escalate into a riot. In '56, ABC radio refused to play a recording of "Love for Sale," a twenty-five-year-old Cole Porter song about prostitution, by Billie Holiday, a forty-year-old jazz singer. In Ohio, dancing to rock-and-roll records in public was outlawed for anyone under eighteen, while in New York, an executive at Columbia Records hosted a program on CBS to discuss with psychiatrists the negative effects of rock-and-roll music on the teenage mind. In '57, Cardinal Stritch of the Chicago Archdiocese banned all rock and roll from Catholic schools, fearing the effect of its rhythms on teenagers. Radio stations even banned Elvis's version of "White Christmas," based on the Drifters' recent R&B version.

If they could ban "White Christmas" just because it was sung to a mild form of rock and roll, how could they fail to ban this new "Shakin'" song by a young white singer who didn't just *hint* that the listeners ought to shake something, but told them to—told them to shake "it," in particular, and while he did not say exactly what "it" was, it would take a very sheltered youth minister not to guess it in three or four tries. The preachers and the politicians heaped all their disgust and disdain and fear of rock and roll on this one song; some even claimed he cussed in the lyric, said the word *hell*, though that was just the way he sang it. The most hurtful thing was that his record even fell out of favor close to home, as Southern stations pulled it from playlists. Sales went stagnant, and the great arc of his rising star began, for just a moment, to slow.

"I's just trying to make a record," says Jerry Lee, innocently, but he was all bound up in the greater story—the just-begun challenge to Jim Crow in the Deep South, which loosed up the fears white folks had over their doomed ideal, and the beginnings of an unbuttoning of sexual mores, and all the rest of it. In Memphis, where the fires of rock and roll had once smoldered underneath Elvis's twitching leg, the great threat now had a new name and a new snarling face, as politicians and preachers shouted this name and its crimes to the rafters, "and they didn't know nothin' about me," says Jerry Lee. Young people were instructed to smash their Jerry Lee records and then go pray hard. Radio stations that had played the song two or three times an hour, sometimes two or three times back-to-back, pulled it from playlists, and thousands of records stacked up in Sam Phillips's storeroom, unsold.

Things looked so bleak so quick that Sam reached out to his older brother, Jud, for help. Jud was pushing used cars down in Florence, Alabama, at the moment, but he had worked in the music business before. A born promoter and salesman, he had ties to disc jockeys and television producers around the country, and when he arrived in Memphis that summer, it was to serve as a kind of vaguely defined marketing director with only one real project: Jerry Lee.

Jud Phillips understood human nature and appetite, says Jerry Lee. And it had little to do with taste or even reality. You could tell people anything, and if you yelled it loud enough, they would believe it. As evidence, there was the city's love affair with wrestling. That year, Farmer Jones, using an Arkansas mule kick and a stump puller, took a two-fall match from Art Nelson in Ellis Auditorium. The people cheered a walking grain silo named Haystacks Calhoun, and booed the bald-headed Lady Angel, who "makes children cry and ladies faint." It was the year the Zebra Kid defeated Nature Boy Buddy Rogers with a head butt, only to be chased into the street, whereupon a spectator presented a metal chair to the Nature Boy so he could beat the Kid unconscious. And the papers covered it like it was real. But the thing about it was, it was unashamed.

Jud, who always had a newspaper at his elbow, was a student of the mob. Instead of apologizing for Jerry Lee, he decided they would flaunt him. It came to him after seeing Jerry Lee perform on a bill with Carl Perkins and Johnny Cash and Webb Pierce in the Sheffield/Muscle Shoals area, where the boy beat a piano half to death. After the show, Jud introduced himself, walked with him to the dressing room, and told him what he was going to do and how he was going to do it. He had been around music much of his life, like his brother, and was probably the best-connected used-car salesman in the South. He had friends in the networks in New York. He believed, if he just showed up there with this boy, audacious, like they were supposed to be there, maybe he could get Jerry Lee and his song on national television.

Sam Phillips was torn between just shelving the offending song and going all in on one last, big gamble. He was not convinced that an expensive lark to New York City with no guarantees of a second of air time was worth the risk. To Jerry Lee, it was beginning to look like the people who had once promised him the stars no longer believed in him. Jud whispered to Sam that he was risking losing this boy the way he had lost Elvis, over nickels and dimes, but Sam told him to hush, that there was nothing much to lose at this point, except a boy with a record no one would play. "I wasn't scared," says Jerry Lee, now, but the battle that went on between those brothers in a locked office would determine his fate.

"He could have been a genius," says Jerry Lee of Sam Phillips. "Especially on making money. And keeping it."

But Jud Phillips believed. As with most people loyal to him, Jerry Lee would never forget that. "Jud was a decent man, and he was a good businessman. He was a salesman. And he saw what Sam didn't." Even when he was drunk, which was more than seldom, his mind was turning, always turning, says Jerry Lee. "He'd throw parties, slip people a little money, do whatever it took," to spread the word, to roust a crowd. Finally, he even talked his brother into two train tickets to Grand Cen-

tral Terminal in New York City. "I'd never been on a train before," at least not one for which he had purchased a ticket. "I thought it was cool." As they rolled down the tracks, he took out a folded *Superman* and decided not to worry about it all, about New York, about the struggle between the brothers. It was not, he knows now, that Sam Phillips had not had faith in him. If it hadn't been for Sam's initial faith in him, he doesn't know for sure what path his music would have taken, and he formed a friendship with the man that he wanted and needed to be genuine, something beyond business and even music; he still needs that today. "He loved me very much," he says. "Aw, yeah, his respect for me was unlimited." He was merely being cautious, says Jerry Lee, and perhaps realistic. Such things, such resurrections, rarely happened in the real world, but did, sometimes, in comic books.

He remembers now, mostly, not the towering buildings but the crosstown sidewalks. "Amazing," he says, "the longest blocks I ever walked. But that's the city, man, that's New York. You don't jump from there, then you don't go."

They moved through the throngs of people from one great edifice to another, asking for a chance to show the powerful people, the kingmakers, what he could do. "I wasn't nervous a bit," he says now, though he might have been, if he had lived long under the Cyclops of television. But few people back home even had one; his Uncle Lee, of course, had been about the first to get one back in Ferriday, but his mama and daddy had only recently gotten a set, believing, as they had always believed, that one day they would turn the thing on and wiggle the wires and turn the antenna toward some far-off tower, and there would be Jerry Lee, sittin' at a piano. It seemed like just yesterday he and his mama sat with their heads tilted at that tiny transistor radio to hear the Grand Ole Opry, praying that the battery would hold at least through "Walkin' the Floor over You."

Jud's old contacts and fast talk got them in the door at the networks, but not an audition.

Jerry Lee watched Ed Sullivan throw him out from a distance. "Get out of here," he said. "I don't want any more of this Elvis junk."

It embarrassed Jerry Lee; it was too much like begging. "Come on, Jud, I don't think he wants us, to even hear us," he said.

So Jud reached out to Henry Frankel, an old acquaintance who was now talent coordinator for NBC, and Frankel reached out to Jules Green, who was Steve Allen's manager. Steve Allen's show, which ran opposite Ed Sullivan's on CBS, was willing to take greater risks to steal a few ratings points from the competition. They featured everything from comedians to ventriloquists to people who spun plates on sticks—and of course, music, as Allen himself was a pianist of the cocktail variety.

Green did not even get up from his desk, just sat there with his wingtips on his desk as Jud walked in. Green was unimpressed by the number of records Jerry Lee had sold and generally unimpressed by the notion of another hillbilly rock and roller. It wasn't too long since they'd had to camouflage Elvis in order to bring him on the show, to keep the public outcry down to a manageable number of decibels.

"Where's your tape?" he asked Jud.

"Ain't got no tape," Jud said.

"Pictures?"

He told Green he had his product in the lobby, holding up a wall.

Green got up and looked through the window of his office.

"All I see," he said, "is a guy chewing bubblegum and reading a funny book. You say he can do something. I don't know."

The kid, with more blond hair than was appropriate, leaned against a post, engrossed in the adventures of Mickey Mouse. He popped a big bubble and looked bored. He had already been through a *Superman*.

"If you got a piano," said Jud, "he can show you what he can do."

It was one of those rare times when being unknown saved a per-

former. Green did not know about any ban, about all the stations and sponsors lined up against him, and Jud did not volunteer. Why open the door on a mean dog when it's only going to bite you?

"Jerry Lee," Jud said, "come on in here."

This part, Jerry Lee remembers exquisitely.

"I took my bubblegum out and stuck it on the top of the piano, and I laid my Mickey Mouse funny book down, and I did my thing."

He played "Shakin' " all the way through, hot and perfect.

By the time he was done, Green was reaching for his wallet. "I'll give you five hundred dollars right now," he told Jud, for a promise that he take Jerry Lee back to the hotel, lock the door, talk to no other television producers of any kind, and bring Jerry Lee back to audition for Steve Allen tomorrow at 9:00 a.m.

The next morning, Allen stood right in front of Jerry Lee as he played it again.

"He played drums with his pencil on the piano," recalled Jerry Lee. "I can still see it. It's funny, how somethin' as little as a tapping pencil can change your whole life, change everything."

Jud told Steve Allen that if he would give Jerry Lee three minutes of air time, there would not be one viewer who would get up to change the channel, or do anything except sit there enthralled. Allen did not see how a man could keep a promise like that, but this was not his first hootenanny, and in a time when people were still feeling their way blind through this new medium, he could see for miles.

"I want you to do that song, Jerry Lee, do it just like that on my show tonight," Steve Allen told him. Years later, when asked why he gave the boy his chance, Allen would say only that he loved quality and knew it when he saw it.

"He even liked the talking part of the song," the part that so frightened other people, said Jerry Lee. "He heard that, and he knew we had a serious record. He knew we had something to sell."

Jerry Lee shook his hand and thanked him for the opportunity.

It was July 28, 1957.

"I wasn't nervous," Jerry Lee says.

Steve Allen waited onstage for the signal.

Three . . . , two . . . , one . . .

Allen, benign and bespectacled, welcomed America to step out from behind its TV trays and coffee tables and join him for a solid hour—give or take a commercial or two—of variety-show entertainment, with Shelley Winters, Tony Franciosa, the Four Coins, Jodie Sands, singer Jerry Lee Lewis, pantomimist Shal K. Ophir, and "our regular cast of crazies, Tom Poston, Don Knotts, and Louis Nye."

Jerry Lee waited in the wings. He was twenty-one years old.

"I wasn't nervous," he says again.

But he also did not see any real point in standing around doing nothing, watching a panto . . . pantonomer . . . whatever the devil that was. He and the band went across the street and had a drink.

They came back just a minute or two before they were supposed to go on, to some angry glares from the producers and a worried look or two from Steve Allen himself. They didn't know any better, Jerry Lee says. This TV stuff was like walking on the moon.

"I've been waiting on you for an hour, 'cause I didn't know where you were," said Allen, on camera, as Jerry Lee, J. W. Brown, and drummer Russ Smith sauntered onto the stage, off camera, to set up. If you listen to the show, to the noise on the set, you can hear them setting up. Allen, the old pro, went on smoothly. "Now, we're gonna have a word"—*crash, thunk, bang*—"from our, uh, stagehands, apparently. We want you to stay tuned for rock and roll sensa-"—*thunk, bang*—" . . . you think this is knocking the joint apart, wait till you hear Jerry Lee Lewis. He destroys the piano and everything."

Allen cut to a commercial, in which a perplexed but perfectly coiffed housewife watches her son track rainwater in on immaculate floors, but it does not matter, because her floors are waxed with Johnson Stride

Wax, "the wax spills can't spot." Then with less than five minutes left in the show, the camera reopened on Allen. "There's been a whole lotta shakin' going on here all day, as a result of a fella dropping in by the name of Jerry Lee Lewis . . . as you know, you young folks in particular, he has a new record out. . . ." He fumbled around for a while, like he was trying to decide how to warn the people behind their TV trays what he was about to inflict on them. "And now here he is, jumpin' and joltin', Jerry Lee Lewis!"

Come on over, baby

Jerry Lee, dressed like he was going to the movies in a striped, short-sleeved shirt, black pants, and white shoes, did what he does. He seemed trapped halfway between wild joy and burning anger, and he glared into the camera like he did it every day, like a little boy on a playground saying, "You wanna make somethin' of it?" till it just gave in, cried uncle, and took its whuppin'. The only difference he made, the only concession to TV, was slight. When the offending finger rose into the air, when he would have rotated it around salaciously and sung "wiggle it around just a little bit," he sang instead "jump around just a little bit," with no discernible rotating or talk of wiggling whatsoever. It would be about the only compromise he would ever really make, for a lifetime, and most people did not even notice it. He banged the keys so hard they seemed to jump back up to meet his fingers, and his hair bounced like some kind of live animal on his head, and at the end, when he kicked that stool back, it went flying all the way across the stage to land near Steve Allen, who picked it up and flung it back across the stage at him. It looked spontaneous and playful and real, but of course it was just good TV. As it happened, Milton Berle was backstage during rehearsals, and he told Allen, "Now, when he kicks that stool back, you pick it up and throw it back so that it goes by in front of the camera."

When the boy was done, he just stood up and hitched up his pants

and looked around as if to say, "Well, there it is," and the studio audi-ence thundered and thundered inside the small studio. "Not a whole bunch of people, a small stage. They didn't even know me. . . . But they saw me, and they liked me. That's what you call opening the door, and I *flew.*"

Such shenanigans did not happen every week on national television, where producers were still scouring the country for jugglers and come-dians; this looked like a party, and because of television everyone was invited. Steve Allen came out onstage dancing, though in a kind of goofy, very white man's way, slapping his hands together and motioning for all the other guests—there was a passel—to come out and join them onstage. Jerry Lee was grinning like he stole something and got clean away, and he would have plopped back down on the bench and played all night, played all the way through the commercials, if they had let him.

"Mama and Daddy even saw it, saw me on the TV. They flipped out."

Allen would later say the boy was pure gold under a camera; the show brought great numbers, better even than Ed Sullivan's, and in television nothing much really mattered except the arithmetic. "He was quality," Allen later said. And after that night, "he was a star."

"That broke it all loose, that night," said Jerry Lee. "Steve Allen asked me back for the next week, and then asked me back for a third time, and it just busted wide-open. The records started selling forty, fifty thousand copies in a single day. We were a smash. Steve Allen put us back on top, and I never forgot that.

"The second one I did, Jane Russell came back to the dressing room. She asked me, 'What's it like, to go out in front of a live audience and a live microphone?' I said, 'Honey, you got no problem. Just do it.' And she kissed me on the cheek."

Apparently the gatekeepers of American morality were willing to crack the gate a little if the money was right. "Everybody lifted the ban on it," he remembers. "We was on top of the *world*, man."

Back at Sun Records, Cash and Orbison and Perkins sulked. Billy Lee Riley got drunk and, in a jealous rage, tried to tear up the studio until he was restrained.

Jerry Lee walked to Memphis on the clouds.

He did not know at the time how far out on the lip of disaster Sam Phillips had come in sending his boy on that trip to New York. He had pressed and shipped hundreds of thousands of records all around the country so they'd be ready in the stores immediately after the Steve Allen appearance. By September, "Shakin'" was the number-one record on the R&B and country charts and was kept off the top of the pop charts only by the megahit "Tammy" by Debbie Reynolds. Sun Records siphoned time, attention, and money away from other projects to focus on its new star, and when reporters asked Sam Phillips if he had any plans to sell his new boy away like he had Elvis, Phillips told them to go to hell. The record that had been chained down by censors still had its detractors, as the movement against rock music ebbed and flowed, tiring in some cities, flaming up in others, "but when one station would ban it, two more would pick it up," says Jerry Lee.

He truly did not understand what it all meant, any better than Elvis had. He had seen Elvis in stardom from the outside looking in. He had no idea what lurked inside it, good and bad. But there was one difference between them: while Elvis sometimes looked helpless, Jerry Lee helped himself.

"I knew I had been making a hundred dollars a night, and suddenly I was making five thousand, then ten thousand a night," says Jerry Lee. "Do I know what people were thinkin'? Man, I don't even think they knew what they were thinkin'. And if you didn't like it, I just laughed, just gave you the finger and went on."

There had always been women, pressing up between the footlights, waiting backstage, but now they climbed the stage, rushed it. The first

time was in Nashville. "I was on this little bitty stage, but I remember, man, I was just gettin' with it. We were playin' the National Guard Armory, and suddenly here comes these girls, a mob of girls. I thought to myself, *I don't like the look in these girls' eyes*, and the cops couldn't do nothing about it. They was kissing me and pulling at my clothes, and pulling at my hair. . . . Man, I mean they just mobbed me. They tore off clothes, tore 'em off down to my underwear. I had these ol' stripedy shorts on. . . . After that, I started wearing boxer shorts, in case this happened again. I was hollering, 'Wait a minute, baby! Hold on!'" The girls ran off with pieces of his clothing like trophies.

"One scrap of it caught on this metal bracelet and it dug into me and like to pulled my arm off. It scared me, a little bit," he says. "It was a set-up deal. The girls planned it. They got together and planned it all.

"Had a leopard-skin suit on. I liked that suit."

But later, when someone had given him some pants and he was being escorted to safety by police, a photographer caught him grinning. "You can't kiss three hundred girls at one time," he says, so it was just a great waste of exuberance.

But if they had devoured him, he thought, "what a way to go."

Quickly he supplanted Elvis as public enemy number one in the eyes of the moralists who railed against rock and roll. Elvis was out in Hollywood making Westerns and love stories. Jerry Lee said he knew that Elvis still knew how to rock—"he was a rocker, oh, man"—but he was also the man who did "Love Me Tender," bought a pink Cadillac, and still seemed even now genuinely surprised at the big, wide world and a little lost in it. Elvis, when he was asked about his music, always said, No, sir, or No, ma'am, he wasn't going to apologize for his rock and roll, because he did not believe he did a thing wrong by singing it and dancing like he did. Jerry Lee knew that he and Elvis had some of the same fears and doubts, but Elvis pushed his down deep

and lived with them, the way a child lives with an invisible friend. He might talk to it sometimes, but not when the grown-ups were around. At least, that was how it seemed to Jerry Lee. "Elvis cared what people thought," he says, almost puzzled.

For Jerry Lee, fame was a thing that sometimes flogged him and sometimes let him be; he was capable, in the dark times, of losing all sight of the good in his music, of believing it was evil, until suddenly things would just clear and he'd see it all so much better. The thing about rock and roll, he said, was that it made people crazy bad, but more often it made them happy, made them forget life for a while, as another singer would sing it, and if a young woman scaled a stage to fling herself on a good-lookin' rock-and-roll singer from Louisiana every now and then, squeezing on him like to break his back, what harm did that do?

"I knew Mama was proud, and I knew Daddy was proud," and armed with that, he did not greatly care whom he offended in the world of strangers. His mama's pride grew as he got further and further from the bars, from Sodom, and that meant the world to him. "She backed me, one hundred percent. She knew I had to do these things. Then she watched me on the television . . . and she thought it was just the greatest thing she had ever seen."

And television kept calling—including a call from a young DJ from Philadelphia with a show called *Bandstand*. "He called me and said, 'You don't know me, but my name is Dick Clark,' and I told him, 'No, I don't know you.' And he said, 'Well, I have a small TV show . . .' And I said, 'Look, you need to talk to Sam and Jud.'" Clark told them that his sponsors said they'd give him a nationwide nighttime show if he could get Jerry Lee Lewis. There was only one catch: the producers wanted Jerry Lee to lip-synch the song, as other guests had done.

Jerry Lee played the show, but he didn't play by the rules. "They didn't want me to do it like I do it, but I did it out loud, and I didn't skim over nothin'," he says. "I did it all."

It was about then that Sam Phillips gave him his first big royalty check for "Shakin'."

It read: $40,000.

Jerry Lee wasn't sure for a while if that meant four thousand or forty thousand, and he was just about as happy either way. He put it in his pocket and just carried it around with him, for weeks, months, till the ink faded and it was so creased, it was almost cut in two. He went to Taylor's Restaurant and had some steak and gravy and black-eyed peas and turnip greens, and he might have even had some beets, though he didn't even really like beets, and, man, it was good, and as a goof he tried to pay with his forty-thousand-dollar check.

"Uh, I don't think we can cash this," the waitress told him.

He went home and went about the business of keeping his promises. He bought his mama a nice new house in Ferriday, not a mansion on a hill but a good, clean house with hot and cold running water and wiring that didn't glow red in the walls and burn the place down, with lights that didn't flicker when the refrigerator clicked on. He bought his daddy some land, a farm, because a man was nothing without land, just a borrower.

"I bought Mama a new Fleetwood Cadillac," he said. "And I bought her a new one every year, and she got to expecting it. If I didn't, she'd just take one of mine. She drove off one time in a white one with red leather interior. I had to call her and say, 'Mama, you got my car?' And she said, 'Yeah, I got it.' She got to where, if I saw her walking around one in the yard, I knew she was gonna take it."

He bought his daddy a big Lincoln. He gave his sisters a thousand dollars at a time, for shopping sprees. If other kin had a crisis and needed help, they came to him, and he dug in his pocket and gave them cash.

"They accepted it, and they wanted it," says Jerry Lee, and they deserved it, for the faith they had in him, so early and for so long. If he ever had any doubts about that, all he had to do was shut his eyes and

imagine that piano on back of his daddy's old truck as it got bigger and bigger coming down that dirt road, till it was so big in his mind and his eyes that it was all he could really see, for years and years.

Elmo grabbed hold of the rock-and-roll dream with both big hands, and Jerry Lee loved every minute of it, seeing his daddy's dreams come true through him. A more traditional family, one from a Norman Rockwell painting, might have dreamed it differently, might have hoped to see their child go off to college and come home a doctor or a lawyer or a captain of industry, but what Jerry Lee's people had stirring in their blood was music, and when you make it in music, their kind of music, no one hands you a sheepskin and one of those funny flat hats. So Jerry Lee handed his daddy the keys to a new Lincoln, and Elmo got drunk not long after that and drove it into something that did not move, and so Jerry Lee bought him another one, because he loved him, and because that piano tilted the world.

He tells how he bought Elmo a brand-new Cadillac, and how his daddy, flying drunk through Mississippi, "just didn't make a curve, and turned it over about three times, and he just got out and took off walking. 'Where's your car, Daddy?' I asked him, and he looked at me and said, 'Son, I have no idea.' Well, that day I bought him one just like it, red with white leather—I mean, a sharp car—and parked it in his driveway. And he just come out the door and got in it and drove off, like he never had a wreck. I don't think he even knew the difference. I don't think he ever did. I said to him, 'Looks like your car's goin' good, Daddy,' and he said, 'Yeah, son, it's going all right.'

"In California, I bought him a new Harley. He drove it all the way back, and he was going a hundred and ten in Greenville, Mississippi, when they finally run him down. The phone rang, and it was the police chief, and he said, 'Is this Mr. Jerry Lee Lewis?' and I said, 'Well, I don't know, it depends.' And he said, 'I've got a fellow here who says he's your daddy, and he's coming through here doing a hunnert-ten, and said he's had just *one* beer.' And I heard Daddy in the background, say-

ing, 'Honest to God, son, just *one* beer.' And I said to the police chief, 'Yeah, that's him.' I asked if he could let him go, and he said to me, 'Tell him to slow down.'

"Them was good days, too," says Jerry Lee.

In the studio, as he searched for another hit, there was time to record some more fine old music, the kind he'd heard as a boy. One day, he says, "Jack Clement caught me at the right time, in the right mood," and he sat down at the piano alone and cut a version of "That Lucky Old Sun," a number one hit by Frankie Laine in 1949. The song was one of those pieces of music that just ride easy in your head, and Jerry Lee's piano gave it a barroom, blue-collar undertone. In a voice that was smooth and easy—in great contrast to the shakin' and shoutin' music he became famous for—he sang about a workingman, burned and wrinkled by the sun, sweating for his wife and children.

> *While that lucky ol' sun ain't got nothin' to do*
> *But roll around heaven all day.*

"That'd make the hair stand up on the back of your neck," says Jerry Lee.

The one bleak spot was his marriage to Jane. She was still living back in Ferriday while he bunked with the Browns in Coro Lake, and sometimes he could forget he was married at all. He knew his boy was being cared for, there so close to his people, but Jane was sick of the distance between them and was insisting that she bring Jerry Lee Jr. to stay with him in Memphis. But Jerry Lee was still living with his cousin J. W. and his family and was in no hurry to live anywhere else. More and more, he was spending time with his cousin Myra, who didn't look thirteen a bit, not to him. He believed she was of age, by all the customs and standards of his history, his experience, and, after a failed reunion with

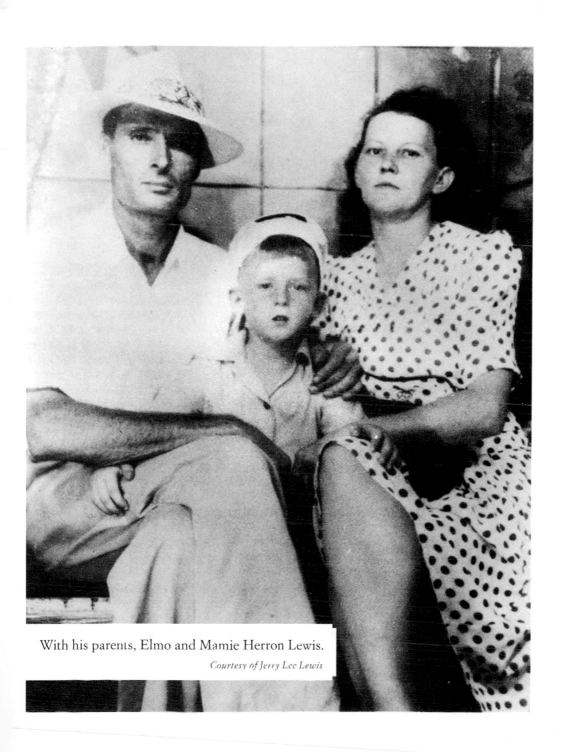

With his parents, Elmo and Mamie Herron Lewis.

Courtesy of Jerry Lee Lewis

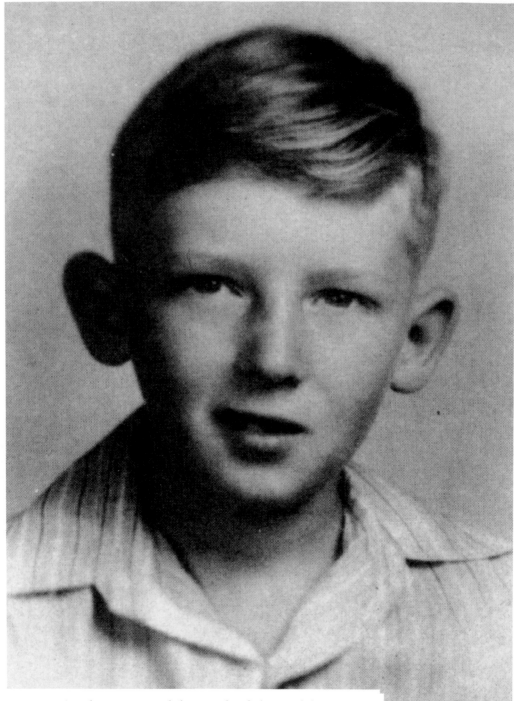

As a boy, at around the time his father took him out to the levee to see the party boats on the Mississippi. "That'll be you on there someday," Elmo told him. "That'll be you."

Michael Ochs Archives/Getty Images

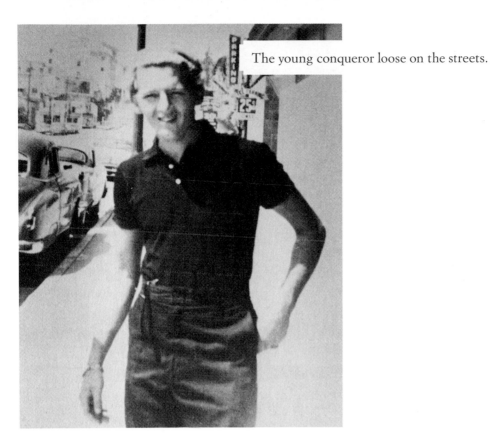

The young conqueror loose on the streets.

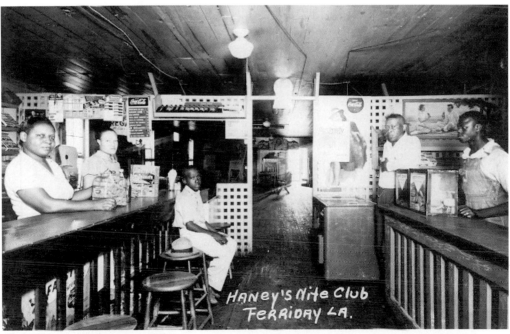

HANEY'S Nite Club
FERRIDAY LA.

The bar at Haney's Big House, with proprietor, Will Haney, second from right. "I just introduced myself to the atmosphere," says Jerry Lee. *Concordia Sentinel*

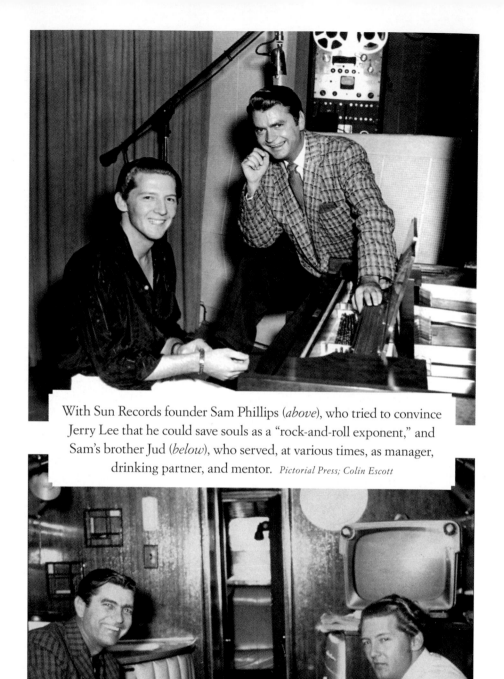

With Sun Records founder Sam Phillips (*above*), who tried to convince Jerry Lee that he could save souls as a "rock-and-roll exponent," and Sam's brother Jud (*below*), who served, at various times, as manager, drinking partner, and mentor. *Pictorial Press; Colin Escott*

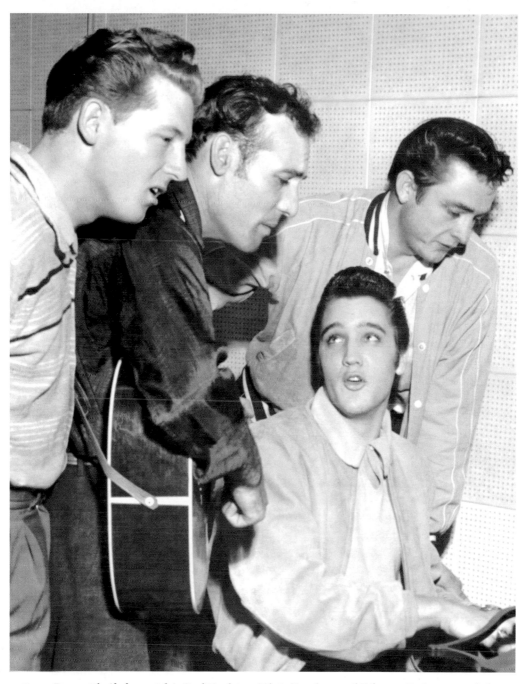

Jerry Lee with (*left to right*) Carl Perkins, Elvis Presley, and Johnny Cash, around the piano at Sun, December 4, 1956: the afternoon jam session that went down in history as the Million Dollar Quartet. "I knew there was something special going on here," Jerry Lee says. *Michael Ochs Archives/Getty Images*

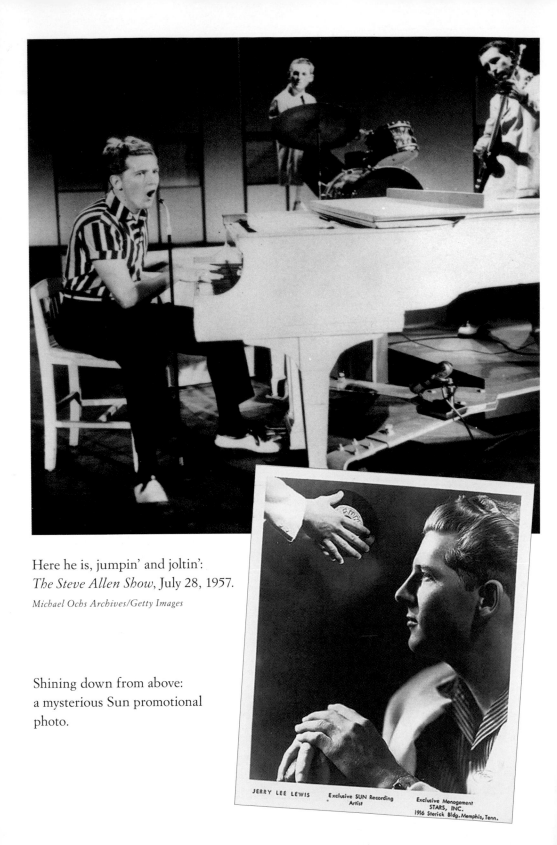

Here he is, jumpin' and joltin':
The Steve Allen Show, July 28, 1957.
Michael Ochs Archives/Getty Images

Shining down from above:
a mysterious Sun promotional
photo.

JERRY LEE LEWIS Exclusive SUN Recording
Artist

Exclusive Management
STARS, INC.
1916 Sterick Bldg. Memphis, Tenn.

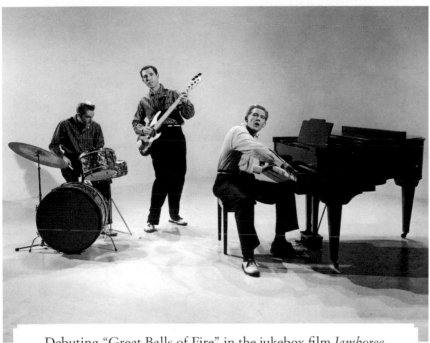

Debuting "Great Balls of Fire" in the jukebox film *Jamboree*.
Michael Ochs Archives/Getty Images

Signing autographs for fans at the Bell Auditorium,
Augusta, Georgia. *Museum of Augusta*

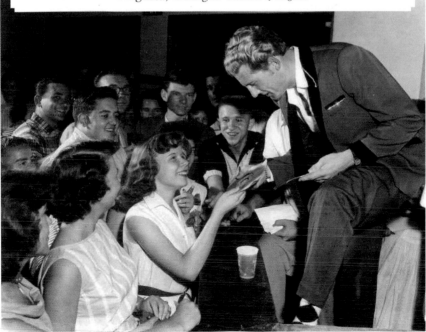

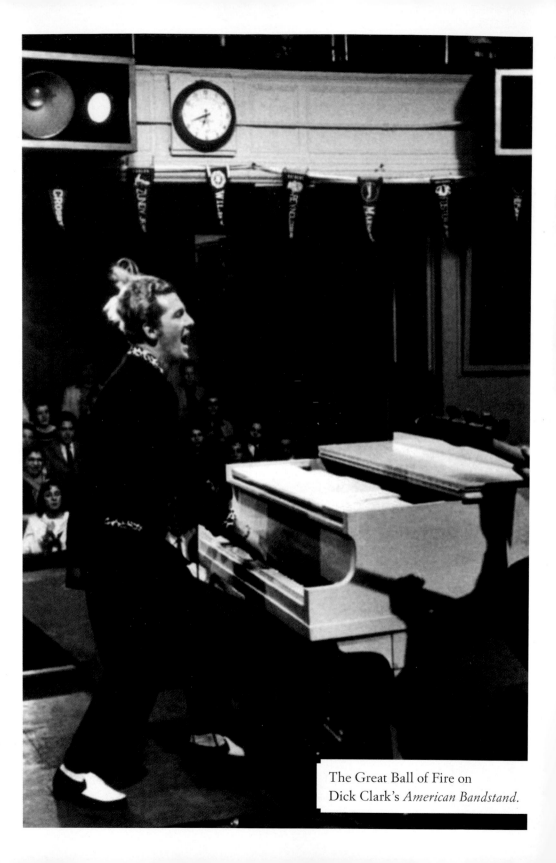

The Great Ball of Fire on
Dick Clark's *American Bandstand*.

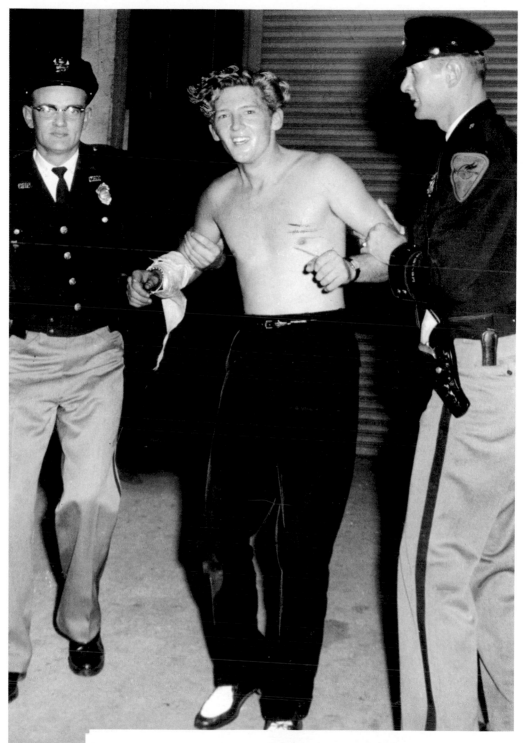

"I thought to myself, *I don't like the look in these girls' eyes*, and the cops couldn't do nothing about it."

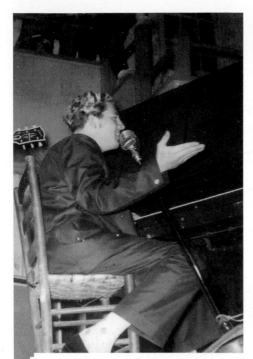

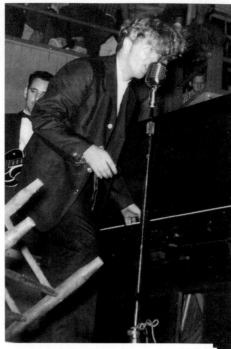

Valdosta, Georgia, probably early 1958. *Courtesy of Pierre Pennone*

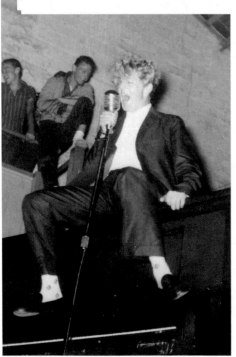

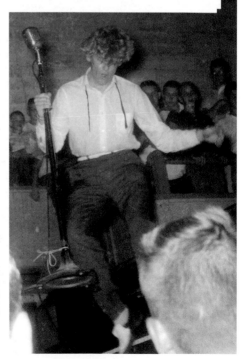

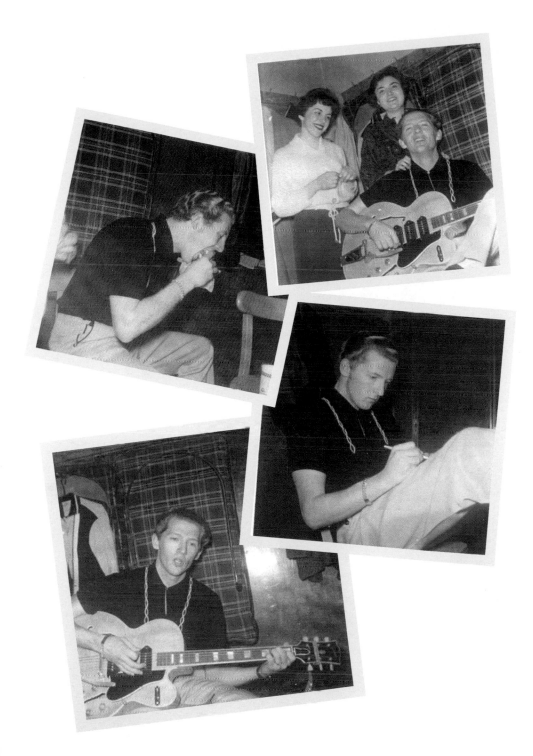

With fan club president Kay Martin (*upper right*) and a fan backstage at the Loews Paradise Theater in the Bronx, New York, March 31, 1958.

Courtesy of Kay Martin/Pierre Pennone

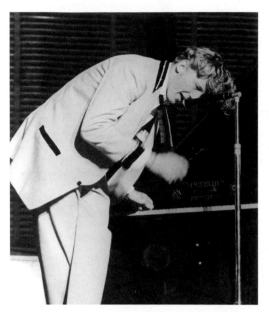

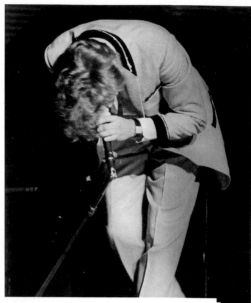

At the Granada Theatre in Tooting, South London: his last concert before leaving England, May 26, 1958. *Pierre Pennone*

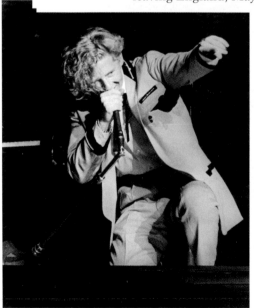

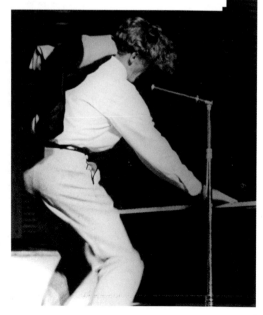

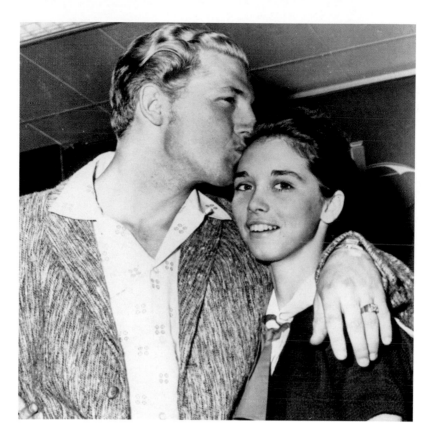

"Why don't we leave our personal questions out of this, sir?"
Greeting the press with Myra upon his return from England,
Idlewild Airport, New York City, 1958.

Michael Ochs Archives/Getty Images

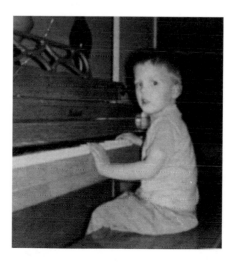

Steve Allen Lewis, who died before his fourth birthday.

Kevin Horan/The LIFE Images Collection/Getty Images

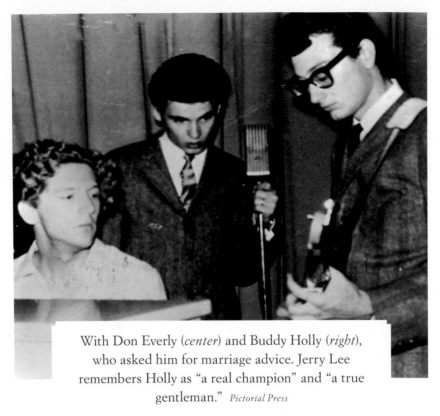

With Don Everly (*center*) and Buddy Holly (*right*), who asked him for marriage advice. Jerry Lee remembers Holly as "a real champion" and "a true gentleman." *Pictorial Press*

With his parents, Mamie and Elmo, 1959.

Bettmann/Corbis

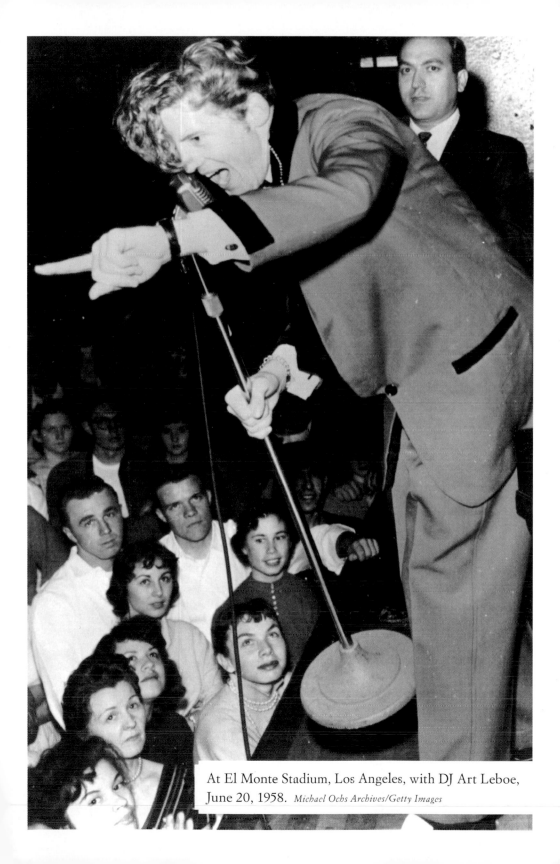

At El Monte Stadium, Los Angeles, with DJ Art Leboe, June 20, 1958. *Michael Ochs Archives/Getty Images*

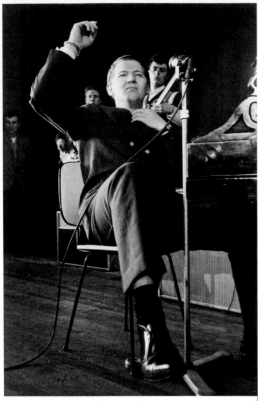

REX USA / Devo Hoffmann

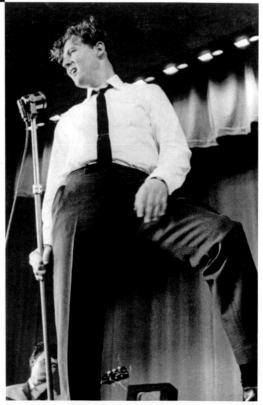

The conqueror returns to Europe,
early 1960s. *Marion Schweitzer/REX USA*

Jane in Memphis, he felt even less married than he ever had, and was becoming suspicious that she didn't feel married, either. But she was no longer fighting, no longer hurling the whole world at him, and it all just died, what love there might have been, in a kind of indifference, and he knew that ducking was all there had ever been. But as always, he hated to drag the laws of man into his life, so he just let it be, as he disappeared into the studio for the crucial follow-up record to "Shakin'."

The sky over Memphis was full of falling stars. He had seen Carl Perkins stall after one big hit, watched Roy Orbison and Billy Riley and the others grasp at straws, and he was determined to do better, recording and discarding song after song, never finding just the right thing. But "Shakin'" was far from done, and he had time, still, to relish it. People were already daring to say what he had known all along. In August, a story clattered across the United Press wire claiming that Jerry Lee Lewis was on his way to usurping Elvis Presley as the king of rock and roll.

He remembers, as "Shakin'" held strong on the charts, sitting with Johnny Cash in the studio at Sun. Cash and Perkins and Billy Lee Riley and the other Sun artists were still rankled over Jerry Lee's New York trip, and Sam's ongoing sponsorship of Jerry Lee to the exclusion of all else, so they just sat, sharing the silence. Jerry Lee was reading *Superman*.

"How many records have you sold?" Cash suddenly asked Jerry Lee.

Jerry Lee looked at the secretary, Regina.

"It's sold about seven hundred thousand," she said.

"How many has mine sold?" Johnny asked.

"About two hundred thousand," she said.

Johnny, in that taciturn way he had, thought on that for a minute.

"Gee, whiz," he said, in that baritone voice. "I wish I was a teen idol. It must be nice."

Jerry Lee told him, yes, it was, and went back to his funny book.

7

TOO HOT TO ROCK

.

Memphis

1957

He spent money like a Rockefeller, on cars and motorcycles and rock-and-roll clothes, and he had more pretty women chasing him than a Palm Beach Kennedy, but it is a fact of history that poor Southern boys have a problem in success just as an oddly shaped man has trouble finding a suit of clothes that does not cut, bind, and itch, till it is maddening, those clothes, and you want to tear them from you and run for home.

"H. E. L. L.," Jerry Lee shouted.

"I don't believe it," said Sam Phillips.

"Great God a'mighty, great balls of fire," chimed in one of the impatient session men.

"That's it! That's it! That's it. It says, it says, *Make merry!* With the joy of God, *only*," Jerry Lee shouted.

Sam Phillips looked at him in wonder, and in some fear. He and Jack Clement had tape set up and running in the studio and had hired

session men to back Jerry Lee on what seemed a sure thing, a song written especially for him by the man who wrote all those hits for Elvis, the great Otis Blackwell. Everything was in place for another earth-trembling hit, but Jerry Lee had gone home. He was still standing there among them, all right, still inside the soundproofed walls with the drum sets and amplifiers and electric cords, but his heart and soul were someplace else—caught, as they had always been caught, between the smoke and grind of Haney's Big House and the dire warning of Texas Street, between the might and thunder of faith and the secular sound of lust and greed. Jerry Lee was refusing to cut the record at all, because to do so would be to serve the devil.

"But when it comes to worldly music," said Jerry Lee, "rock and roll . . ."

"Pluck it out," said Billy Lee Riley.

". . . anything like that," continued Jerry Lee, unfazed, "you have done brought yourself into the *world*, and you're in the *world*, and you hadn't come from *out of* the world, and you're still a sinner. And then you're a sinner, and unless you be saved and borned again and be *made as a little child*, and walk before God and be holy . . . And brother, I mean you got to be *so* pure. No sin shall enter there. *No* sin. 'Cause it says no sin. It don't just say just a little bit. It says *no sin shall enter there.* Brother, not one little bit. You got to walk and *talk* with God to go to heaven. You got to be *so* good."

Riley gave him a hallelujah. As was sometimes the case in the studio, someone had opened a bottle of brown liquor, and it had already made the circuit a time or two among Phillips and the session men, rock and roll being one of those rare professions in which alcohol is as necessary as guitar picks.

Sam tried to argue that Jerry Lee could do good singing his music, lifting spirits.

"All right. Now look, Jerry. Religious conviction doesn't mean anything resembling extremism. All right. You mean to tell me that you're going to take the Bible, that you're going to take God's word, and that

you're going to revolutionize the *whole universe*? Now listen. Jesus Christ was sent here by God Almighty."

"Right," said Jerry Lee.

"Did He convince, did He save all of the people in the world?"

"Naw, but He tried to."

"He sure did. Now wait just a minute. Jesus Christ came into this world. He tolerated man. He didn't preach from one pulpit. He went around and did *good*."

"That's right. He preached *everywhere*."

"Everywhere."

"He preached it on land."

"Everywhere. That's right, that's right."

"He preached on the water."

"That's right, that's exactly right. Now . . ."

"Man, he done *everything*. He healed."

"Now, here, here's the difference . . ."

"Are you followin' those that heal? Like Jesus Christ did?"

"What do you mean? You . . . What? . . . I . . ." stammered Sam.

"Well, it's happenin' every day."

"What do you mean?"

"The blinded eyes are opened. The lame are made to walk."

"Jerry, Jesus Christ . . ."

"The crippled are made to walk."

"Jesus Christ, in my opinion, is just as real today as He was when He came into this world," said Sam.

"Right! Right! You're so right you don't know what you're talkin' about."

"Now, I would say, more so . . ."

"Awww," said Riley, interrupting, "let's cut it."

But Sam Phillips, who'd had just enough whiskey to get his back up, was well into his argument and was not quitting now.

"Never sell, man," said someone else. "It's not commercial."

"Naw, we'll be with you here in a minute. . . . But look . . . Now listen, I'm telling you out of my heart, and I have studied the Bible a little bit . . ."

"Well, I have, too," shot back Jerry Lee. "I've studied it through and through and through and through and through, and I know what I'm talkin' about."

"Jerry, Jerry, if you think that you can't do good and be a rock-and-roll exponent . . ."

"You can do good, Mr. Phillips. Don't get me wrong."

"Wait a minute, wait a minute, listen. I mean, I say, 'Do good . . .' "

"You can have a *kind heart.*"

"I don't mean, I don't *mean* just . . ."

"You can help people."

"You can *save souls!*"

"No! NO! NO! NO!"

"You had it," said that other voice. "You'll never make it."

"How can—how can the devil save souls? What are you talkin' about?"

"Listen, listen . . ."

"Man, I got the *devil* in me. If I didn't have, I'd be a Christian."

"Well, you may have it . . ."

"Jesus!" Jerry Lee almost screamed, and thumped his heart. "Heal this man! He cast the devil out. The devil says, 'Where can I go?' He says, 'Can I go into this *swine* down here?' He says, 'Yeah, go into him.' Didn't he go into him?"

"Jerry, the point I'm trying to make is, if you believe what you're saying, you've got no alternative whatsoever, out of—*listen!*—out of . . ."

"Mr. Phillips, I don't care. It ain't what you believe. It's what's *written in the Bible!*"

"Well, wait a minute . . ."

"It's what's *there*, Mr. Phillips."

"Naw, naw . . ."

"It ain't what you believe, it's just what's there."

"No, by gosh, if it's not what you believe, then how do you *interpret* the Bible? Huh? How do you interpret the Bible if it's not what you believe?

"Well, I mean, there's some people, you just can't tell 'em," Jerry Lee mused.

"Let's cut it, man!" moaned Billy Lee Riley.

"No, here's the thing . . ."

"You can talk," said Jerry Lee. "You can talk, and you can talk." The faith Jerry Lee was raised in does not yield to argument, is not open to interpretation. There had been and would be many moments when he was at war with himself this way. This one just happened to have been captured on tape in the Sun studio, and would be proof that the conflict inside Jerry Lee was not a thing of books and movie scripts but a real, wounding thing. He knows he is not special this way, and that most human hearts are at war with themselves, but his battle was more public because fame simply insisted on it. But it is a matter of history that, sometime while the great city of Memphis had mostly gone to bed, the men in the cramped studio finished their whiskey and finally began to play a rock-and-roll song, which became not just another record but another musical landmark.

Jerry Lee, as always, played it the way he thought it sounded best, regardless of how some songwriter or lyricist said it should be played. When the bass player had a hard time following Jerry Lee's piano lead, "he propped hisself on top of the piano, and he was just layin' there, he was watchin' my hands . . . followin' my fingers. And he was right on it. The drummer was right on it."

> *You shake my nerves and you rattle my brain*
> *Too much love drives a man insane*
> *You broke my will, but what a thrill*
> *Goodness, gracious, great balls of fire!*

"I never will forget seeing Sam Phillips lookin' at me through that window with one finger in the air—*number one*."

It was not the usual tandem of Janes and Van Eaton who played on that historic record, but a couple of session men who happened to be nearby when needed. "Only had a bass, piano, and drums—that's all we had on it." He did not even know the drummer's name. "I knew Sidney Stokes," the bass player up on top of his piano, "but I didn't know him that well, either. And I don't know what happened to them people. That's the last time I ever seen 'em. That's *strange*, isn't it?" But it was the nature of the business, or so he would discover: people just fell away. Only the sound, stamped in that black wax, was forever.

Like "Shakin'," the song had lyrics that could be seen as salacious, but only if you used your imagination. Sam Phillips did not release the song to the nation right away, with "Whole Lotta Shakin'" still holding strong. First, Jerry Lee went Hollywood—well, actually, he went back to New York—for his first movie role, as himself. Otis Blackwell, who wrote "Great Balls of Fire" after buying the catchy title from a New York songwriter called Jack Hammer, was putting together music for a low-budget rock-and-roll movie called *Jamboree*, a kind of tribute to disc jockeys that was slated to include the influential Alan Freed as himself, until he walked away because of a contract dispute. To replace him, the producers brought in disc jockeys from all over the country to introduce the music, and it was the music—not a thin plot based on two young singers in love—that people came to see.

It was mostly music, anyway, that movie. Fats Domino did "Wait and See." Carl Perkins was in it, and Frankie Avalon, with Connie Francis, The Four Coins, Jimmy Bowen, Jodie Sands, Lewis Lymon, and even Slim Whitman, who had told Jerry Lee, "Don't call us. . . ." There were eighteen acts in all, but of course it was Jerry Lee, a late addition

to the cast because of the phenomenon of "Whole Lotta Shakin'," who stole the show, again, with "Great Balls of Fire." But it felt all wrong as the cameras focused on him, because the microphone was muted, and the piano was just a prop, anyway, an empty box, its ivory nothing more than a row of shiny dead teeth.

"This piano ain't got no notes," he shouted, and the director told him of course it didn't, this was show business, told him to just pretend he was playing it and mouth the words like he was singing it for real. And while he saw that as an abomination unto his craft and every honest sound that some man had ever coaxed out of a piano or a guitar or even a comb and tissue paper, he got through it, because the pretending he was doing was for the movies, and he loved movies. At least he finally understood how Gene Autry had sung all those cowboy songs while riding his horse, Champion, how he sang without sounding like he was hiccuping or biting his tongue clean off. "*Ooohhhh*, I said to myself, *so that's how he did it.*" If it was good enough for Gene Autry, it was good enough for him.

It was not a good movie, but Sam Phillips knew it would mean night after night of free publicity on the big screen, and for fans of rock and roll, fans who might never make a show to see a Fats Domino or a Jerry Lee Lewis, it was a godsend. It would run for years in places like Birmingham and Atlanta and Knoxville, and on TV shows like *Dialing for Dollars*, which played old movies sandwiched between *Rawhide* and reruns of *I Love Lucy*.

At home in Ferriday, his personal life had taken an even grimmer turn. Jane had given him a second son, but he looked at the child and could not see himself in his face, and claimed Jane had taken up with another man while he was on the road. In September he filed for divorce, accusing Jane of adultery and other acts of lewdness and wildness, including excessive drinking and public profanity. Jane responded in a

cross-claim that it was all untrue and asked for a divorce on grounds of nonsupport, inhuman treatment, and abandonment. She alleged that Jerry Lee had left them with no money and little to eat and that the baby was *too* his progeny, which led Jerry Lee, through his own lawyers, to say that was a crock, and the unhappy and violent marriage would eventually be dissolved—but, as was Jerry Lee's habit, not in time.

But the messy divorce, miraculously, remained mostly an intensely local matter and did not torpedo his rise at the time, and he did rise, and rise again. Sam was so filled with the promise of Jerry Lee that he bought a full-page ad in *Billboard*, touting him and *Jamboree*. Jerry Lee took on a manager named Oscar Davis, a genteel old flack who had worked with his idol, Hank Williams, back in the day and had been a front man for Colonel Tom Parker, who handled Elvis.

He was not afraid of being handled right out of his natural self, as the Colonel had handled Elvis, handling him until he had wrung just about all the rock and roll out of his soul.

"Don't nobody—nobody—manage Jerry Lee," he says. "Don't nobody handle Jerry Lee. I can't be handled."

But so far, he liked what was happening to him at Sun and in his career in general. The money kept getting better and better, and Jud had stayed on in his usual, vaguely defined role, to help guide the bookings. It was Jud, the gambler, who decided to wrench Jerry Lee from the stigma of hillbilly music altogether. It was not that he would not play country and western again—in fact, for the B side of "Great Balls of Fire," he was about to record one of the greatest, most enduring country hits of his career—but Sam and Jud believed, as did the national magazines, that he was becoming the face of rock and roll. As if to seal the matter for good, they decided to send him to a place where no hillbilly would tread. They sent him to 253 West 125th Street, on the island of Manhattan. They sent him to Harlem.

"They sent me," Jerry Lee said, "to the Apollo."

"This boy can play anywhere," said Jud to the theater's promoters.

Then he crossed his fingers and had a tall drink.

It was not just the Apollo. It was the Apollo in the time of the Little Rock Nine. On September 4, 1957, members of the 101st Airborne Division walked nine black students into Little Rock's Central High School as mobs outside screamed racial slurs and threatened murder in one of the ugliest public displays of racism in United States history. The South had shown its true self in Little Rock, thought black citizens around the country.

It was in this climate that Jerry Lee Lewis and his little band took off for New York.

"I walked out on that stage, me and J. W. and Russ, and there was not one white face in the whole crowd." Their footsteps boomed in the place, as if the stage was a drumskin stretched tight across all the rich history here. "They looked," Jerry Lee recalls now, "like they wanted to kill me." No one yelled or booed; it was oddly quiet. Rock and roll might have been a bridge for the races, but right now the very sound of a Southern accent was shorthand for meanness and racism and even murder, and no one sounded more Southern then in modern music, perhaps, than Jerry Lee Lewis.

The old theater had been built in the Harlem Renaissance, as blacks in the Northern cities regained their footing in the wake of Jim Crow and World War I. Ella Fitzgerald sang here when she was seventeen. Billie Holliday sang here. Cab Calloway shouted here in his white tuxedo, great jazz combos arrived from Kansas City and Chicago and Paris, and big bands and orchestras made it the nation's jewel of black music and music in general—a jewel that newer performers, Sam Cooke and Jackie Wilson and Chuck Berry, could only polish.

Jerry Lee took his seat at the grand piano, a piano played by some of the greatest musical talents the world had ever known. When he said hello, his voice with its Louisiana accent filled the place. Confronted

with the anomaly, he made a snap decision: rather than try to hide it, he decided to exaggerate it. He felt threatened, and a strutting rooster does not run out of the barnyard; he crows louder and scratches the ground. He says he meant no disrespect, but did not see how being apologetic of his Southernness would in any way help the tension. He decided to make himself and his band even *more* Southern, more un-likable. Most people would not have done such a thing, but they do not think with his head.

"I'm happy to be here at the Apollo Theater with my boys," he drawled, marbles in his mouth and sorghum on his tongue. "This here on drums is Russ Smith, from Newport, Arkansas," he lied. Russ, taken aback, began to slightly shake his head; he wasn't from dad-gum Arkan-sas but Biloxi, Mississippi. "And this here, on bass, is J. W. Brown. He's from Little Rock, Arkansas, where's it's too hot to rock," and J. W. did a double-take of his own, because he knew he was from Louisiana even if no one else did.

"Figured I'd just take the bull by the horns," Jerry Lee says now. If they were going to be run off the stage and out of Harlem and out of New York, better get it over with. There was, for a moment, a deathly quiet. "But there was this big, fat feller sitting right down in the front row," who got the joke, even if it was not a very good one, "and he just laughed out loud," says Jerry Lee. He laughed at the guts it took, at these boys coming to play here straight out of the heart of dark-ness of the segregated and violent South. And that made people in the crowd smile, some even to laugh out loud themselves, and the tension just deflated, recalls Jerry Lee. Then he launched into his set, not into a blues song, which would have been expected, maybe, but into his boogied-up "Crazy Arms," a country song this white boy had remade as a blues. The crowd clapped, politely, and then he hit the first few keys of "Mean Woman Blues," and they started to move. "I knew what they were waitin' on. I knew what they wanted," and he gave them the new song, stabbing, beating.

I laughed at love 'cause I thought it was funny
But you came along and mooooved me, honey
I've changed my mind
This love is fine
Goodness, gracious, great balls of fire!

"And real quick, they got with it, and they started dancing."

They came up out of their seats and out into the aisles.

He combed his blond hair at the piano stool and finished with the "Shakin'" song as hard as he had ever played it, and when he kicked back the stool, he tried to knock it halfway down to Amsterdam Avenue. Critics would say, of that show, he was an uncouth hillbilly with a certain animal vigor, but as he walked offstage, the crowd was clapping and screaming and stomping the floor, and the pretty girls were looking at him with that look, and he left the historic Apollo in a great storm of noise.

"Bet they didn't see that comin'," he said to himself as he left the stage.

It seemed like, in those days, he always walked downhill.

"'Great Balls of Fire' accomplished the mission and did a whole lot toward gettin' me right to where I needed to be," says Jerry Lee. "We knew early on it was a classic, that it would be the kind of song people wait on, and it would come down to a choice between that one and 'Whole Lotta Shakin' Goin' On' as to which one I closed the shows on, and it *didn't matter*, 'cause the people just went crazy either way." He did it on *The Steve Allen Show*, slender and slick this time in a dark jacket and white slacks.

"I never looked at the song like it was risqué or anything. WHBQ, they had 'Great Balls of Fire' at number one. And it was number one on their station for six weeks straight . . . they couldn't get it off number one. And they *banned* it! To get it off."

By the holidays, "Great Balls of Fire" was the best-selling record Sun

had ever had. It was not a deep record, no more or less than "Whole Lotta Shakin' " had been, but it was what rock and roll was then, before the crooners stole the music for a little while, when it lost its bottom. In a way, "Great Balls of Fire" was a love song, but a twenty-one-year-old Jerry Lee Lewis love song, a love song going a hundred miles an hour, not a moonlit drive by the beach but a man and woman fleeing the police and the entire disapproving world. Other people might have missed the meaning in it, lost in the rhythm and the beat, but not him. "It says a lot," he said. "It says the truth." Not everybody considers things from all sides or to any depth. Some people make lifetime decisions in the white heat of one moment, at least people like Jerry Lee do. The people who never have, he feels sorry for.

Rock-and-roll music, already, showed the first signs of what it would soon morph into, a kind of musical treacle, but he had no interest in that awful mess, and when he did try to do it, in the studio, he usually just goofed around, to show that such music was beneath him. Producers often wanted a contrasting song for a B-side to a record, but for Jerry Lee that had always meant going back to his roots. For the B-side of "Great Balls of Fire," he had chosen exactly what he wanted, and he didn't think the man who wrote it, forever rumbling in that ghost Cadillac down some Lost Highway, would mind.

Sam Phillips stood behind the glass that day and looked like he was about to cry. He had grown up with Hank Williams, like Jerry Lee but even more so. Hank Williams might have belonged to the world then, or to the Lord, but he began in Alabama.

I'm sorry for your victim now
'Cause soon his head, like mine, will bow

Jerry Lee closed his eyes, sometimes, when he played Mr. Williams. Usually, he didn't even know he was doing it. When it was over, when it was a take, he saw Sam standing in the studio.

"You knocked me out," he said, and walked away.

That side of the record was a hit, too, even in London. It augmented Jerry Lee's legend and proved that he hadn't forgotten his roots even as he made them scream for the rock and roll. But more important, he believes that somewhere Hank Williams looked down and tapped the toe of one boot. "I want to think so," he says.

To not believe in heaven, in salvation, is to not believe in second chances, but the haunting question is in the tally of a man's sin, the cost. Can *all* of a man's sins be washed away? Can they if he has led the people away from Him in song? "That's the big deal that me and Sam had that argument about. Well, we'll know one day. That's what worries me."

Jerry Lee would continue to live in a kind of purgatory. Back home, his cousin Jimmy Lee had more and more come to see Jerry Lee not just as a lost soul but a kind of Pied Piper for the Devil himself, and he preached on it hard, on the wages of sin, railing against the bald wickedness of secular music, and not in some vague way but naming his cousin directly. He would make it a lifetime crusade, beating Jerry Lee like a tin drum, over decades. Then, when they met back in Ferriday, they would share some fried chicken, maybe even play a little piano together like they had as boys, as if it had never happened. It had always been an odd family that way, in its ability to turn the other cheek when kin were involved, but then they were descended from men who could take a long, hard pull of corn whiskey and, wobbling, preach the gospel until they passed out, two spirits in one body. If a man like that could live with himself, then surely cousins could live with cousins.

But as '57 passed into '58, the two men's lives took such drastically different paths that Jerry Lee believes his success ate at Jimmy's mind. While Jerry Lee was driving Cadillacs and all, their cousin Mickey Gilley was over in Texas trying to get a hit as a country singer, Jimmy

was sitting in Louisiana in a wore-out Plymouth, twisting the starter and praying for Jesus to heal his car. He desperately needed the car to get to his revivals, but the valves were burned up, and it was finished. But he prayed and prayed, and suddenly the starter caught and the engine purred, and when he sold it later to a mechanic, the man told him the valves had in fact been healed, and Jimmy knew this was a sign.

Later, after preaching at a revival in Ferriday, Jimmy was invited by Elmo and Mamie back to the new house Jerry Lee had bought them, to have some supper and spend the night. He pulled up to the house to see a driveway covered in Lincolns and Cadillacs, to be told by Mamie that Jerry Lee liked to drive a different one every now and then. He went back into a guest room to take off his suit—he just had the one—to find a closet full of expensive suits that belonged to his famous cousin. He reached into his pocket to find the offering for that evening's crusade, a single dollar bill and about a dollar fifty in change, and spread the money out on the bed. "Where are you, O Lord," he asked aloud, and he felt God's presence explode all around him, and he rededicated himself to the Lord right there next to Jerry Lee's closet, saying that even if he had to put pasteboard in his shoes, he would walk a righteous path and not be tempted by the mammon that had brought his cousin low.

"At first, I think Jimmy was scared for me . . . really scared for me," says Jerry Lee. "He saw the cars and the clothes, and he didn't dig that." But even as Jimmy's fame and fortune as a minister grew—and it would grow, hugely—it seemed as though his identity as a man of God remained bound to his wilder cousin.

There was only one other person in the world who halfway understood what was happening to Jerry Lee. "Elvis knew," he says, because he had lived it, too. They spent some evenings together at Graceland, Jerry Lee playing the piano. Sometimes he would play all night, Elvis just standing there by the piano, sometimes singing, sometimes lost in the past,

lost in thought. He looked, Jerry Lee says now, like he was dreaming standing up. Like a lot of people who had all they thought they would ever want, he had to travel back to a time when he didn't have it, didn't have any of it, to be happy. One night, Elvis asked him to play a song called "Come What May." Elvis "loved that song," Jerry Lee says:

> I am yours, you are mine, come what may.
> Love like ours remains divine, come what may.

Jerry Lee would finish, and Elvis would ask him to play it again and again, till the night passed into morning, like a tape stuck on a loop. "Over and over and over," says Jerry Lee, "I just kept playing."

He came to see Elvis as one of the loneliest and most insecure people he had ever known, at least among the famous people he had met. "He was just kinda damaged," Jerry Lee says now. It seemed to Jerry Lee like he was acting out a script written for him by people like Colonel Parker, playing the rock-and-roll idol, when all he really had to do was be one. "He was a good person," Jerry Lee says, but he was trying to please everybody, and that wore him down.

He had befriended him and accepted his friendship in return, and now, as his own career bloomed and his own records climbed the charts, was more determined than ever to take the crown. But in '57, after he had gotten to know him, gotten to see the good, almost guileless person he was underneath the stardom and the insecure boy who lived even deeper inside all that, it was complicated. One night, Elvis asked Jerry Lee if there was a song of his he wanted to hear. "I said, 'Yeah, "Jailhouse Rock," ' " half joking, because that was a big production number that a man does not begin to sing in a rumpus room. "But he did it live, did the whole thing. He did the dance and everything. All he was missing was the pole. And I was starting to think, *Dang, how long is this gonna go on?*" till finally Elvis had done the whole show, and there was nothing to do but applaud. It was one of the odder things Jerry Lee

had ever seen, Elvis standing there, taking his bow in an almost empty room.

The tension that Jerry Lee sensed between them would never go away and would grow over the years as their lives, in both similar and wildly different ways, grew more and more bizarre. But they remained friends as '57 vanished into history. Almost always, they wound up together at the piano; almost always, it was old love songs, generations old, or gospel that they sang. There was no tape this time. He was welcomed, Jerry Lee said, even after Elvis began to withdraw from the world of normal men, in part because among the armies of ass kissers who surrounded him, Jerry Lee never fit in.

"What do you think of my acting?" Elvis asked him.

"Well," Jerry Lee said, "you ain't no Clark Gable."

They talked about everything young men talk about—everything but the one thing that, as it turned out, both of them wondered about in the deepest parts of the night. Finally, Jerry Lee asked him the same thing he'd been bothering Sam Phillips about: "Can you play rock music . . . and still go to heaven? If you died, do you think you'd go to heaven or hell?"

Elvis looked startled, trapped. "His face turned bloodred," remembers Jerry Lee.

"Jerry Lee," he answered, "Don't you never ask me that. Don't you *never* ask me that again."

There is religion, and there is faith, in Jerry Lee's eyes. Religion is just religion; anyone can put a sign or symbol on a door, and claim it as faith, pray to it. But true faith is beautiful, and terrible. He and Elvis understood that. "We was raised in it," he says, "in the Assembly of God. . . . Him being Elvis, I thought he was the one person I *could* ask. Seems like sometimes we didn't have no one to talk to but each other.

"You'll be judged by the deeds you done. . . . And people don't want to believe all this kinda stuff, 'cause they're looking for . . . they're

searching for a way out." But there is no way, he says. There is only the judgment, in the end.

"I think it stuck with him a long time. I fought that battle myself. I do know Elvis cared for me. I know." They were true friends then. "He didn't come around much, after that. I could tell he was scared. So I never did ask him that again. And I never did get an answer, neither."

It would be hard to make up the life he briefly had, in '57 and into '58, a life ripped from the pages of one of his funny books, in which all the women were breathtaking, all the men heroic.

One day, on a trip to Los Angeles, he spent the afternoon with Elizabeth Taylor on the lot at MGM. She smiled at him with those otherworldly eyes, the most beautiful woman in the universe, and when he apologized for not being much of a talker, she told him it was all right, she was beset with talkers.

"Well, what do you think of it?" she asked Jerry Lee of the studio.

"I don't know. . . . What do you think?" he asked.

"I think it's pure shit," she told him (though he spells out the word when he tells the story now).

"I'm glad my mama didn't hear you say that," he said.

He met her because her husband, Mike Todd, knew his agent, Oscar Davis. The four of them went to dinner, and afterward, in their hotel room, "Elizabeth was sittin' right by me. . . . I ain't never seen a woman that beautiful in my life. I've seen a lot of other women, but that one took the cake. And Michael Todd said, 'Jerry, would you mind settin' here with Liz while me and Oscar go downtown here to a bar I know? We'll go have a couple drinks. We'll be right back.' He says, 'Will you kind of, just, look after her for me?'

"There I was, a boy from Louisiana, I didn't even know what was goin' on. All I knew was, Elizabeth Taylor was sittin' *right by me*. And

I *was her guardian.* I don't think I had enough sense at that time to be nervous. We talked for a long time."

He shared a marquee with Sam Cooke, who called him "cousin," a pure singer whose words seemed to linger on the stage even after he took his bow, like smoke rings in the air. He toured a circuit of all-black venues with Jackie Wilson, watched him glide across the planks like there was Crisco underneath his alligator shoes. "Jackie Wilson could blow you away, I tell you. He could do anything. Oh, man, what a singer." The two of them stayed friends till Wilson's death.

On the road, Patsy Cline pushed him into a bathroom and told him a dirty joke, sang "Walking After Midnight" like a honky-tonk angel just before he went onstage, then took a seat in the front row and wolf-whistled like a sailor. He saw a man named Ellas Otha Bates tuning an odd, box-shaped Stratocaster guitar with more unnecessary mess on it than a Shriner's hat turn into "Ladies and gentlemen, Mr. Bo Diddley" and lay down a beat onstage that was the bedrock of rock and roll. And he *heard it*, right there.

He heard "Wop bop a loo bop a lop bam boom" through a dressing room wall, screamed out by a man known as Little Richard, who wore more mascara than Cleopatra, who sang every breath like it was going down in history, like he would never have that chance again. "He was a trip," Jerry Lee says. "He was somethin' else." He was a great singer and wailer, but mostly a showman to his bones. "His voice *was* rock and roll."

He heard Ray Charles. "An utmost, really, genius. His personal knowledge was—it was incredible. He was just so *great* . . . such a *good man.* I'd go see him, he'd say, 'Hey, Jerry Lee, you're looking good!'" He still takes offense at the indignity Charles suffered when he was arrested for carrying heroin, "which he had been doin' for years. And they come down pretty hard on him for that. They didn't *understand,* you know?"

He met the greats, and some even cooked him supper. He chatted

with Fats Domino, and wondered, "Why do they call him Fats? He ain't fat. He just kinda *looked* fat. But he was a great piano player . . . humble as he could be. Cooked me beans and rice."

He marveled at the smooth vocals of the man they called Gentleman Jim Reeves, and sat with a despondent young man named Michael Landon after the moneymen tried to twist him into a teen idol. "I give up, Jerry Lee, 'cause I just ain't a singer," and the next time Jerry Lee saw him, he was riding across the Ponderosa in the same gray pants and green jacket every week, shooting the bad men with Hoss and Adam and Pa, and trying not to tick off Hop Sing.

He finally met one of the music's true beacons, the man who called on Beethoven to roll over and Johnny to be good—watched him take the stage, long and whipcord lean, moving with that easy grace, long arms and big hands dangling at his side, his anger at the white man still smoking because of the way they tried to box him out. That man took one look at Jerry Lee and his spine went stiff as a ladder-back chair, and promoters whispered, yes, there would be trouble here. "Chuck . . . Chuck Berry," says Jerry Lee, and shakes his head, smiling. And the promoters were right.

He stood in the wings as Buddy Holly, "who was a rocker, too, oh, yeah," screamed "all my life, I been a-waitin' " with as much raw passion as he had ever seen. Holly finally yielded the stage to him only after four encores but stayed backstage to watch and dance and whoop like a fan, yelling out, "Man, this is almost as good as Texas!" He was especially fond of Buddy. "A real champion," he says. "He was hotter'n a pistol, yeah. He done a great show. And he could play the guitar . . . as good as Chet Atkins. He was a gentleman, and he never lied, he never cheated or anything like that on his girlfriend."

He saw everyone, played with everyone, and it seemed that no matter where he played, he outdrew the big names who had played before him—even Sinatra, even Elvis—till he was at the top of every billing every day, which is where he should have been all along.

He is asked, after all this time, if there was ever anyone he was afraid to follow onstage—though *afraid* is probably too strong a word. He says there was one man.

"The only person I ever had a problem with, was Roy Hamilton."

Hamilton was a good-looking, lantern-jawed rhythm-and-blues singer from Leesburg, Georgia, who could croon and deliver some rockin' soul. He'd had operatic and classical voice training, had been a Golden Gloves boxer, and, like Jerry Lee, had started off singing in church. He influenced everyone from Elvis to the Righteous Brothers and sang his heart out onstage, from lungs already infected and weakened by the tuberculosis that would help kill him by age forty.

"He had some great songs—I mean, 'Ebb Tide,' 'Unchained Melody.' He had that record 'Don't Let Go.' He was just beginning to hit. We both were, really. I was doin' a show somewhere, and I was the star of the show. I was closing the show. And I heard him do *his* show. He closed his part of the show with that 'Hear that whistle? It's ten o'clock! Go, man, go! Go, man, go!' And he had these boys backing him up, singers—Get-a-Job Boys, they called themselves." (This was the Silhouettes, whose record "Get a Job" was their only hit.) "And they backed him on that, and it was tremendous.

"And I said, '*Man*, I got to follow *that* cat on the stage? I didn't like that at all. I said, 'That's an impossibility, to follow him onstage.' And his manager said, 'You're right, Jerry. You got your work cut out for you tonight.' I went out there and I opened up with 'Great Balls of Fire" and immediately went into 'Whole Lotta Shakin' Goin' On.' " He usually closed the shows with those records.

"I finally got their attention pretty good. But he . . . really done it. He should have closed that show."

But there was no time to be humble in '57. A great and fearful void had suddenly opened in rock and roll as Elvis prepared for his induction. And swaggering into that frightening place came that boy from Black River, playing his piano on a flatbed truck, but this time on a

Hollywood set, and it all made the fans fall out on the floor and the promoters smile that crocodile smile, till it was clear that the only person who could stop Jerry Lee from ascending the throne was Jerry Lee himself. The acclaim was not universal, but detractors were hooted down or their criticism dismissed as snobbery. Some critics sneered at him outright—not his music, but him, chided him for combing his hair onstage and other loutish behavior, while admitting, even though he beat the piano to death, he beat it in perfect key. "I didn't care one way or another, 'cause I wasn't doin' the show for them, anyway," he says.

Even Liberace, who could play the instrument with great skill beneath all that Old World lace and powder and Vegas glitter, marveled at this untrained boy's native ability. "He said, 'Nobody can play a piano, that fast, and hit the right notes . . . and sing at the same time,'" Jerry Lee remembers. "He said there must be another piano somewhere, hid." Finally, in Hot Springs, he came to see for himself. "He went backstage, where I was playing, and he set back there and watched and listened to me play. He didn't believe it till he saw it with his own eyes."

At Sun, the usually tightfisted Sam Phillips packed up thousands of records to give away at disc-jockey conventions, and Jud laid the groundwork for promoting the next record, another Otis Blackwell sure thing called "Breathless," with a campaign unlike anything the industry had ever seen before. They were men he trusted then, handling parts of the business he could not even pretend to care about. "I was paid to play piano and sing," he said, repeating another mantra he would hold to all his life, "not any of that other stuff." The business part of it—the production and bookings and all that junk—took something natural and bled the fun out of it. Playing piano, he would stress, was like making love to a woman, but he seduced *everybody*.

"Elvis, he charmed the women, and he leaned more toward the women in his music," he says. "The women was his deal. But I had the women *and* the men going crazy for me, because my music had guts."

In Graceland, Elvis watched Jerry Lee's hits march relentlessly past

his on the charts, and when hangers-on talked a little too much about the new boy, because they had all come to think of Jerry Lee as Elvis's friend, Elvis said to shut up.

The darker side of rock and roll was yet another thing he shared with Elvis. Since the days at the Wagon Wheel and Blue Cat Club in Natchez, he had been taking pills, pills to keep him sharp, keep him awake in the endless nights. He ate them like M&M's, those amphetamines. "People would just give me a handful—I'd put 'em in my shirt pocket, and reach in and get one." It became a kind of magic shirt with a bottomless pocket. People, believing they were helping him, would continue to do that for years, till "I had a full pocket of 'em, all the time. I don't think I ever was a full-fledged addict," he says, but that reliance on pills to make a show or get through one would deepen, worsen. At the time, in the mid- to late 1950s, he was indestructible, seemingly bulletproof. "But it was easy to get hooked on them pills, especially them pain pills," and the slow process of destroying his body, night after unrelenting night, had begun.

He was hardly the first. Country music stars had been hooked on amphetamines forever—for Hank Williams, it was morphine—and blues and jazz musicians had made the needle and reefer part of their national persona. But with Jerry Lee that kind of thing was more dangerous. As his daddy had discovered, he had no governor. He was quickly becoming known as not a rock-and-roll singer but a wild man who would outplay, outdrink, outfight and, well, out-*everything* anybody. He'd steal your girl-friend or your wife, in front of you, dare you to make something of it, and then leave you at the emergency room and her at the motor court.

Most of that is true, he says, but not so much the drinking. "I never drank that much liquor," he says, knowing that will probably make some people shake their heads and grin at the audacity of it. He did, he says, come to have a taste for Calvert Extra, "and I'd buy a fifth and set it on the piano lid. It kind of cleared my voice, usually." But it did not

take a lot of liquor to coax him into bad behavior. He was a fighter by nature—he liked the thrill of it then, when another man meant to cause him harm—and a lover, he says, by design.

"It's rough, when they're *beggin'* to get on your bus, or on the plane. It was real life. But it seemed like a dream."

The women—other men's wives, often—were another, more immediate threat. "I'd be playin', and I'd look up and see a bullet sittin' on top of the piano,' and I'd say, 'Oh, I wonder who left me this,' but I had a good idea who left it there. I showed it to the audience," further cementing his legend. He did not have a lot of respect for husbands who could not keep their women happy. He knew how to do it; if they didn't, they should try harder.

"I always had this dream, that I had a horse, this special horse, bullets wouldn't hurt it, and the horse had a speedometer on it, and it'd go sixty, a hundred miles an hour, and I'd set 'er on one hundred and we'd go jumpin' fences, wide-open across the land, and never got tired," he says, and smiles. "And I'd have a gun, the fastest gun, and no one could touch me." He is not certain what that dream means; he is not the kind of man to sit and wonder about dreams. But he has an idea.

Like men do, and have since the beginning of time, he saw no reason why he could not have everything, why he could not have the wild rock-and-roll life and all its excesses, and a family life to root him, to hold him, and there was still the ghost of his raisin' whispering always in his ear. "I *was* bad about gettin' married, though. You'd run into 'em that wouldn't turn you aloose, so you marry them. I'd just say, 'Ain't no use to count you out. The rest of 'em had it.'"

In Coro Lake, the ascending monarch strolled down the street with Myra, his biggest fan. He was still living there with J. W., Lois, the boy Rusty, and Myra. He had enough money to buy a mansion, would

have enough soon to buy his own Graceland, if he wanted to, but he didn't want a mansion, didn't want to be surrounded by yes men inside the walls and nutcases leaving love letters twisted in the iron of the gate. He liked being the richest perpetual houseguest in the history of Coro Lake, because he liked to be around Myra when he came home. She was slim, with wavy brown hair and a swan's neck and big, big eyes, and if she was a child, he was a Russian monkey cosmonaut.

"I'll race you," he said to her.

"You'll beat me easy," she said.

"I'll run back'ards," he said.

She took off, giggling.

Jerry Lee could fly, backward, a skill any man who has played some football must have and one a man who is prone to take other men's women would perhaps need. He was going full speed when he tried to swing around, lost his balance, "oh, man, it was an adventure," and went tumbling across the asphalt of East Shore Drive. He tried to catch himself but succeeded only in scraping much of the skin off the palms of his priceless hands. "Tore 'em up," he says. He was not badly hurt, but he did play his next show in bandages, and if there was any kind of warning in it, any irony, he missed it, but if he had caught it, he would have ignored it anyway.

"Myra was a twelve-year-old kid when I first got there. I paid no attention. . . . We wasn't doin' nothin' at that time. But I got to watching her, and she was a grown woman all of a sudden."

He always got what he wanted, and he wanted Myra. He did not ask himself what it would mean to his place in rock and roll's hierarchy or history, nor did he ask himself what society would think or demand in return—what penalty he would pay for not caring that he offended the sensibilities of more careful women and men. "I wasn't worried about my career," he says. "If I wanted to do something, I just did it."

Many people have asked why someone, anyone, did not explain it

all to him, that it didn't matter whether he considered it right or wrong
based on his culture. It was only that, if he was to be the new king of
rock and roll, there were customs and practices he would have to hold
to in order to rule in this wider world. But if anyone did see the danger
in what was happening in Coro Lake, anyone with any influence, they
either hoped it would go away or pretended, as money flowed in, that it
was not happening at all. But even if someone—Sam or Jud or someone
he trusted—had vigorously questioned Jerry Lee on his relationship
with Myra, he would have merely reared his head and hitched up his
pants, looked down at them from a high place, and told them nobody
handled him, then taken Myra to get a milk shake in his Cadillac, the
top cranked down so everyone could see.

"I used to take her to school," he said, wheeling up at the steps in
one of his big convertibles, the rest of the girls giggling and squealing at
her famous cousin. The legions who have condemned him for it, for ro-
mancing a thirteen-year-old girl, have painted a picture that had noth-
ing to do with reality, he said. His own sister married at twelve. People
celebrated it, because, as his mama said, the child knew her own mind.
Marriage to a girl of thirteen or fourteen was routine in his family's
history, and had been for as long as anyone could remember. It might
be offensive to some, to many, but it was what was.

"Myra was not a baby girl. She was a woman. She looked like a
grown woman, blossomed out and ready for plucking," he says now.
He does not care how that sounds, and says it, partly, just to show he
doesn't care. "She looked like a woman to me." She was not innocent of
boys, not the way books and movies tried to make it seem, he says, and
for months they had been kissing and making out. J. W. and Lois would
say they knew nothing about it, that they felt betrayed by Jerry Lee, but
he believes it would have been hard not to figure out that something
was going on in that house, especially if they had looked outside and
seen them in the car. They talked on the phone when he was on the
road and disappeared in his car almost the minute he got back. "She

was my third cousin, and when I talked to her on the phone, I'd say, 'How you doin', cuz?'

"One night, we parked out in front of the house. . . . After we got through, she started crying. 'Now I've done this,' and it wasn't the first time, 'you'll never marry me, will you?' I said, 'Sure.' And I lived up to my bargain.

"I thought about it," he says now, "about her being thirteen and all, but that didn't stop her from being a full-fledged woman."

Finally, J. W. did ask why he was calling the girl so much from the road, he would write in his own memoir, but it was too late to stop what was in motion.

"I wasn't even trying to hide her," says Jerry Lee. "I liked to ride around in them convertibles too much, and it's hard to hide a woman in one of those, 'specially if she's sittin' on my lap."

The fact that she was kin, his cousin, was also not troubling to him even in the least, because marriage between even first cousins was routine in his culture and certainly in his family line. If cousins had not married cousins, the great tribe in Concordia Parish would not have existed at all. It was not just accepted, it was, by all evidence, preferred. By such standards, a distant cousin was almost a rank stranger, a foreigner. "She was my third cousin. I was gonna marry her, either way," says Jerry Lee, "even if she was my sister. . . . Well, maybe I won't take it that far."

Jerry Lee's divorce from Jane was still not final in December of '57 and would not be for about five months, another of those ridiculous laws and conventions that should have had nothing to do with him. But he had filed his papers asking for it and so had she, so as far as he was concerned, that marriage was dead and done—Jane had kept custody of Jerry Lee Jr.—and he believed he was free to remarry. He had been taught that marriage was a covenant between a man, a woman, and God, a covenant no man could put asunder, but it was a fact of life that men and women fall in love and sometimes fall slap out, and marriages die. "I think the reason I kept gettin' married is I couldn't

find nobody," nobody lasting, he says. As that year wound to its close, with everything he had ever dreamed of in his reach, Jerry Lee drove due south in his Cadillac across the Tennessee state line into northern Mississippi, where marriage had always been an inexact science at best, allowable to almost anyone with a few dollars and a good story or a plausible lie. With Jerry Lee was a woman who went into the Jefferson County Courthouse that day and signed a legal document stating that her name was Myra Gayle Brown and she was twenty years old. Jerry Lee signed it too, and they drove back to Memphis with that silly little piece of red tape snipped clean in two. The real Myra was in Memphis that day, in seventh grade.

The second week in December, in a lull in his touring schedule, he proposed in the front seat of his Cadillac. Myra would write that she was frightened and reluctant and that he pressured her, but Jerry Lee does not recall any of that. "We was in front of her house, making a little love," he says, "and I said, 'You want to get married?' and she said, 'I don't see why not,' and we decided to get married."

The next day, on December 12, 1957, he drove south again, through the Christmas shopping traffic, with a Myra Gayle Brown beside him. Again he headed into Mississippi, to the town of Hernando in DeSoto County, where the young people of Memphis had been going for years to marry in secret. At about one o'clock in the afternoon, they pulled up to the chapel. The Reverend M. C. Whitten, a Baptist, performed the short ceremony, and with no family or friends to witness, Jerry Lee and Myra were married before God. The minister, who was accustomed to such things, did not question the union. There was no honeymoon—no possibility of one—so they drove back to Coro Lake. They told no one, because Myra was afraid of what her mother and father would say. Jerry Lee did not much care if they knew or not but agreed to wait, at least a little while, before telling his cousin J. W. that he was now his father-in-law, too.

He has been asked, a thousand times, if he loved the girl.

"At one time," he says, "I thought I did."

He thinks about it a moment, considering.

"There was love there."

It lasted about a week before they were found out, before a well-meaning maid saw a marriage license in a drawer and pointed it out to her parents. Here stories drastically differ. J. W. and Lois said they were stunned, shaken to their very core, heartbroken, incensed, and of course betrayed. J. W. also said it sent him into a killing rage, said he was bent on murder and didn't mind suffering the consequences, said he took after the boy in his car with a loaded pistol on the seat beside him. That might make for a good screenplay, said Jerry Lee, but it was not as dramatic as that.

"I wasn't running from J. W. I might have been drivin' a little fast," he said, smiling, "but I wasn't runnin'. He said he was gonna shoot me, but he wasn't gonna do nothin'." He doesn't even believe it was much of a shock to anyone except maybe Sam and Jud Phillips, who understood, immediately, the danger in it, not from J. W. but from the inevitable bad press.

J. W. did come into the Sun studio asking if Jerry Lee was there, and he did have a pistol with him—Jerry Lee maintains it was posturing—and Sam told him to sit his pistol-waving behind down and listen to reason.

"Now, J. W., I understand that you're mad, and I understand you want to shoot Jerry Lee," said Sam, intimating that there were many times he'd felt like doing it himself. "But you need to understand one thing, son. You can shoot him, but you'll make a whole lot more money not shooting him."

J. W. went home, and Jerry Lee went unshot.

"Talk is what talk is, just a bunch of yapping," says Jerry Lee. "I done what I wanted to do," and for J. W. or anyone else to pretend to be

shocked by that, to be caught flat-footed by his courtship of Myra, by the fact that it led to a wedding, is a revision of the way things were in those days, he believes.

He would be painted as a man leering over the cradle, while Myra would be depicted as either a nervous and confused little girl or a giddy, gushing schoolgirl, torn between puppy love and a great, deepening regret. In that portrait she seemed to go overnight from a child playing with dolls to a wife. Tearfully, in shame, she crammed her clothes and little girl's belongings into her dollhouse, the closest thing she had to a grown-up suitcase, and left the sanctuary of her parents' home. This would become the lasting and damning portrait of Jerry Lee, and many people believed no more damning than he deserved. But it was greatly exaggerated, says Jerry Lee. "When this so-called news broke, it was like I had committed an unforgivable sin," he says. "I did *not*."

The marriage was, to the outsiders who stumbled across it, puzzling. Myra was routinely pulled over by police when she went for a drive in one of Jerry Lee's Cadillacs, because they believed she was a teenager taking her parents' car out for a spin. Once she was detained and her car dismantled by police after she tried to pay for a meal with a hundred-dollar bill, the same day a nearby bank was robbed by someone matching her description; the police themselves were unable to decide if she was a child joyriding in her daddy's Caddy or a grown woman capable of sticking up a bank. But somehow the news of Jerry Lee's marriage to Myra mostly remained bottled up in Memphis and the surrounding area, contained by the river and the bluffs on the Arkansas side, the best-kept secret in rock and roll. For their first Christmas, Jerry Lee bought Myra a red convertible Cadillac of her own, with white leather interior.

J. W. even briefly considered filing criminal charges against Jerry Lee, but he let himself be talked out of that, too, by a prosecutor. "Talk . . . ain't . . . nothing," says Jerry Lee. "Me and J. W. never had no problem."

He told Myra's mother, Lois, that he loved her daughter, and told J. W. that he would take care of Myra, that she would never want for a thing, and that was the end of it, as far as he was concerned. "I've always tried to be nice to my women, buy 'em what they want, keep 'em satisfied, keep 'em in a pretty car," he says. He does not care that his attitudes about such things seem frozen in the past. It *was* the past, where this all happened, and it is where he is happiest, much of the time.

Jerry Lee and Myra went to New York City that Christmas so he could perform in a series of important holiday shows, and J. W. and Lois went with them. This was the controversial heyday of Alan Freed, the disc jockey who popularized the very words rock and roll for a national audience. Freed was putting on a package tour in New York that holiday season of a scope no one had ever seen. Fans hoping to get a seat in the Paramount Theater lined up for an entire block in midtown, pushed and shoved into place by police. Buddy Holly, Fats Domino, and Jerry Lee Lewis were headliners on a bill that would also include Paul Anka, the Everly Brothers, Frankie Lymon and the Teenagers, Danny and the Juniors, the Rays, Lee Andrews and the Hearts, and the Twin Tones, all crammed into a two-hour show that would be replayed throughout the day. Fights erupted on Forty-Third Street as fans pushed and fought to get in, smudging the face of rock and roll just a little bit more, but it was tame outside compared to the fit that Jerry Lee was pitching inside.

Buddy Holly would go on first among the headliners, and Freed wanted Jerry Lee to go on next, leaving the more established Fats and his orchestra to close the show. Fats had a whole stable of number one hits and was already a legend in his own time, truly, but Jerry Lee had the biggest record in the country in "Great Balls of Fire." The problem was, Fats's contract guaranteed him top billing in the show, and Fats's manager drew it like a gun. Jerry Lee had no choice but to go on before him—that, or walk—but as usual, when Jerry Lee Lewis

lost an argument, it meant there would soon be the sound of things breaking.

Jerry Lee took the stage to screams. On his newest hit, he beat the piano with every part of his body, elbows, feet, and derrière, beat like he was mad at it, and it was as if his sweltering music was some kind of contagion that spread to the crowd. Women fainted; hundreds, maybe more, mobbed the stage. Police formed a thin barrier as Jerry kept beating, beating, even as it began to dawn on him that what was happening in the audience was off the scale of anything he had seen, something that made the rabid girls in the Nashville National Guard Armory look like teatime at the Junior League. Some of the young people dove into the orchestra pit and clawed at Jerry Lee's legs, trying to tear off a piece of him to take home, till he snatched off his own shoes and hurled them away (one of them was said to have hit J. W. square in the face), till finally the band just had to flee the stage, leaving by a side door. He remembers it all, but it happened so often, he says, that it kind of runs together. "Seemed like it was *every* night."

Fats did his set in a decimated, shell-shocked room, with about half the seats empty, and told Freed if it was all the same to him, he would play before Jerry Lee from then on. The show broke quite a bit of furniture but also broke every attendance record the Paramount had ever set, and *Billboard* raved again, calling him "one of the most dynamic chanters on the current scene" and quoting Sam Phillips saying that Jerry Lee was "the most sensational performer I've ever watched, bar none," and everyone knew who the "bar none" was he was talking about. Myra, back at the hotel, saw none of the craziness, none of the excitement; she and Jerry Lee had a quiet supper in the hotel when he came back, like he was home from a long day of selling insurance. It would be his routine, to try and keep his home life and rock-and-roll life separate, or as separate as possible.

The year came to a close as the crowd roared in New York, first for Jerry Lee and then for that dropping ball, which seemed to signal not

just the passing of the year but the passing of the young, dark king and the rise of the young, fair one—though the people who love Elvis like a religion say that was not so then and will never be, because their King was so much more than just a singer of songs. In Memphis that winter, Elvis readied to leave for Germany and the Cold War; girls wept at the gates of Graceland and said they would wait on him for the two years of his hitch and forever if they had to. It was enough to know he was still out there somewhere, like a distant star.

But as far as Jerry Lee was concerned, it was over already and had been for some time. In the coming months, he had four substantial hits as Elvis slipped. But the people who said he yearned to be Elvis have it dead wrong, he said. He might have once wanted to be, when Elvis was the essence of rock and roll, but that had shifted, altered, become something else. "I wanted to play that piano and sing and make hit records, and not worry about nothin' except where my next check was coming from. . . . Naw, not even that." He wanted to stand at the zenith of rock and roll and hear the multitudes call his name, then take his bow. And when it was over, when he was home from the road, he did not want them to camp out on his lawn or block his driveway or twitch at the mere thought of him or any of that nonsense. He wanted both lives; he wanted everything.

It was awkward at best, living with J. W. and Lois, so he bought Myra a three-bedroom rancher in the quiet Memphis neighborhood of Whitehaven, on Dianne Drive, and in no time the driveway was clogged with big cars and other expensive toys. It cost about $14,000, an impossible dream for a man riding a garbage truck, a life's pursuit for a man laying brick, and one night's pay for Jerry Lee. Myra, though she was three years too young for a driver's license, continued to drive and continued to crash, and when Jerry Lee heard about it, he just laughed, because when you're a rock and roller, the Cadillacs, like the women, fall out of the trees, though now of course he'd have to throw the women back. Myra quit school and went about the business of being Mrs. Jerry Lee Lewis

full time, sometimes traveling with him, other times staying home. To help her with the loneliness, he would later buy her a poodle they named Dinky, though Dinky was said to be badly behaved, prone to accidents, and hard on furniture and carpet and nerves. But that was the kind of real-life problem that all real-life couples have, and it was real life there on Dianne Lane, except for the preponderance of Cadillacs.

Otis Blackwell's next great creation—he was as bankable as Coca-Cola—was something different, something without so much rough edge as his first contribution, "Great Balls of Fire," and certainly without the grit of Jerry Lee's first great hit, "Whole Lotta Shakin' Goin' On." But it was a singular song that moved fast and had nuances in almost every breath, spiced as always with Jerry Lee's signature rolling, thumping piano sound. It was not a one-take recording this time—it was a complicated song in some ways—but something Jerry Lee and the session men worked over and over till they came up with a song on which he almost wailed on one line and whispered on the next, a song that even now people have trouble trying to categorize or even explain. But if "Shakin'" and "Great Balls of Fire" were about sex, theorized music historians, then "Breathless" was about the feeling that came after.

> *My heart goes 'round and 'round*
> *My love comes tumblin' down*
> *You . . . leave me . . . breathless*

It was a slicker song, but Jerry Lee's piano gave it that locomotive quality, and his accent mussed its hair a little bit, and at the end of the day it was unmistakably him, but with a little wink to it. "I think it was a great song," he says. It was like Otis Blackwell was writing blank checks for the great singers to fill in.

With what he felt was another sure hit in the bank, Jerry Lee took Myra home to see his people and found no criticism of his marriage among the kin in Concordia Parish, and those were about the only people—outside of Sam and Jud Phillips, perhaps—whose opinions mattered to him all that much anyway. His cousin Jimmy, who had condemned pretty much everything about his life over the past few years, lambasting him to the point that his sins had become a kind of cottage industry on the Louisiana and Mississippi revival circuit, said not a word about his marriage to the girl. "Jimmy was human, too," Jerry Lee says, a mantra he would repeat over and over again where his cousin was concerned.

In January of '58, he left for his first real international tour that did not involve a Buick or a can of Vienna sausages. Though he was a little reluctant to fly that far over water, he boarded a plane for a whirlwind tour of Australia, with stops to perform shows coming and going in Hawaii. He would be playing, again, with his friend Buddy Holly, and with Paul Anka, the boy crooner whose "Diana" was one of the top hits in the country that year. He was glad to see Buddy, but not so much Paul Anka, whom he saw as an example of the slow softening and weakening of rock and roll, a purveyor of music that had no honky-tonk, juke joint, or even church in its makeup. Jerry Lee even now lacks the capacity to pretend to like someone, and he was not fond of the fifteen-year-old Anka, disliking him only slightly less than Pat Boone.

It was not a happy tour, clunked up as it was with child singers and big orchestras. It left him wishing he and Buddy Holly could just bust out on their own and go do some good, simple, driving rock and roll and leave this mess behind. He found some peace in Hawaii. "We spent the night at the Hilton, went swimming in that beautiful water, wasn't even scared of sharks." But the next night, in Sydney or some such place, he found himself in a backstage area crowded with unnecessary musicians

and difficult access to a bathroom, badly needing to pee. Desperate, he found an unguarded bottle of beer. He poured the beer in the trash, found a single, semisecluded corner of the staging area, and turning his back, let it go. He filled it up and set the bottle back where he found it. "I had to pee somewhere," he says, shrugging.

A large man, one of the musicians in the orchestra, walked up, took the bottle, and took a swig.

"Yeeeeaaaaggggghhhhh!"

He flung it down, cursing and spitting.

"Just name the man," he screamed to everyone there. "Just show me the man . . ."

His bandmates gathered 'round, ready to attack.

"I want to kill somebody!" the offended musician shouted.

"I don't blame you," Jerry Lee shouted back. "I would too."

He promised to help, because musicians had to stick together.

"I'll get him," Jerry Lee said. "I'll find him."

He walked away, as if hot in pursuit.

"He was a horn player. I think, the saxophone."

Anka, meanwhile, was getting on his nerves. He cannot recall exactly what it was about the boy; maybe just the fact he was so dad-gum nice, so good.

"He was a drip," Jerry Lee says.

Anka was a milk drinker. Jerry Lee told him it came from kangaroo, down here, or some other marsupial, and told him to have some beer.

"The guy who was watching after him was trying to get it on with this little ol' gal. . . . I got him a beer."

Anka, he says, liked the beer. "He drank all that beer and got knee-walkin' drunk, and we all walked up to the roof of the hotel. . . . Tallest building in Sydney, Australia, and it was only twelve stories high. But if you jumped off of it, it'd make a pretty good splash, I imagine."

Anka, he remembers, walked to the edge. "I don't like the way things are going," he said. "I think I'm just gonna jump. I'm gonna jump off this thing."

"That's a good idea, Paul," Jerry said, disgusted. "That's the very thing you ought to do." He sauntered over to the edge and looked down. "It's clear."

Buddy Holly, who was watching from a safe distance, got worried.

"He might do it, Jerry Lee," he said.

Jerry Lee looked at him and quickly shook his head.

"Well," Jerry Lee said to Anka, "jump."

Anka looked down.

"Well, you gonna jump, or you gonna make us stand here all night?"

Anka hesitated. "Well," he said finally, "I'm not gonna give you the satisfaction."

"Son," Jerry Lee said, "you better have some more beer."

The boy was never in danger, says Jerry Lee. "Nawwww, you couldn't have pushed him off. You couldn't have got him off of there with a bulldozer."

Buddy Holly, on the other hand, was smokin' then, one of the driving forces in rock and roll after less than a year of making the big time, and as Jerry Lee watched him on the stage in Australia and Hawaii, he knew that the climb, the race, was never over, never really won. "*Hmmmmm,* I remember thinkin', *this boy's gettin' pretty good.*" He opened for Elvis in Lubbock, caught the attention of a moneyman, and proved—even in those ugly black-frame spectacles—that he could rock it right down to the floor.

"He was my buddy."

A few months after that night, he says, the phone rang in his house in Memphis. Holly called him about every other week, and they would talk music and the rest of it.

That night, Buddy was happy.

"Jerry, I'm thinking about marrying this girl. Now, just what do you think I should do?"

"I really can't say, Buddy. I don't know what to tell you."

"Well, you've experienced it pretty good."

"Yeah, that's very true," Jerry Lee conceded. "That should tell you something."

But Buddy was serious. He wanted a real answer. "What do you think?"

"If it's what you want to do, do it."

Buddy went on to tell Jerry Lee about the girl, a beautiful girl he'd met in New York City named Maria Elena. He'd already proposed to her, it turned out—proposed on their very first date.

"If you love her," said Jerry Lee, "it don't matter what nobody else thinks."

"Breathless" sold a hundred thousand records that spring, and it climbed the charts, but it didn't shoot up as "Great Balls of Fire" had. " 'Great Balls of Fire' was number one for six weeks," said Jerry Lee, and had hovered at or near the top of the country-and-western, rhythm-and-blues, and pop charts. He performed "Breathless" in prime time on Dick Clark's evening variety show, but it still hadn't really broken loose. The song had a break in it that left people on the dance floor just kind of frozen in midstep, one of its quirks. "They learned how," said Jerry Lee. "I showed 'em how," but in the meantime Jud Phillips went searching for that one big shove.

Clark's nighttime program, *The Dick Clark Show*, was sponsored by Beech-Nut Gum, but Clark wasn't selling enough chewing gum to satisfy the sponsor, and Jud, hearing Clark's lament while they were out drinking in Manhattan, had an idea that would serve both the television host and Sun Records. For fifty cents and five Beech-Nut Gum

wrappers, Clark would give away a record of "Breathless." Beech-Nut was a strong gum that Jud said, grinning, left you "breathless." In three weeks, there were fifty thousand takers, and the demand kept swelling until the song busted into the top ten in every chart. And Jerry Lee just kept blazing, till the real rock-and-roll star, the genuine man, began to be swaddled in myths.

"I was in the William Morris Agency one day, up in New York," he remembers, "and there was this beautiful woman sitting behind the desk." As the receptionist listened, rapt, he regaled her with a mile-long line of talk, full of tales of rock-and-roll wildness, and the bottomland, and anything else he thought she wanted to hear.

Then something occurred to him.

"What if I told you that none of that was true?" he asked.

The woman looked stricken. "Please don't tell me that!" she said. "That's the Jerry Lee Lewis I *know*. The one people love."

Well, he told her, that's all right, it's all true. She relaxed, her dreams restored.

"Like I said, people like to remember things a certain way."

In March of '58, he traveled back to New York as a headliner of an Alan Freed package tour called The Big Beat, starring him, Buddy Holly, and Chuck Berry. Holly was almost congenial in agreeing to take third billing, but as the two other headliners came together backstage, it was like watching two trains closing in on a single track.

In some ways, he and Berry were much alike, perhaps even more alike than he and the outrageous piano player Little Richard, whom Jerry Lee had always admired. He and Berry were both natural show-men with original sounds; both took roots music and smelted and hammered it into the very design of rock and roll. Jerry Lee was a white man who could feast on traditionally black music; Chuck Berry could twang country with the white boys, could sound more Texas swing and

Opry than blues and R&B, and talked between sets like a New England schoolteacher. Like Jerry Lee, he lived with demons—different ones, but demons.

The older of the two, Berry had not grown up poor in St. Louis—his daddy was a deacon and his mother a school principal—but that did not protect him from bad decisions: he did three years for armed robbery in St. Louis, leaving jail on his twenty-first birthday. He hung bumpers on cars on an automobile assembly line, worked as a janitor in an apartment building, even worked as a beautician. He had always loved music and especially loved country and western. But when he heard the blues singer and guitarist T-Bone Walker, he knew he could play it just like that and make a dollar. He was denied the big stage for years as he fought his way into the spotlight, sometimes even turned away from his own bookings when club owners learned he was a black man. Like Jerry Lee, he had been influenced by the music of Jimmie Rodgers and Hank Williams, and even bluegrass greats like Bill Monroe. He went to Chicago to make his name—recommended to Chess Records by Muddy Waters—and had a hit with a rewrite of the old song "Ida Red," now renamed "Maybellene." It was a little country too, and in black clubs people grumbled a bit but then got up and danced to "that hillbilly black cat." He followed it with other hits, "Roll Over Beethoven" and "Johnny B. Goode" and "Sweet Little Sixteen," and suddenly rock and roll had a songbook. Jerry Lee and Elvis and other white rock singers of the era admired Chuck, especially that "Brown Eyed Handsome Man" song, but it wasn't until they toured together that Jerry Lee saw the man's showmanship; he wasn't concerned about who was the better musician—he knew that with certainty—but at least it would be a head worth taking.

With his litany of big hits piled up around him, Berry insisted on being given his due, and insisted that no one—no one—follow him onstage. In fact, just like Jerry Lee, he insisted no one could. He made a good case for it, putting on one of the most dynamic and unusual

rock-and-roll shows ever done, duckwalking as he played that white guitar, gliding across the stage on one foot, jerking and twisting and moving, spreading his legs out so far he almost did the splits, then hopping along the stage that way, a thing that might have ruined a lesser man or at least ruined the stitching in the straddle of his trousers. In the end, that was what people said about Chuck, as much as anything else: Chuck was a man. He'd had more women than most people had *thoughts* about them, and he'd done time on top of it all.

Jerry Lee didn't much care about any of that. He loved the man's music, and he respected him, but he had pulled himself up from nothing, too. They stood jaw to jaw backstage, one hot word away from fighting right there behind the curtain, with newspaper and magazine reporters everywhere and film and still cameras pointed from every direction. Jerry Lee's father had made the trip this time, and as he saw the man get right in his son's face he sidled closer. Elmo was of the school that believed no man should ever threaten another man more than once before knocking him down if not out, and he believed, too, that just because a man was down, you did not put the boot heels to him.

"Daddy didn't walk around no man . . . and neither did I," says Jerry Lee.

It was a bad time to inject violence of any kind into rock and roll. Crowds increasingly had been getting out of control, acting out, using the music as an excuse to steal, fight, cut, even riot; every teenager with a leather jacket was suddenly a desperado, a tough guy, or a moll. Freed, sensing potential disaster, took Jerry Lee aside and pleaded with him to let Berry close the show, almost as a humanitarian act. Jerry Lee didn't much care about Freed's anxiety, but in a way he knew it might be fun to show Chuck as he had shown Johnny Cash, as he'd shown poor Fats, as he'd shown everybody. Chuck may have *thought* no one could follow him onstage. Jerry Lee *knew* that no one on this earth could follow him. No matter where he was in the billing, he planned on being the last thought in the audience's heads when they left.

After Frankie Lymon, after the Chantels, and after Buddy Holly did his usual rockin' set, Jerry Lee took the stage of the Paramount Theater in Brooklyn in a jacket trimmed in the fake fur of some jungle cat and plowed into his boogie. He did "Breathless" and "Whole Lotta Shakin'," and by the time he got to "Great Balls of Fire" the crowd was already out of control and police were moving to cut off the inevitable mass lunge for the stage. He shot that piano stool backward with such force that it went clear off the stage, skittering into the wings and sending people leaping out of the way.

Then he did something that has been written about and argued about and celebrated and denied ever since: he reached inside the piano, took a small Coke bottle of clear liquid, and poured gasoline across the top of the instrument, then struck a match and set it aflame. "I just sprinkled a little bit on it," he says, but it went up with a *whoosh*! Instead of walking offstage, he just kept playing and playing as the piano burned, and the crowd screamed. Jerry Lee played, hunched over the flames, the smoke in his face and hair, till the song was done, and then swaggered off stage toward Chuck Berry.

"First time I ever saw a colored guy turn white," Jerry Lee says. He left the piano burning onstage. "They had to call the fire department and everything."

"I want to see you follow that, Chuck," he said, as he walked past Berry.

Some accounts—and there are several—say that he said, "Follow that, nigger," but he says he did not. There was no room for that mess then, in a music where color and style blended to make the music itself. But it is a fact that he immolated a piano, sent it straight to its ancestors, though even that story has shifted and changed over the years. In many interviews, he has flatly denied it, even gotten belligerent with the interviewer.

He also says he could swear it was outside Cincinnati where it happened. But it hardly matters now. "I do know I like to get in a lot of

trouble for that . . . for burning that piano. That story just kept blowing up. They just kept saying it."

The battle between the two men continued for years. In another show, after closing his regular show with "Great Balls of Fire," instead of yielding the stage to Chuck, he walked over and picked up a guitar.

He had been playing guitar since he was a little boy, picking out tunes on Elmo's old acoustic, as well as drums, violin, bass, and just about every string or percussion instrument used on a stage. He slipped the strap over his shoulder, took one long look over at Chuck, and started hollering:

> *Deep down in Louisiana close to New Orleans*
> *Way back up in the woods among the evergreens . . .*

Chuck stood with murder in his eye.

Jerry Lee kept playing.

"Finally, Chuck walked across the stage and sat down at the piano."

The crowd roared and roared, enjoying the joke, but Chuck was not smiling.

"He did not play very good piano," said Jerry Lee.

Later, in a hotel lobby, the two men clashed again.

"Chuck was poppin' off to me," says Jerry Lee. "We had been drinkin'."

"Me and you gonna get this straightened out," Chuck said, "straightened out right now."

Elmo, who had been drinking seriously, who drank like he drove nails and pulled corn, without resting, reached into his pocket, pulled out his Barlow knife, and slipped it under Chuck's chin.

"You know what we do to men like you back home?" he asked, keeping the tip of the blade pressed into the soft flesh of Chuck's jugular. "We cut their heads off and throw 'em in the Blue Hole."

Jerry Lee can still see his daddy standing there, can remember

thinking that it would be a sight if his daddy murdered Chuck Berry. He did not quite know how he would explain it to his mama, who loved Chuck's music—maybe just by saying that Chuck was being mean to him. Then she would not only understand but be in agreement.

Chuck was a fearsome man, but Elmo, even deep into middle age, had not declined much; he still looked like he could do what he said, and might enjoy it. "Well, Chuck took off running, and Daddy took off running after him."

Alan Freed, who was standing steps away, asked Jerry Lee, "You think he'll catch him?"

"I don't know," said Jerry Lee.

They took off running after them.

"But we gave out," remembered Jerry Lee, "and set down on the curb."

He did not see his father that night—"like I said, we was drinkin' "—and after a while the prospect of Elmo's taking Chuck Berry's life became less compelling, and he went to bed.

"The next morning, Chuck and Daddy was sitting together in the hotel café, eatin' breakfast."

The show moved around the Northeast and finally to Boston in May.

"Boston had banned rock and roll," says Jerry Lee.

It was as though the crowd came into the Boston Arena intending to give the city fathers exactly the ugliness and violence they had warned would occur if the paganism of rock and roll was allowed to flourish. Jerry Lee could feel it, an ugliness beyond the usual good-natured hysteria that followed a great show. But they had paid their money and come expecting to hear his music. "You give 'em what they deserve," he said, "always." But he had barely started playing when the crowd rushed forward and began to push and swell against the police cordon, bulging out toward the stage like some kind of blob from a science-

fiction movie. "The cops were holding 'em back, tryin' to hold 'em back, and I was thinkin', *Please don't turn them people loose on me.* But they mobbed the stage and got to fightin' and carryin' on." Riots broke out around the city; the teenagers put on their leather jackets, to be dangerous, and looted stores, and stabbed at old people and other helpless people with their knives, and the enemies of rock and roll said, "See? See what happens?"

"I just kind of snuck out," said Jerry Lee. The prosecutors in Boston tried to charge Alan Freed with anarchy, with trying to overthrow the actual government, but it was hard to make those charges stick, since a bunch of dumbasses throwing bricks and waving switchblades could not be proven to be an actual armed revolt. Jerry Lee was not trying to overthrow the government; he was singing rock and roll and truly did not understand how that would make you want to do anything bad, beyond some spur-of-the-moment fornication.

In Haney's, when people took to fighting, the floorwalkers came up and cracked some heads and dragged the offenders out into the weeds, and the music never stopped. But what do you do when the stage you are playing on really is the world itself, and there ain't a bouncer big enough to straighten out all the fools who use the music as an excuse to debase themselves and attack their fellow man? Jerry Lee did not believe he was making good people into bad people or making bad people worse. He believed that any such urge must have been in a person or not before they ever bought a ticket. So he just kept pounding, and his stage shows got wilder, but it was always just a show. "People come to expect things a certain way, and they're disappointed if you do it different," he says. So he kicked the stool, and beat the keys with his whole body, and went wild—every time.

He says adamantly that he rarely abused a good piano, but promoters had seen him go wild so often on the keyboards, seen him pound the keys with his feet and other body parts, that some gave him inferior pianos to play. He could get more out of a mediocre piano than most,

but could not get great sound out of a hulk, out of a wreck, and one night in Florida he lost his temper and pushed the piano offstage, down a ramp, and out a stage door. "It was harder to do than you would think," rolling it down a sidewalk with half the audience running along beside him.

"What you doin', Jerry Lee?" they cried.

"I'm takin' it swimmin'," he shouted back.

He wasn't sure if he could actually make it to the water, but the topography was in his favor, and he pushed and pushed till all at once there was a great splash and the people cheered and cheered. "It's insulting," he says, "to give a bad piano to a piano player like me."

That spring, even as Jimmy Lee drove around condemning evil and immorality like he'd just discovered them, his cousin's music became the soundtrack for a movie about smoking dope and blond hussies in tight pedal-pushers doing God knows what on a drive-in screen the size of the First State Bank of Louisiana.

High School Confidential, directed by Jack Arnold, the same man who gave America the horror classic *Creature from the Black Lagoon*, was the story of an undercover agent, played by Russ Tamblyn, who wades into the dark jungle of a public high school to confront a plague of demon marijuana. Designed to capitalize on the cravings of American teenagers of that time to rebel against something, for God's sake, anything, *High School Confidential* was about drag racing and delinquents but mostly dwelled on the dimensions of Mamie Van Doren, the villain's squeeze. And while that was a hard show to steal, Jerry Lee did steal it, shouting the title song from the bed of an old 1940s-era pickup truck, banging that dead piano the same way Gene Autry sang to his horse Champion, till no one could tell, not in a million years, that the real version of the song was recorded back at Sun, and all this stuff was just pretend.

Honey, get your boppin' shoes, before the jukebox blows a fuse.

The song, written by Ronald Hargrave, was done for another low-budget, quickly made B movie, but its singer was Midas then, and the song took hold with live audiences and appeared to be another sure hit whenever Sun got around to releasing it. Jud and Sam celebrated another freight-car load of free publicity, as the movie opened around the country with the voice and face of their star looking down from the big screen.

With such a hurricane wind at his back, how could it not last forever?

His friendship with Elvis had faded as his own star rose, as Elvis hid more and more at Graceland in the company of his family and friends and employees—when you could tell the difference—and finally shipped off to Europe. It was surprising how different their lives were starting to seem, these two boys born in the bared teeth of the Depression South, with mamas they loved above all others and daddies who drank and did time in prison and a brother who died, leaving their parents to pour all their love and hope for a better life into the living son. Elvis's parents had bought him his first instrument, and he learned to make music by watching people around him, studying, absorbing everything he could from the black people in the fields and the white people in church, and on weekends he gathered with his people around the radio to hear the Opry and Hayride, and snuck off to hear hillbilly blues on WELO in Tupelo, hosted by a singer named Mississippi Slim. They were brothers, the blond boy and the dark boy, separated only by three hundred miles of cotton fields. They had both taken the music of their South, black and white, hillbilly and blues, and made it shake. They were alike, those boys, but not the same.

A few months before, as if in some crazy moment of déjà vu, Jerry Lee was lounging around Sun when he saw Sam come walking toward him through the usual crowd of hopefuls and hangers-on.

"Are you gonna be here a while?" Sam asked.

"Sure," said Jerry Lee. "Why?"

"Elvis called, and said he wants to see you."

It was like someone had just rewound time to the day he first met Elvis, not much more than a year before. The difference was in Sam himself. He was a smiling man by nature, a hand-gripper and an arm-squeezer. You made contacts, smiling like that, made money. But he was not smiling now.

Elvis, Jerry Lee believes, wore a mask in the winter of 1958, in those last months before he left. He made himself appear stoic, brave, patriotic, the face Colonel Tom Parker decided he would show reporters and weeping fans as his induction neared. Elvis talked of doing his duty. He would not ask for special treatment, would not become a singing serviceman but would wait to be selected, go where the army's bureaucracy decided he would go, and live off his seventy-eight dollars a month instead of whatever unearthly amount he was making back home. If the army decided he should peel potatoes and tote a rifle in the Cold War he would do it, because the Colonel had decided that was the best of all outcomes to this train wreck of dreams. But that was not the face that looked back at him in the mirror in his mansion on the hill, or the face he pressed to the telephone when he sobbed to his mama, telling her he would just disappear into those two long years; the world would move on to other talented boys.

That face, the haunted one, was the one Jerry Lee saw staring into his through the glass at Sun Records, as Elvis opened the door and walked up to him. They shook hands, but Elvis just stood there, as if he was a little lost.

"You got it. Take it," he said to Jerry Lee. "Take the whole damn thing."

Then, Jerry Lee recalls, Elvis started to cry.

"It happened. It did," Jerry Lee says. He just stood there, awkward, frozen. Grown men only cried when their mamas died, or maybe their children, and when they were in the grip of the Holy Ghost. They did not cry before other men, in a lobby crowded with people in the middle of the afternoon. He remembers how the room went quiet. "They didn't say a word, them people. They didn't even move." He remembers trying not to look at Elvis, trying to look at anything else, at the drab green walls covered in that ugly surplus paint. He remembers the dust on the tiles, and secretary Sally Wilbourn looking up from the desk, her face bleak. He remembers Sam coming up from the back to handle things, how he came to stand at Elvis's side, nodding his head, gently, talking softly, saying it's all right, son, it's gonna be all right. Finally, there was nowhere else to look, and Jerry Lee will never forget the tears running down Elvis's cheeks.

"You can have it," Elvis told him.

"I didn't know," Jerry Lee told him, "it meant that much to you."

What he meant by that, he says now, was that he knew Elvis had already moved on to Hollywood, that he was inching away from the music that had made him. He seemed headed for a life of soft ballads and pop music, says Jerry Lee, because what Elvis really wanted to be, and what he told people he wanted to be, was "a good actor," and, failing that, he might have to settle for just being a movie star. But in '58 he was still the king, and with the induction just days away and the blond-haired boy rising, rising, he believed his time was over.

"That ain't nothing to cry about," he said, like they were little boys on a playground.

Elvis broke down, sobbing.

"I just wondered . . ." he said, but could not finish.

"What?" said Jerry Lee.

"I just wondered," Elvis said, "why you didn't have to go. Why do I have to go and do eighteen months and you don't have to?"

"'Cause I ain't that crazy," he said.

After he threw that first notice into the Black River, no one had ever pursued it. Besides, he says, he had already been rejected years before. "I tried to enlist, then, with Arnell Tipton, to go fight in Korea. 'You're 4F,' they told me. Said there was something medically wrong. I really don't know what they thought. I wanted to go. They said, 'We'll take Arnell.' And as soon he got over there, a sniper killed him."

Elvis had seemed angry when he came in—Jerry Lee knew how to handle anger, knew how to rise to another man's anger the way a game rooster knows—but now he just seemed like his heart was broken. "He was not just crying, he was sobbing. . . . I didn't know how to handle it."

He felt Sam's hand on his arm, tugging.

"He'll be all right," Sam said, softly. "Elvis is emotional. He'll be all right, just ignore him. Pay no attention to him. He'll quit here in a minute."

So Jerry Lee stepped away.

This was not how he had imagined it, not how he wanted it.

"I wasn't likin' this," he says, thinking back.

He wanted to be thought of as the best rock and roller there was, but he wanted to take it one hit record at a time.

Finally, Elvis dried his eyes and just walked out the door.

"Sally Wilbourn and the rest of them people hung their heads. They wouldn't even look at me."

"It was . . . a sad thing, a sad scene. Not something I would ever care to go through again." Both young men were embarking on great and uncertain journeys, Elvis to Germany, and Jerry Lee on a trip to England that would change his life. It was devised by his manager, Oscar Davis, and the William Morris Agency, designed to expand his overseas fan base through some thirty-six theater shows over six weeks. It would put some serious cash in his pocket—he was said to be pulling fees upwards of $30,000 a show—and Sam and Jud were hoping the tour would make

him a true star overseas, just as Sun released his first long-playing album at home. "Whole Lotta Shakin'" and "Great Balls of Fire" had already been hits in England, "Breathless" was moving strong into the top ten there, and "High School Confidential" had just landed. The timing, it seemed, was perfect.

The only foreseeable complication was Jerry Lee's new bride, Myra—whether the British would take to her. Sam and Jud urged him not to bring her along on the trip, to keep her a secret at least a little longer. But he said no, he would not do that; Myra deserved the trip, and he had nothing to be ashamed of and neither had she. Besides, his fame was growing so swiftly and surely that he ought to be able to absorb a little bad publicity if it came. He really believed there were things in his life that were the world's business and things that were his business, like the things that happened between a man and his wife. He believed it.

After all, he was the king of rock and roll. Elvis had said so. And one thing was for sure: he would never give it up, never just hand it off in tears. They would have to take it from him.

8

ENGLAND

. .

London

1 9 5 8

It was quite a sendoff, that May. They followed him cheering through the streets of his hometown, hundreds of them, which was a lot in a place the size of Ferriday. It had been decreed by an act of the city council to be Jerry Lee Lewis Day, May 17, 1958, and instead of the quiet ceremony and polite applause that usually followed such things, there was a great upheaval in the low, flat land. They came walking in their overalls and oil-stained khakis and faded flower-print dresses to take a small part in celebration of the fearless boy who dangled from the high iron, who took the music from their dirt and made it something the rich folks and even the Yankees paid money to hear, and if that was not by God a trick, they didn't know what was. They left their little wood-frame houses and hurried across the crawfish dirt that had soaked up a thousand years of floods, queuing up for a city block. Then the drum major struck up the band and they marched, through the good smells of Brocato's Restaurant, by the little church where he forgot which song he was to play, and along streets where he walked coming home from the late-night show, watching for werewolves. They marched past the

cotton buyers in their bow ties and the boys dumping ice on the catfish, buffalo, and gar at the fish stand, marched behind the black and gold of the Ferriday High School Marching Trojans, which blared out "When the Saints Go Marching In." And at the head of it all, reclining in his chariot, was the shining man, golden hair tousled and gleaming. He rode in a new 1959 Cadillac convertible, fins so sharp you could hurt yourself. "The last really pretty car," he says. "Hasn't been a really pretty car, since the fifties."

Just a few days before, on the thirteenth, Jane Mitcham Lewis and Jerry Lee Lewis had been officially and finally divorced. Immediately afterward, Jane stood on the steps of the Shelby County Courthouse in Memphis and told a reporter with the *Press-Scimitar* not only that she was still in love with Jerry Lee but that she planned to do everything she could to reconcile and rekindle their romance. It was not an unusual thing, such a declaration; there is just something about a divorce that gets people to thinking of romance. Jerry Lee just knew he was down to one wife again, at least, and did not think on it anymore. He couldn't see how it had much bearing on this day or any of the perfect days to come.

After the parade, after the home folks had trickled back to their homes, he would go to the new house he had bought for his mama and daddy here in Ferriday, the one with the driveway lined with gleaming Detroit steel, and he would eat his mama's fine cooking prepared on her brand-new stove, then drive back to the high school and play a dance in the gymnasium out of the goodness of his heart. Then he would rush back to Memphis to fly away, first to the bright lights and unchecked room service of New York, then to the British Isles for a five-week tour that would make him an international star. And if he happened to see his cousin Jimmy while he was home, he'd tell him he'd decided to buy him a new car, too, a brand-new '58 Oldsmobile for him to drive on the revival circuit even as he preached against rock and roll, so that he could better do God's work. But for now, for just a few blocks more,

he rode in that new leather, face to the sun, his future limitless, his conscience clear.

Jud met Jerry Lee in New York to try once more to talk him into keeping Myra a secret at least until the tour was over, to just not mention the marriage if he was unwilling to leave her behind altogether. Somehow Jerry Lee and Myra had remained mostly undiscovered outside Dianne Lane, but Jerry Lee had his back up about the England trip and said they would not sneak around in England. "She's my wife," said Jerry Lee. He would not hide her by leaving her behind. "That wasn't right. That wasn't right at all," he says now. "I was *glad* it was gonna be out in the open. I wasn't hidin' nothin'," he says, something he has stressed again and again. "I was out in the open with *everything*."

"If you do this," Jud told him, "you're gonna flush the greatest talent that this country's ever seen right down the commode."

He could not imagine going to Myra at the last minute and telling her that, out of fear over what might happen, he, Jerry Lee Lewis, was going to slink off to England alone. Myra and Frankie Jean were looking forward to a great vacation of shopping and sightseeing while he played his shows. To leave Myra behind, he says now, would have been to admit he was ashamed of her and what he had done by marrying her, but he was not, and in that conviction he was trapped. They all were. Jud went back to Memphis to closet himself with Sam and worry, and—it would come out later—to start planning for the fallout they knew was coming. They could feel it, the way you can feel lightning pull at the hairs of your arms before it strikes.

A harbinger of things to come waited for them in New York. Dick Clark, whose career had been greatly served by the rise of Jerry Lee Lewis, whose Saturday evening show had been pulled from the fire by the Beech-Nut–"Breathless" collaboration, had scheduled Jerry Lee for the Saturday before he left for England. But then suddenly, after a mys-

terious phone call in the middle of the night warning that Jerry Lee was about to be wrapped in scandal, Clark canceled him. "After we took him nationwide," says Jerry Lee.

To him, it was hysteria over nothing.

"Stupid," he says.

It began on May 21, 1958. Jerry Lee, Myra, Jerry Lee's sister Frankie Jean, the drummer Russ Smith, J. W., Lois, and the little boy Rusty arrived in New York, to be joined there by old Oscar Davis, the man who had managed Hank Williams. Jud was there, to wish them bon voyage. Jerry Lee wanted his mama and daddy to go, but they had never been on a plane before. Elmo and Mamie had traveled before to see their son, and they loved the fancy hotels—Elmo thought room service meant he had his own butler—but the New York to London flight, ten hours in all, was over water all the way, and Mamie didn't think her nerves could take it.

They almost didn't make it to England at all. The number two engine on the plane carrying the entourage burst into flames, raining small pieces of itself down over the Atlantic, and the pilot made an emergency landing in Ireland. The group boarded another plane and finally landed at Heathrow on the evening of the twenty-second. There an immigration official looked at Myra, at her passport, at her boarding card, and back at her face. "It was noted that the date of birth shown on her passport was 11 July, 1944," wrote A. R. Thomas in his report on the arrival of Mrs. Lewis. "This seemed to be an unusually young age for a married woman, but since both parties come from the Southeastern part of the United States, where the legal age for marriage is lower than is usual in other parts of the world, no action on my part seemed to be called for. Mrs. Lewis' appearance was fairly well in keeping with her age, although she might have passed for a couple of years older. She was as tall as an average fully-grown woman. . . ."

There was some hope that Myra might pass unnoticed through the airport and into the semiprivacy of a hotel with the rest of the entourage, some hope that Jerry Lee, with the power of his music, could somehow preempt any coming disaster or at least get through his shows and return safely to America, where the story might be, if not contained, at least spread out a little more, in the way a firecracker does less damage on a driveway than it does under a tin can. There was no hope that the British would understand, or accept. The British were not built that way, and their own rock-and-roll revolution was at the time merely in the grumbling stage. Though the young people of the British Isles hungered and clamored for American rock and roll, the politicians and ruling class were highly suspicious at best of the wild boy from the American South and were already harrumphing mightily.

England took itself quite seriously in 1958, and with every right. It seemed like just yesterday that a German madman had sent bombers across the Channel to flatten whole blocks of London. V-1 and V-2 rockets had rained upon them from space itself, and they had buried their dead and soldiered on, as if the whole ordeal had merely chipped some old crockery and run them late for tea.

But the reporters here were of a different stripe from those Jerry Lee had encountered in the radio stations and on the music beats back in the States, where a manager or studio executive might still slap a young music scribe on the back and buy him a whiskey or six to keep a rumor bottled up just a little while longer. Here, reporters joked, there had not been a really good story since the surrender, and the country's own pioneering rock and rollers were of such a milksop variety, most of them, that they were never considered much of a threat. But the papers loved a smashing scandal, and if outrage was unavailable, then feigned outrage would do just as well.

From Customs, Jerry Lee and Myra walked straight into a battery of blinding flashbulbs and shouted questions from a small mob of reporters. One reporter broke from the mob chasing Jerry Lee and asked

Myra who she was, and of course she answered him. "Jerry's wife," she told him, and though Oscar Davis hustled her away, it was too late.

The reporters, who are paid to dig, dug at first just a little, and Jerry Lee, sensing that what Jud had warned of was coming true, told them that Myra was fifteen, but when asked if it was his first marriage, he replied that no, sir, it was his third. That alone was enough for a scandal, and the more Jerry Lee and Myra tried to answer the reporters' questions, the more they constructed their own gallows.

When reporters asked Myra if she didn't think she was a tad young to be married, she replied that age doesn't matter back in Tennessee. "You can get married at ten, if you can find a husband," she said.

When a reporter asked Jerry Lee if Myra was too young, he replied, "Look at her."

The morning after their arrival, the newsboys waved the headlines at the passing cars.

JERRY BRINGS WIFE NO. 3, FAIR AND 15
(Like a Well-Scrubbed Fourth-Former!)

Looking at the headlines from those few days in May of '58, you'd think Jerry Lee Lewis wasn't a rock-and-roll singer at all, but an invader come ashore uninvited in the middle of a royal wedding, tracking mud through the Church of England. He still has trouble finding the sense in it, even after all this time. He does not agree with much of the history that has been written about it all these years, does not agree that the British people—or at least the rock-and-roll fans who had clamored for his visit there—suddenly turned on him en masse, because he remembers more chants of worship than cries of derision. He does not remember it as history does, and so it is ridiculous to waste his time or his thoughts on it for very long. He is not just being belligerent. He knows it was bad for him in the end. But he still cannot see the great sin

the London press used to crucify him, cannot fathom what the big deal was and what people were so upset about, as a growing frenzy of self-righteous indignation and overinflated condemnation slammed into his marriage and career one newspaper at a time.

"It wasn't nothin'," he says.

He shakes his head, incredulous.

"I mean, it wasn't *nothin'*."

As scandals go, it was an odd one. There was some subterfuge in it, and considerable lying on the part of his manager and even a little himself, but not very good lying. But the fundamental fact is, it all happened because Jerry Lee was not trying to hide Myra—even if he did try to fudge her age—and when the news of it swelled into scandal, the people around him acted like they'd never met the girl, or feigned outrage of their own, or ran and hid. Instead of damage control, the people who might have rallied around him instead blundered around the Westbury Hotel, while Jerry Lee himself gave interviews in which he intended to explain himself but only poured kerosene on the roaring fire.

"They come down on us hard," he says. Neither Jerry Lee nor Myra understood that what they said to the press would be used against them in sneering contempt, and it got worse with almost every hour. The papers painted a picture of hillbilly culture gone mad, and it seemed like every move he and his entourage made only riveted the image further in the minds of readers. One reporter wrote that he interviewed Myra's mother, Lois, in her nightgown, clutching a sheet to herself, talking about how they would all have to get to the bottom of these charges right away. Every other story seemed to mention that a member of the entourage was in some stage of undress—even elegant old Oscar Davis, who apparently came to the door in his boxer shorts. They quoted Myra as saying that Jerry Lee had given her a red Cadillac for Christmas, but

that she sure wished she had a wedding ring, though. "Gee, it's fun being married," she said. "The girls back at the school were mighty envious when I married [Jerry Lee]." Jerry Lee himself told the reporters, "I'm real happy with my third wife." And all this was said *before* the first press conference. Oscar Davis, apparently living in some alternative universe where reporters do not recognize a diamond mine when they blunder into it, had merely pulled one reporter aside and told him not to print any of it, to respect their privacy.

Jerry Lee never doubted, even as he rode to his first show in the back of his limousine, that he would blow it all away once he took the stage, that he would just send the damning stories and the accusing headlines into scrap on the London sidewalk. The reporters had taken their efforts to be polite and twisted it into something ugly, but the reporters were not the reason he was in England. "I came to play rock and roll," he says.

The first show was at a sold-out theater in Edmonton, in northeast London. Two thousand people waited quietly and politely for a taste of real American rock and roll. Warming up for Jerry Lee were the Treniers, identical twins Claude and Cliff Trenier out of Mobile, Alabama, a dynamic twosome who had successfully made the turn from jump blues to rock and roll and were considered pioneers of the music. They had a naughty song called "Poontang," but they elected not to play that in Edmonton, doing their more palatable songs to polite and friendly applause before leaving the stage to make room for the main event. Unlike fans in America, those waiting for Jerry Lee neither stomped nor cheered, merely waited with polite and reserved anticipation. To Jerry Lee, it was a little off-putting. He believes it would have been a different story, a different England, if only he could have played first, before the newspapers put the bootheels to him, if the music had been the story that rocketed around the country in the first few days of his tour.

He could have acted contrite, could even have toned down his attire a little, to bow at least slightly to what was happening all around him in

this foreign and hostile place, but to Jerry Lee that would have been more like a curtsy. He ascended the stage at the Regal Theater in perhaps the most written-about outfit in British history outside of a royal wedding: a hot-pink suit with sparkly lapels. As he swaggered across the stage, the people applauded with reserved vigor, which was less than he was used to but still far from hostile. He did a few songs, starting slow, and the crowd was blank and unresponsive. He took a break, as some idiot in the crowd sang a snatch or two from "God Save the Queen," then came back to the stage and did it up right, gave them a good, hard jab of rock and roll, and he remembers that they cheered louder then, cheered the way people were supposed to cheer when Jerry Lee Lewis played the piano. He does not recall any ugliness, any jeers, any meanness, and when it was over, he figured everything in England was going to be fine.

But the press was only getting started, and now reporters in London and Memphis were digging into the near past. Some seemed content to flog Jerry Lee with opinion pieces and old news, but the *Daily Mirror* dug deeper, and in public records back in the United States discovered that Myra was not fifteen at all, but only thirteen, and that Jerry Lee was not divorced from Jane when he and Myra were wed, and that she was his cousin, and the sum total of all that was the hottest rock-and-roll star in the world was in London cohabiting with a thirteen-year-old relative who was not legally his wife.

That news made the British press nearly hysterical. Jerry Lee, having tried unsuccessfully to soften the matter by fudging Myra's age and date of the marriage, now pretty much told it all to reporters who could barely believe their luck. He told about Dorothy and about the shotgun wedding to the pregnant Jane—all of it—believing that surely they would understand that it didn't matter that he married Myra before he was divorced from Jane because, in a way, he was not really married to Jane, having still been married to Dorothy. He appealed to them as men, telling reporters about how Jane's father and brothers came to him "with hide whips."

"I was a young fool when I married at fourteen and sixteen," he told them. "My father should have put a foot on my neck and beaten a worm out of me."

It seemed like plain talk to him, the way men talked to men. Surely they would understand.

They did not. They went almost giddy when Jerry Lee told them that he married bigamously. The headlines grew uglier, and he became not a singer with a few secrets but an international incident. He played a second show, this time in London proper, to a four-thousand-seat theater, but it was less than half full. Outside, newsboys waved the late edition.

CLEAR OUT THIS GANG!

As Jerry Lee will tell you, the fans still lined the sidewalks of the Westbury Hotel in Mayfair, just hoping to get a look at him. He does not believe they had turned on him.

"The newspapers did all they could to destroy us," he said. "The things they wrote . . ."

In the papers, he was presented as some kind of serious threat, an example of the unlettered Southern American at his virulent worst. Oscar Davis, apparently believing it was his reputation he was supposed to safeguard instead of his star's, abandoned Jerry Lee completely, announcing that he was as surprised by the news of Jerry Lee's marital tangles as everyone else and that he knew nothing of any marriages or of Myra's age, making him perhaps the least-informed manager and acting publicist in rock-and-roll history. Even the British government took a hand in the affair, sending officers from the Home Office to inspect Jerry Lee's and Myra's passports and immigration status. The headlines screamed:

BABY SNATCHER!
'GO HOME'
CROWD SHOUTS AT SINGER

'WE HATE JERRY'
SHOUT EX-FANS

Spokesmen from the theater chain that had hired Jerry Lee said that
if they had known of his past, they never would have hired him. Col-
umnists called for his arrest and deportation and for an investigation by
the child welfare office. Even Parliament weighed in. Sir Frank Medli-
cott, of the constituency of Norfolk Central in the House of Commons,
questioned why a man of such nefariousness was granted a permit to
work, prompting this exchange between the lord and the minister of
labor, Iain MacLeod:

MEDLICOTT: "Is my right honorable friend aware that great of-
fense was caused to many people by the arrival of this man, with
his thirteen-year-old bride? Will he remember also that we have
enough 'rock and roll' entertainers of our own without importing
them from overseas?"

MACLEOD: "This was, of course, a thoroughly unpleasant case."

Young women who had once professed to love him announced they
were going home to smash his records. At a show in Tooting, South
London, fans chanted "We Hate Jerry!" and cried "Cradle Robber!"
from the audience. Offstage, Jerry Lee kept talking to reporters, and
they only wound the noose tighter; by now several theaters had can-
celed and the tour was in jeopardy. Jerry Lee refused to quit. He was
convinced that the bad press would die down and he could go back to
the stage with audiences untainted. But the taint was overwhelming.
Reviewers described him as a drooling bumpkin making more noise
than music. Even the most highbrow critics in the States, even the ones
who despised his genre, had often been forced to admit that, what-
ever danger to society he might pose, the music was there, the music

was good. But the British appreciation for American music was not yet deeply ingrained, and such matters were easily overlooked.

Oscar Davis, perhaps believing that the press might be distracted by some sleight of hand, went to the American embassy to ask if Jerry Lee and Myra could be married there—on American soil, so to speak—but the officials at the embassy said that was impossible. So he promised the press that Jerry Lee and Myra would be married again, legally, as soon as the couple got back to Memphis, but nothing would placate the papers; the stories grew more and more strident, and calls for Jerry Lee's ouster, even arrest, grew louder. Four days into the tour, theater owners bowed to the pressure from the newspapers and the growing hostility in the government itself and canceled all his remaining engagements because of "unfavorable audience reaction and for other reasons."

Jerry Lee and the others packed their bags for home. Oscar Davis stayed behind to try to collect some of the money they were owed. "I will stay behind until this arrangement has been made," he told reporters. "I think I shall keep Jerry back home in the States for some time."

Jerry Lee remembers looking out the window of the hotel and seeing throngs of people but not an angry mob. He does not remember any signs with ugliness scrawled on them or any catcalls or anything like that, only a crowd of people gathered as other crowds had gathered, to cheer or to get a look at the man the magazines had called the future king of rock and roll. As he and Myra and the others departed through a side door into a waiting limo, people flung themselves on the car, not cursing, not trying to hurt them, only behaving as other half-crazy fans had done. He will never understand how what he saw and what the newspapers insisted were such different things.

"I'll be back," he told them, through the glass.

It would have been better to just fly off immediately. But instead he and the others were trapped at the airport for eight long hours, as

reporters, inexhaustible, tried to pick at his fears, tried to get him to
admit that the events of the past four days were just the beginning of a
kind of awful landslide for his career. Jerry Lee, also inexhaustible, just
kept talking about the good life that awaited them, once he got home
to where people appreciated and understood folks such as him. "Look,
I make money, not lose it, see," he told reporters. "There's plenty of
work back home. I'm well breeched, you know, and I don't have to
worry about money. . . . I shall be glad to get home. I just bought a six-
hundred-dollar lawn mower that I want to ride around."

The reporters watched with great regret as he checked his tickets and
prepared to leave their island. As Jerry Lee and Myra looked through a
newspaper, Myra exclaimed, as if with disappointment, that there were
no pictures of them on the front page. One of the last pictures had been
a mug shot of Jerry Lee with the caption "Lewis: Bigamist."

"Who is this De Gaulle fella, anyway?" Jerry Lee joked, looking at
the newspaper. "He seems to have gone over bigger than us."

Now and then, a teenager would come up and ask for his auto-
graph.

"I've lost nothing," he told the reporters who hung on to the end.

He boarded the plane with Myra clinging to him, with the British
government believing it had chased away an undesirable and a threat to
the very fabric of England itself. "The thoroughly unpleasant case," the
minister of labor reassured Sir Medlicott, "was ended by the cancella-
tion of the contract and the disappearance of the man."

He would not concede, ever, that he was wounded by it, not as he waited
to board the plane, not as he touched down in New York, and not now.
It would have an undeniable effect on his life and career, but a man is
wounded, Jerry Lee says, only when he lies down, "and I don't."

In New York, with Myra by his side, he confronted the phalanx of
waiting television cameras not as prying eyes, but as a welcoming party.

"I stepped off the plane in New York and some news reporter said I had a bigger crowd than Clark Gable," he says.

Asked, leeringly, about London, he seemed completely unfazed. "We had a very nice time," he replied. "People treated us real nice."

"Why did you leave?" the reporter asked.

"Well . . . I don't answer those questions, sir," he said, then joked: "My manager might knock my head off or something."

"When were you married?" the reporter pressed.

"Pardon?"

"When were you married?"

He wrapped his arm around Myra's shoulder protectively and smiled again. "Why don't we leave our personal questions out of this, sir?"

"When we got to Memphis, I went to see my lawyer, and he told me if I wanted to get married, I could," says Jerry Lee. So he took Myra home to Ferriday, and with his people looking on, he married her again, with a legal license procured from the Concordia Parish Courthouse. But the ugliness followed them across the ocean even before they could say their vows in his parents' house, as newspapers and magazines here retraced the agony of his London ordeal. It was not as intense here, but it rolled on, and before long some radio stations bowed to pressure from sponsors not to play his music. Other threats would surface, from people who had hated his music all along and from inside his circle of friends and business associates. Dick Clark had already written him off. And it was only beginning.

Sam and Jud Phillips seemed unsure how to respond, at least publicly, to the attacks on their marquee star. They knew the threat was serious, potentially career-ending, but they seemed unsure whether to try to laugh it off or treat it as a serious matter requiring stern action. Oscar Davis was no longer in the equation—or in the country, for that matter. Having remained behind, ostensibly to collect money owed

to Jerry Lee, he was last heard from somewhere in France or Italy or some damn place, and he watched the saga of Jerry Lee Lewis play itself out from across the waters. Conspiracy theorists would say it was all a plot, that Oscar was in league with his old friend Colonel Tom Parker to torpedo Jerry Lee's career, but Sam Phillips would later say the man had merely been given an impossible job. "Jerry Lee can't be managed."

In the end, Jud and Sam decided to treat the scandal as both threat and farce. First, Jerry Lee signed his name to a long letter that seemed intended to be contrite, but was in its final draft neither apology nor explanation nor defiance, but a rambling and confusing mixture of all three. Published as a full-page ad in *Billboard*, it merely rehashed parts of the scandal for American audiences, while leaving Jerry Lee sounding like anyone but Jerry Lee.

Dear Friends:

I have in recent weeks been the apparent center of a fantastic amount of publicity and of which none has been good.

But there must be a little good even in the worst people, and according to the press releases originating in London, I am the worst and not even deserving of one decent press release.

Now this whole thing started because I tried and did tell the truth. I told the story of my past life, as I thought it had been straightened out and that I would not hurt anybody in being man enough to tell the truth.

I confess that my life has been stormy. I confess further that since I have become a public figure I sincerely wanted to be worthy of the decent admiration of all the people, young and old, that admired or liked what talent (if any) I have. That is, after all, all that I have in a professional way to offer.

If you don't believe that the accuracy of things can get mixed

up when you are in the public's eye, then I hope you never have to travel this road I'm on.

There were some legal misunderstandings in this matter that inadvertently made me look as though I invented the word indecency. I feel I, if nothing else, should be given credit for the fact I have at least a little common sense and that if I had not thought the legal aspects of this matter were not completely straight, I certainly would not have made a move until they were.

I did not want to hurt Jane Mitcham, nor do I want to hurt my family and children. I went to court and I did not contest Jane's divorce actions, and she was awarded $750.00 a month for child support and alimony. Jane and I parted from the courtroom as friends and as a matter of fact, chatted before, during, and after the trial with no animosity whatsoever.

In the belief that for once my life was straightened out, I invited my mother and daddy and little sister to make the trip to England. Unfortunately, mother and daddy felt that the trip would be too long and hard for them and didn't go, but sister did go along with Myra's little brother and mother.

I hope that if I am washed up as an entertainer it won't be because of this bad publicity, because I can cry and wish all I want to, but I can't control the press or the sensationalism that these people will go to to get a scandal started to sell papers. If you don't believe me, please ask any of the other people that have been victims of the same.

Sincerely,

Jerry Lee Lewis

Then, as if replacing the mask of tragedy with that of comedy, Sam had Jack Clement and Memphis radio personality George Klein piece

together a novelty record that used snatches from Jerry Lee's records to make fun of the whole thing:

KLEIN: "How does it feel to be home?"

Oooohhh, it feels good!

It was called "The Return of Jerry Lee," and it didn't work either.

Jerry Lee himself had always put his faith in the music, but the tide was still washing out, and even great performances couldn't pull it back in. Charlie Rich, a new Sun artist, gave Jerry Lee a rueful raver called "Break Up"; it shot to number 50 on the Hot 100 but then slid quickly down. Its flip side, a mournful ballad called "I'll Make It All Up to You," hit the country charts for a blink in time. Then he reached back to Moon Mullican and covered "I'll Sail My Ship Alone"—by now every song title seemed a self-portrait—but it went nowhere.

To Jerry Lee, it seemed like Sam Phillips had lost confidence in him almost overnight. He had been the artist on whom Sam's hopes were pinned, he had played and sung his heart out, and for a time he'd been rewarded with Sun's almost exclusive promotional attention while other artists smoldered. Now, only five hundred days since his first big hit, he was falling fast. Sam was a millionaire by this point, or close to it, and he was taking the money he'd made from Sun and his song publishing business and investing it elsewhere, in radio stations and zinc mines and other ventures. Jerry Lee kept recording singles, and Sun kept pressing them, but precious few radio stations would play them; he wondered whether Sam even sent them out to disc jockeys anymore. Sam would never again risk significant money on his prodigal son.

"People ask me what effect England had on me, and mostly the effect was on Sam Phillips and distribution," Jerry Lee says now. "He just was not puttin' my records out there."

Sam was in a corner. In the eyes of his harshest critics, his boy had

committed not one offense but two, simultaneously: bigamy and cradle robbing. Marrying a cousin was also frowned on by most in the wider world, even if it was a third cousin and even if it was culturally commonplace. Phillips could have simply fired him, of course, cut his losses, and moved on. Instead, he kept recording him. Sun had more than a hundred Jerry Lee recordings in the vaults by 1960, and in the years to come he would cut nearly a hundred more. But most of them would linger unreleased for years. Jerry Lee has long suspected there was some ulterior motive behind Sam's fading interest, fueled perhaps by old loyalties.

"I'm not crazy by a long shot," he says, but he wonders, sometimes, whether Sam was halfway glad his boy no longer posed a threat to Elvis's throne. "I think that's . . . a dead cat on the line, somewhere."

Sam himself later tried to explain to Sun researcher Martin Hawkins why he kept so much of Jerry Lee's work in the vault. "I was always very cautious about putting out a lot of product on my artists just to ensure a certain level of income. I think that opportunity has been abused, always has, by the major record companies. . . . You only have to look at some of the crap they put out on Elvis Presley, just because he was in some picture show or something. I think each record should be for the good of the artist's long-term career, not for short-term gain, and didn't want to wear Jerry out with an over-abundance of availability."

Sam acknowledged—how could he not?—that Jerry Lee's scandal stayed his hand. "When Jerry took a beating from the press it would have been stupid to try to cram product down people's throats. Believe me, just before that happened, Jerry was the hottest thing in America. The press tore him up in England over his marriage to Myra and it rebounded back home. It was a devastating, unnecessary, stupid damn thing, but what could we do about it? I think Jerry's innocence back then . . . backfired. They scalped him. It turned out to be a very ghastly and deadly thing. So many people wanted to do in . . . rock and roll, and this is just what they were looking for.

"It should never have played a role of such significance in Jerry's life."

Finally, Jerry Lee became so frustrated with Sam's refusal to release and promote his records that he forced his way into Sam's office. What happened next has been told countless times by countless people who were not there, but the one who *was* there, the one still alive to tell, tells it this way:

"People said I punched Sam. I never punched Sam. I snatched him across the desk by his necktie, and I told him, 'You're gonna release my record. It's gonna happen, or I'm gonna whip your butt.' He told Sally to call the law, and she called the law. He said, 'Now wait a minute, I've got as much right to decide when . . .' and I think I slapped him. But he released the songs," or at least some of them.

Shortly after returning from England, he cut a session's worth of solo performances at Sun, including a song Elvis loved, "Come What May," the Hank Williams standard "Settin' the Woods on Fire," and several moving takes of the country ballad "Crazy Heart."

> *We lived on promises we knew would fall apart*
> *Go on and break, you crazy heart*

He says of that time, simply, "We did some good records," and even *Billboard* wrote that his releases might do well if they had some kind of promotion. Jud left Sun to start his own label, and while he would return as Jerry Lee's manager and remain his friend, he would never be able to restore the magic of those early days.

Jerry Lee's live shows were sellouts some nights and bitter disappointments the next—not because of the music, for the music was there, but because of the venues, and it would be that way for years. One night he might fill a coliseum, but the next he'd find himself in some supper

club, playing for people who never liked him in the first place, who preferred big-band music and were hoping to hear some. It was a time of one-hit wonders, all now long gone with nothing more than an occasional spin on an oldie station to hang their whole life on, but Jerry Lee had never been that. He was a true star from the start, with a succession of huge and lasting hits built on a foundation of grit and talent. And as he fell, he snarled and growled and clawed on the way down, in a rise and fall unequaled in American music.

"I don't blame Myra. She had nothing to do with it. . . . Well, she did later, with books and things, but not then," he says, refusing as always to accept that his marriage was in any way something to be ashamed of, that he did anything wrong in marrying her. "We don't get along too well, now, but it ain't because of no grudge. She was my wife."

And of his persecutors? "They just couldn't comprehend it, really," he says. "I think they were saying to themselves, *Why can't I do that? Why can't I have that? Why can't that be me?*"

Elvis was reading a book on poetry in the Brooklyn Army Terminal, waiting for his flight to Germany and his assignment to the Third Armored Division, when he was asked what he thought of Jerry Lee's marriage to a thirteen-year-old girl. "He's a great artist," Elvis said. "I'd rather not talk about his marriage, except that if he really loves her, I guess it's all right."

During his tour in Germany, Elvis met a beautiful fourteen-year-old girl named Priscilla Beaulieu at a party in the town of Bad Nauheim. She was the stepdaughter of a US Air Force officer stationed there. They dated until he returned to the States. Later, when she was in high school, Elvis got permission from her parents to bring her to live with his family, promising that they would be chaperoned by his father and stepmother. It was even arranged that she would attend an all-girls school, Immaculate Conception High School

of Memphis. Her parents agreed to this with the understanding that
Elvis would keep Priscilla chaste and marry her when she was older.
Not long after arriving, Priscilla moved into Graceland proper with
Elvis; she would deny that she and Elvis had intercourse, though
she did admit they did everything but. Elvis continued relationships
with Nancy Sinatra, Ann-Margret, and others, but kept his prom-
ise to Priscilla's parents, marrying her when she was twenty-one, on
May 1, 1967, at the Aladdin Hotel in Las Vegas. Colonel Parker had
worried that Elvis was putting himself at risk by closeting the girl in
Graceland, but the strategy worked, and his career was never really
threatened.

It is one of the things Jerry Lee has trouble getting his mind around.
He married Myra, lived with her openly, and was crucified. Elvis, with
the help of Tom Parker, whom Jerry Lee and many others view as Elvis's
puppeteer, constructed a facade, a blind, and lived in sin inside it.

"He hid her in his house," said Jerry Lee. "He wasn't honest at all.
He hid that little girl in there, and then he acted like he wasn't doin'
nothin'. He flat-out lied. I've not lied about *nothin'*. When I got married
to my thirteen-year-old cousin, I blew it *out*. I told the whole *world*.

"You know that movie," he says, "that movie *The Man Who Shot
Liberty Valance*—that's a great movie." It's the story of a mild-mannered
and well-meaning man who takes credit for a thing he did not do, a
thing that makes him seem heroic. The man, played by Jimmy Stewart,
hid the truth for a lifetime.

"I . . . ain't . . . hid . . . *nothin'*. Elvis, he hid. I didn't want that, never
that. I never had no desire to do the kind of music he did or the kind of
movies he did. Me, I wanted to get out there among the people. I just
needed to be out there, out there where the people was at. . . ."

Sometimes he would think of the screaming multitudes he had once
reached, and a dark sadness would descend on him, but the truth is that
that same cloud fell upon him even in the fattest times, a thing not of
the outside world but in the blood, passed down. But his mama knew

that it would always lift, like black smoke, and swirl away, and that a person had to just go on and live regardless, as he had to live now. She told him that if he wanted to quit, to lie down, she would lie down and die with him, and if he'd had even the *slightest* intent of giving up, that seared him, boy, the way old men used to light a fire under a half-dead mule that has fallen in a field with the job half done. "It wasn't how I was raised," he says again, repeating the only code he ever cared much about. "My people were still behind me, Mama, and Daddy, and them."

He packed the trunk of his Cadillac and headed out into the great honky-tonk wilderness, filling the gaps between the rare big arenas with $250 shows. He did not want his career to wind up this way—he won't pretend so even in his most contrary mood—but if what Elvis had was the best of everything, then he could keep it.

"I was goin' out to play the piano and sing, and make the women holler," says Jerry Lee. So he drove on, searching for neon, for those roadside signs blinking JERRY LEE LEWIS, ONE NIGHT ONLY. "And I'd hook them old pianos up and kick it off. . . ."

9

"WHO WANTS SOME OF THIS?"

.....................

Des Moines

1 9 5 9

He might have been just a little drunk, might have had some pills to get him up and level him out, but that does not mean it was not pretty, what he was doing. His fingers knew where to go on the ivory and his voice was soaked in sorrow as he sang with the broken heart of an old man stitched up in a young man's skin, because hadn't he lived a whole lifetime already, roared and stomped and finally shot to the very highest, with tens of thousands chanting his name and clawing at his legs, before falling smoking into places like this?

His eyes were closed, in great deference to the music he played, but he knew every inch of this beer joint outside Des Moines, knew every breath of Early Times and Evening in Paris, every drunken laugh and curse, and every crash of long-necked bottles on a slick concrete floor, because it was not so long since he'd been here before—here or in a thousand other places like it—on his way up. He had started from nothing, from the colorless mud, and outplayed and outsang them all, till even Elvis, who was weak, came to him and handed him his crown, just handed it to him, as if he wasn't going to take it anyway by force

of will. But now the people who ran the music had turned on him, and even some of the people he played it for had turned on him, and here he was in a honky-tonk in Iowa playing a knee-high stage but by God playing still, fighting back, coming back, playing some big rooms for good money when he could, but if you had glimpsed him here through the dirty window, you would have thought it was a long way from Memphis.

He cannot be certain what he was singing, after so much time, but thinks it was probably Hank Williams.

> This heart of mine could never see
> What everybody knew but me

He was near the end of the tune, in the last few lovely, hopeless lines, when a drunk defiled the song, and tried to put his dirty and undeserving feet on his stage.

"You son of a bitch!" the drunk roared from the crowd.

It was loud enough to cut through the music and through the din of the beer joint itself, and then the man laughed, deep in his big belly, proud of himself. Jerry Lee stopped playing—he hated to stop playing—and looked out through the blue smoke and tightly packed bodies for the loudmouth who had ruined that lovely song. "I was still packin' 'em in, still filling up them clubs," he says, but since London in the spring of '58, the louts had gotten a little braver, and sometimes the bravest or drunkest of them would shout something from the audience about him or his young wife or something else with bile and ground glass in it, and he would have to find the nitwit right away and call him out for it.

He located the man, a big man, but soft-looking, a big country boy . . . no, a city boy. He had on a T-shirt. Country boys dressed better when they went to town. City boy for sure. This would be easy.

"I heard you," Jerry Lee said. He saw his road manager and his boyhood friend, Cecil Harrelson, easing forward, looking at the man, then looking to Jerry Lee. Cecil was too willing to pull a knife back then, and

Jerry Lee shook his head. The music died, and the place went quiet, as quiet as a room of drunks can.

Jerry Lee rose from his piano bench. He was twenty-three years old.

"Why don't you march your dead butt up here," he said, into the microphone, "and say that to my face."

"I *will*!" the man shouted, and came on. He pushed his way through the crowd and came straight at Jerry Lee, put one foot on the edge of the knee-high stage and started to heave himself up.

Jerry Lee, still holding the long, chromed microphone stand in his two hands, lifted it from the floor and with one, quick, stabbing motion jabbed the metal rod into the man's face. The heavy, weighted base of the stand struck the man mostly in the forehead, and he staggered backward, flailing, sliding on the floor to collapse on his back in the spilled beer. A knot the size of a baseball rose in the middle of his forehead, and one or two of the drunks wailed, "He's killed him!" but drunks are always saying such as that.

Then Jerry Lee, his blond hair flying, leaped off the stage and into the audience and, still holding the microphone stand like a spear, screamed at them, at all of them: "Does anybody else want some of this? Do you? I'll give you *all* some of it!"

"But they didn't want none," he says, from the distant dark of his room.

The bar owner called an ambulance, then called the law. In the movies, Jerry Lee would have sat back down and finished playing the song, but the crowd was angry, not at the drunken nitwit but at Jerry Lee; he was a lightning rod for that kind of thing in 1959 and was wounded just enough to make people think they could say anything they wanted, piling on. He watched the paramedics strain to put the big man in the back of the ambulance. *Yeah, a city boy*, he thought. *He went down too easy for a country boy.*

"You know, I can still see that boy's face," he says now.

It appeared the man would live, but he would likely carry the cres-

cent imprint of the butt-end of the mike stand on his face for weeks. It would make a good story, though, to drink on later, about how he told that criminal, that baby-snatcher, that man who married his *cousin*, just what we thought of people like him up here, and how Jerry Lee knocked him ass over teakettle, sucker-punched him, really, when he wasn't looking. Jerry Lee, telling his own story, would forever wonder what the man expected to happen when he cursed Jerry Lee Lewis and Hank Williams in one foul breath, then tried to despoil the sanctity of the stage—his stage. It might not have been much of a stage, might've been a pretty sorry excuse for one, to tell the truth about it, but it was one more step up on the way back to a place where they paid in thousands instead of hundreds and had some paid security in the joint, so a man didn't have to thump these big whippers his own self.

The chief of police came, since it involved a celebrity and all, but there wasn't much he could do. Jerry Lee was clearly defending himself; the fact he had baited the man up there with the intention of knocking a knot on his head was one of the finer points of the law that could not really be discussed at midnight in a beer joint full of people under the influence of a few fifty-five-gallon drums of Pabst Blue Ribbon. But the crowd milled, humming in anger like a gang of extras in some old movie show, some mob working up its courage right before Marshal Dillon rode in and stared them down.

The chief told Jerry Lee and his band they should maybe ease off toward their cars.

"Jerry Lee," he said, "I don't think you should stay here."

"We were leaving anyway," Jerry Lee told him.

"I mean," the chief said, "I think you need to leave town."

"It was just like a Western," Jerry Lee says. Some of the people in the bar jumped into their cars and followed them back to the hotel—it had happened before—but they didn't want none, either, just wanted to act like they did for a little while longer, only wanted a slightly bigger part of the tale.

He went to his motel room—a year ago, he had stayed in the finest hotels—and waited a little while, waited till it came: the knock, but soft, not hammering and angry. He opened the door to his room and there she was. She was often there, but with a different face, a different name in almost every town. He cannot remember the names after all this time; it's unlikely he remembered them five miles down the road. "There's been so many . . . too many, I guess." But he remembers the fights. Some men just remember rage so much better, remember it better than softer things, as if anger was the only emotion that really mattered to them in the end. It's why the rich men down here with the soft accents, the ones who know where their great-great-granddaddies came from, hang sabers from an old war over their mantels instead of pictures of their grandbabies and driftwood from the beach they walked on with their dead wives.

"I fought my way out of a bunch of beer joints," he says. "Had Cecil with me then. I got where I could read an audience, read the meanness in 'em. Every now and then we'd just see a crowd we had to straighten out . . . cursing me from the audience.

"I enjoyed a good fight back then. We had some pretty good fights in Iowa."

The next day, he and his band loaded their equipment into two Cadillacs shrouded in forty thousand miles of dust and rolled another five or six hundred miles, whatever it took to make it to the next date. Fifty-two years later, with that ill-tempered Chihuahua between his feet, he leans back and travels it again.

"I never shunned a show. If I had to cut my price down to nearly nothin', I'd take it. To keep workin'. . . . It was brutal strength was what it was, what it took. I played a show every night. Wasn't no freeways then. We seldom hit a two-lane. Akron . . . Cincinnati . . . Louisville. We'd do little towns and big towns. We'd do one in Ohio, leave for New York, then do one in Ohio, again. . . . Wore out more Cadillacs . . . But wasn't no choice. We made the dates. Wasn't no stopping me. We'd pull up just in

time, go in and get with it, and then we got back in the car, and we moved on down the road. But we made the dates. Some smart aleck sucker-punched me here in Memphis . . . another in Alabama. He was a big man, too. I musta knocked him fifty feet. Happened again in—where was it? I couldn't get to him, but Cecil got him. Fight our way in. Fight our way out. I came home once, had the Hong Kong flu. I got up, went to Dallas. Got up, played a show. They said to me, 'I don't think you're gonna make it.' I made it. . . . Texas. Played all over Texas. Birmingham . . . the most beautiful girls I've ever seen. The band hung in there with me. I don't know what I'd done, if they'd given up. . . . Pull up to them ol' clubs, and rock 'em right on down. Got to where we made them furnish our drum sets. But we *never* stopped. I never stopped packing the clubs, the audi-toriums. . . . Went on for eight or nine years like that, be gone months at a time. Tough on a family, I guess. But I kept going. Back then you could get them real good pills. . . . I'd sleep when I could. We'd see a motel on the side of the road and I'd say, 'Boys, pull in here, get me a room,' and I'd get up and barely make the show. Sometimes they'd be five, six of us in a car. . . . I finally got the boys a '63 Ford to use on the road. They drove it so hard, they melted the head. . . . Played this one club, Mama and Daddy came, out walks this woman without a stitch on, and I just said, 'She's just workin', Mama, same as me.' But I built my audience back up again, rebuilt my whole foundation. I went in them honky-tonks and them nightclubs, and I went *on* with it. . . . Had to keep on goin', 'cause if you quit, you die, and I wasn't raised to quit.

"It was brutal, I tell you. It was killin'. . . .

"It was beautiful."

He had played the Paramount on Forty-Third Street in New York City. He had played the storied Apollo, the Boston Arena, and colise-ums everywhere. He had played *Steve Allen*, *American Bandstand*, and just about every other place a young legend would play, and he never lip-synched a word except in the movies. It was almost like bad luck somehow, doing that. And not long after that came London and the

ugliness, then the long road that some people believed to be the only fu-
ture he had left, the road that he believed—no, he *knew*—would bring
him back to the top, to riches and fame again. It would not break him,
this road, but once in a while, it would break his heart. In Newport,
Arkansas, he walked into a club and saw that chicken wire stretched
across the stage again, strung there to protect the band from a crowd
that had so little respect for the music that they felt they could fling
their contempt, spray it, at the musicians on the stage. He had seen it
before, a screen like this, on the way up, but had it really been only a
year or so before?

"Take it down!" Jerry Lee shouted.

The owner told him it was for his own protection. He'd need it if the
bottles started flying.

"*Take . . . it . . . down,*" he hissed, "or I won't go on."

They took it down.

"It's your funeral," some smart aleck said.

That night he played Hank Williams and Jimmie Rodgers and some
Moon Mullican, even some older music, pretty songs, ancient songs,
songs that sounded almost like church, and he dared the people in the
audience to do something, anything, to assault his stage or try to lessen
his music, lessen him. Then he played some honky-tonk, to make them
think about the women and the men who had done them wrong, to make
them think about their mamas and cry about their daddies maybe just
a little bit, and when they were halfway to redneck heaven, he hit them
right between the eyes with some nasty, gutbucket blues, with the mess
he'd heard sizzling in Haney's Big House when he was still just a little
boy, and he had them hollering for the blues and they didn't even halfway
know what it was. And finally, when he thought they were ready, when
he decided they were deserving of it, he kicked that raggedy piano stool
back so hard it slammed into the wall with a glorious snapping sound. He
played and played through the evening and into the next day, played until
the sweat ran down his face and blinded him, and when he whipped his

golden hair back out of his eyes, the girls bit their lips and went against their raisin'. He beat the ivory till his fingers hurt, till he transcended this little honky-tonk in the hip pocket of Arkansas, till this one more bleak stop on a bleak and endless road was transformed into the night of a lifetime, not for him but for these pulpwooders and insurance men and waitresses and notary publics who danced and screamed and begged for more till finally there was no more and the screams filled the room and poured into the dark, till the nighttime fishermen on the White River and cars passing on Highway 67 must have heard it, surely, heard it emanating like the rings of some great explosion, till Jerry Lee dropped wearily into the passenger seat of a dusty Cadillac and rolled on. And as the wind rushed into his face in the small hours of the morning, as the pills and the liquor and passing miles finally rocked him to sleep, he was not sure exactly where he was headed or sometimes even where he had been. He was sure of only one thing.

"Jerry Lee Lewis don't disappear."

"People, seemed like, were comin' to my shows with a chip on their shoulder."

The days ground by rough and noisy. "Seems like we had to fight every night." He was in the Midwest, again, he thinks in '59, still, or '60, doing one of those songs he used to play with a sandwich balanced on his knee back in Black River, but the audience was noisy this night — one of those crowds of people who might love the music but did not yet understand that it took precedence over drinking and fighting and cheating and too-loud talk about who was doing what with whose husband and the gross injustice of the water bill.

He kept a drink and sometimes a bottle on top of the piano now and then, to mellow him out, and he dissolved a pill or two in the glass to hold him up. But it was no big thing. They were just part of sundown.

"Iowa, again, a honky-tonk on a lake," is all he can remember about

the place where it happened. "It was an unruly crowd."

He played for as long as four hours some nights, then played until the boys playing behind him began to wonder if he would ever stop. That night, in the break after a long set, he waded through the usual handshakers and backslappers and women who wanted a kiss and a squeeze, and past some people who just looked at him hot and mean. There were a few in every crowd who just wanted to see him on the way down, to sneer and relish it. "I got some dirty looks back then," he says. How long had it been since they mobbed him, since he couldn't get off a stage without having the fingernails leave trails on his arms and rip at his clothes? Some days it seemed like yesterday, and some days it seemed like such a very long time ago. But it was all just temporary, a hiccup, he was sure, then . . .

"Hey!"

It sounded like thunder down in the bottom of a well.

Jerry Lee looked up to see perhaps the biggest man he had ever seen. "Up steps this guy," he says, remembering, "up steps this guy who had to be seven feet tall. He had on a sleeveless T-shirt, with arms about this big around," and he takes his two hands and makes a circle about the circumference of a telephone pole. He did not know if he was a city boy or a country boy, or even if he was altogether from this earth.

"It was the Giant," said Cecil Harrelson, the road manager then.

They remember it, Jerry Lee and Cecil, the same.

"Which one of you guys is Jerry Lee Lewis?" the giant roared.

Jerry Lee thought that should have been obvious. Even people who didn't like him knew who the hell he was.

The giant, impatient, bellowed again. *"I WANT JERRY LEE LEWIS!"*

That shut up even the most oblivious drunk. A beer joint never goes silent, but this was close.

"Well, I'm here," Jerry Lee said.

The man stepped into the light. He was bigger in the light.

"I am gonna beat on your head," the man growled.

Jerry Lee searched his mind for some offense he had made to this man the width and breadth of a chifforobe, and decided it had to be something about a woman, with an outside chance that, this time, he might even be innocent.

He had rarely taken a step backward when confronted by any man, except his daddy. But as this man came closer he seemed to block out the light itself, till Jerry Lee was staring into his Adam's apple. The man pushed him not so much with his arms as with his whole presence, "and I remember he backed me all the way to the door, then out the door, and then all the way out to the car."

Finally, his back pressed up against a door handle, he had nowhere else to go.

"So," he says, with a certain amount of fatality, "I busted him in the mouth." He did not throw the punch with just his right arm but with his arm and his shoulder and the weight of his body, used his hips to torque some force into it, the way Elmo threw a punch, and all the Lewises before him, the way daddies taught their sons to throw one: to hurt. But all the Lewises in every dustup and brouhaha since the Yankee War couldn't have knocked that walking piece of furniture out with one lick. "He went down to the ground, and bounced right back up," says Jerry Lee.

The man drew back a fist and aimed it at Jerry Lee's head.

"Here come Cecil," says Jerry Lee. Cecil leaped onto the man's back, snaked one of his arms around the man's throat, and tried his best to choke him to death, but the man didn't even wheeze. But Cecil locked his own arms under the man's big arms from behind, just enough to keep him from swinging free at Jerry Lee, and that was good enough. Jerry Lee, giving up on hurting the man about the head, started slamming his fists into the man's body with everything he had. Cecil could hear bones break.

The man finally began to sag, and sank to his knees. He knelt in

the parking lot, and ran his fingers over his rib cage. "I got seven broke ribs," he said, thickly.

Jerry Lee and Cecil, exhausted, just stood gasping for air.

The man walked his fingers down his torso, counting off on the other hand.

"Seven," the man said.

"Well, this didn't have to happen," said Jerry Lee.

The man nodded. "Where y'all from?" he asked.

"Louisiana," Jerry Lee said.

The man nodded again.

"Well," he said after a while, "I think I'll call it a day."

But he just kept kneeling there.

"He left in a big white ambulance," recalls Jerry Lee.

He forgot to ask the man why he wanted to fight him. In time, it would be clear. Not in every town, but in a lot of them, men lay in wait to take a swing at the Killer, suspecting he might be just mortal enough to fold.

"They just wanted to whip Jerry Lee Lewis. Just wanted to beat on my head, like that feller did."

The man seemed almost friendly as the paramedics took him off.

"He was a hoss," Jerry Lee says.

"He was a giant," says Cecil.

"Haven't been back to Iowa since," says Jerry Lee.

It was just a part of livin' then. He did not enjoy the disruption of his shows, did not enjoy the reputation that preceded him in those days. But as it became inevitable, he embraced it, snarling. It would have been easy if they'd just been a bunch of young rogues making noise, but there was a legend at stake here, and this was real music, good music, "and the music always came first. We gave 'em a good show, and then it was time to move on." He played Le Coq d'Or in Toronto and the Peppermint Lounge in Pittsburgh. He played Café de Paris in New York, the drive-in in Fayetteville, Georgia, and the Adel, Georgia, elementary school auditorium. He played an Alan Freed show in the Hollywood

Bowl, and the Gator Bowl in Florida, and a club at Coney Island. He drove to Los Angeles from Memphis, then drove back to Montgomery, and filled up the space in between with whatever gigs he could find. He played a series of all-black clubs across the northern United States, paired again with the great Jackie Wilson in what promoters had billed as a kind of battle of the races for the soul of rock and roll. He played gymnasiums in Tennessee and Mississippi, and festivals in Arkansas where old men whittled ax handles and sold them for fifty cents apiece.

Bad luck literally flung itself at him. "I was comin' back from the Wagon Wheel, me and Doc Herron," he says, of a trip home from the road. "I had this big ol' Limited Buick. Piece of junk. I was doin' seventy-five, eighty miles an hour. And I was cruisin' along. It gets foggy over there, sometimes, in Louisiana—off of Natchez, comes off that hill, that fog does. And Doc says, 'Watch that horse!'" The horse was launched across the hood of the Buick, through the windshield, and into the front seats. "And I just fell right down, right in [Herron's] lap. And that's the onliest thing that saved me. The horse hung on to my car.

"Finally got stopped, and the horse just fell off on the road. Wasn't supposed to be out. Against the law, horse to be out. What you gonna do, though, you know?" Some people would have sued, to get their car fixed. "I don't sue nobody," he says, and he would have felt silly, anyway, making such a big thing about a Buick. Besides, a "poor old colored guy owned it, that horse. Wasn't nobody gonna speak up for the guy."

He shakes his head at the memory. "I had a lot of hair—long, blond hair, you know. I got out of the car and I shook my head for . . . must've been like three hours, and I just kept gettin' glass, just kept fallin' out of my hair. Shattered glass."

On February 27, 1959, Myra Gayle gave birth to a seven-pound baby boy, Steve Allen Lewis. Little Stevie came into this world with a fine head of hair, like his daddy. Jerry Lee named him for the man who

had been kind to him and straight with him and took a chance on him when no one else would, a man he would never say a mean word about, no matter how grim things might get. Photographers pushed their way into Myra's hospital room to record mother and child. Jerry Lee was no longer collecting $40,000 checks, but he was working almost every night and still drawing a rare fat payday from some big shows, so he bought Myra and Steve Allen a new house in Coro Lake, with white shag carpeting, a small waterfall in the foyer, a white grand piano, and a swimming pool in the back. He rarely saw any of it. He truly believed that if he ever slowed down, he would just vanish, so he fought back one road trip, one little club at a time.

He recorded almost every time he landed back in Memphis, many of them good songs, but it was as if he was singing them into the wind. He had twenty-one recording sessions at Sun between '59 and '63, resulting in eighty-five songs, but few of them were potential breakout singles. He cut a hot, "Breathless"-like single called "Lovin' Up a Storm," and a novelty song called "Big Blon' Baby," and another Otis Blackwell tune, "Let's Talk About Us." He even cut his father's signature song, "Mexicali Rose."

It was just the beginning of what writer Colin Escott would call "the locust years," a quagmire that just sucked him down deeper no matter how many miles he drove or how many shows he played. As if in some cruel joke, his music grew in popularity in England and Europe, where young people continued going wild for each new record he released. Yet in the States the taint of scandal was slow to dissipate, and while at one show he might have standing room only, others, unpromoted, left him staring into empty seats. "I played for two old ladies one time in Kansas," he says. "I told 'em, 'Y'all don't owe me nothin' for this show.'"

But he was also facing a bigger problem: the changing style of rock and roll. The truth is that the American music scene was morphing around him, changing into something he did not recognize and could hardly stand. It was losing its guts, its backbone; the day of the coun-

try boogies and the hard rockers was blinking out almost as soon as it arrived. You could listen to the Top 40 all day and not hear a lick of Hank Williams in it, or Junior Parker or Moon Mullican or Arthur "Big Boy" Crudup. As the 1950s died, the great roar of rock and roll faded to a kind of simpering sigh. In late 1957, after an airplane engine exploded into a fireball on one of his tours, Little Richard announced that he'd been saved, had joined the clergy, and was preaching of the end of time. Elvis had been overseas since the fall of 1958. In 1959, Richie Valens, J. P. Richardson (known as the Big Bopper), and Jerry Lee's good friend Buddy Holly died in a plane crash. And in December 1959, the great Chuck Berry was sentenced to three years under the Mann Act for transporting a fourteen-year-old girl across state lines.

Into the breach flooded a wide array of music for twelve-year-old girls. It was the time of Ricky Nelson, and Fabian, and Frankie Avalon, the time when Chubby Checker replaced Fats Domino at every hamburger stand in the nation. It was the dawn of surf rock, ushered in by the Ventures' "Walk—Don't Run" and culminating in two years with the arrival of the Beach Boys and songs like "Surfin' Safari." It was the time when indies like Sun Records were being eclipsed by new labels: Berry Gordy's Tamla/Motown, with the Marvelettes and the Miracles and the Supremes; Phil Spector's Philles, with the Crystals and the Ronettes and the Righteous Brothers. It was all very catchy and pretty, but it was a long, long way from Haney's Big House.

As if in disgust, great black musicians with heart and grit went their own way with a music called just "soul," and Sam Cooke, Solomon Burke, James Brown, and Ben E. King did their thing without great regard to the once grand experiment of rock and roll. It was not that there was no good music on the air—Roy Orbison finally broke through with "Only the Lonely" in 1960 and proved that soft rock could still be rock—but it was clear that great change was upon the industry. By the time Del Shannon's relatively stripped-down "Runaway" broke in 1961, it was treated as a rare return to rock and roll. Carl Perkins had long

since faded away. Johnny Cash had gone all the way over to country. Elvis returned from the army with what critics called "less menace" and "more maturity"; he cut one decent album for RCA, did a TV show with Frank Sinatra, then gave one last live show in '61 and did not perform again live for eight years. And somewhere out there, somewhere at the end of some gravel driveway in a club with a two-drink minimum, Jerry Lee Lewis gave them the boogie-woogie and the lowdown blues, and when it came time to slow it down and sing them something pretty, he sang them Ray Price or Gene Autry, which was about as sissy as he was willing to get.

"It seems," he says, "like they let rock and roll wither, a little bit."

Jerry Lee himself was still calling the tunes, and with the well of new songs drying up, he dug back into the bottomless bag of classic American music. In the fall of '59, he cut takes on Chuck's "Little Queenie" and Hank's "I Could Never Be Ashamed of You," and released them as a single, to little commercial effect. Six months later, he backed a throwaway new song—"Baby Baby Bye Bye"—with a Stephen Foster song, "Old Black Joe," which was more than a century old. The stations that no longer boycotted his music outright simply didn't play the new records much. He was rumored to be starring in a movie in Hollywood, but it was never made. He was rumored to be a sure thing for another film, something called *Rally 'Round the Flag, Boys*, but that went to some guy named Paul Newman, who couldn't even sing. At Sun, his star was dying. Sam Phillips was building a new $400,000 studio and pushing records by Charlie Rich and others, but not Jerry Lee. Sam had started to refer to him as a tragic figure, said he wouldn't throw "good money after bad." The musicians union was boycotting him for transgressions that had occurred with backup musicians before Oscar Davis went on the lam with the payroll.

It wasn't that Sun didn't try to rescue his career; it was just that what they tried had almost nothing to do with Jerry Lee Lewis. His single for the fall of 1960, "When I Get Paid" backed by "Love Made a Fool of

Me," matched a midtempo pop number with a generic ballad and had a piano part that sounded suspiciously like Charlie Rich. In a bid to get around any lingering discomfort over his name, Sun even had Jerry Lee record an instrumental take on the old Glenn Miller hit "In the Mood" under the pseudonym The Hawk, believing that great talent would find an audience even without the name attached, but since no one in the known universe played piano like Jerry Lee Lewis, it was laughably clear who it was, like a football in Christmas wrapping.

One dilemma seemed to intersect with another till it all just wrapped around itself in one suffocating ball. The radio stations wouldn't play him, so the songwriters wouldn't bring him good material. Without the songs, his records suffered. He remained the wildest live show around—still explosive, still dynamic, still the fierce, good-lookin' devil he'd been in '57, when it seemed like the collective police departments of the Eastern seaboard couldn't contain the people who wanted to love him to death. People still walked out the doors of the auditoriums or out the gates of the county fairs shaking their heads, stunned, some of them, and amazed, some of them—and almost every one of them mightily entertained. "The day I don't see that look in their faces, that's the day I quit. Not before."

In the midst of this, one of his rocks, his foundation, split in two. His mother and father had always been quietly at war, against each other and both against the world. Mamie and Elmo, leaning on each other, balancing each other, had survived the Depression, the ordeal of prison inside and outside the walls, and the death of a child; one of them was strong as iron inside, the other like steel outside. Mamie's faith had never weakened, but Elmo's had never really been strong enough to suit her, and as he drank and caroused into middle age she finally told him to go on about his sorriness without her, though she loved him anyway and always would. They separated in 1961 and later divorced, and the

one thing that Jerry Lee depended on more than anything in this world had come apart beneath his feet.

"I tried to make them both happy," he says now. "I never took sides. I imagine Mama had it pretty rough. Daddy? Daddy was up and goin'."

His daddy would continue to follow him on the road when he could, and they would open a bottle of whiskey, kill it together, and speak of finer days. "Sometimes you just need to drink a little whiskey with your daddy," he says. Elmo even went into the studio at Sun and recorded his own version of "Mexicali Rose."

"He finally got to be me," his son says.

Then, in February 1961, Jerry Lee went back into the studio for one more try. For the very first session in Sam's new Nashville studio, he chose the Ray Charles hit "What'd I Say," and when it was done, he knew he had a hit, finally, after all this time. The original was less than two years old; it was the song that broke Ray Charles out of R&B into the pop charts, and it would put Jerry Lee back there, too. He had such deference for Ray that he was honored even to try it, but he knew it was the kind of song he was meant to play. "A great song," he says, and he didn't try to copy the original but did his own thing, channeling all those nights at Haney's into this one record. And he knew Ray Charles—"*Mister* Charles"—did not begrudge it; he was too much of a gentleman. Jerry Lee and the boys had tried it several times before at Sun, almost every time he came to the studio, but hadn't yet captured what he was seeking. On this session, though, he managed to conjure all the soul of Ray's version and give it something else besides—a little extra rock-and-roll drive—and people liked it, people on both sides of the pop/country divide.

It would not be deliverance, would not be another bolt of blue lightning, but it might be a handhold on which he could pull himself up to another hit, and then maybe another. "I liked that record," he says

now. *Billboard* said so, too, and spoke of him the way it had when he was new. "It's been a long dry spell . . . [but this] song can bring him back with the proper push." By late that spring, it reached number 30 on the Hot 100, and Jerry Lee was invited back to New York, back to the Paramount, where he played with Jackie Wilson.

The disappointments and time weren't showing on him, not yet. His face was fuller, and there were lines there that had not been there before, but he was still thin and sharp as a straight razor, and he still looked dangerous staring down from the posters on the auditorium walls.

In the early months of '62, with "What'd I Say" still ringing in their ears, promoters in England reached out to Jerry Lee to see if he would even consider a return to the country where he had been castigated and all but ruined before. "They insisted I come back," says Jerry Lee, "said people were screaming for me to come back, and I said, 'Well, I might come back to England, if the money's right." The tour was scheduled for April, with some of the concerts to be played in some of the same venues where he had been canceled before, as if the disaster of '58 had just been some bad dream. It was, for a man of Jerry Lee's character, a chance not to redeem himself in the eyes of the British people—he couldn't care less if they approved of him or not and would not approach the island with even a trace of apology on his lips—but it would be one more chance to play them some good rock and roll, and maybe this time that would be the thing that mattered.

He would take Myra with him again, by God. He wouldn't go unless he could take her with him again.

He returned to the club circuit to make a living, and to await his return to England. "It really wasn't so bad," he says of the constant touring and the endless string of small gigs and honky-tonk bars. "It was sometimes, when you'd get a sad phone call from home," from a

wife who wondered what went on out there in the great unknown of the road. But they both believed the talent would win out, that he would be a star again, and if the unthinkable happened, and he was not, no one could say he did not chase it down with his last breath. "We didn't get along that good, later on," he says, but there was a time when they were in agreement on this much: it would get better. Still, he hated the sad phone calls, dreaded them, sometimes beseeching, sometimes accusing. "Ain't no woman rule me," he says.

Sun surely wanted another strong hit to follow up "What'd I Say," but Jerry Lee's next several singles matched a motley assortment of covers—a standout take on Hank's "Cold, Cold Heart," an early cover of Barrett Strong's "Money"—with novelty tunes like "It Won't Happen with Me" and "I've Been Twistin'," an update of Junior Parker's old Sun R&B hit "Feelin' Good." In an effort to placate Jerry Lee, Sam even signed his teenage sister, Linda Gail, cutting several sessions with her and even putting their duet on "Seasons of My Heart" on the B-side of his cover of Joe Turner's "Teenage Letter." It did not placate him.

He was in Minnesota on Easter Sunday 1962 when the phone began to tremble on the nightstand. It was not Myra this time but Cecil, telling him he had to call the hospital in Memphis, had to call home.

Construction on the Coro Lake house was still ongoing. It had rained hard that Easter Sunday, and the swimming pool had partially filled with water. Inside the house, seventeen-year-old Myra was working on supper, on a big pot of spaghetti, and thinking about buying groceries. Elmo was there, and Jerry Lee's uncle George Herron. Steve Allen was at Myra's side, munching on jelly beans and candy chickens. It had been a good day. She had dressed the boy up like a little man and taken him to church for the first time. Now he had candy on his hands and his face and he was happy.

A few minutes later, Myra noticed that the boy wasn't by her side

anymore. She called to him, then panicked and ran outside, searching. No one had seen him leave the house. She called his name, louder and louder, and a neighbor heard, and came to see what was wrong. He found the child at the bottom of the pool, and while there had been a rumor of a heartbeat, just enough to give Myra false hope, the child was dead.

They buried the boy in the cemetery in Clayton, under the trees just now going green, beneath the rising voices of the great intermarried tribe. Jerry Lee's cheeks were dry and his backbone was straight. He had done his crying in a locked room, and he will not let anyone inside it even now. He says only that he questioned it, questioned why it happened to him, his boy, but only briefly. "Why did this happen to me? I don't understand. But I will understand someday. It knocked me to my knees, but you don't see me cryin', don't see me carryin' on. I accepted it. What can you do but accept it? And live with it. I didn't question God. 'The Lord giveth and the Lord taketh away. Blessed be the name of the Lord.' But you don't forget. He's always, always on my mind." The hateful thing was how little time he'd had with the boy to store up some kind of memory, some kind of picture to carry. His own brother had died on a dirt road before Jerry Lee was old enough to store up the memories he needed to build something fine and lasting to cushion that one awful moment of death, and now his son was gone, taken while he traveled a million miles of highway, believing he had a lifetime to see the boy grow up, to listen for the first signs of musical talent, that thing passed down in the blood.

A few days later, he was supposed to leave for England. Family and friends assumed he would cancel, that he would closet himself with Myra and grieve, which was the decent thing. But he could not. He could not stand being left here with his own doubts about his choices and ambition and the burning need to succeed that had sent him across the country again and again to try to reclaim what had been his for only a little while. He had drunk and fought and sinned across the land,

chasing and chasing, and it would be noble to say that his desire for it all was reduced to insignificance by the death of his son, but it would be a lie. Instead, as he stood over that small grave, he knew that his drive was the only thing that could save him. "It never took my desire," he said. "I had to go to England. It wasn't easy, but I had to go. You get a family, you hate to put 'em through all the stuff, all the fightin' and the carryin' on that comes with a life like mine, but I didn't know any other way." To give up and stay home and hurt would make it all useless, pointless.

But there was another reason. Those who sometimes dwell in the dark, who live in what some people just call *depression* but that they know is something far worse, know there are times when that quiet is too awful to stand, and that the worst of all things is to be alone with your thoughts. You can stand it out on the stage, or in the crowd, where you can stomp and howl and burn and rave, where the lights scorch your wired eyes and the drums drown out the cries inside your mind. "The show covers everything," he says again. He believes it with all his heart.

Myra stayed home, planning, if things went well, to perhaps join him later. He came off the plane at Heathrow in a dark suit and white shirt, to stare into the same wall of reporters and photographers who had met his plane in England just a few years before. They asked him about Myra, asked where she was, and when he told them she was grieving and unable to travel, they asked him why he was not grieving and why he was able, and for just a few minutes, there with the flashbulbs exploding into his face, it seemed like it might be like it was before. They asked him if he did not feel it was callous to play rock and roll just eight days after his son's drowning, and he talked to them about "the mysteries of the Lord," and how he had to keep going, that this was the best thing for him now, to just keep singing and playing and keep working.

"They were screaming for me, this time." He opened in a theater in the industrial town of Newcastle, where working-class Brits, people with grease ground into their hands, had been sneered at by the upper classes for generations. It was a two-show gig to near-capacity crowds. He waited in the wings in an elegant black suit, white shirt, and black tie, peeking at the crowd. They cheered and stomped and howled and waved banners and signs that said WELCOME BACK JERRY LEE, as if what had happened before had all been some kind of bad dream.

It galls him to admit to any kind of fear, but he felt a sliver of it as he climbed that stage, walked to the edge of the curtain, and took that first look. "I was a little nervous," he says. But he knew, even before he hit the first key and sang the first line, that this time it would be different, this time he would get to prove what he could do. He had always believed that they'd wanted him before, before it was all poisoned by the newspapers and their feigned outrage, which he now knew to have been phony all along, like a kind of sport. Now he looked out into the crowd and all the long miles and disappointments in the dusty Cadillac sloughed away, and he itched for the opening acts to hurry up and clear him a runway.

He surged onto the stage at a dead run, slid several feet like he was on ice and landed on his knees at the grand piano, and tore into "Down the Line." He told the crowd he was going to drown his sorrows in his music, then, unhappy with the backup band's tempo, showed the young drummer how to keep the beat. He pounded into "Whole Lotta Shakin'" and leaped on top of the piano. He did a wild, fifteen-minute encore as fans tried to storm the stage; later some tried to break down his dressing-room door. He would call it, later, one of the finest moments in his life, proof that he was still him, still the rocker he had been. He called Myra and told her to come to England. She arrived with a black ribbon in her hair and a Bible under her arm. A reporter stopped her in the terminal and asked her if she had any regrets.

"I love Jerry. Jerry loves me. That's the real story of my life."

There was still snobbery, still outrage that the man had been per-mitted to bring his smut back into their grand old England, and there was criticism of his decision to come and play music like his just a week or so after his son was buried. But mostly, he was spared. The reporters had already gone at him once, and gleefully, and nothing bores a news-paperman more than old news. A cat will stalk a live mouse for a very long time, but will play with a dead one for only a little while before losing interest. The only real news in Jerry Lee's life was the tragedy of his son, which was the opposite of scandal; the press couldn't worry it for long without appearing tacky and callous itself. And this time Jud Phillips, who was nobody's idiot, made the trip as publicist, plying the press with good whiskey, with such copious amounts of free liquor that some of the reporters assigned to the Jerry Lee Lewis story didn't write anything at all.

That left Jerry Lee free to sing and play, and he did it with that still-young man's fury and vengeance and with an older man's broken heart, and they were still screaming as he left; he could hear it even through the walls of his dressing room, and he felt young again, and thought of the first time, the first time he ever approached a man about singing a song for folding money in a club, and how simple it had all been. "Julio May, owned the Hilltop in Natchez," he recalls. " 'What you doin' in here, boy?' he asked me, and I told him, 'Sir, I play the piano and I sing,' and he looked at me for a minute, and then he said, 'Well, get up there and do it, then.' " The drumming on his door—the fans had fought past the security and found him—brought him back. The security guards said they couldn't guarantee his safety if he lingered, and again he was forced to flee a crowd that climbed all over his car and pressed their faces and lips to the window, only this time there was no doubt: "They loved me in England."

The tour continued to go well. Some writers would say that not ev-ery theater was full, but Jerry Lee remembers it as a triumph, night after

night, an unending standing ovation. In Glasgow, the crowd rushed the stage, Jerry Lee climbed atop the piano, and a few fans followed him there, too, breaking the lid. The instrument was left in such a pitiful condition that promoters were forced to cancel an upcoming classical concert.

He was invited back for another tour the following year, and the one after that.

On the opening night of his May 1963 tour, he walked onto the stage in Birmingham to a standing ovation and left it running, chased by fans who had ripped away his jacket, tie, and half his shirt. "No matter what you have read, no matter what you have heard, watching Jerry Lee Lewis on stage always produces a profound shock for the ears, the eyes, and for the very soul," wrote Alan Stinton in the *Record Mirror.* "What Jerry does on stage is so beyond the realms of human imagination that no one can fully anticipate the aura of sheer magical excitement which he creates." And the crowd chanted:

We want Jerry!
We want Jerry!
We want Jerry!

At home in Ferriday, planting season had come and gone for the spring crops, the bounty of the Southern table. Old men walked through fields of tomatoes and okra and squash, searching for blight, hoping for rain but not too much, thumping off the stinging, leaf-eating caterpillars and stomping them underfoot. In the rows of yellow squash, the old men took the first blooms and pinched them off the way their fathers had taught them to do. They were wise old men and knew that sometimes a bloom is not a bloom at all, just a flower, just something pretty to look at, and nothing would grow from it. They call them false blooms.

10

AMERICAN WILDERNESS

.

The Road

1963

He was supposed to be done again, finished again, but he was too hard-headed to lie flat. He had merely risen again, this time in neon almost two stories tall, glowing over the Memphis streets. He had a regular gig playing the Oriental, a nightclub owned by his latest manager, Vegas-hard-and-slick Frank Casone, who hung the giant electric Jerry Lee over the club to usher in the tourists. It had blazing yellow hair and blinking neon fingers and looked just like him, people said, a Jerry Lee you could see from space. He swaggered out onstage as if against a crosswind, listing a little, and as he approached the piano, he located a petite blonde beauty standing with her girlfriends near the stage.

"He just picked me up—I didn't weigh but ninety-eight pounds, soaking wet—and sat me down on the piano," said Gail Francis, who had ventured bravely into downtown Memphis after dark to see the infamous Jerry Lee Lewis play real rock and roll. Her girlfriends were jealous.

"I was a looker then," she said.

She remembers that he seemed very drunk or a little bit high or

maybe both, but the moment he reached the piano stool and stretched his fingers out to rest them on the keys, well, there was just something about it, something hard to explain after all this time, something sweet and sad but magic just the same.

"He was mostly there in spirit," she said.

The place was jammed, she remembers, "mostly girls, and he sure had some admirers there," she said. She cannot remember everything he played and sang, but remembers singing along to "Great Balls of Fire."

"It was exciting. It was fun, sitting on that piano. I know I'll never forget that."

But mostly, she will never forget his face. "The look on his face . . . it was worth everything," she said, worth the kidding she would take, worth the tiny scandal if her people ever found out. "He was happy. You could see it. You could tell he loved it, tell that he just loved being there."

He was still big in Memphis, would always be big in Memphis, and his fans there knew what he had endured and what he had lost. They thought he might be jaded by now, tired of the old hits that were only a reminder of how great he had been. They thought he might be sick of the endless road and constant newspaper stories of scandal and excess, sick of the eternal comeback, of every grubby little part of it. But the man Gail Francis saw in the Oriental that night was flying above all that, or maybe just flying, still desperately in love with the music. After the show, he invited her and some of the girls to a party with the band, and she said no, but a few girls said yes, they might.

"She told me that story a million times," said her daughter, Alicia. "She told me, 'Jerry Lee Lewis lifted me up on his piano, and I just weighed ninety-eight pounds.' A *million* times."

But even that neon glow winked out eventually. The man who couldn't be handled had a falling out with Frank Casone, as with every manager he ever had, and of course lawyers were involved, and those

days at the Oriental blended and blurred into a kind of lost decade. It is not that he did not sing and record good songs or that he slipped from sight; he only slipped, again, from fame.

It felt, sometimes, like he was the only one who remembered, and he was not even in his late twenties yet. It seemed like the good songs were bound up in logging chain and padlocks. The cradle itself, the original Sun Studio, went still. Technically outmoded, it became a storage room for brake pads, fan belts, and antifreeze. Sam Phillips stayed in the business, building one new studio in Nashville and another on Madison Avenue in Memphis, but he would never regain such luster. Then again, as an original investor in a chain of Memphis-based hotels called Holiday Inn, he didn't have to; he had gotten the best of it, anyway. Would there ever be another night when men drank great gulps of whiskey and argued about God?

He was playing Hot Springs, Arkansas, in late August 1963, when Myra went into labor again, this time with a baby daughter. Jerry Lee jumped in his Cadillac and headed south—not to be with his wife and new baby, but back home to Ferriday, where another family member was in need. "People got mad at me because I wouldn't drive from Hot Springs to Memphis when she was born. . . . But my Uncle Lee was dying of stomach cancer," and he went down, then.

Lee Calhoun had always been good to him, even if he'd let him sit and worry a little while in that St. Francisville jail; he had left a check on the table when Jerry Lee needed a car, and looked after his mama, twice, when his daddy was sent off for making liquor. He'd given them a place to land, his mama and daddy, when they were adrift in the Depression, when the whole country all but rolled over and died. He had to go home and pay his respects; his new life would wait till the old one was done, and was respectfully laid down.

Phoebe Allen Lewis was born on August 30, 1963. She would always

say that her daddy would have been there if she had been a boy. "I was glad to have her," says Jerry Lee. "I called her My Heart. She was beautiful. I picked her up and held her. She favored me."

The little girl toddled through some of the darkest days of her father's legend. At first, she was just too young to know. Having Jerry Lee Lewis as a father had, at times, great benefits.

"I had an enchanted childhood," said Phoebe. She would creep out of her crib and later her bed and sneak into the bedroom of her parents.

"Get out of here, Phoebe," her father would roar, "and shut the door and go to bed." But he would always give in, and she would snuggle up between her mother and father.

"I slept every night between my mama and my daddy," she said, between a mama who tried to raise her within the rules and a daddy who had never recognized, let alone followed, a rule in his life.

"I'd be drinking from a bottle and Mama would say, 'Phoebe, you're too big for that bottle,' and took it away, and then Daddy would take it to the store and fill it with Coke or chocolate milk."

She remembers living on bologna sandwiches on white bread with mustard, but her parents always watched her around the pool, made her stay out of the pool for at least thirty minutes after eating "so I wouldn't get the cramps." Their house outside Memphis was filled with famous and almost famous musicians, most of them in various stages of drunkenness or chemical dependency, people she came to know only as "Daddy's drinking buddies." The one constant was music; there was always music, pouring from the piano and the record players scattered throughout the house. Men, half drunk or fully so, picked guitars barefoot on the sofas, in the yard, all of them, every one, looking for a hit.

Late that summer, Jerry Lee did make it into Sam's new studio on Madison to cut eight songs, this time reaching back to Hoagy Carmichael's "Hong Kong Blues," from 1939, and even further back, to "Carry Me Back to Ol' Virginia," a Reconstruction-era ballad by the African American minstrel performer James A. Bland. They were the last songs

he would record for Sun Records. He was fed up with the label's inability to move his records and needed a change. The Sun session was by that point just an obligation; he had already signed a five-year contract at Smash Records, a subsidiary of Mercury, which wanted to record him in Nashville, in the heart of a country music establishment he had despised since it first condescended to him as a younger man. Memphis, the beating heart of rock and roll, had given him everything, and now he was driving away from it, due east into the rising sun, into a place where people really did, here and there, hang steer horns on their Cadillacs.

He would always blame Sam Phillips for failing to promote his music, for failing to pay him what he feels he was owed—a million dollars or more, he believes, though it would be nearly impossible to prove such a thing today. "Sun Records owes me a lot of money," he says even today, long after the Sun catalog was sold off. "I mean, *chunks* of money. They were sending me some pretty good money there for a while, but they . . . they ain't sent nothin' in a long time." But the teeth of that particular resentment have grown dull and flat with age, and it doesn't hurt so much. "I had some good times, with ol' Sam, with *Mister* Phillips. Him and Jud, we had some times." Most of his Sun recordings were eventually released, after the company was sold, in a seemingly endless parade of box sets and compilations. Phillips would take his own place in the halls of rock-and-roll fame—sinking his teeth into it from the moment Elvis walked into his studio, assured of it when he signed Jerry Lee.

When asked about his place in it all—in the development of Jerry Lee Lewis—he would not demur. "I just believe I was the one person who could do that," he said.

Jerry Lee does not believe that. But in a way Phillips did what he'd promised—made him rich for a while, long enough to fill the driveways with Cadillacs and keep his promises to his mama and daddy that he would be a star—and for that his onetime ward is

grateful. Sam made him a star, yes, but a shooting one, and failed to do all he could, Jerry Lee believes, to hold him up in the sky where he belonged. "I would have had more hit records. I know it." People can argue whether Jerry Lee did what *he* had to do, but it is Jerry Lee's star and Jerry Lee's sky, and he will decide his place in it. "I always knew I was gonna be a star," he says, "but I never figured on the rest of it." And he never wanted to understand it, this business beyond the stage. "Money hasn't ever been my God, so to speak. But boy, I tell you, these people, when it comes right down to the dollar bill, that's their goal in life—making money. . . . I never got into stuff like that. I just didn't. I figured that if they owed me money, they would pay me."

In one of the constant refrains of his rock-and-roll life, he would play in the coming year a small club in Germany, and for his performance there—called one of the greatest live albums of all time—he would also go unpaid. But for the people who truly love early rock and roll, there was no way to put a price on it, anyway.

He returned to England in March of '64 for a Granada Television special called *Don't Knock the Rock,* to run through his biggest hits and "I'm on Fire," his first single for Smash. His golden hair was darker, longer, by now, and he was maybe a little heavier, the skinny kid now disappeared into a grown man in a somber dark suit. But from the first line of the first song, from the first ringing, crashing notes of a piano being beaten to death with absolute elation, it was clear this was Jerry Lee in his element. Seated at a piano perched atop a rickety-looking pedestal, he launched into "Great Balls of Fire" as the pedestal descended; when it reached the ground, he was swarmed by hyperventilating fans. At one point they mobbed the piano, and they reached out to touch his hair, his clothes. He stood on the piano, took off his jacket to screams, then pulled off his tie. "I would throw it out there," he told them, "but

there's too many of you and I ain't got but one." The TV cameras scrambled throughout the show, shooting the performance—and the crowd's reaction—as if it were some kind of news event.

"What happened with Myra," he says, "it didn't stop the women from screaming. They still come out, and they screamed *more*."

But that made-for-television performance was nothing compared to what happened in a nightclub in Hamburg, Germany, a few weeks later. The scene was a hole-in-the-wall called the Star-Club, lately famous for its role as a proving ground for a Liverpool quartet who were just now taking America by storm. "I went in behind the Beatles," he says of the legendary performance he gave there on April 5. But the Beatles didn't leave the place trembling, as he did. *Live at the Star Club*, the resulting live album, was one of the grittiest, most spectacularly genuine pieces of recorded music ever made. "Oh, man," Jerry Lee says now, "that was a big monster record."

To a roaring greeting from the crowd, he opened with a growl and a flourish:

Mmmmmmmmm, I got a woman mean as she can be

It is nearly impossible to describe what followed without the music itself as a backdrop. Some critics have called *Live at the Star Club* raggedly recorded, but most would say that did not amount to even a little bitty damn. His music and voice are commanding, certain, but still wild. The piano sounds like it is actually breaking at times, like he is playing more with a tack hammer than flesh and blood. His blues has gut and bottom to it, just plain ol' nastiness, and the single country song is plainly sung by someone who has lived it. "Your Cheatin' Heart" has been called perhaps his most soulful and passionate Hank Williams performance ever, given even greater emotion by his piano break, more Haney's Big House than Grand Ole Opry—a thing he had been doing to his country songs since his mama

was feeding him cocoa and vanilla wafers. In just fourteen songs—he played more, but at least two weren't properly captured by the recording—he covered miles of ground, from a scorching "Long Tall Sally" and "Good Golly Miss Molly" to "Hound Dog" and "Down the Line." He did all his big hits from before the fall, except "Breathless," then closed with a "Whole Lotta Shakin'" that sounds commanding and almost valedictory. The entire thing *feels* live, as if you yourself have made the trip across the ocean and through the streets of Hamburg to sweat and drink and be wrestled to the floor by Jerry Lee Lewis.

But as proud as he was of the music—he was backed by a British group, the Nashville Teens, who were neither from Nashville nor teens—he says it was not greatly different from what he did on the road night after night in the United States, not greatly different from what he would do every night of his life till the last night, the last note. He treated it like the live show it was, giving the engineers or even his backup band barely a clue ahead of time, but playing what he felt like, rolling into a riff and a song and expecting the rest of the world to fall in behind.

Asked about it now, he recognizes its impact on others but doesn't dwell on it for long—because, like other great performances, it is tainted for him by the business dealings that surround it. At first, and for decades, the album was available only in Europe, held up by legal constraints; back on this side of the Atlantic where he really needed a power album, it was rarely heard.

But perhaps worse than that, he believes he was never properly reimbursed for the record. "They never paid me a penny," he says, certain that he should have received the money directly. The record company that released it did tell him they wanted to once, but he believes they tried to short him. "Come up to my room one time," he recalls. "I was doin' a tour, and they had a check for, I don't know, thirty-three or thirty-four thousand dollars, which was a pretty good little chunk of money back then." But it wasn't what he was owed, just a token sum. "I

wouldn't even let 'em in the room. They wasn't livin' up to the bargain. And they still owe me the money, and Mercury sold out to Universal, and Universal now owes me the money. I want them people to jar loose some of that money and give it to me." The black and white of it, in the ledger, may never be known. But he feels it, he believes it, and it is a belief that most of the rock and rollers of this generation share about their own finances, and it colors their worldview to this day.

He does not worship money, he says again, but he also despises being cheated.

"I got it comin' to me. It's mine."

In summer of '64, he followed the Star-Club phenomenon with a live show in Birmingham, Alabama, that resulted in an album titled *The Greatest Live Show on Earth*. The show proved to an American audience in a large venue that, even in the midst of a recording downturn, Jerry Lee Lewis was still a hurricane force onstage. He played big Boutwell Auditorium, where the Memphis wrestlers went when they told their fans they were going on "world tour." Every seat in the room was filled; people even stood along the walls to hear him rip through staples like "Mean Woman Blues" and "Hound Dog" and a few fresh tunes like Chuck Berry's "No Particular Place to Go" and Charlie Rich's "Who Will the Next Fool Be." "A good show," he says, though some fans would find it almost tame compared to Hamburg. But the big live shows—and the hundreds of smaller ones he continued to do to make a living—could not return him in any significant way to the stardom he had enjoyed before without new songs and the radio play he needed. Instead he slipped in and out of the public eye like a ghost, one who shook the house and wailed through the night but, in the morning, was gone.

In England, he was being slowly edged out by the act who preceded him at the Star-Club, the Beatles. "Boy, when they broke, they broke, didn't they?" At home, where they had hit with great force in February of '64, he couldn't turn on the radio without hearing them:

She loves you, yeah, yeah, yeah

"I never did care for the Beatles all that much, to tell the truth."

Sometimes it seemed to him that the real troubadours were dropping away—even Patsy Cline was dead, killed in a plane crash in Tennessee—and he was forced to sit in purgatory while old Johnny Cash kept churning out number one country hits, as though Johnny was singing right at him:

> *I fell into a burning ring of fire*
> *I went down, down, down, and the flames went higher*

As the arms of obscurity snatched at him, he kept recording, looking for a hit, and kept touring, taking gigs that would have killed his pride if he hadn't so loved the simple act of playing. "Wasn't no place too far for me to go to sing my songs," he says. "Wasn't no place too rough." And when he didn't have a gig, he played anyway, showing up at clubs around Memphis to commandeer a piano. No one was going to say no to the Killer. "I played Bad Bob's, played Hernando's Hideaway, played for the love of it, for the joy of playing."

In December of '64 he finally returned to American television, in what would become a series of appearances on the new ABC music show *Shindig!* But again it was too little, the return of a ghost playing the rock and roll that started it all. The nation's popular music itself continued to weaken and simper into a cloying mess. Some days, spinning the dial on his radio on his way to another show in God knows where, it seemed like he was trapped in a perpetual never-ending loop of Herman's Hermits and "Puff the Magic Dragon."

At first the boys at Smash had little more luck with his records than Sam Phillips had. They released a retread album of his Sun hits, *The*

Golden Hits of Jerry Lee Lewis, which made the charts briefly before
vanishing. When "I'm on Fire" failed to catch, he tried the Ray Charles
hit "Hit the Road, Jack," an Eddie Kilroy country ballad called "Pen
and Paper," and a song called "She Was My Baby (He Was My Friend)."
He rocked out on "Hi-Heel Sneakers," a single lifted from the Birming-
ham album, but it barely made the charts.

People took to asking him, with irritating regularity, if the old Sun
magic was gone. In 1965, he answered with what has been described as
his first great album, *The Return of Rock*—a record that recalled the
bravado and precision, the sharpness, of the Star-Club performance,
and added a fleet-fingered swing. He did Joe Turner's "Flip, Flop and
Fly," and the old, old blues "Corrine, Corrina," and "Don't Let Go," the
song Roy Hamilton had blown him away with onstage. He did three
Chuck Berry songs, "Maybellene," and "Roll Over Beethoven" and
"Johnny B. Goode," and proved he could still make people sweat and
blush with his take on Hank Ballard's "Sexy Ways," which delivered
what "Whole Lotta Shakin' Goin' On" only winked about:

> *Come on darlin', now, I want you to get down on your knees*
> *one time*
> *And shake for Jerry Lee Lewis, honey—yeah!*

The album cracked the Top 200, but it peaked at 121, and it lacked
the breakout song he needed to bring him back.

The problem, as always, was material, not technique. In a way, he
believes now, his sound was better than it ever had been. The producer
who cut *The Return of Rock* and most of Jerry Lee's music at Smash was
Jerry Kennedy, who understood the science of music and mechanics of
sound, how it bounced and flew and settled into the ear and even into
a person's mind. Kennedy had been in love with music since he could
walk, and as a child he'd been in the front row at Shreveport Municipal
Auditorium to hear Hank Williams play one of his last shows. He had

been a backup vocalist as a child, could play the guitar and dobro, had worked with Elvis at RCA and Jerry Lee at Sun, and as a producer at Smash was determined to get the best sound he could out of Jerry Lee's piano. At Sun, the piano had sometimes been lost in the mix—even when Jerry Lee was beating it to death—but Kennedy knew how to bring it right up front. "Jerry Kennedy, he was gettin' the piano sound he wanted," says Jerry Lee. "It was a knockout. He'd take a quilt, a big, thick quilt he had, and cover the whole piano up—big grand piano— cover it up where nothin' could get through it," trapping the sound so that the engineers could highlight it in the mix. Jerry Lee believes now that the Mercury team were perhaps the smartest pure engineers he ever knew; the title "producer" might sound important, but to him Kennedy was like a great mechanic who made the car run sweeter, smoother. His critics would say he did not always make it run stronger, that once he hit on a formula, he stuck to it, and that sometimes he bled the spirit out of a record with too many strings and sappy backup vocals. Either way, for a decade or more, his handprint on Jerry Lee's music and career would be plain to see.

Among other things, Kennedy recognized that his artist was at his best in front of an audience. One time, Jerry Lee recalls, they were recording at Monument Studios, on the "main strip" in Nashville. "Jerry said, 'Do you mind if I just stop some people out here on the street and invite 'em in to hear you cut this song?' I said, 'Naw, that'd be great!' And they set up about twelve chairs. And they come in, and they set down, and they were real nice, they never uttered a word. They just set there and they's just . . . astonished."

But he was still trying to make tarnished gold shine again, still caught in a rut of recycled music. Remaking old songs was everyday business for him, but hits like "Great Balls of Fire" and "Breathless" had come from established songwriters who knew how to join a fresh catchphrase to a catchy riff and come out with a hit. Throughout the mid-1960s he cut one album after another full of other people's music:

Country Songs for City Folks in '65, *Memphis Beat* in '66, *Soul My Way* in '67. He cut tough country songs like "Skid Row" and tough blues like "Big Boss Man"; he read the lyric of Willie Nelson's "Funny How Time Slips Away" like he was thinking out loud. But none of it was new, not really.

"That was a hangup for me," he says, "tryin' to do a song that's already been a multimillion seller. You don't tackle somethin' like that. That wasn't Jerry Kennedy's fault. That was my fault. I said, "I wanna do 'Detroit City.' 'Cause I can beat the original on it.' " But later, he admitted, "Boy, I sure am wrong on this one!"

One of them almost *was* a hit: Porter Wagoner's agonizing prison ballad "Green, Green Grass of Home," which he cut for *Country Songs for City Folks*. "That should have sold fifty million records," he says, but Smash dropped the single without any support. "They didn't do nothin' for it. It was number one in every station in Alabama. And nothin' in Memphis. And nothin' anywhere else. Nothin'. And that don't make sense. . . . You got a record number one and sellin' like crazy in Alabama," he laughs, "but you leave Alabama and you ain't never even heard of the song." His hunch was justified when the Welsh heartthrob Tom Jones, who had worshipped Jerry Lee since boyhood, heard the album and recut the song, making it an international number one hit the following year. To Jerry Lee, it seemed like Smash was waiting on a sure thing to get behind, and he lost faith in the label—the business side, not the studio team—early in his time there.

His reliance on pills and whiskey again ratcheted up. Once he could eat them by the handful and they didn't faze him, maybe gave him a little nudge in the late nights or a soothing pat on his fevered head when he needed to go to bed. He could still drink his three fingers and six fingers and drink until he couldn't measure them even if he had to take off his socks and shoes, and though he maintains now that he never drank that much, the stories of his tolerance are legendary.

But as he entered his third decade, the late nights and pills and liquor

finally began to show, not in his still lean body but in his face. He had a grown man's face now, with a line or two, but more than that—he just looked like he had lived some heartache. The world had finally marked him. "I could still take care of my women," he says, which was the real barometer of a man. But sometimes he took it so far, ate so many pills and drank so much, that it made him crazier than he was already prone to be, and when the dark moods that were part of his blood descended, the chemicals fed the rages and made the darkness even blacker, if such a thing were possible. He would rail at the world, stomp, rage, and scream, and it seemed there was always a reporter there, unbelieving of such good fortune, to chronicle the madness of Jerry Lee Lewis.

"That was blues and yellows time. . . . I tell you, greatest pills ever made," he says. "People said it made me crazy, but I was crazy before the blues and yellows. That would keep me going. Desbutal. Man, you couldn't beat the Desbutal. Went hundreds of miles a day on them . . . biphetamines [black beauties], Placidyls, up and down. I took 'em all."

It seemed like everyone in the business was popping.

"Back in those days, people were desperate to get a pill. Man, amphetamines, we thought, was the real answer. They thought, psychologically, that it's really helping you, you know? But it's not. It's a miracle that any artist that is still around got through that. It's only by the grace of God. That's about it, you know?"

But friends and longtime fans would marvel how all of it—the drugs and straight whiskey and the lack of sleep—seemed mostly like something he could slough away on command; he says it was because it was exaggerated to begin with. In family photos and publicity shots and even television interviews and footage of his shows, he is always tall and straight and steady, as if it were all something he could just switch off if he wanted to and be a regular man, the man he used to be. Some would theorize that he had just done so much of it from such an early age—from the days when truck drivers at the Wagon Wheel tipped him with big bags of amphetamines—that his body was able to somehow

metabolize it, and maybe that was true, for a while. He was still the best-looking man in the room, and while he might have been a little drunk then, from time to time, he was rarely a sloppy one. Since he was a teenager, he had known that pills could do, for a long, long time, what food and rest were supposed to do, so he popped the lid off a bottle and made himself strong, and endeavored to persevere. He was Jerry Lee Lewis, the Killer, and he was nobody's victim.

"I'll tell you this, I never dropped no drink. Calvert Extra. I never dropped no drink."

But underneath the chemicals was a plain streak of ornery, with bright flashes of outright crazy. He began to collect guns, nickel-plated .357s and even machine guns, carried them with him in the touring cars, on private planes, and even took pocket guns onstage, a habit that would continue for years and years. "I'd go up onstage, pull my pistol out, set it on the piano," he says. There were threats, and rumors of threats, and they still had to fight their way out of the beer joints they played, and he used that trick with the microphone stand again and again, from the Midwest to Atlanta. He had learned to take the microphone off the stand and fling it out like a rock on the end of a rope at a rude fan or a drunk, holding to one end of the cord so he could snatch it back if he missed and fling it at the offending target again.

His bandmates, playing with the great Jerry Lee Lewis, on the ride of their lives, soaked up the crazy and spat it back at the world.

"It was Buck Hutcheson with me then, on guitar. He could pick, but he couldn't drive. Tarp Tarrant played drums. Tarp did a lot of my fightin' for me. Herman 'Hawk' Hawkins played bass. Danny Daniels played the organ for me. Me and him fought once, over a woman. I had him whipped but I just went weak, just lost my strength. . . . Don't know what happened. I never got tired."

In Grand Prairie, Texas, in 1965, members of his band—Tarp Tarrant, Charlie Freeman, and Hawk Hawkins—were arrested, along with a teenage girl who was just along for the ride, for possession of prodi-

gious amounts of prescription pills. But the pill-and-whiskey-rich at-mosphere of the mid-1960s made them invincible and unstoppable—as long as there was bail money. They didn't just play music but played it strong and hot and tight and a little bit wild, in town after town, and then they moved on to some place beyond the blurry horizon where they were some other sheriff's problem.

"The women?" Jerry Lee says. "Well, they were always sympathetic with me."

They all wanted to heal the wounded artist. He let them try.

"I'd have 'em go to bed with me, and they'd wake up the next morn-ing and I'd be gone. But I remember once . . . It happened in El Paso. I remember we'd been to Juárez and watched some dirty movies. . . . Anyway, there was this girl, this beautiful girl. Blonde. I met her back-stage. She never even mentioned her name. The next morning I woke up and I reached out to put my arm around her and she was gone. I wondered what happened to that girl. I always did. I kinda hated to see her leave. I bet she was married."

There was not a lot of romance in it.

"I'd just say, 'Wake up, baby, it's time to rock again,' and they'd be ready to rock," he said. "If we was flying, I always kept an empty seat on the plane, in case there was somebody." The faces usually changed with the zip codes. "But I gave 'em a plane ticket home," he says.

If this was exile, he could stand it for a good while longer.

"Really, man, I lived it all," he says. "I guess my reputation for all that stuff went ahead of me, too, and I had to live up to it, had to travel hundreds and thousands of miles a day, play good music, and take care of the women, too," and he grinned at that, at the burden.

But Jerry Lee did not want anybody's sympathy, certainly not a beau-tiful woman trying, as the country song goes, to catch a falling star. He hungered to be back on top again, on top of everything.

He took care of business, one little radio station at a time. He con-fronted disc jockeys who had banned his records and pumped the

hands of the ones who had stuck with him, and sometimes there was a hundred in his hand as he did it.

"Greased them pockets," he said. "I learned it from Jud. And I started gettin' my albums on the air. . . . Three hundred, five hundred, whatever it took. 'Money makes the mare trot,' Mama said. It had to be a good song, but the money didn't hurt. It wound the clock up every time," giving him a little more time to record, to search for that big hit.

But for now it was small-time, still. Sometimes they dragged trailers behind their Cadillacs to sleep in, a kind of gypsy caravan rattling across the country. Once he was riding with songwriter Bill Taylor as his wife, Margaret, slept in another vehicle. The two men were riding, drinking, when suddenly one of the trailers broke free of its hitch and came whizzing, freewheeling, past them in the adjoining lane.

"That looked just like my trailer," Bill said.

"That is your trailer," Jerry Lee said.

They watched it roll down the highway.

"Wonder if Margaret's in there," Bill said.

It coasted to a stop.

"Guess I better go see," he said.

It was an unusual time but a kind of life that would become less unusual over the years. He was still wandering, playing music that still made people glad to be alive. At a show in Arkansas, "my dressing room was one of those trailers, out in the back somewhere," he says. He signed autographs there, including one for a college-age boy he would later recognize, some three decades later, on television. "He was runnin' for president. Bill Clinton. Stood in line to get an autograph. . . . I *knew* I knew him."

To his musicians, it seemed like Jerry Lee was determined to play and party his life away without interruption, and even when they saw the Memphis city-limits sign, it was no guarantee that he would turn them loose and let them return to their homes, to their own lives. He would

insist on playing on and on and on into the next morning at his house outside Memphis, drinking and hopped-up, as his band's families wondered if they would ever come home. It wasn't so much the need to party that was driving him, but that hunger for a hit, the key to his comeback, and he believed the best way he could accomplish that was inside the craziness, singing and drinkin' whiskey and searching for chords and taking pills and listening almost desperately for the song that would change everything. Phoebe, a little girl then, remembers it this way.

"He'd be on the road, going, going, going . . . and then he would come home and go to his office, and I'd hear records playing."

Back in Ferriday, the hateful old racial order had begun to smoke and curl. Firebugs and bomb throwers, careful to hide their faces and not set their sheets ablaze, would turn parts of black Ferriday into kindling— which was odd, because there had been little agitation here. In '64, Will Haney's friend Frank Morris was burned to death in his shoe shop. The FBI descended on Ferriday, but his murderers never went to trial. Three years later, Haney's Big House, the landmark blues club that had helped transform Jerry Lee from a talented church piano player into something more, burned to the ground. It would never be rebuilt; Haney would soon succumb to old age, and the great days of blues and R&B would drift away like smoke. It was as if the ground on which he'd built his musical life was turning to soot and ash.

The Smash label vanished, absorbed into Mercury. But Mercury, under any name, could not find him a hit, and he could not find one on his own. By the late 1960s, he was referring to his label mostly with disdain. The Beatles had drawn more than fifty thousand to Shea Stadium while he played for hundreds in auditoriums or less in the bars. Television producer Jack Good kept signing him for more episodes of *Shindig!*, and Jerry Lee got them to put Linda Gail on, too, to help her get her own career started. But what was there for him to play? One day

he found himself on TV playing the Huey "Piano" Smith song "Rockin'
Pneumonia" on a harpsichord.

Pills melted in whiskey, whiskey infused blood, till the road and
home and the rest of it were indistinguishable. Smoke, blue and swirl-
ing, shrouded it all. He had always liked a good cigar but now smoked
big Cubans, the biggest and richest he could find, procured from his
British contacts now that Castro was cozy with the Russians. Now and
then he would stroll from his office with a bottle of whiskey in one
fist, a fat Cuban in his teeth, and a big .357 or .45 in his other hand.
He would aim it at the stars and fire and fire until there was just an
empty click.

Jerry Lee's marriage to Myra, and his home life in general, was strained
at best. "Myra had a bad habit of surprising me. I'd look up, and she'd
be at the show," he says. "In Atlanta, in sixty-seven, after a show, some-
one told me, 'Jerry Lee, Myra's in the next room.' And I said, 'Well, tell
her she'll have to wait her turn.' I was taking a lot of them pills then.
Another time they said, 'Watch out—Myra's hiding behind the curtain
in a polka-dot dress.'"

But as in most things having to do with love, he has a blind spot for
his own infidelity. He does not pretend it did not happen, only that,
somehow, it should have been forgiven because it was his. "I never seen
a woman wasn't jealous. I used to be jealous, but I pushed it aside. But
that ol' green-eyed monster can do a lot of damage."

Myra would threaten to leave him, even see a lawyer, and would al-
lege gross infidelity, physical and psychological cruelty. Worst of all, she
felt, Jerry Lee blamed her for the death of their son, had never forgiven
her, and never would. There was love there in spite of it all, but there
was no hope, not even a chance for it, as he played a show somewhere
almost every night of the year.

In the midst of all these bad times, of the awful drought, fate did

send him one kindness: a guitar man who would stick with him to hell and gone.

It was 1967, and he had an opening for a picker.

"I met him back in Monroe, Louisiana. My mama and Linda Gail, my sister, wanted to go hear this boy called Kenneth Lovelace," and told him he should go with them.

"I said, 'I've heard a lot of musicians before, you know?'

"And they said, 'You ain't never heard one exactly like this.'

"I said, 'What does he play?'

"He plays everything," said Linda Gail. "From a mandolin to a fiddle to a violin, to a piano, to a guitar . . .'

"Yeah," Jerry said, but "can he really master these instruments?"

She said, "Yeah, he pretty well mastered 'em."

Jerry Lee saw this boy—tall and rail thin and kind of unassuming, his hair a tight ball of curls. He looked a bit lonesome up there.

Then he started to play.

"I hired him on the spot."

They went straight to Waco for a show there in some honky-tonk. He was standing behind Jerry Lee, intent on his guitar strings as they blistered through "Whole Lotta Shakin'," when he got a rude surprise.

"Jerry Lee kicked the stool back and I was right in the way. It caught me right below the knees," he says. *Well, that's the last time . . . ,* he told himself." He would be sure, as he saw Jerry Lee getting revved up, to step back and to the side, out of the line of fire.

Kenny grew up in music in Cloverdale, Alabama, outside Florence, not far from the recording hotbed of Muscle Shoals. He started playing guitar at age seven, moved on to fiddle, then to what his kinfolks called the "tater bug mandolin," because it looked like a tater bug. He was playing square dances at age eight and competing in fiddlers' conventions around the South; in time he could play almost anything, any genre,

almost any instrument. But more than that, he would become one of the rare people on earth who had the great, deep patience to survive night after endless night with a man like Jerry Lee Lewis, one of the few who could understand, even anticipate—and therefore survive—his moods. The two men would become true friends, bound by mutual respect and by a love of music above all else. He would be one of the people Jerry Lee could not run off, because where would he go to find such an array of music ever again, and get to play it, night after night, and where would Jerry Lee find a man with such splendid musical radar?

It became almost eerie, how good he was at that. He did not join the band so much as become its de facto leader. Jerry Lee was still the genius in charge and always would be, but he was a mad genius. The mild-mannered but precise and efficient Lovelace became the grown-up element in a band and profession lacking in such, who knew that Jerry Lee's rages were not the end of the world. He backed Jerry Lee on a '56 Fender Stratocaster that he played like an extension of his own bones, and would mesh, almost in a spooky way, with Jerry Lee's wild piano, and never seemed to be caught off guard, no small thing for a picker playing behind a man who could change direction like a mechanical bull.

On the last night of a ragged, exhausting tour, Kenny says, "Jerry and I would hop in the backseat, and he'd get the guitar and I'd get the fiddle, and we'd play all the way into Memphis."

"He's like a brother to me," Jerry says. "We've shared so many things." And no matter how ugly things got, "he always bounced back." He joined the band in bad times; somehow he knew they were temporary. "He's as good on guitar as I've ever heard. He can play the *melody* of a song on the guitar. I mean, very few people can do that. He gets deep into the music. . . . If he ever missed a lick," he says, he can't recall it now.

He had spent years wondering whether he'd have to fire a drummer in the middle of a set or tell a guitar player to pick up the tempo or else. "That's where the Killer part comes in," he says, smiling but not really.

But with Kenny in place, he says, he put together a road band "that nobody could ever *touch*."

During one show, somewhere, he looked up from the keyboard to see a young singer named Janis Joplin sitting next to him on the piano bench. "Might have been Port Arthur," her hometown, he says. He never really liked visitors onstage unless they were invited. Later, in his dressing room, Janis asked him if he thought her sister was attractive. Jerry Lee responded honestly. "She might be all right if she'd do something with her hair." She slapped him, hard, and he slapped her back. "And she come across that desk after me and I was fixin' to knock her brains out." But that was the way it was. The stage was for the music— there was a purity to it then—and the dressing room was for the foolishness, the fighting, and everything else.

Lovelace, who would play behind him almost half a century, will always remember the nights in those mean, beginning years, and the tiny dressing rooms before the show. Jerry Lee always hung back until the last minute, till the band members began to wonder if he would show. "The band would go get him. 'It's time, Jerry Lee,' we'd tell him," said Lovelace. And Jerry Lee would answer:

"Okay, Killers. Y'all hang in there with me."

Killer: It was the highest compliment he knew how to give, say the people who have known him the longest, but it is complicated. It draws people into his tightest orbit, lets them know that he considers them worthy to be there. It is also genuine fondness, his way of sharing some of whatever it is that sets him apart from other men. But it is also a way of binding people to him, a kind of brand, and he will bestow it on a whole room, if he needs to. And sometimes it is just his way of being friendly, to a young man, or a child, who stumbles up half scared with an old album in his hands. In time the name would almost haunt him, as people started to use it to describe a certain viciousness, a label for

a man they suspected might be capable of anything, even killing. But when Jerry Lee looks you in the eye and calls you that, he is cutting off a little piece of himself and giving it away. It makes people grin like they've gone goofy and want to thank him, or at least run and tell some- one, quick, as if it might fade away.

On the road, he had the band of his dreams. In the studio, he had one of the most talented soundmen in the business and the best session men Nashville had to offer. All he needed was some poetry.

Jerry Lee was done with Mercury, and the executives there were pretty much done with him, quietly waiting for his contract to expire. Between gigs and with no intention of cutting another record for those tin-eared Poindexters as long as he lived, he was back home in Ferriday, to maybe catch a fish with Cecil Harrelson, whom he had made his new manager. When he had rested up a bit and drawn sustenance from the low earth and his mama's cooking, he would get back on the road and sing those old songs again. It was January 1968, a decade since the fall. "It got better," he says. "It had to get better."

What happened next varies greatly from one account to the next, but it went something like this: In Nashville, a sometime rodeo rider named Eddie Kilroy had gone to work for Mercury as a promotions manager. Kilroy, who had played in a country band with Mickey Gilley, had sipped some whiskey with Jerry Lee a few years before and believed he was country at heart, real country, not one of those guys who was all hat and no cow. He called Jerry Lee and asked him if he would consider driving to Nashville's Columbia Studio to cut an original country song, and Jerry Lee told him he would study on it. He had lost any love he ever had for Nashville but decided it couldn't hurt to hear a song. He called Kilroy back and said he would give it a try for old times' sake.

Mercury's big bosses had little faith it would work, though Jerry Kennedy had been trying to take Jerry Lee country for some time. But

when Kilroy started calling writers and asking for material, there were few takers; people in Nashville like to do things according to formula and didn't think boogie-woogie Jerry Lee was a bankable country artist.

The song Kilroy had in mind had been written by Jerry Chesnut and sung by Del Reeves. Reeves didn't sing it right, and it hadn't been released. But it was a good song, with brown liquor and lost love pooling between the lines.

Jerry Lee looked at the words—real words, the kinds of words a man felt when he held a woman he could not truly have, could only even hold for as long as a jukebox played. But could he sing it in a way that would make other people feel it?

He stayed up all night learning it, sipping a little whiskey, and the next morning he sang it, this song every woman and every man already knew. Who knew the sound of a heart breaking could be so pretty?

> *I just put in my last dime*
> *Heard you whisper we'd meet again*
> *Another place, another time*

"I remember we did it in two takes, and I picked the first one. 'That's your record,' I told 'em, 'right there.' "

At first, he wasn't sure he thought much of it. Often a song has to grow on him. "This is ridiculous," he thought. "I know I've had better records than this." But the more he listened to it, the more real, the more human it became. He listened to the words. In a wide world of phony and sissy music, this was something different.

"It was a real song."

Jerry Lee thought he *might* have a hit, but there had been so many disappointments. He would have to wait and see, as country disc jockeys around the nation introduced the song to the working people who mostly made up that base. In the meantime, he had to make a living. But with few recording prospects, his contract with Mercury limping to

a close, and the businessmen apparently glad to see it happen, he had a choice.

He could return to the road, where bookings were becoming bleaker.

Or he could do something else, something he had never considered before.

That year he also had a different kind of offer to play his music on a stage, but not as Jerry Lee Lewis, not even as the Killer, but as a villain of a different age. Jack Good, the Oxford-educated producer who had welcomed Jerry Lee to *Shindig!*, had long dreamed of directing a rock opera based on Shakespeare's dark *Othello*, and he had decided more than a decade before that his villain had to look and sound and strut and leer just like Jerry Lee Lewis.

Jerry Lee received a seventy-page script from Good, whom he liked and trusted, and a guaranteed $900 a week for as long as the play would run.

And so it was that, at the age of thirty-five, Jerry Lee Lewis started training to become a Shakespearean actor.

11

"HE WHO STEALS MY NAME"

....................

Los Angeles

1 9 6 8

Iago draws the darkness to him. Swathed in robes of green velvet and blood red, he leers from within a thin black beard, a great cigar jutting from his white teeth. He is a fetid breath of pure evil, a thing beyond conscience, who believes himself wronged and will destroy the whole world in recompense. He controls and traps those around him, baiting them to act on their jealousies and their rage. If Mephistopheles himself had risen to walk across the boards, he could not have conjured a more perfect and lovely meanness than this villain, this Iago with the oddly lyrical Southern drawl. He strews his evil seeds, planting them in the weak, dark places in strong men, and rejoices as they take hold and grow.

In the medieval gloom, Othello, the Moor of Venice, watches his beautiful new wife Desdemona exit the stage. He says to Iago, his trusted soldier:

"Excellent wretch! Perdition catch my soul, but I do love thee! And when I love thee not, chaos is come again."

"My noble lord—" Iago says.

Iago inserts a worm of doubt. "Did Michael Cassio, when you wooed my lady, know of your love?"

A storm crosses Othello's face. Iago has lit the fuse. Later, cigar glowing, he strolls to a lush green-and-gold grand piano, vines snaking around its legs, and begins to play, in a stop-time blues cadence:

> *Cassio loves her, I do believe it*
> *She loves him, 'tis of great credit*
> *I hate the Moor! Yet I am sure*
> *He'll satisfy his wife, every day of her life*
> *With lust of the blood, permission of the will*
> *Oh, that's what you call love, she's going to have her fill*
> *I love her, too, you know I do—*
> *Not out of lust, but 'cause I must*
> *For I suspect the lusty Moor*
> *Between my sheets has done my office more than once before*
> *With lust of the blood, permission of the will*
> *That's what you call love, he's already had his fill*

The piano pumps out his malice.

> *I'll even with him, wife for a wife*
> *Make him jealous, plague his life*
> *The thought of that gnaws my inside*
> *And never will—no, never shall my soul be satisfied*
> *By lust of the blood, permission of the will*
> *I'll have my revenge, and I'm gonna have my fill*

He stops playing.
"Let me see, how, how, how, how? Let's see . . .
He slams his hands on the keys, hard.
"Oh! I *have* it! . . ."

The Moor is noble, the Moor is free
He thinks men honest—ha!—that seem to be
I'll plague him with flies, poison with lies
And everywhere he goes I'll lead him gently by the nose. . . .

Then he breaks into a rolling piano solo of glee. Before the end, he brings up one golden boot and plays with his heel, in case there was ever any doubt who really lived inside Iago's diabolical schemes.

Later, when enough people had died, when Iago has been led away to the dungeons to rot and the curtain falls, Mamie Lewis rose in the front row of the Ahmanson Theater in Los Angeles to applaud, and the whole theater rose with her. The other actors took their bows, but Mamie, wearing the white evening gown her son bought for her, knew whom the acclaim was for. Jack Good's long-ago idea of a rock opera based on Shakespeare's most complex villain had finally come together in this play called *Catch My Soul,* starring veteran stage actor William Marshall as Othello, Julienne Maris as the doomed Desdemona, and Mamie's son as Iago. Why would it even be a surprise that he would steal this show, too?

"Never thought I'd do anything like this," Jerry Lee would say. He never knew there were so many words, twisting around like kudzu, working their way into people's very hearts the way the vines back home wound their way through a rusted car. "That Shakespeare," he says, "was somethin'."

The songs were no problem—though, he would admit, he did not always know what some of the words meant—but sometimes he found the spoken parts, in their early modern English, almost nonsensical. He bought a portable tape recorder and recorded the dialogue of all the other actors, leaving gaps where he would recite his own lines. He spent months at it, only to receive a phone call from Good telling him that the theater that had booked the play, in Detroit, had canceled. Then, on Christmas of '67, Good called again to tell him the play was on again,

at the Ahmanson Theater in Los Angeles, and rehearsals would begin in January.

He headed off to Los Angeles in his Lincoln limousine, with Myra and Phoebe in tow, and the fate of "Another Place, Another Time" hanging in the air. In the furnished apartment they rented off Sunset Boulevard, he played the new record over and over, sure it would be a hit.

"It better be," said Cecil, who'd taken an apartment across the commons, "or they'll drop you off the label."

But there was nothing more he could do about that now. He had a play to learn.

Some wondered if he would take it seriously. "I did," he says now. He worked twelve hours a day on rehearsals.

In one rehearsal, puzzled, he recited the line:

"Your heart is burst, you have lost half your soul: even now, now, very now, an old black ram is tupping your white ewe."

He asked Jack Good what exactly that meant.

Good told him.

"Aw, hell," Jerry Lee said, "I know all about that."

Other lines were so true they needed no explaining.

> *Who steals my purse steals trash, 'tis something, nothing;*
> *'Twas mine, 'tis his, and has been slave to thousands:*
> *But he that filches from me my good name*
> *Robs me of that which not enriches him*
> *And makes me poor indeed.*

Good's greatest worry was that Jerry Lee, being a rock-and-roll star, might not make the curtain on time, since running late is a rock-and-roll certainty. So—not wanting to make Jerry Lee mad, by insisting he be there—he had the entire cast arrive at the theater at two o'clock in the afternoon for the evening performance. But he should not have worried.

Jerry Lee took that aspect of the production seriously, too. He was, he says, honored to be part of it. It was—at least at first—wicked fun.

"I liked the costumes. I liked the little goatee I had. The makeup was superb, and my hair was perfect," he says, and for a moment it appears as if his body has been invaded by some alien species.

Graham Knight, a computer salesman from Aberdeen, Scotland, is one of Jerry Lee's biggest and most loyal fans. He has seen him perform hundreds of times since they first met in 1962, when he used to drive him to his shows in Britain. So of course he was sitting in the Ahmanson on opening night. It was surreal, he said, seeing Jerry Lee inside a part yet still unmistakably him. Jerry Lee was not a schemer like Iago—he did his meanness straight on—but the danger in Iago, the malice for those he suspected of wronging him, fit him well. But "I expected him to go into 'Great Balls of Fire' at any moment."

It was the first time, he says, that he didn't see Jerry Lee do an encore. "Jerry would always do another number," as long as the people were applauding, said Knight. "In this, he stuck to the format and bowed with the other actors" at the close, almost humble.

The applause was not as wild as Jerry Lee was used to, but it rolled on and on.

"It was first-class," he says. "I looked out there and saw all those big stars looking at me."

On that opening night, Hollywood turned out for this most unusual spectacle. Angie Dickinson was there, being stunning. Steve Allen was there, applauding wildly, next to renowned composer Burt Bacharach, and Jerry Lee's devoted fan Tom Jones, at that moment one of the biggest sex symbols in the world. Sammy Davis Jr., the timeless song-and-dance man, clapped in the front row. Zsa Zsa Gabor was there, dripping in diamonds, her platinum hair piled high. They all lined up with reporters to get backstage.

Andy Williams shook Mamie's hand. She had always liked Andy Williams.

"I never knew whether to go on before or after your son," he told her. "If I went on before him, they shouted for Jerry, and if I went on after, they booed me."

Jerry Lee remembers, especially, Angie Dickinson. "I mean, she was on *top* of it."

Mercury sent a bottle of champagne. Sam Phillips sent a case.

It was not Laurence Olivier's *Othello*, this production, but it was by God a show. "Jerry Lee Lewis, Louisiana-born genius, with fiddle, drum, and piano, played a unique Iago," wrote the *Christian Science Monitor*. "He read the lines extremely well. But his big coup was the way he played the psychedelic green and gold grand to punctuate his attack on Othello's susceptibilities."

The *Los Angeles Times* wrote: "When Lewis tells a wiggling Chorine, 'Shake and break it and wrap it up and take it,' it fits the play better than, 'Oh, mistress, villainy hath made mocks with love!'"

Variety wrote that Jerry Lee's stage acting debut "makes of Iago an often chilling contemporary schemer, despite a singsong recital of lines."

Several reviewers noted that Jerry Lee did not even try to mask his Southern accent, and sometimes would "garble the lines," wrote the *Los Angeles Times*, "which was exactly the intent."

The response was so strong that Jerry Lee moved Mamie and Linda Gail to Los Angeles for the duration of the play. It ran for five weeks and grossed some $500,000, and there was talk of Broadway.

"I just didn't have any interest in that," says Jerry Lee, and it is one of the few times in his life when he made a decision about his career that he has genuinely regretted later. "I mean, I knew I could handle it, but I never was so glad when something was over. [Jack] wanted to take it to Broadway, but I told him, 'I can't do it, Jack, I'm sorry.' It could have been one of the biggest plays that's ever been, if I had stuck with it. But me with my hard head. . . . Now I wish I'd gone ahead and done it, for Jack. I let him down." The play, he says, drew other acting offers. "Some

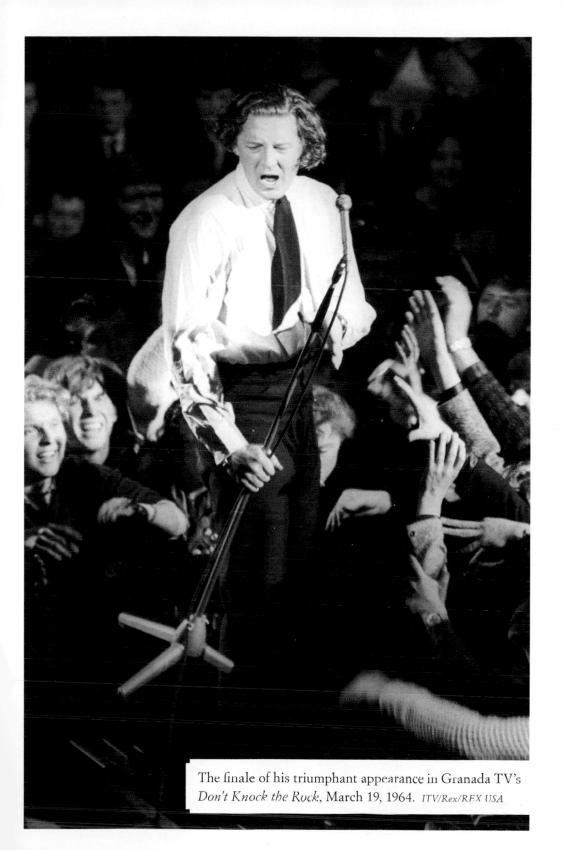

The finale of his triumphant appearance in Granada TV's *Don't Knock the Rock*, March 19, 1964. *ITV/Rex/REX USA*

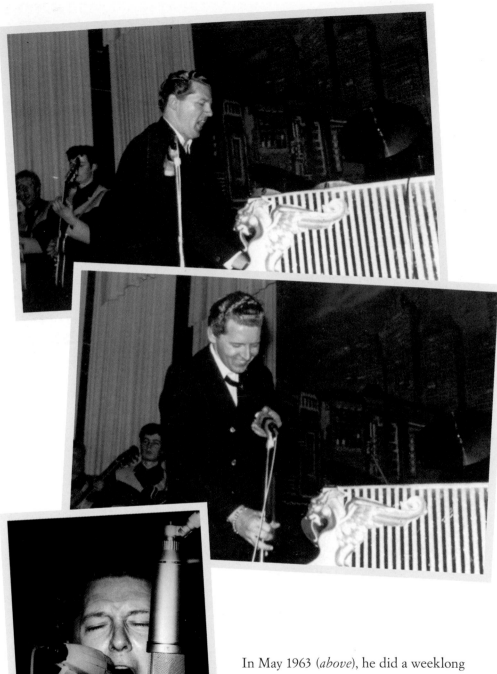

In May 1963 (*above*), he did a weeklong stint at the Star-Club, a raucous joint on the infamous Reeperbahn where the Beatles had lately cut their teeth. On April 5 of the following year (*left*), he returned to record one of the greatest live albums of all time.

Pierre Pennone; K&K Center of Beat/Retna Ltd

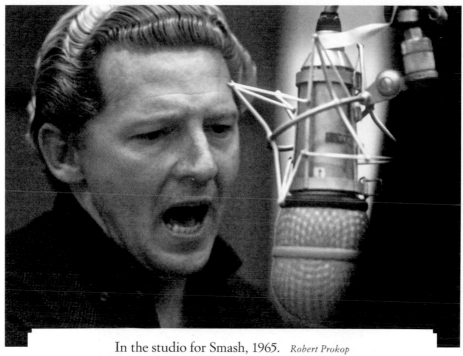

In the studio for Smash, 1965. *Robert Prokop*

A Chicago live date captured for the cover of the Smash
album *Memphis Beat*. *Robert Prokop*

TOP The wild man reborn as a seasoned country star.

REX/Dezo Hoffman

BOTTOM "No, never shall my soul be satisfied!"
As Iago in *Catch My Soul*, 1968.

Backstage at the London Palladium, 1972. *Gijsbert Hanekroot/Redferns/Getty Images*

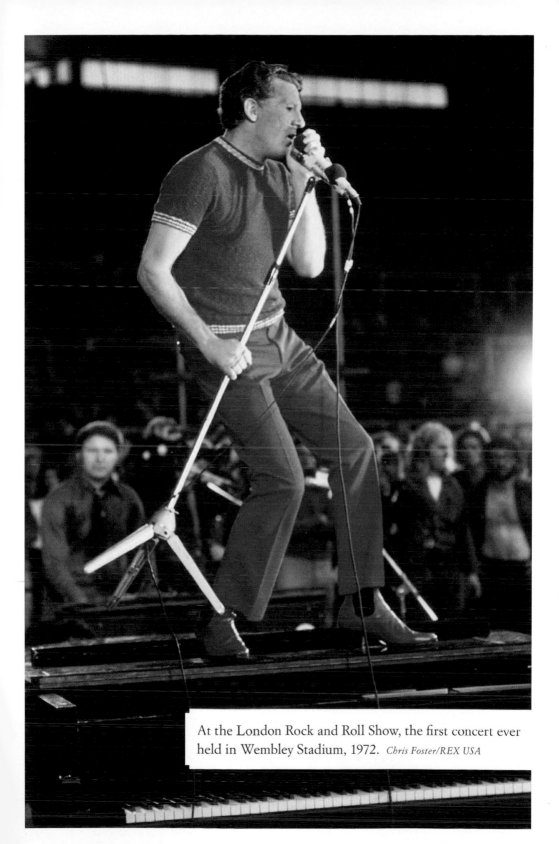

At the London Rock and Roll Show, the first concert ever held in Wembley Stadium, 1972. *Chris Foster/REX USA*

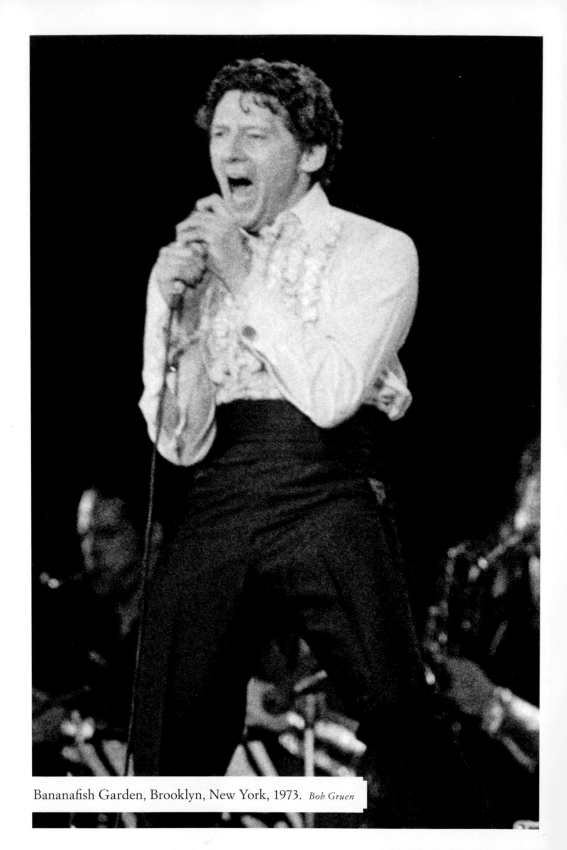

Bananafish Garden, Brooklyn, New York, 1973. *Bob Gruen*

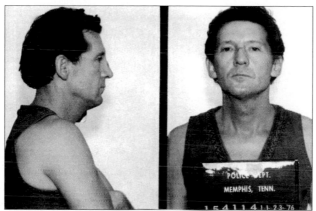

TOP "Where's Daddy at? Is he still cussin'?" With Elmo in Texas, 1970s.
Raeanne Rubenstein

BOTTOM After pulling into the gates of Graceland, early morning,
November 23, 1976. *Memphis Commercial Appeal*

TOP In his private plane, 1970s. *Raeanne Rubenstein*

BOTTOM Onstage with Linda Gail. *Raeanne Rubenstein*

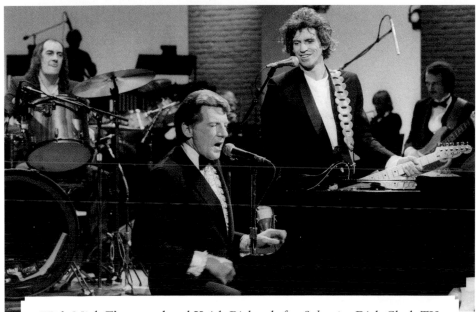

With Mick Fleetwood and Keith Richards for *Salute!*, a Dick Clark TV special, July 1983. *Richard E. Aaron/Redferns/Getty Images*

The boys of Ferriday, Louisiana: with Mickey Gilley *(left)* and Jimmy Lee Swaggart. *© Christopher R. Harris*

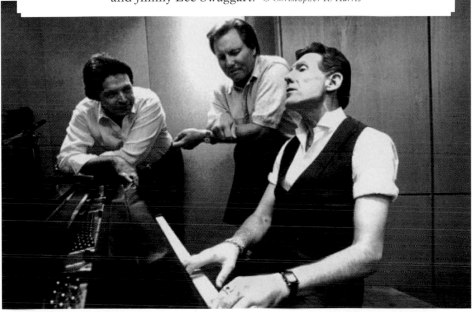

TOP With his fourth wife, Jaren Pate, in 1978.

Memphis Press-Scimitar

MIDDLE At his wedding to Shawn Stephens, June 7, 1983.

Globe-Photos/ImageCollect.com

BOTTOM After Shawn's death, on April 24, 1984, he married Kerrie McCarver.

Zuma Press

Getting his star on
the Hollywood Walk
of Fame. With him is
Dennis Quaid,
who played Jerry Lee
in the 1989 motion
picture *Great Balls of
Fire*. *AP Photo/Doug Pizac*

At home in Nesbit,
Mississippi, with his
Sun gold records.
LFI/Photoshot

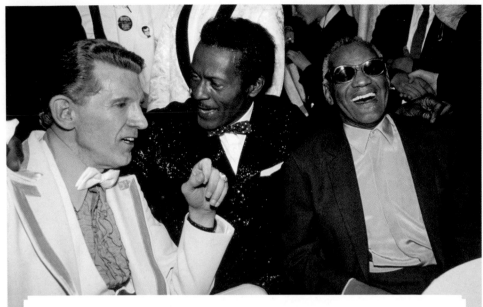

With Chuck Berry and Ray Charles at the first Rock and Roll Hall of Fame induction ceremony, January 23, 1986. *© Lynn Goldsmith / Corbis*

At the *Great Balls of Fire* premiere party, at the Peabody Hotel in Memphis, 1989. *AP Photo/Todd Lillard*

Back at the Hall of Fame, 1995 (*left*), and onstage with Levi Kreis at Million Dollar Quartet, 2010.

© *Neal Preston/Corbis; Bruce Glikas/WireImage/Getty Images*

Frankie Jean (*left*) and Linda Gail (*right*).

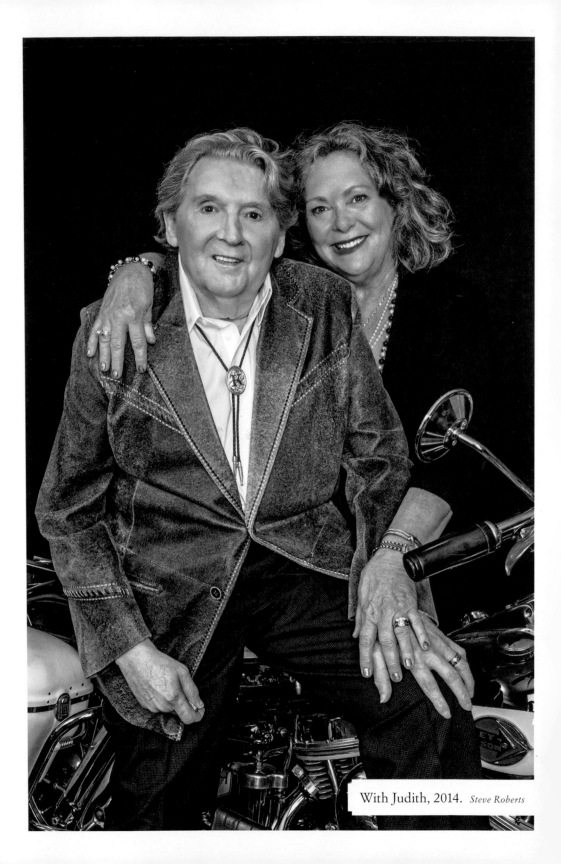

With Judith, 2014. *Steve Roberts*

people in Hollywood, they begged me. They begged me to go to France and do a movie with Kim Novak. I had my chance at Hollywood, but doing that play had showed me how hard it was. It was *work*."

The truth is, he missed being the genuine Jerry Lee Lewis.

"They didn't understand . . . I play piano and sing songs. I loved *that*."

He had proved that he could do it and make a dollar doing it, and nothing gave him more pleasure than showing people he could do a thing they thought was beyond him, too complicated for the country boy. But as Elvis had so feared, there is always a risk for a performer, if you disappeared for too long from *your* stage, from your true calling. But Shakespeare and Iago would linger in his mind. He left Los Angeles with a healthy respect for the words, and even months later, taping a TV show called *Innocence, Anarchy, and Soul* in London—Shakespeare's own backyard—he was able to interrupt a scorching rendition of "Whole Lotta Shakin' " to smite the audience with Shakespeare:

> *Divinity of hell!*
> *When devils will the blackest sins put on,*
> *They do suggest at first with heavenly shows,*
> *As I do now.*

The crowd, at first flabbergasted, started to cheer as he continued, verse after verse.

From the wings, another voice calls the part of Rodrigo to him:

> *Thou didst hold him in thy hate.*

Iago:

> *Despise me*
> *If I do not! I have told you often*

And I will tell you again and again,
I hate the Moor! Three great ones of the city,
In personal suit to make me his lieutenant,
Off-capped to him, and by the faith of man,
I know my price, I am worth no worse a place:
But he . . . :
"I have already chosen my officer."
And what was he?
One Michael Cassio, . . .
That never set a squadron in the field
Nor the division of a battle knows
More than a spinster, . . .
But he, sir, he must be lieutenant—he!

Then he took his seat at the piano, the crowd still going crippled-bat crazy, and went back to singing about whose barn, what barn, my barn.

He has always wondered why the entire play was not recorded, perhaps for television—it was not—because he would like to see it all again. And he has often wondered about Shakespeare himself, what kind of man he was, what a conversation between them would be like. Were they not, in a way, both stylists? Shakespeare just took history, took Rome and Venice, and remade them to suit his own mind and to entertain the people.

"I wonder what Shakespeare would have thought of my music?" he wondered then and wonders still today.

His time with Shakespeare at a close, he returned to the South, a place where history truly does, now and then, repeat itself. He returned to find that the inertia that had held him prisoner for years had been shattered, been obliterated again, by the force of a single song.

Chairs are stacked all over tables
And it's closing time, they say

He had to go back into his past to find his future.

I could wait here forever
If they'd only let me stay

"It was the kind of thing Hank Williams would have wrote," he says, and so naturally the people felt it in their hearts. "Another Place, Another Time" was as strong as he hoped. The record had climbed into the country charts even as he spouted Iago's treachery in the shadows of the Hollywood Hills. Soon "Another Place" was battling for the number one country slot, and his entry into mainstream country music was already in place before he even crossed the Tennessee state line. It was undeniably a tearjerking country song, but it had grit in it, and it had his piano, thumping the slow, steady heartbeat of the song. There were no pyrotechnics in the music here, nothing that would make a piano virtuoso even blink—and no sweeteners, for that matter, just the counterpoint of Kenny's lonesome fiddle. It was the kind of song you would expect to hear on the very jukebox he was singing so mournfully about, the kind of song that was born in a honky-tonk where the air smelled like Winstons and Juicy Fruit. "It sounded real," says Jerry Lee.

Producers at Mercury were anxious to get him back in the studio to record more of the same. He had barely landed in Tennessee when he was hustled back into the studio with sheets of lyrics for three new songs written by Glenn Sutton. These songs were of the kind they were starting to call "hard country," not because it had a rock beat or crossed over into rock in any real way, but because it was more substantial than the cloying, overproduced mess out there on country radio.

For the follow-up single, he cut Sutton's "What's Made Milwaukee Famous (Has Made a Loser out of Me)," another heartbreaking barroom anthem. His voice is so mournful, you believe him, and even after a thousand songs about a man trapped in a neon prison as a woman waits at home, it sounded somehow new.

Well it's late, and she's waiting, and I know I should go home
But every time I start to leave, they play another song

His voice cries out, not so much for sympathy as for some kind of company, maybe even some kind of second chance. These were not whining songs; it is hard to feel sorry for Jerry Lee Lewis in any context, in any era, and he doesn't want you to feel sorry for him. They were, this new generation of Jerry Lee songs, simple ballads about losing, wanting, and walking on. Jerry Lee sang of shared misery, of a familiar pain, and knowing they were not alone made it easier, somehow, for his audience to get up the next morning, go back out in the world and do it all over again. As Hank Williams had sung it to them more than two decades before, Jerry Lee reminded them that a broken heart was common as dirt, and the could even be kind of pretty, neighbors, if the melody was sweet and the words all rhymed.

It was music for people who worked in the pipe shops and steel plants and cotton mills, who sold insurance and slung wrenches and drove taxis and trucks and wiped the tables at the Waffle House. Many of them were the same rock and rollers who had shook it till it hurt when the music was still new and dangerous, in the time of the two-tone shoe, but they had gotten a little older, saner. They had to get up early now; they had mortgages on two-bedroom brick ranches with chert-rock driveways, and payments on new Buick Rivieras every five years. Rock and roll had deserted them, with Top Forty playlists and all that magic-dragon crap. So they had simply gone home to the country, to country music and the country radio stations they had been weaned on; Jerry Lee merely joined them there, thanks to his own ear and the work of a few good songwriters.

"They wrote what people feel," he said of the writers of those songs and the songs to come. "I sung it like people feel."

He did it again in "She Still Comes Around (To Love What's Left of Me)":

I know I'm not a perfect husband, although I'd like to be
But payday nights and painted women, they do strange things
 to me

By the end of the summer of '68, he was the hottest country artist in the nation.

He might even have worn a rhinestone or two in those heady days, he says, "but not like Porter Wagoner." It was all coming together. "Songs were great. The words were perfect, the melody was perfect, the song was perfect. All I had to do was play it, sing it, be done with it. Go on to another one. Number one. Number one. Number one. 'Bout thirty-three number-one records in a row."

He cut songs of great romance, like "To Make Love Sweeter for You":

You've cleared the windows of my life, and now that I see
 through
I'll do my best in every way to make love sweeter for you

It was perhaps the closest thing to a pure love song he would ever cut, and it would be his first number one on any chart since "Whole Lotta Shakin' Goin' On," a long, hard ten years before.

But if there is a song he was meant to sing, it was probably the sadly beautiful "She Even Woke Me Up to Say Goodbye":

Once again, the whole town will be talking (yes they will)
Lord, I've seen the pity that's in their eyes

It is not the song of a man wronged unfairly; it is a song about a man who deserves every heartache and knows it.

Baby's packed her soft things and she's left me, she's left me,
 she's left me

Some songs make people think they were written for them. This is the opposite: in this song, it's as if Jerry were living inside the lyrics. "A couple of years later," he says, he realized that "these people was writing songs for me all of my life. I said, They're tellin' me something."

Finally, in the wake of "Another Place, Another Time," Jerry was back at the top of the songwriters' wish list—and they obliged with a slew of new material that fit perfectly with his voice and leather-worn persona. Some of them actually were created for him—like "Think About It, Darlin'," written to capitalize on one of his catchphrases. "Songs like that," Jerry Lee says, "that's a masterpiece. I mean, that and 'Help Me Make It Through the Night' by Kris Kristofferson," which was also covered by everyone from Elvis to Joan Baez. Jerry Lee did it with some blues. He took care to stick to the writers' words on those great country songs, especially those of Kristofferson, who would become one of his dearest friends. "You don't mess with Kristofferson," he says. And his new country style was the perfect complement to these simple, plainspoken songs: It was familiar enough to slide easily onto country radio playlists but warmer, more intimate, and with a little more honky-tonk feel.

This new run of songs changed everything for Jerry Lee. "It put me back on top," for the first time since 1958. And it made him richer than he had ever been as the firebrand of rock and roll. Gone were the days when he loaded his band into two dusty Cadillacs and sprayed gravel across the United States and Canada. Once the first few big records hit the airwaves, the hits came in a cascade, more than thirty in all, till Jerry Lee's voice, singing new songs and covers like "Before the Next Teardrop Falls," leaked from the window of every station wagon, pulpwood truck, and Airstream trailer in the South and Midwest, in Bakersfield and Detroit City and, of course, Nashville.

"I played that good kind of country, not that other kind," he says, and you only had to listen to Top 40 country radio for five minutes in almost any area to know precisely what he was talking about. When he

played his live shows, he mixed his country hits in with the rock and roll and blues and his old, old music, his childhood songs, as he always had. He never considered himself a country music artist—labels were bridles to him—but rather a rock and roller who was reaching back into his roots. Nashville might have saved him, but it was Memphis that swelled his heart.

He lived for a while athwart the two, appearing in April 1969 with Little Richard and Fats Domino in a rock-and-roll revival TV show called *33⅓ Revolutions per Monkee*, proving that a man with talent can survive anything, even the Monkees. Then it was back to Nashville, four more times that year: a duets session with Linda Gail that ranged from hard country to rock to soul, then a solo session in which he cut Jimmie Rodgers's "Waitin' for a Train," one of his finest renditions of the white man's storytelling blues:

> *I walked up to a brakeman, just to give him a line of talk*
> *He said, "If you've got money, son, I'll see that you don't walk."*

The session with Linda Gail became an album (*Together*), and he would continue to feature his sister onstage and on television specials to come. She was a fine talent in her own right, he says—"It's in the blood"—though some would call that evidence of his largesse, that he would do anything for blood.

Kenny Lovelace had as close a view as any as Jerry Lee rose out of the wasteland and into country stardom. Elvis must have seen it, too, had to have seen it, and in the summer of '69 he made a historic comeback of his own.

"We were on the road at the time," says Lovelace. "It was great, man. We was in Columbus, Ohio, and had three or four days off. Elvis found out where we were and called the hotel, but Jerry was asleep. When Jerry woke up, he tried to call Elvis, but he was in the sauna. Elvis called back and said, 'If you have any time off, I'm gonna be opening

at the International Hotel, and starting to tour again. I'd love to have you come out and see what you think of the show.' He just liked Jerry's opinion. So me and Jerry Lee and Cecil Harrelson and Dick West flew out there. They had a nice booth reserved. Elvis came out in the middle of the show and said, 'I'm just so pleased that my good friend came out tonight. And I'd like to introduce you to my buddy, Jerry Lee Lewis.' Everybody in the room stood up and gave him a standing ovation. After the show, we visited backstage. They had a piano in the dressing room. Elvis said to Jerry Lee, 'Would you mind just playing a few notes?' Jerry did some runs; he was just playing around. . . . Elvis leaned against the piano, watching him. 'What a piano player.' "

That fall, there would be evidence on film to show how much mastery he had achieved. First he did the Toronto Peace Festival, in front of twenty-five thousand people, the same event where Alice Cooper was rumored to have bitten the head off a live chicken. Back on the bill with Chuck, Bo Diddley, and Little Richard, he played it smooth and loose and lovely, like he was in a church basement instead of a big stage in an arena filled with screaming peaceniks. Then just a few days later, he taped a series of short concerts on a small stage at the Memphis Holiday Inn for a television show to be called *The Many Sounds of Jerry Lee.* In one of his most diverse and impressive performances ever captured on film, he reached back, back into his Sun days for "Ubangi Stomp" and "Lewis Boogie," did his big rock-and-roll hits and most of his country hits, and surprised the audience with an almost casual show of versatility, playing drums on Bobby Bland's "Turn on Your Love Light" and strumming guitar on "He'll Have to Go" and "Green, Green Grass of Home." He even sang "Danny Boy" with just a microphone, like a genuine pop crooner. But what was most impressive about the Holiday Inn shows was that they were perhaps the first time a camera had truly captured his sheer talent on the keys, his windmilling hands on "What'd I Say," showing everyone who'd never seen him live exactly what all the fuss was about and reassuring his oldest fans that going country had not turned him weak.

In October, with a pile of smooth country hits in the can, he loosened up in the studio and had some real fun with Merle Haggard's "Workin' Man Blues," the old R&B ballad "Since I Met You, Baby," and a new A-side, "Once More with Feeling," all part of a continuing metamorphosis. He insists even today that there was never any real evolution in his art—"I was a master of the piano by age fifteen," he says, preempting any such talk—but still there was a difference in these Mercury records that had nothing to do with genre. He was more mature—less wired, perhaps, but more assured, proving that he had not done the same thing over and over in those endless road shows but that they had been one long, roving practice session. He was also simply older. His spirit had not mellowed, not a bit, but his voice had, and his subtler delivery did justice to his far more mature material. Where once he had hollered through "Whole Lotta Shakin' "—and still could, of course—now he approached his ballads almost elegantly, though with that constant earthy undertone. He could sing a love song, and you still knew, watching him, that it was not one woman he had wronged or disappointed but one hundred, and you knew that if you messed up his song, he would come off the stage and kick your ass up to your watch pocket. As a pianist he had even more finesse and precision, yet he still loved to beat it to death for the sheer joy of it.

He was not just on top of the world again; in some ways, he was looking down upon it. On November 14, 1969, the astronaut Charles Conrad Jr. carried a collection of Jerry Lee songs with him to the moon on Apollo 12. "Whole Lotta Shakin' Goin' On" not only went to the moon, as he always said it would, but it landed on it—the only sound, at times, in that little spacecraft on that cold, distant orb. He would look at the moon sometimes, especially on the nights when it was big and full, and grin about that. Some of the old people at home in Louisiana said we never went to the moon, that they made all that stuff up, but he knows

that we did, and that the astronauts heard a little boogie when they got there.

In early '70, he did *The Johnny Cash Show*; he was gracious to his host, and Johnny treated him like a long-lost pal. He was acceptable now in the world of country music, and in the wider one. All seemed forgiven. What had once seemed a slow, inglorious burnout was now a genuine comeback: you could tell by the Cadillacs that once again filled his parents' driveways—though Mamie still stole his when she took a notion.

"I left the keys in it," he says now, "so she wouldn't have to ask for them."

"Mama, you take my new car?" he asked when he saw a bare spot in the driveway about the size of a Fleetwood.

"All the way to Ferriday," she answered.

"And I would have to buy her one just like it to get it back. I'd call the dealer and he'd say, 'I happen to have *one left*.' A salesman always has *one left*."

The offers for live shows poured in. He even played Vegas, in an extended engagement at the International Hotel. Elvis was playing the main room.

"I was playin' in the lounge. I mean the lounge was as big . . ." and he laughs. "It was as large as this whole house. Just the *lounge*. I mean, the main room would seat, like, three thousand people. And the room I was in would seat, like, twenty-five hundred. I was hittin' [Elvis] tit for tat on that." With its more casual atmosphere, the lounge was a better match for Jerry Lee. "You can really let your hair down there, you know. I was doin', like, six shows a night. I didn't mind. I loved it!"

He had watched Elvis's show in the big room, but to him it was like he'd lost what made him great—the leanness, not in his body but in his performance. "I didn't particular care too much for that," he recalls now. "He had an enlarged band, with horns and violins, stuff like that, and I don't think it ever come off that good. He was tryin' to prove

somethin' that really didn't need provin'. He was takin' away from his old style."

For his own shows, all he needed was the raw, stripped-down power of his piano and voice. He wanted as little fanfare as possible. "I never give 'em a chance to introduce me," often just coming onstage during the warmup and starting to play. One look at the faces there, he says, and he would know what to play and how to play it. Playlists were for timid people. "I can read my audience like *that*. I can tell what they want and what they don't want. If it's there, if they really want it, if they got an addiction for it, so to speak"—he laughs—"I can deliver it to 'em." He'd play the big hits, of course, but sometimes he'd give them whatever he felt like in the moment—a bit of Bob Wills, or Tom T. Hall, even a sip or two of Jolson. It seemed he could sing anything then, sing the water bill, and they would have given him a standing ovation. The women stood three deep at his dressing-room door, and the husbands left bullets on his piano lid, thinking they were clever, that such a thing had never been done before.

The only thing missing was a musical heir. His boy, Junior, the son he'd had with Jane when he was still playing the Natchez clubs, was now fifteen. He had learned to play the drums—was learning still—and moved out of his mama's house and joined his daddy on the road and soon onstage. He was handsome even before he was old enough to drive, like his daddy on *The Steve Allen Show*. He was clean-cut, in the beginning, and wore his hair swooped up high on his head, like his daddy had done. He had a smile full of big, white teeth, and looked like he was getting away with something just sitting there. Born thirteen months after his wedding with Jane, Junior was every inch his boy.

"I loved him. . . . I loved my boy."

At first he just banged a tambourine, for the fun of it, while he learned the drums. Then Jerry Lee decreed there was no reason why

a band could not have two drummers, and Junior took a seat behind his daddy, keeping time. He traveled around the country and around the world, seeing and doing things most teenagers only imagine. He ate with rock stars and listened as his daddy swapped stories of the old days with other legends. He would prove to be a talented drummer, with his family's ear for music. Jerry Lee knew the rock-and-roll lifestyle was seductive, dangerous, but to deny the boy a chance to experience it, him being a Lewis, would be like telling a Flying Wallenda not to walk a wire. "He done good" on the road and stage, and the excesses of the road, the drinking and drug use, were not preordained, though it would mean the boy would have to rise above not only temptation but the natural bent for addiction and wild behavior that had been in the blood of Lewis men since the Civil War. The Lewises made music, and they raised hell along the way.

But Junior was not his daddy, say the people who played with him. He was not a Killer, but a gentler soul, and he seemed to draw out a tender side in his father. Kenny Lovelace remembers how Jerry Lee would turn from the piano bench, watch the boy play, and when he would hit a particularly hot lick, would grin. "My boy . . ." Jerry Lee says now, and his eyes track away to a dark corner of the room, as if he can almost see him there. His other son, Steve Allen, had left the world so soon, so early, and there was so little to recall. But in this boy, this young man, he could see his own face. "My boy . . . Lord . . ." He will not talk of him for long, and it has been too long already.

His next album, *There Must Be More to Love Than This*, was full of cheatin' songs, "Home Away from Home," and "Woman, Woman (Get Out of Our Way)," and the title song. It was once again prophetic. Myra, left mostly at home as he chased his newfound stardom, had hired detectives to follow her husband on the road and by 1970 had evidence to support her suspicions of gross and prolonged infidelity. She filed for

divorce while Jerry Lee was on tour in Australia. Her petition alleged cruelties without end, beatings, and threats on her life. Jerry Lee denied the worst of it—"I never hurt none of 'em"—but the other women were, as he once said himself, "hard to hide," especially if you are not trying too hard. They had been married thirteen years, and while there had been love in the beginning, it was pretty well stomped flat by then. "Bogged down," he says. "But she did try to get me back several times. She knew she made a mistake." (Four months after the divorce was final, Myra married Peter Malito, one of the private detectives she had hired to gather evidence of Jerry Lee's infidelity.) The new album also featured a song called "Life's Little Ups and Downs," Charlie Rich's paean to marriage and forgiveness. But forgiveness was just one more pleasant fiction, sung in pleasant rhymes.

Much has been written about how the divorce from Myra tugged him into a dark place, became the catalyst for some kind of decline, some escalation in his drinking or drug use that somehow tipped the balance he had found that allowed him to record, perform, and party. If people think that, he says, they were not paying attention for about two decades. It did not cripple him or stifle his creativity or sap his energy. His marriage to Myra had been so long in trouble that this end was inevitable; he behaved little differently in the wide-open days after the marriage than in the wide-open days before its slow death. It might seem right to say it knocked him to his knees, but that is not what happened, not what took his wind in the years to come. He is impatient when people tell him he should have felt something he did not. "Don't no woman rule me," he says again, what he always says when he is done talking about a woman or her hold on him. He is not saying he did not miss her at times—they were married a long time—only that he moved on. In the narrative of his breakup with Myra, the role of tortured, jilted spouse is not one he is willing to take on.

He took his happiness, as always, in the music—in a rocked-up version of the chestnut "Sweet Georgia Brown," recorded since its incep-

tion in 1925 by everybody from Bing Crosby to the Beatles. It remains one of his favorite records—"one of the best things we ever done"—and in this case he gives much of the credit to Kenny Lovelace. "He did that fiddle break on that thing—it's *somethin' else*, isn't it? I mean, you can never capture that again, like that. Oh *man*! What a *record*! It's so far above—so far ahead of anybody's thinkin' in the music business that they could never comprehend the meaning of it. It had the flavor of everything." Onstage he turned the song into a celebration, hands flying, fingers stabbing, his face, in those days at least, joyous. If you don't like it, he likes to tell the audience, "you need to get yourself checked," 'cause you might already be dead.

He could do anything, it seemed, except live the way people said he ought to, but even despite his foibles, he somehow soared. Pearry Lee Green, who'd almost gotten kicked out of Bible college when Jerry Lee rocked Waxahachie, never gave up his conviction that his piano-playing friend was born to bring people to the Lord. In 1970, he was at a conference of ministers called the Full Gospel Businessmen's International in Sydney, Australia, when he learned that Jerry Lee was in town. Jerry Lee was drinking that night, but he asked Pearry Lee to sit on the piano bench with him in front of a well-lubricated, rowdy auditorium crowd of three thousand people. "You're going to be surprised," he told the crowd, "but I was going to be a preacher." He told the crowd of the "singspiration" and how the organized church refused to accept his gift. Then he sang a hymn, an old one from his childhood. The rowdy crowd grew quiet.

"I'm going to tell you something, he had every kid in that place crying," said Pearry Lee. "I don't think in my life I've ever seen that many young people with tears in their eyes. Jerry Lee's voice just melted their hearts. If I'd been preaching, I'd have given an invitation for salvation."

12

JET PLANES AND HEARSES

. .

Around the World

1 9 7 0

The locust years had come to pieces on the ground. He had cast them down at the close of the last decade, along with everything else that reeked of small time. "I was *still* what they had been waiting for, and they *still* loved it, and they *still* knew I loved doin' it." He still fought the old devil, the one that swirled in the liquor and rattled around in pill bottles, the demon Satan who lived on the painted lips and swam in the made-up eyes. He still feared the cost, but not enough to cast down the music or all it had given him, and in a way, all it demanded in return. His mama had told him not to give up when things were bad, Mamie standing there in her always modest dresses, hair pulled back severely, still no makeup or lipstick on her face or lace at her neck or cuffs to offend her God. She had stood thus, her big black purse held before her like a shield, and told him to use his gifts to lift the people's hearts, and if she had worries or doubts, she buried them deep down, like some lost hairpin in the bottom of that purse.

In the midst of his comeback, Mamie Lewis fell ill. The doctors said it was cancer, and he could not stand it. It is one of those things people

often say, in heartbreak, but in his case it was true. He did not weep and he did not curl up in a ball and refuse to face the world, but he took every step, every breath, with the knowledge of her impending death. "I worshipped her," he says now. "I didn't even know a thing could *be* like that." His kin said he could not even bear to see her weak and hurting, and so he went home less and less as her condition worsened. "You don't question God. Whatever comes. I never did."

But if ever a man had a right to believe he was being punished, to believe a terrible price was being exacted from him, it was Jerry Lee in 1970. He had conquered the world again, only to see what was most precious to him threatened by something he could not buy off or change. He had seen the ravages of the disease in the face and body of his uncle Lee Calhoun, seen the great man reduced to skin, bones, and pain, and now the same curse had taken hold of his mama, whose strength had carried the family through awful times, even death. He had once believed it was his daddy, Elmo, who had the steel in his spine, who could stand against the world and spit in its eye, but as he had gotten older, he came to see it was Mamie's strength, more than anything, that bound the family together, even when the State of Louisiana through divorce said it was legally dissolved. He knew his Bible—it was the only book he had ever truly read—and knew it to be the Word of God and therefore the last word. He had lived his whole life in terrifying closeness to it, especially in those verses that warned of the cost, the parts that asked what it profits a man to gain the whole world but lose his soul. It is easier for a man to live in ignorance than in such closeness; the preachers say God will be more merciful to the ignorant.

"I never stopped praying for her," he says. "Never was a time I didn't pray for her." He did wonder if his prayers had the weight they might have had if he'd lived as a better man, but still he prayed on. Jesus washed the feet of a beggar and forgave a whole world of sin; surely he would hear Jerry Lee pray for his mama.

His cousin Jimmy continued to remind him of the cost of his sins

in front of untold thousands. His ministry was growing. He had gone from a traveling tent preacher in a two-tone '58 Oldsmobile to a man whose words challenged and condemned sin across the land, his voice thundering from a syndicated radio show called *The Camp Meeting Hour*. He told the faithful and the seekers, their hands pressed to the warm plastic of their Philcos, that they could be healed if they prayed and if they believed, and they did believe, not just in the Word and the Law but in the man who came to them through the electric air, and they rewarded him with an ever swelling audience and did send him money so that his ministry could grow. Now he rode in new leather, and his own closets poured forth fine garments. *The Camp Meeting Hour* had swelled to include more than 550 stations, the largest daily gospel program on earth. He was destined for television, the key to the whole world, where his charisma would be as a sounding bell.

It did not hurt that Jimmy Lee was tall and good-looking, with a voice that seemed to drop from the pages of Deuteronomy itself, or that he could play the unabashed hell out of a piano. By the 1970s, he was already a force among Assembly of God officials, who had once refused to ordain him because, he believed, his cousin was that rascal Jerry Lee Lewis. He was a recording star in his own right now, with hit after hit album of gospel, many comprised of songs he had played with his cousins back when you could hear the pianos ringing halfway across town. He told his listeners that God spoke to him directly, and so his flock knew he was a prophet, because God did not often speak to them in that way. Jimmy preached both for Jerry Lee and against him, warned of the wages of sin, and wept.

Jerry Lee had always thought that at least part of Jimmy's antagonism came from their old, lingering jealousy. But now both men lived in great wealth, so it couldn't be that alone. The sin of it all was still in the songs and in the lifestyle.

But it was hard for Jerry Lee to stay angry at his cousin, even when it seemed like his life, his sins, were the stanchions upon which Jimmy's

sermons rested. "We were always just like brothers," he says now, "and he was a *great* preacher, and a great person. But he had enough sinners out there to preach about without worryin' about family, about ol' Jerry Lee. He probably says he was doing it *for* me, and, well, maybe he was."

He did, over time, begin to feel used.

"He's never said that he was sorry. I don't think it would hurt him to apologize. But he won't."

But he also knew that his cousin was not preaching from the wind but from a Bible they both knew and believed.

"I forgave him, as it happened."

Later, Jimmy would write that Jerry Lee's fame was built on "glitter and glamour" and smite him with Proverbs 14:12: "There is a way which seemeth right unto a man, but the end thereof are the ways of death."

He knew his mama made exceptions for him, from love. He knew she never approved of the rock-and-roll lifestyle, but he saw it more in how she reacted to others. "Waylon Jennings took one woman with him to the airport and brought another woman back with him on the plane," he recalls. "Mama never got over that. Waylon told her, 'I'm so sorry, Miz Mamie, that you had to see that.'" But she never called her son on his own behavior. He was her boy and always would be.

He could not bear to think of her in the hospital bed, wasting, hurting. He tried to think of her as she was when he was a little boy, when he was always running off to Natchez or Vicksburg or farther places, and how relieved she would be when he came sauntering up in the yard licking on a nickel ice cream. "I charged it," he told her, when she asked where he found the money for such extravagance as that. He could tell she was always at war with herself, in moments like that, wanting to pinch a welt in his arm or knock a knot on his head, but before he made his last step up into the old shanty house, she would gather him up in

her arms and squeeze him till he could barely breathe. "My baby," she always said.

"Family," he says, shaking his head. "If you ain't got family . . ." It was the one place you could go, could retreat into, when no one else would have you. There were days when he wondered if, when his mother left him, there would be anything left at all.

As his mother's flesh weakened, he saw his own son, Junior, succumb to the same appetites, the same temptations, that his cousin had long preached about from his gilded ministry in Baton Rouge.

It was a time when pills of every kind were almost as easy to obtain as a fast-food hamburger, easier, because they rode in guitar cases and shaving kits and overhead bins, rattling, always rattling. Drugs were a kind of cultural currency, now—not just for touring musicians but for the most sheltered middle-class child on a tree-lined street. Jerry Lee watched, haunted and overmedicated himself, as his son slipped into a set of habits that was as much a part of the music as guitar strings and drumskins. It just seemed like people had to have them to make the music, and by the time he was sixteen, Junior did, too. Jerry Lee tried to tell the boy to quit all that, his band members recall, to spare himself the demons his daddy lived with. Not everyone could take the demons into their body and survive like Jerry Lee. Not everyone could just absorb them, dilated eyes hidden by dark glasses, and walk tall. The drummer, Tarp Tarrant, later said that Jerry Lee blamed him for it, for giving them to Junior, and put a knife to his throat as a warning. Jerry Lee would have killed anyone who threatened his son in any way, and not worried about the rightness or lawfulness of the act until later. He may have never even considered what role he himself played in it by bringing his son into this world. But it was the life his son hungered for and the only life Jerry Lee had to share.

With his mama sick and suffering and his only living son at risk, Jerry Lee decided on a change. He did not, as many have said, renounce rock and roll. He never renounced the music. He did renounce the

lifestyle and its most common venues, the bars and clubs where it was played beside a running fountain of whiskey and beer and other substances. He told reporters in early December 1970 that he would play no more shows in places where liquor was served, and would play only at coliseums, theaters, and fairs, and would end his shows with gospel music, and would even give testimony. He swore off drinking and cursing and fighting and wild parties and rejected the attentions of loose women. He would do a clean show and live a clean life, and he would ask God to help the people he loved. He told the *Tennessean* of Nashville that he had made a stand for God. "I'm just letting the people know. . . . I've gone back to church and I got myself saved, and the Lord forgave me of my sins and wiped them away."

He prayed for his mama.

He prayed for his son.

He prayed his promise and said he would do anything if God would spare his mama.

Later that December, Jerry Lee and his band performed at a Sunday service at a country church on Highway 61 South outside Memphis. In a live recording of the show, he sounds happy, at ease, as if some great burden had been lifted, and maybe that was true.

"First song that I ever sang in church, neighbors, was an old, old song that my mother taught me back when I was just a kid about eight years old," he told the congregation. "That's been a while ago, but I can still sing it."

> *What will my answer be? What can I say*
> *When Jesus beckons me home?*

"Very true song," he says.

He sang "I'll Fly Away" and "Amazing Grace" and "Old Rugged Cross" and "Peace in the Valley," preaching all the while: "Hallelujah, glory to God, there will be peace in the valley too, brother. I'm looking

for that day, I guarantee you." Then he introduced his band: Edward DeBruhl ("He's a good boy, a good Christian-minded boy. Me and him have set around the motel room many nights playing religious records and crying"), Kenneth Lovelace on electric guitar and fiddle ("one of the finer musicians in the United States . . . an all-around musician and an all-around guy"), "and Jerry Lee Lewis Jr. is playing on the drums tonight," said his father, proudly. "Junior comes from Ferriday, Louisiana, and you know, he kinda likes to wear his hair long, and I told him yesterday, I said, 'Son, y'oughta get a haircut, you know, and he wouldn't do it. He's a little bit too big for me to try to make him get a haircut—bigger than I am—but I'm not really worried about his hair. He's a good boy. I'm just worried about his soul, him being saved. I appreciate Junior very much, and I love him with all my heart. He's my only boy." And the boy looked at his daddy and grinned and laid the beat down in perfect time.

It was the rockingest day in the history of Brother E. J. Davis's church, though he was a little scandalized when Jerry Lee got so full of the spirit that he played part of "I'm in the Glory-Land Way" with his boot.

The congregation shook the boards. Jerry Lee laughed with joy. "Thought I'd better do that just to show you I could still do it," said Jerry Lee. "I didn't hurt it, Brother Davis. Brother Davis got an evil eye on this piano tonight. I'm not gonna jump up on it, Brother. I guarantee you. Not tonight."

He followed up that date with a studio gospel album titled *In Loving Memories*, and even had Mamie come in and sing in the chorus on the title track.

> *Well, I stand here so solemn, with a blank look on my face*
> *As you lay there dressed in pure white lace*

It was clear that her sickness consumed him, too, say the people who watched him suffer through the winter of 1970 and on into the spring of '71. It also seemed that he had in some ways blamed himself, as if her death was somehow the cost he had to pay for his success and his sins. As she was beginning to fail, he recorded Jimmie Rodgers's "Mother, the Queen of My Heart," a parable of a prodigal son who promises his dying mother that he will "always go straight," a promise he cannot keep.

> *Ten years have passed since that parting*
> *That promise I broke, I must say*
> *I started in drinkin' for pastime*
> *Till at last, Lord, I was just like 'em all*

Mamie died two weeks later, at midnight of April 21, at the hospital in Ferriday. As with the death of his little boy, he did not cry in front of his family, not in the church in Ferriday as the preacher stood over the specter of death and warned that time was nigh, nor at the little cemetery in Clayton. He stood straight and silent, like his mama used to do, and watched the earth take her. "I've learned," he says. "I've learned to do it." The preacher preached again, and then, with those lovely voices, her kin sang her favorite hymns. They call it "singing them into heaven," but his mama didn't need no help.

"She was the best mama in the whole world," he says. "I took care of her. She took care of me."

She had dragged a cotton sack all day, in the rising dust, to buy him a shirt to wear, to sing a song.

"I miss her," he says.

His kin would say he would never recover. Some would say he wanted to die, that he tried to kill himself with all the excesses of his fame, with

all the weapons of destruction his money could buy, but then, had it not always been that way? Some would say he blamed himself for refusing to give up rock and roll and play only church music, only gospel, or at least something tamer, easier. But then he would have had to have been another man entirely, and he doesn't believe his mama wanted that. "Mama was *always* with me," he says, again and again. It might be dramatic to say she condemned her son for his music, but that is just a lie. "My talent was a gift from God, *not* from Satan." His mama was the first to tell him that and would remind him of it in his moments of doubt, he says fiercely. "If my mama had not been for me, she never would have accepted any of the things my music got for her." She would have refused houses and cars and cast the other presents from her. He holds to this belief in his lingering doubt.

"A man ain't meant to be alone." He says it, and the Bible says it.

In '71, for once actually legally divorced before remarriage, he married a twenty-nine-year-old divorcée named Jaren Elizabeth Gunn Pate, a secretary in the Memphis sheriff's department. They separated two weeks later, and would not live under the same roof again. He would later say that he married her at least in part because she was pregnant, though not with his child. Five months after the wedding, Jaren gave birth to Lori Leigh Lewis, and listed Jerry Lee as the father on the birth certificate. He disagreed, but quietly. He has long refused to air the matter in public, a choice his kin view as a kindness. But people close to him, including some in his own family, say that one of the reasons the marriage was in name only was that the child was not his.

It was not a happy marriage, but at least it was a long one; she moved out of his house and into a house he paid for in Collierville, Tennessee, and they would live that way indefinitely, separated but still legally wed, seeing each other now and then. It would seem an odd arrangement, but Jerry Lee did not want to live with her and he did not want the or-

deal of a divorce, and there was no one then he wanted to marry in her place. So he let it limp along for eight years. The marriage was mostly invisible, coming to light only in court records when she filed for non-support for herself and the child; most people had assumed the union had just dissolved years ago, and the ones who knew better accused him of abandonment. When the marriage did end, it would not be in a courtroom but in another tragedy.

In the meantime, he had unrenounced rock and roll and all that it implied, including its enticements. Now, instead of recording any more new country songs, he went back in time to a song that seemed to have little or no room in its history for a remake—and found a hit in that, too, in fact his biggest hit in years. The song was "Chantilly Lace," a signature song for the Big Bopper, recorded on the Mercury label in '58, a novelty song that rode the Top Forty at the time, and deposited the punch line "Oh, baby, you *know* what I like!" in the public consciousness for good. The original version was so recognizable and such a novelty that Jerry Lee wasn't sure there was room on the airwaves for a new version. He had to be talked into it by someone he trusted.

Jud Phillips had rejoined Jerry Lee's life as a kind of ad hoc adviser, because he was one of the few people on earth who could hang with Jerry Lee on an all-nighter or three-day binge. Jud had not renounced anything, and he had some of his best ideas when he was flat on the carpet. "Jud was the man that was callin' the shots on those records," recalls Jerry Lee. One day, Jerry Lee says, they were sitting around, trying to find a hit, "and he was so drunk that he couldn't stand up. He's just layin' there on the floor. And he said, 'It's time to do 'Chantilly Lace.' "

Jerry Lee was skeptical, he says, but "I never called Jud wrong."

"Jud," he said, "I don't know the song. I don't even know the words to it."

But he already knew what Jud would say. "Then just fake it."

Jerry Kennedy remembers what followed as a wild session, with

Jerry Lee pounding through chorus after chorus. What Jerry Lee re-members is what it took to get started.

"I had never played it before," he recalls. He knew he'd have to do something different to it: "I took the song, and put my style to it. And rewrote it word for word," putting his own sly spin on the ball:

> *Hellllloooo, you good-lookin' thing, you*
> *Yeah—huh? This is the Killer speaking . . .*

But the real problem wasn't what he would do with the song—it was making sure a huge room full of studio musicians, including a full complement of strings, wouldn't kill the spontaneity with sweetness. "I went in and told Jerry Kennedy, I said, 'You turn on the red light, like we're not recording.'" Like Sam Phillips, he believed that some-times the best performances came when everyone was relaxed. "But we *were* recording. I told him to just leave it, leave the tape running, and capture that first take. I said, 'Don't worry about the band hittin' a bad note or anything, because they know the song.' And we nailed it. One take."

Afterward, the conductor of the string section came over to Jerry Lee, happy with the rehearsal.

"I think we can do it again. We got it."

"You just cut the record," said Jerry Lee.

"Aw, no, it couldn't be!"

"Oh, yeah it is," Jerry Lee said. "That's a hit."

He was right. "Chantilly Lace" spent three weeks at number one on *Billboard*'s Hot Country Singles chart; it was a Top 50 pop hit in the States and a Top 40 hit in the United Kingdom. For many loyal fans, the record captured everything they loved most about him. When he sang the old rock and roll, it reminded them of a time when there would have been no such music without that little bit of hillbilly in it; and so it reminded them of being young. But where the jolly, unthreatening

Bopper had sounded only mildly lecherous singing about that "pony-tail, hangin' down," Jerry Lee breathed a different kind of attitude into the song.

> Do I like what?
> I sure do like it, baby. . . .

"Chantilly Lace" was a highlight of a new album, *The Killer Rocks On*, along with his cover of a Kristofferson song that Janis Joplin had made famous not long before, "Me and Bobby McGee." With its rueful, retrospective quality, "Bobby McGee" fit him perfectly, and from then on, people would call for it at his live shows. "*That's* a song," he says now.

Jerry Lee's friendship with Kristofferson was a kind of mutual admiration society. Jerry Lee had always responded to strength and confidence in real men, and in Kristofferson he saw all of that. This was a man who had finished the army's ranger school, flown helicopters, and boxed at Oxford, and yet who still wrote gentle songs like "For the Good Times." More than that, he seemed to not give one damn what the music establishment—or anyone, for that matter—thought of him. And like Jerry Lee, he had made it work for him. A Rhodes Scholar, he would always hold to the teachings of William Blake, who believed that if a man had a God-given talent, then he should use it, or reap sorrow and despair. Jerry Lee just knew the man wrote songs—words—that stuck in people's hearts like fishhooks.

Even with Jerry Kennedy's strings sweetening the sound, *The Killer Rocks On* was his grittiest album since *The Return of Rock*. He took the occasion to blow through Elvis's "Don't Be Cruel," Charlie Rich's Sun hit "Lonely Weekends," and Fats's "I'm Walkin'" at double time, but also contributed a soulful reading of the old blues song "C. C. Rider," and takes on two recent Joe South songs, "Games People Play" and "Walk a Mile in My Shoes," that fit his voice—and country radio—

perfectly. The old men in overalls called it "that long-haired country," but he made it rock.

If you could see you through my eyes, instead of your ego
I believe that you'd be surprised to see that you'd been blind

The Killer Rocks On would be more than an album his fans would wear out from start to finish. It would mark an emergence from a country cocoon, his rebirth as a bona fide rocker.

Having made millions singing country, he spent them partying like a rock star. He had languished too long, touring and slaving and waiting for this rebirth, not to enjoy this ride when it came. "There wasn't no time to lollygag around," he says. "In one time around Nashville, there was more Jerry Lee Lewis stories than you could count. And, yeah, some of 'em was even true."

It was a time of epic excess, but even the wildest rock stars of the 1970s learned that when it came to playing good music and then partying like there really was no coming dawn, they were milksop amateurs compared to Jerry Lee. He was even starting to look different: He had always considered long hair effeminate, but he'd enjoyed that beard he grew for *Catch My Soul*, and now he grew it out again and let his curls grow past his collar. He traded in his sport coats and two-tone shoes for boots and snazzier threads. Heading to England for a historic concert at Wembley Stadium, the first concert ever in that arena, he looked downright casual in his short-sleeved orange shirt and tight matching pants next to Little Richard and Chuck Berry. While he was backstage, he noticed a skinny, big-lipped kid on the stage, jamming like an overexcited teenager, waving a movie camera around. It was Mick Jagger.

"He was rolling on the floor with his camera," says Jerry Lee. "He had every album I had ever made—*with him*. I told him, 'I am not going to sign all them albums.' "

On a spring tour of Europe that year, he was wild onstage, wilder

than perhaps he ever had been; the audiences loved him for it, because it was the persona come to life in front of them—not Jerry Lee Lewis, but the Killer. He was climbing the piano again at every show now, growling and threatening and clouding up and raining all over them. In Paris, he punched the air and climbed the piano to bump and grind, and the screams drowned out the music. Backstage, in interviews, he was exhausted, contemplative. He looked like what he was, a man with a troubled soul drifting out of control.

Or maybe, he says now, he just knew he had a role to play.

"I give my audience what it wants," he said backstage as a French reporter translated. In the black-and-white video, his skin seems pale as bone, though maybe it's just a trick of the light.

It may have been the role of a lifetime, but it took a toll.

"They *want* it that way," he says now. "They want somebody that's mean. That turns over pianos. That turns Rolls-Royces over. That gets married when he gets ready.

"That's the Killer, you know? The *Killer!* Killer! Killer!"

In a blur, Jerry Lee and his entourage returned to London in January 1973 to cut an album with a cadre of gifted British musicians, including guitarists Peter Frampton and Albert Lee. Released as *The Session . . . Recorded in London with Great Guest Artists*, it was a contentious, hard-driven encounter in which the British would say they were driven like mules and many ass-whippings were threatened by an impatient and well-lubricated Jerry Lee. But the record was another hit, climbing into the charts on both sides of the Atlantic. The single was "Drinkin' Wine Spo-Dee-O-Dee," proving that Jerry Lee could reach as far into his past as he wanted now, with this new momentum, and find a hit. He also cut another record that would be a kind of anthem for him, the Charlie Rich song "No Headstone on My Grave," about a man defying death but promising to meet his mama in the by-and-by.

Jerry Lee would later say that the long-haired Brits in the funny bell-bottom pants were fine musicians and pretty good boys; they just needed some straightening out, like any band does sometimes. During the session he even tried giving them a little introduction to the long, long, long dead American songwriter and pianist Stephen Foster, leading them through "My Old Kentucky Home" and "Swanee River" in rock-and-roll time. "A lot of folks think he was a kinda . . . *settled*-type cat, you know," he told them. "But he was a rockin' muthahumper, Stephen Foster."

His price per show, for concert halls, was back to $10,000. Elmo was traveling the world with him, now happy as a toddler with his mouth full of jawbreakers, calling down for room service and giggling at the grown men who brought it up in their silly pillbox hats. Phoebe could go to the finest schools, boarding schools, away from the craziness for a while, then return to the storm to watch her daddy rock and rave. Now, on silver wings, he floated above the mean little beer joints and honky-tonks and jukes where he had been forced to make his living. He had taken the riches from his country stardom and purchased his first airplane, a DC-3, with room for all manner of hangers-on and amiable drunks and pretty women with no particular place to go. He hired his own pilots to fly him in style to the big shows and TV specials, though "I never liked to ride on no airplane," he says. He had lived his whole life swinging from one near-disaster to another, surviving crisis after crisis, fighting his way out or thinking his way out and sometimes just taking it like a man, but a man in an airplane had no power over anything, unless of course he was flying the thing himself and sometimes not even then. The wind could knock him out of the sky or he could get lost in a cloud or in a sheet of rain and never be seen alive again. "Airplanes don't leave many cripples," he says.

He remembers one trip in the 1970s, a trip from Las Vegas to Knoxville. The long flights often turned into mile-high drunks, and so it was this day. He was half-asleep on that flight when he glanced out the

window and noticed "it looked like to me we were getting mighty close to the ground."

He looked up to see one passenger come half running back from the cockpit.

"Jerry Lee, I don't know if you know it, but your pilots are both asleep," he said.

"Well," Jerry Lee said, "I better go wake 'em up."

He opened the door to the cockpit and looked inside. The men were asleep, and by now the treetops were almost brushing the wheels.

"They wasn't drunk, just asleep," he says. "They didn't fly me again."

It was a freedom he had never had before, even at the height of his rock-and-roll days. He could just go when wanderlust struck him. He would get off the phone at his house in Memphis and announce to whoever was lying around there, "Hey, y'all wanna go to Europe?"

"I reckon," they would say, and off they'd go.

"It was the most perfect DC-3 in the country. It was beautiful on the inside. And it had everything you could want on a plane." There was only one problem: "It was slow, slow, slow."

He laughs about it now. "I remember one time, we was passing over San Antonio, Texas. And I looked down at the freeway and *cars* was passin' us." He asked the pilot, named Les, if that was normal. "Les, looks to me like those automobiles down there are passin' us."

"Oh, yeah, that's true," the pilot said. "We got a *real bad headwind.*"

"I said, 'I want a plane that will go faster than this.' So I got a Convair 640. It was made by the people out of Switzerland. . . . Nice bar, nice restroom . . . Had twenty-five seats on it—I mean, seats like this," in his living room. "Anything you wanted, you know? Rolls-Royce engines on it. . . . And every time I'd leave town, my daddy—he didn't mean anything by it, but there would be twenty-five people on that plane! People I didn't even know."

One time, they were slated to head over to London. "I got Les to fly us to Kansas City, catch a plane out of Kansas City. And some old guy

sittin' on the plane, he says, 'Jerry Lee . . . I want you to know how much I appreciate this. I have never been overseas in my life. This is really gonna make my year.'

"I said, 'Well, you just enjoy it, sir.' He thought we was flyin' to England. We's just goin' to Kansas City."

The insanity of the lean years had continued, now with better and louder toys. They carried guns on the plane. They carried pills. After one transcontinental plane ride—he cannot recall exactly whether it was going or coming—Elmo, who had been drinking for several states, suddenly bolted out of his seat, leaped behind the wheel of a waiting limousine, and went squealing off over the tarmac, for all practical purposes stealing the car, only to crash it a mile or so down the road. Police arrived to see a gentle and frazzled old man sitting in the backseat, telling a tale of how he had been sitting there all along. He was Jerry Lee Lewis's ol' pappy, he said, and he'd just been waiting in the backseat when some guy stole the car with him in it and ran it into the ditch. What was most impressive was that Elmo was still limber and quick enough to switch from the front to the back before the law got there.

Gunfire was commonplace. He had a friend named Arthur who walked up to him drunk at a party.

"Jerry Lee, I think I might have ruined myself," he said.

"What do you mean you ruined yourself?" Jerry Lee asked.

"I stuck my gun down the front of my pants and it went off," he said.

"Well," Jerry Lee said, "you might have ruined yourself."

Sick of dealing with outsiders and certain that he could run his own business as smoothly as any carpetbagger, Jerry Lee had formed Jerry Lee Lewis Enterprises, Incorporated, located in a suite on Airways Boulevard, retaining as his manager the trusted Cecil Harrelson, who had backed him in ten thousand honky-tonks, and hiring as creative director Eddie Kilroy, who had brought him the Chesnut song that put him back on top. Cecil was in the family officially now, having married Linda Gail, who would divorce him and marry Kenny Lovelace, then

divorce him and marry Cecil again on her way to eight marriages, a
Lewis family record.

The days of the Cadillac were done. He bought a Rolls-Royce; all
the real rock and rollers had a Rolls. It had a twelve-cylinder engine and
would outrun any police car in the states of Mississippi and Tennessee.
The days and nights were wild and fat and rich, and he could take it,
man, even feed on it, because he was Jerry Lee Lewis. He was taking
pills again, had never really stopped. He had a never-ending supply of
them, some even legal, from George Nichopoulos, the man who med-
icated Elvis, the man they called Dr. Nick. But he could not medicate
himself effectively enough to dissolve the pain of his mother's death;
some days it could still find him, after so much time. Reeling, hurting,
he did himself great harm in those days, but instead of crashing, he
reeled on. He supported relatives when they fell on hard times and even
when they didn't, and if there was anyone keeping track of the money
he spent or the money he owed or the money that was owed him, they
were sleeping through it all. There were few records or no records, and
that would haunt him one day. The rules, the laws, seemed silly still.
He reeled toward the next stage, the next record, the next large payday.
Like most episodes of his life, he sang his story from the stage, singing
Creedence Clearwater like he meant it:

> *Don't go around tonight*
> *Well, it's bound to take your life*

His temper, always infamous, worsened. Graham Knight tells of a
concert in England in '73 when Jerry Lee became furious at a drummer
who could not keep up or keep time. "He told the drummer to get off
the stage, and if he told the drummer to get, the drummer would go,"
he said. "After the drummer left the stage, Jerry continued playing the
show, playing the melody on the piano with the right hand, and playing
the drum with the left."

Knight remembers it was the music, still, that sustained the man more than any chemical. Even in England, the end of a show did not mean the music was finished. "I liked the times when he would be in my Mini, sitting in my passenger seat, Kenneth Lovelace in the back. He'd be playing his guitar, and Jerry would sing. And we would drive a couple hundred miles that way, back to London. We'd stop at a truck stop, and Jerry would ask for a cup of beans. Truck drivers would come up to him in the middle of the night. 'Are you Jerry Lee Lewis?' they would ask. 'The one and only,' he said."

But the demons even outran the music, and he found he could not run fast enough to beat them and still hold the road. Jerry Lee remembers smoking down the two-lane in his Rolls-Royce somewhere up around Bolivar, Tennessee, blue and red lights in his rearview mirror. "I's moving on pretty swift," he said. "Burnt up two more cop cars trying to catch me. I looked up and I saw that the road ahead of me was completely blocked with cop cars. *Why*, I thought, *they must be waitin' on me.*"

Another time, he was blasting down the Tennessee blacktop, his tape deck blaring through custom speakers in a car that cost more than most of the houses he roared by. He tried to take a curve at a speed he can no longer recall, but one beyond the physical mechanics of even his vehicle. "I turned a Rolls-Royce over," he says, "and it was layin' up on its side. And this song—it was one of my favorites that was playin', 'One Rose,' Jimmie Rodgers song. And I was listenin' to that tape, and—boy, I was about half loaded, too, to be honest with you. And I was sittin' there, and I guess the cops threatenin' me, and everything, to get out of that car. I said, 'I'm not gettin' out of this car until that tape finishes playin' 'One Rose That's Left in My Heart!' And they just backed off and waited till it finished. It had warped the tape or somethin' when it turned over. 'Ooonnne rooossse, that's left innnn, my heart, deeear . . .'"

At the station, "I was rantin' and ravin', and kickin' and carryin'

on," he laughs. "They had a time with me. They put me in a cell back there, and he said—the sheriff—'When you settle down, Jerry Lee, and you quit all this cussin' and rantin' and ravin' and carryin' on, and threatenin' us and everything, we'll let you out and you can go home.' I said, Maaan, you gon' let me out, now . . .' He said, 'That ain't gonna get it.' So I ranted and raved about an hour or so, an' I finally calmed down, kinda laid down on this bunk and took a little nap, I think.

"He come back by and said, 'You through with all that rantin' and everything?' I said, 'Yeah, I'm ready to go home.' "

For some four years now, he had been the most bankable country star in the world. He lived the heartache in his songs every day, but he did not ask for the sympathy of the people who bought his records. How do you ask that of men and women who counted every penny, who prayed to make their payments and pay their power bill? They gave it to him anyway, and the fan mail poured in. People said they prayed for him and thanked him for the happiness he brought them. "I hope it lifted people's hearts," he says, and he believes it did. He even still played a city auditorium or high school stage once in a blue moon to stay in touch with those people; three days after the massive concert in Wembley Stadium, he played a school in Indiana. But the love that people gave him, from the factory floor, from the sweatshop sewing plants and typing pools and the double-wides and dirt roads, had not reached as far as the Ryman, the members-only institution that had rejected Hank Williams and been cool, at best, when Elvis took the stage. Once, a long time ago, when his mama was alive, he would have liked to have played there, because it would have meant so much to her. He had seemed such a natural choice back when he did "Crazy Arms" and "You Win Again," but no one called, and then the Opry banned him outright, because of his rock-and-roll reputation, forbade him to play the show

that his mama had hoarded a battery all week to hear on her transistor radio. And now it was too late.

Then, as if to prove how fate messes with a man, in the midst of the heartache and craziness and self-destruction, he was asked to play the Ryman, with all that it implied.

"They asked me to play the Opry," he says, "and I only did it because this time they begged me to."

It was January of '73. It was still the same Opry, with the same austere old men glaring from backstage as if they had been hacked out of hickory and nailed to the Ryman walls. Ernest Tubb and Hank Snow and Roy Acuff, the ageless men who had looked right through him when he was a big-eyed boy standing backstage, stood there in the same suits that hung straight down from their skeletal frames like they were draped on crossed broom handles. Some of the acts had changed, but *the* act remained: Minnie Pearl, a tag still flying from that same silly hat, still shouted, "Howdeeeeee!" and told stories that depicted country folk as backward but somehow wise at the same time; the Opry regulars did bluegrass and old, old country, and newer, younger guests did some safe music that fit the mold. Little Jimmy Dickens still walked around under that massive white Stetson, like he had a bathtub on his head.

As Jerry Lee stood there in the wings, waiting, he shook hands and nodded and was polite, but he had not forgotten. He remembered the last time he had stood here, invisible unless he was in someone's way. And then a sweet voice had asked him, "Son, are you lost . . . ?" And then he heard his name announced, and he strolled to his piano, across those scarred but historic boards, to great applause.

The old, thin men in the fine, glittery suits and Stetsons stared from around the curtain, uncertain. What heresy would he unleash?

Instead he did "Another Place, Another Time," a song written to be

played here, expected to be played here, and when he was through, the people began to applaud, warmly, loudly. But almost before they could bring their hands together, he blistered into Ray Charles's "What'd I Say" and a medley of "Break My Mind" and "Mean Woman Blues," followed by "I Can't Seem to Say Goodbye" and "Once More with Feeling," and the Singing Brakeman's "Waiting for a Train," and the people in the polite crowd whistled and roared.

"Played right through the commercials," he says, ignoring the broadcast schedule, any schedule. They could work around him. Then he looked into the wings and motioned for Del Wood, the one member of the Opry who had been kind to him when he was here as a teenager wandering Music Row.

"Ladies and gentlemen, many years ago, I had the privilege of meeting a fine lady. Her name is Del Wood. . . . I was just a kid at the time, about nineteen years old. I came backstage—I don't know how I got in, I just slipped in—and she treated me with the most . . . I don't know, she was so courteous. I'll never forget for as long as . . . I live. This meant so much to me. And I'm gonna ask Miz Wood if she would come out. . . . No one has asked me to do this in any way, shape, form, nor fashion. . . . I just talked with her backstage, and I said, 'Honey, I want you to come out, and let's me and you just sit down to the piano and play "Down Yonder."' "

The crowd whistled and cheered as she walked out.

"This is a privilege to Jerry Lee Lewis," he said.

"Took the words right out of my mouth," she said. "It's a privilege to me."

And the piano started to ring. She could play anything, that woman, ragtime or gospel or honky-tonk. They'd called her the Queen of the Ragtime Pianists when she toured with the Opry for the soldiers in Vietnam, but she was a star only in memory now. Now she sat with the still-young Jerry Lee, and they played together, sometimes laughing out loud.

"I'm gonna tell you one thing about that lady," Jerry Lee said, as she walked off to thunderous applause. "If she can't get it, you can forget it, because it couldn't be got."

Then someone in the crowd screamed out "Johnny B. Goode," and he got back down to it. "Yes, yes," he said, and played it for them, then went into another medley of "Whole Lotta Shakin' Goin' On" and "Workin' Man Blues" and "Rock Around the Clock," and then finished with a red-hot second round of "Shakin'." He slowed down to do "Me and Bobby McGee," played "Chantilly Lace," then another medley of "Good Golly Miss Molly" and "Tutti Frutti." The crowd screamed and whistled and shook the ancient floorboards. They behaved in a way that this old place had not seen since the last inappropriate boy had climbed the stage, the one who said he could throw his hat onto the stage after singing "Lovesick Blues" and his hat would get three encores. They hollered and stomped like they'd hollered for no one but him, not even that boy Elvis.

"Elvis," he says now, "was *not* ready."

He looked around at the old, worn building, so ragged to hold such gilded history.

"It was a barn," he says now.

Then Jerry Lee looked out across the seats and played . . .

Hear that lonesome whip-poor-will
He sounds too blue to fly

Two months after the Opry show, he gave a thunderous performance in Brooklyn, backed by a full set of horns, that was broadcast nationally on the ABC series *In Concert*. Then, in September, he returned to Memphis to cut a new album, *Southern Roots*. During these sessions, he insulted the producer, threatened to kill a photographer, and drank and medicated his way into but not out of a fog. In that haze, he did the raunchy classic "Meat Man," written by his friend Mack Vickery, a song that needs little explanation:

I got jaws like a bear trap, teeth like a razor
A Maytag tongue with a sensitive taster

He seemed still unstoppable, making repeat engagements on the now classic late-night TV series *The Midnight Special*. The show brought him into even greater numbers of living rooms, carrying him even higher into that odd place where legends and stars of the here-and-now breathe the same rare air.

He was in Los Angeles that October playing the Roxy, when a scruffy, nearsighted young man appeared backstage, almost breathless.

His son punched him in the arm, excited, then kept punching him.

"Daddy," Junior said, "ain't that John Lennon?"

"Yes, son, that's John Lennon," he said.

Lennon rushed up to Jerry Lee and dropped to his knees.

He bowed, and kissed his feet.

"Thank you," Jerry Lee said, not knowing what else to say.

"I just wanted you to know what you meant to me," said Lennon. "You made it possible for me to be a rock-and-roll singer."

"He was very sincere," Jerry Lee remembers. "He said, 'I just wanted to show you and tell you how much I appreciate what you done for rock and roll.'"

Jerry Lee had not thought much of the Beatles' music, but it turned out they were decent boys—at least this four-eyed fellow with the scraggly sideburns and sissy-looking hair.

"He was real nice," Jerry Lee said. "He was serious. I didn't know what to think. I guess it is flatterin', when you have people kissin' your feet."

He does not know if any of the other Beatles were there that night in the entourage. "They were in a box of seats, and they were diggin' the show. I know that. I don't know what they were smokin', but there was a lot of smoke comin' out of that box."

He purchased that year a big brick house in the country in Hernando County, Mississippi, framed by a beautiful lake, with stables, green pastures, and lush, dark trees. There, about fifteen minutes south of Memphis, inside the pastoral limits of the hamlet of Nesbit, a man could take a swim in his piano-shaped swimming pool or step out his back door and fire his hogleg unmolested at snakes or clouds or the moon and stars, and it was nobody's business but his. He had envisioned it as a place where he and his daddy and his children, and maybe even boy grandchildren, to carry on his name, would live, perhaps not in serenity, not exactly Walton's Mountain but still a good place, their place. It was the anchor, a place to come home to.

But he rarely saw it. In 1973 alone, he traveled to eighty cities to play and sing his songs, often doing more than one show in each locale. That fall, he crisscrossed the country west to east and north to south. He started in Syracuse, then Nashville, then off to Europe for a couple of whirlwind dates, then a week in Los Angeles taping an episode of the television drama *Police Story*, then off to Memphis for *Southern Roots*, then Oklahoma City and Corpus Christi, then Kentucky, Florida, Nebraska, Minnesota, Wisconsin, L.A. again, and Indiana. He closed the year in relatively sane fashion, playing five nights apiece at nightclubs in Birmingham, Atlanta, and Fort Lauderdale, wrapping up on Christmas Day.

Sometime that October, between Texas and Kentucky, he put in one more appearance on *The Midnight Special*, this time electing to give the audience the century-old "Silver Threads Among the Gold," which he'd just recorded for *Southern Roots*.

> *Plant a kiss upon my brow today*
> *Life is fading fast away*

In time, Junior had straightened his life out, at least as much as a rock-and-roll drummer was allowed in those wild years, and was growing into

a solid man with no true meanness in him; he was like Elmo that way. Jerry Lee saw in his son a good musician but increasingly his own man, not a spoiled kid. He would not be one more person who would just ride in the big man's wake, a thing Jerry Lee never resented and in fact encouraged of the people he loved. He kept his blood kin close, because blood was everything; anything else was only paper. But it made him proud to see his son take charge of his life, become a capable man. Junior was not afraid to get his hands greasy, knew how to turn a wrench and how to rig a tow bar. He would not be one of those Southern men who stand helpless at the side of the road next to a broke-down car; he would raise the hood and start slinging wrenches.

On November 13, 1973, on a break from the constant tour, he drove to Cockrum, Mississippi, in his Jeep, a present from his father, to pick up a Ford and tow it back to his father's house. Police investigators believe he was taking a curve on Holly Springs Highway when the car he was towing struck the abutment of a bridge and caused him to lose control of his Jeep. It flipped, killing him. He had just turned nineteen.

His funeral was on the fifteenth, in the Church of God in Ferriday, another of the churches Lee Calhoun had built. It was an open casket, but the undertaker covered the boy's face with a cloth of satin. His father stood with the congregation at his back and looked down at his second dead son.

"I did pull that thing back from his face," his father says, "and I kissed him on the forehead, and I spoke to him."

They buried the boy in the cemetery at Clayton, which had been so much smaller when he was a boy. He heard the same songs again. He never shed a tear that anyone could see, not ever. But for a long time, when he closed his eyes, all he saw were passing coffins. "Seemed like I was always on my way to the graveyard. At one time, it seemed like I was burying somebody every week. If it wasn't my mama, it was my boys . . . a steady stream, and it would just keep going, and going, and I would put on my suit and my tie and I would get it done. I buried my people, and I still didn't break down, I still didn't cry at the church.

"Because you got to be strong, don't you? You got to be strong."

He had the stonecutter fashion a heart-shaped headstone, and later, alone with the dead, he walked through the green of the lovely and peaceful place and read the words.

HIS LIFE WAS GENTLE, AND THE ELEMENTS SO MIX'D IN HIM, THAT NATURE MIGHT STAND UP AND SAY TO ALL THE WORLD, THIS IS A MAN!

"I lost my two boys. And I went on. I went on living." He still toured, but the passing of the caskets had left him with a hole in his middle he could stand only when he was thoroughly numbed. It is the only excuse he has ever offered, and he does not care much if anyone accepts it or not. But whereas in the past it had seemed he didn't *care* if he lived or died, now he seemed to taunt death, daring anything and anyone to take him down, even seeming at times to dare the audience to try. A brawl in a Memphis bar in '73 was just one of several fistfights he welcomed then, though this one left him with a broken nose that never properly healed, one that would even affect his voice in coming years. He does not recall much about it, of course, just that he gave as good as he got. He had always loved his audiences, was always quick to shut up a drunk or call a heckler's bluff, out of respect for the stage and for the people who came to hear the music, "people who paid their hard-earned dollar." But now he seemed ready to rise to it, daring anyone to challenge him.

He hates to concede any weakness when his back is up; it is almost always up. But he says that his son's death, so close to Mamie's, "really knocked me off my feet. I didn't know a thing could *hurt* that *bad*. It seemed like it was all I done, was bury my people. It seemed like all I did was stand and watch these people I loved . . ." There was a hopelessness in it, because what was it all for if the people he loved most were gone? His mama's death was a thing of pure dread, something that

wore him down, but his son's death on the highway hit him with such unexpected force that he still feels it, like a physical thing, in his chest. His friends and bandmates and family wondered if he would recover. He was not a man who cared about a lot of things, and now much of what little he actually cared about was just stripped away.

In the spotlight, he would just stop sometimes in the middle of a song and glare balefully into the darkness at faces he couldn't even see, as if inviting the audience to rise up against him.

"I walked the aisles back then," said his daughter, Phoebe, "looking for a gun."

13

THE YEAR OF THE GUN

. .

Memphis

1 9 7 4

The car was supposed to be a fine American driving machine, but he never could find a Corvette that would hold the road in those days. "Wrecked a dozen of 'em," he says. "I was coming home one time— might have been drinking—and I run one up under the front porch of a house. A little girl come out, her eyes real big, and I don't know why . . . I just said, 'Top of the mornin' to you,' and she run back inside. And this woman stuck her head out the door and said, 'Oh, Lord, it's Jerry Lee Lewis.' "

A lot of people had that reaction to him then. He was not yet forty, but already people seemed surprised to see him, or maybe see him alive after all the stories told. At another *In Concert* taping, the announcer introduced him as "a man who's so unreal, it's hard to believe he's really here." He took the stage in a black tuxedo, lean and tall and straight, older now, but otherwise not a mark on him. The scruffy beard was gone, his hair long but perfect. "Oh, yeah," he said into the microphone,

over the screams of the audience, then launched into "Haunted House," the silly but catchy record from one-hit wonder Jumpin' Gene Simmons, the story of a man who moves into a new house to find it occupied by a green-skinned monster from outer space, who eats a hunk of raw meat "right from my hand . . . and drank hot grease from the frying pan." It's a goofy song, no doubt, but also a song about defiance, of refusing to be run off from something that belongs to you, and Jerry Lee turned it into another snatch of autobiography:

> *Jerry Lee Lewis'll be here when the morning come*
> *Be right here, ain't gonna run*

Then he tore it up some more.

> *I bought this house and I am boss*

The music dies.

> *If God's wi' me, they ain't gonna run me off*

His hands flew and stabbed, then he stood up and peeled off his coat, flung away his tie, and undid his cuffs so he could slap the piano unimpeded. He stood up to sing, sat down to play, and when he did play, he stuck the microphone into his waistband like a pistol.

He was supposed to be ravaged by grief, eaten away by pills.

"Tortured?" he says now, and smiles. "Me?"

He looked like the Jerry Lee of old, gun-barrel straight and bullet-proof on the outside, though inside an awful corrosion was beginning in his stomach, where all the excess of his life had pooled. But as he sang that silly song, it was like he knew the next great comedown, the next big slide, was beginning, and somehow he wanted to tell everybody there on national television that he was not going quietly.

Jaren had filed for divorce by now, but no one seemed in much of a hurry to do anything about that. Jerry Lee saw her occasionally; usually some kind of narcotic or alcohol was involved. He did a few sessions, mostly tepid; nothing much came of them either. He played a stage for money almost every night somewhere, then came home and went to the bars to play some more. He had always taken refuge in his live shows; now he sank into the music deeper and deeper, till it was all that mattered, but even that would be affected. He was still a big star, and acted with impunity in public; the beauty of Jerry Lee was that he would have acted that way anyway. He threatened and howled, and dry-humped the piano on the big stages. At home in Memphis, in the smoke and two-drink minimums, he played still for the joy of it, and punished anyone who interfered.

In March of '75, a waitress at Bad Bob's lounge in Memphis said he attacked her with a fiddle bow. He was convicted of assault and battery and fined $25; she was fined $15 for malicious mischief, for breaking the bow after she took it away from him. She sued him for $100,000, saying that he "brutally and savagely attacked her," but like most lawsuits involving Jerry Lee, he just ignored it till people got tired of bothering him. He does not recall attacking anyone, but if he did whack someone with a fiddle bow, he is sure it was because they were interrupting a song or made him mad or otherwise needed whacking. It was an ignoble event in an awful and ignoble year, and it was just fine with him.

He was hanging out then with his friend Mack Vickery, who, with a comedian named Elmer Fudpucker, had become the opening act for some of Jerry Lee's live shows. Fudpucker, whose real name was Hollis Champion, would tell a few jokes, much the same rural humor that had become a staple at the Grand Ole Opry with Minnie Pearl, and then Vickery, an accomplished songwriter who could do a dead-on Elvis impersonation, would play some country and some old rock and roll. A native of Town Creek, Alabama, he had come to Memphis in '57, too,

to be a rock-and-roll singer but had discovered that his best chance at fame was in putting the words and rhymes in other people's mouths. He had written for Faron Young, Johnny Cash, George Jones, Waylon Jennings, Lefty Frizzell, and others. He had Jerry Lee's irreverence about convention and the straight world—he recorded an album called *Live at the Alabama Women's Prison* and sometimes went by the pseudonym Atlanta James. Articulate in both song and life, he would come to be viewed as Jerry's Lee's "speechwriter." Jerry Lee saw in the man not just a drinking buddy but a true blue-collar poet, and many of the things he said onstage were things he first said to Vickery or heard back from him.

"He was one of my best friends," says Jerry Lee, who rarely uses such language, even with people he has known all his life. "He was good, kind, gentle . . . he was one person I could depend on. We sat around and laughed and played music. It was like we were brothers."

The shows they played together were legendary, Jerry Lee says, if for no other reason than their duration. He alone would take encore after encore, and not just in the paid shows but in the impromptu concerts he did for free in the Memphis clubs.

"Sometimes I'd play for four hours," he says. "People remember things like that."

He started to frequent a place outside Memphis called Hernando's Hideaway, which some would come to jokingly call his office.

"It got so ridiculous that Kenny Rogers, the owner—we called him Red—he got to where he was making good money off of me. He said, 'Stay around, ladies and gentlemen! Jerry Lee landed his Learjet out at the airport and he'll be here in about thirty minutes.' And that place was packed *out*, you know? You couldn't get a seat. Nowhere! Not even standin' outside!" No matter how late he was, the crowd never left. "They knew I'd show up sooner or later. And I said, 'Boy, ol' Kenny's moppin' up.' I didn't mind."

The patrons at Hernando's Hideaway remember him busting through the door with his entourage, sometimes still in his rock-and-roll clothes from the show. People would rush to bring him something to lubricate his voice; then he would take the piano by divine right and play until dawn.

"Never got tired."

He fesses up to the pills, but the liquor, he swears, was exaggerated. It always had been.

"People thought I used to drink a fifth of whiskey a night," he says. "I'd buy a fifth of Calvert Extra whiskey. And I'd keep it to myself—I hid it in my shaving kit, you know? I drank on that fifth of whiskey for about a week, a week and a half. And everybody thought I was drinkin' a fifth of whiskey a night. That's something that got started. They still think it."

There were, of course, many, many exceptions; people just naturally loved buying Jerry Lee Lewis a drink. They would talk about it all their lives, how they bought the Killer a fifth.

In July of '75, he went back into the Mercury studio to cut a song that was written for and about him. "A Damn Good Country Song" was by Donnie Fritts, a member of Kris Kristofferson's band:

> Well I've took enough pills for the whole damn town
> Old Jerry Lee's drank enough whiskey to lift any ship off the
> ground
> I'll be the first to admit it, sure do wish these people would
> quit it
> 'Cause it's tough enough to straighten up, when they won't leave
> you alone
> My life would make a damn good country song

Maybe it's just the nature of country music that a man sings his life out loud. They sing about broken hearts and loving their mamas and

beer and babies and trains, of course, and watermelon wine. But sometimes a man sings it down to the bone, as real as a car wreck, or a cave-in.

The year of the gun, for Jerry Lee, was actually a rolling barrage of years and many guns, but since he and almost all the people who should have been keeping watch on him were not clear in the head, exact dates are hard to pin down. Jerry Lee was a Southern man, and therefore had never been far from a gun of some kind, requiring one the same way other men require a pocket watch or suspenders. Like most Southern men, he had been witness from boyhood to the awful mystery of guns, until the day his people placed one in his own hands and lectured him about the power, the responsibility, and he nodded and promised and remembered, for a while—for he had also been raised to know the awful mystery of liquor, and had long ago succumbed to the great temptation to hold the one while his blood swam with the other.

He had never needed an excuse to party, but now there was a wildness and a bald recklessness that set new standards even for him, and mixing with the other barroom smells was an almost regular reek of cordite. Lost pills and empty casings mixed in the shag carpeting. He carried a pocket pistol pretty much all the time now—pearl-handled automatics, dependable snub-nosed .38s and over-and-under .22 derringers. Southern men will tell you that there are really only two things you can do with guns, shoot them and look at them, and Jerry Lee did not like looking at them all that much.

In the drunken excess that was Jerry Lee Lewis Enterprises, Incorporated, on Airport Road, Jerry Lee became bored looking at his .38 one night and fired it into a wall. Then he reloaded and fired it some more.

"I was shootin' people's caps off their heads," he says.

He is asked why.

He just stares blankly.

It was because he wanted to.

"Anyway," Jerry Lee says, "I didn't know the bullets was going through the walls. Just went right on through."

The next day, his neighbor in the adjoining suite, a dental technician who fit and manufactured dentures, came to work to find twenty-five holes in the wall. Worse, a display case of dentures, some of them antiques, had been shot into scattered false teeth and shards of pink porcelain gums.

"He was very upset about that," says Jerry Lee.

The man stormed over and told Jerry Lee he had shot his teeth off the wall.

It took Jerry Lee, who was hungover, a minute to process.

"What do you mean, I shot your teeth off the wall?"

He was relieved to realize they were not actually in someone's mouth.

"I've had these teeth for *forty years*," the man said.

There was great shouting and threats, and the police were summoned.

"I just got in my car and left," Jerry Lee says.

The police needed to arrest someone. They waited for someone, anyone, to approach the door of Jerry Lee Lewis Enterprises. "Elmer Fudpucker drove up," said Jerry Lee, "so they took him to jail."

Elvis was also prone to shoot things in his seclusion. He shot at least one television, which went on display at Graceland. He was rumored to have shot more than one, but that would have made him a serial killer, so hard evidence of that, in his more carefully manicured image, is scarce. If Jerry Lee had shot a bunch of televisions, they would have piled them up and hung a sign on them that read THE KILLER WAS HERE!

Jerry Lee says now Elvis was just being a copycat.

"I started shootin' things, so Elvis got out his gun and started shootin' things."

Well I know I've earned my reputation
Can't they see I've found my salvation?
I guess they'd rather prove me wrong
My life would make a damn good country song

Again as his life got wilder, his time in the studio went dry. The old honky-tonk formula had worn itself thin, and country radio had gotten sweeter, and even when he found himself a damn good country song, it was only a marginal hit.

"You can only have so many hit records, and record so many, and do 'em different every time, every time, every time, you know?" he says. But he was still Jerry Lee Lewis, and he still did what he wanted. The euphemism *muthahumper* had begun creeping into the lyrics of his songs—a rare concession for the most dangerous man in rock and roll. His performances and even studio recordings were marked by a rotating repertoire of catchphrases and mannerisms:

Think about it
God almighty knows
I guarantee it
This is J-L-L, and I'm hell when I'm well

And always, always, his name, Jerry Lee, inserted wherever the lyric called for "me," or even where it didn't.

He tried what he could to personalize the endless parade of country songs. One day he decided to play the piano from the *inside*. "One record I had out, I said, 'I wanna try somethin' here.' I reached inside the piano, and kinda moved the quilt back a little bit"—he laughs—"and I took my hand, and I said, 'Let's take a take,' and I said, '"I wanna hear this. I wanna kick it off with my fingernail right down the strings.'" It did not make music history. Another time, as a lark, he cut a bluesy parody of "Great Balls of Fire," singing the words slow and low. "I was

jus' cuttin' up on that. Jerry Kennedy . . . he never said a word. He just cut it. I was havin' a *ball*! But even the musicians was lookin' at me kinda weird."

The harder he tried to find a hit, it seemed, the more complicated—and less like him—the music became. The new music had a sophisticated, almost Hollywood sound, a style called countrypolitan that had put Charlie Rich back on the charts. Hard country like Jerry Lee's style was vanishing in a wash of saccharine strings, or so it seemed; the spontaneity of his recordings, the perfect imperfection Sam Phillips had sought, was being polished out by multitrack recording and overdubbing. He hated to sing in a booth over one of his own prerecorded backing tracks, but it was becoming routine.

In February of '76 he had surgery to correct damage to his sinuses, the result of that broken nose. He believes his voice was never affected by the damage, that his body was fine and his hands were still "perfect." He was not like other men. By now he had been recording music for almost two decades and was still viable, still spending the money he earned from his dream; few could say that, and even fewer could say they had been there for the very beginning of something and were still recording and playing it two decades later in anything more than nostalgia shows.

He found a kind of second residence at 6907 Lankershim Boulevard, at the Palomino Club in the San Fernando Valley. He had been playing the storied Palomino almost from the nightclub's first days, watching as the onetime neighborhood bar grew into a hot spot for country, country-rock, and good music in general, on the West Coast and in the nation as a whole. It had been a destination for Johnny Cash, Merle Haggard, Willie Nelson; Patsy Cline did "Crazy" here, Buck Owens did "Love's Gonna Live Here," and Jerry Jeff Walker sang "Up Against the Wall, Redneck Mother." Linda Ronstadt and Emmylou Harris stopped hearts here, and George Harrison jammed with Bob Dylan and Taj Mahal. It was a place where patrons could come in from the harsh California

daylight and sip a beer in the cool dark as the musicians—famous and more obscure—played, rehearsed, or just jammed. Patrons wandered backstage for autographs. In its layout in the early 1970s, it could hold more than four hundred people. Jerry Lee packed the place and would play the Palomino at least once a year for three decades. He loved it.

"Come out of there," he says, "with more money than we could tote. And they got their money's worth."

He played what he wanted when he wanted, but in '76 he played little of it cold sober. His shows achieved a level of wildness perhaps unequaled in his career—so much so that it nearly got in the way of the music.

One such performance from the Palomino was captured in *All You Need Is Love: The Story of Popular Music*, a seventeen-part television documentary chronicling performers as diverse as Bing Crosby and Bo Diddley. The filmmakers caught Jerry Lee in a kind of red-faced frenzy, standing on the keyboard in white loafers, keeping time by banging the fall board against the cabinet. It is not exactly anything new, any of it, but it seems uncontrolled and a bit joyless compared to some of his wild shows of the near and distant past. He wanders around the stage, shirt unbuttoned and tied at his waist, crashing through a rendition of "Shakin'" in which it's hard to make out what he is saying; he stares briefly off into space, then sticks his face close to the camera, nose still swollen, and announces:

You know what I mean. . . .

And I'm lookin' at every good-lookin' thang in America right now. . . .

Meat Man! You know what I am. . . .

He doesn't seem to notice the audience. Some called it one of his wildest performances; to others it seemed bleak, and a foreshadowing of darker things.

Celebrities still came to the Palomino every night then. One night, Phoebe came backstage to see her daddy. "She was pretty young at the time. And she come back cryin', you know? And I said, 'What's wrong with you, girl?'

"Do you know who's standin' in line out there to get your autograph?" she asked.

"I have no idea, baby. There's usually somebody standing in line to get it."

"She started callin' off their names. She said, 'Keith . . . Ronnie . . .'"

"Oh, yeah," he said. "The Rolling Stones. They come around and see me quite often."

"That," he says now, "was when they were the hottest thing in the country."

The Stones saw in Jerry Lee the same trailblazer that John Lennon had. But Jerry Lee connected somehow with the Stones, who lived the rock-and-roll life full tilt—but who always, first and foremost, *played the music.* They took old blues and introduced it to a whole new generation, as he had done with so many genres.

"We had some great times," he says. "I used to flip a bottle of Crown Royal, flip it and catch it. Well, Keith then started doin' it. They must have dropped fifteen bottles of Crown Royal whiskey—the best whiskey—lost it all! Busted all to pieces, you know? And they'd just reach to get another one. It was a trip! I laughed. I said, 'Don't do that no more. You're wastin' that whiskey.'"

Again he told people to do as he said, not as he'd done.

"I worried about 'em. I warned them. I talked to 'em. Just like I did John Belushi."

Belushi was another regular, a fan of Jerry Lee and already well on his way to the addictions that would kill him.

"I could see he really wasn't payin' that much attention to what I thought was right and wrong. He was just like me; you wasn't goin' to tell him what to do. He was dead set in his ways. . . . He liked what he was doin', and you wasn't going to stop him from doin' it."

In September of '76, probably not long after that Palomino performance, Jerry Lee was celebrating his forty-first birthday at the house he had purchased for Jaren in Collierville. They were still married, though

Jaren had twice filed for separate maintenance so that she could remain married to Jerry Lee without actually living with him.

Butch Owens, his bass player, arrived with a friend, Dagwood Mann.

"Was there drinking going on?" says Jerry Lee. "*Unconsolable* drinking."

Dagwood Mann pulled out a big .357 and handed it to Jerry Lee.

"Careful," he said. "It's got a hair trigger."

"Whaddaya mean, a hair trigger?" Jerry Lee said, and laughed, pretending to look for a hair on it.

"It went off," says Jerry Lee. "It hit a Coke bottle, and that Coke bottle flew into a thousand pieces."

"I-I-I-I been shot," screamed Butch Owens.

"It appears to be that way, Butch," Jerry Lee said, too drunk to be overly concerned.

"Why?" asked Butch.

" 'Cause you appear to be sittin' in the wrong spot," said Jerry Lee.

For reasons that only very drunk men could comprehend, the revolver was cocked when Dagwood Mann handed it to Jerry Lee. Jerry Lee still does not know exactly how it happened.

He will not even admit that he shot the man, not with a bullet, anyway. "I believe it was a piece of the Coke bottle that went into Butch," says Jerry Lee. "He stuttered a lot when it happened, whatever it was."

Jerry Lee was charged with discharging a firearm within the city limits, but the shooting was, in criminal terms, judged to be accidental. But Butch Owens sued Jerry Lee for $50,000 and won, claiming that just before he was shot, Jerry Lee told him, "Butch, look down the barrel of this," and then aimed at the Coke bottle next to him. As he lay there bleeding, Jaren yelled at him for ruining her white shag carpet.

"I just know it took him a couple days to talk right," says Jerry Lee.

He was being sued by everybody, for broken contracts and such. Jaren had lawyers after him, to pay her for not being his wife and not being divorced from him either, which was a whole new level of marital hell he had not even known existed. In Memphis, people talked bad about him, and talk bad about him today, how he let his wife and daughter live on welfare, how he ignored their needs while he partied the night away at Hernando's and Bad Bob's. In the clubs, it seemed like even cocktail waitresses were waiting to pick fights with him, then send in their lawyers to collect. The airports wouldn't sell him fuel for his plane unless he paid in hundred-dollar bills. Band mates quit him and sued him for back wages. Myra sent lawyers for not meeting the commitments of their divorce. He had to keep a close eye on Elmo, who had somehow gotten himself married during all this. At the Denver airport, drug agents in black Ninja outfits stormed his plane, and their hellhounds sniffed out every pill in the fuselage. He was interrogated about an international drug cartel, which was preposterous, as trying to hide drugs on Jerry Lee's plane would be like trying to hide a pullet in a chicken house; drugs spilled from the seat cushions.

One night, going home to Nesbit in his white Rolls, feeling no pain, he felt the liquor run warm through his blood. He had never seen anything wrong with going out and driving off a good drunk. The exits whizzed past him like fence posts, and as he pulled off the highway on his exit he noticed a long line of trucks in front of him. "I'd pulled into the weigh station," he said. "People were looking at me, all them guys in their big trucks, like I was crazy." He pulled onto the scales and waved.

His physical health continued to deteriorate, but again it did not show that much on the outside. The whiskey and chemicals had eaten a hole in his stomach, and it burned night and day, but he medicated himself and went on. By the fall of '76, it seemed like the only person who halfway understood him was his old buddy Elvis. They had seen each other off and on over the years, but Elvis had withdrawn from everyone lately. His

weight had ballooned. "He had got big, boy, real big," said Jerry Lee, and Elvis was ashamed of that. Instead of going out, like Jerry Lee did, he hid in his mansion, eating pills. The music had saved both of them, and now fame was doing its best to kill them both. The larger, pill-ravaged Elvis slowly devoured the slim, pretty boy, and in '76 he watched the outside world pass on the gray blacktop on the black-and-white screen of his closed-circuit televisions. They didn't see each other in those days but talked on the telephone, mostly about times different from these.

Jerry Lee was a little weary of the way their legends had diverged. Elvis's legacy had been carefully groomed and handled, and little ol' ladies prayed for him and bought clocks with his face inside the glass, while Jerry Lee's legend had run amok, a tale of crashed cars, pills, liquor, gunfire, divorce, lawsuits, and sexual profligacy. They had both loved their mamas.

On Monday, November 22, 1976, during one of the many reconciliations—or cease-fires—with Jaren, Jerry and his still-wife were speeding through Collierville in his Rolls-Royce when somehow he managed to turn it upside down. They were not badly hurt, but Jerry Lee was charged with driving while intoxicated and reckless driving, though the Breathalyzer would show that whatever was wrong with Jerry Lee's faculties that day, alcohol was not involved. He was arrested and bailed out later that day, and when reporters approached him, he lashed out. He wanted to know why the press always hovered around him in the worst of times, while they always gave Elvis a pass. "Y'all hate my guts or something," he told the *Commercial Appeal.* "I'm no angel, of course, but I'm a pretty nice guy."

The Rolls was pretty well finished. He bought a brand-new white Lincoln Continental. He had always liked a good Lincoln.

The next day, Elvis called him.

"Come out to the house," he told Jerry Lee.

Jerry Lee said he would if he had time. Elmo had managed to get himself arrested for driving drunk in Tunica, and that would require some straightening out. Later that night, Jerry Lee went looking for a

drink himself, at the second-swankiest nightclub in Memphis, and for some reason he settled on champagne. He never did have much luck with champagne.

Walk on, Killer

"I was at the Vapors nightclub that evenin'," he says. There the owner of the club had given him, as a gift, a brand-new over-and-under pocket pistol, loaded of course. "Charles Feron, he owned Vapors, he give it to me. A .38 derringer." He spent the night drinking champagne, playing with the gun, watching pretty women, and talking to old friends. Midnight came and vanished in a fog.

Finally, unsteadily, he stood and announced that, sorry, boys, but he had to go to the house.

"Me, pretty well drunk, with that derringer—it ain't somethin' *strange*."

He knew he had something to do on the way home—oh, yeah. He had to stop off by Graceland, " 'cause Elvis called and *wanted me to*. Elvis called *me*. It was his idea for me to come over," he says. "I was coming to see him, answering his beck and call."

He took the derringer with him, and a mostly full bottle of champagne.

As he got in the car, Feron told him not to put the gun in the Continental's glove compartment, because he could be charged, if he was pulled over, with carrying a concealed weapon. So Jerry Lee just put the loaded pistol on the dash, in front of God and everybody, and—holding the champagne bottle by the neck—drove off toward Graceland. He didn't bring the cork; it was a bottle without a future.

Just before three o'clock in the morning on the twenty-third of November 1976, the long white Lincoln Continental thundered down Elvis Presley Boulevard, weaving between the lines.

He was not angry at Elvis, he says now. He was not eaten up with jealousy. What he did feel, and had always felt, was disappointment at the way Elvis, who should have fought him to the death for the crown, had been managed by Colonel Tom Parker into such a sorry state, into a paunchy semirecluse behind locked gates. "He didn't go nowhere," he says. "He didn't see people."

As he slalomed around the white lines in the Memphis dark, he remembered better days. Once, in 1957, Elvis had pointed him out to George Klein, a friend and Memphis DJ.

"He said, 'Take a good look, boys, 'cause there goes *the* most talented human being to walk the face of God's earth.' Elvis just had a strange way, is all."

Elvis had only ever said one mean thing to him, back when they were both playing Vegas. In the only real argument he could recall, Jerry Lee had called him Colonel Parker's puppet.

If Jerry Lee was so smart, Elvis reportedly responded, how come Elvis was playing the big room, and Jerry Lee was playing the lounge?

But Jerry Lee wasn't thinking about that, not now. "We was just two kids when we got started. Cars, motorcycles, women . . ." The world belonged to them both then, and they had lived as if in some shared dream.

Harold Loyd, a cousin Elvis had hired to man the gate at Graceland, watched the big car, brand-new and gleaming, whip into the driveway, tires squealing, and rumble toward the gate. It did not seem to be slowing down. To him, it looked like the driver—he did not yet know who it was—was trying to ram through the gates of Graceland. The big white Lincoln just kept coming. Finally the driver hit the brakes, but too late. The car slammed into the iron gates, and rocked back on its springs.

"I hit the gate," he says now, nodding. "The nose of that Lincoln was a mile long." He misjudged it. " 'Cause I's drunk." He did not mean to ram those famous gates, with their wrought-iron music notes.

The champagne was empty. Disgusted, he drew back the empty

bottle and hurled it through the window of the Lincoln. Or at least he meant to.

"I thought the window was down. It broke the bottle *and* the window," showered him in broken glass, and cut a gash across the bridge of his nose.

"I don't know what the problem was, except *I was drunk*."

Jerry Lee stepped from the car, wearing a Western vest and no shirt underneath.

"I'm here to see Elvis," he announced.

He remembers wobbling.

"Boy," he says, "I was drunk."

Loyd was so frightened he hid in the guard shack.

Other accounts would claim that Jerry Lee stepped from the car brandishing a small pistol, saying he was going to see Elvis or else, even implying that he intended to do Elvis harm. "That is ridiculous," Jerry Lee says, and patently so; if he had planned to ram through the gates of Graceland and shoot Elvis, he would have done a much better job than this. He never brandished "nothin'," he says. The derringer he had placed on the dashboard had slipped onto the floorboard; he never pointed it at anyone, he says.

The idea that he brought the gun there to shoot Elvis is not even worth talking about, he says. It makes a good story, but a better lie. "I really didn't mean to do nothin' to harm Elvis. He was my friend. I was his."

But Elvis, watching on the closed-circuit television, told the guards by phone to call the police. The Memphis police found the gun in the car and put Jerry Lee, protesting, hollering, threatening *them*, away in handcuffs. He *was* mad then.

"The cops asked Elvis, 'What do you want us to do? And Elvis told 'em, 'Lock him up.' That hurt my feelings. To be scared of me—knowin' me the way he did—was ridiculous.

"He was a coward. He hurt me. That did."

He was charged with carrying a pistol and public drunkenness, and released on a $250 bond. When he failed to show for his hearing the next day, a Memphis judge ordered that he be arrested again, but rescinded that order when it was learned that Jerry Lee was in the hospital. The burning in his stomach had been a peptic ulcer, the first proof of a sickness that would almost kill him.

Elvis never commented publicly, and the story would not die. It became fable, told by Graceland tour guides even today. The fact still grates on him.

"I don't know . . . everybody got carried away with that," he says. "They wanted a big story out of that. They wanted to know the real truth about it." And, as the years went on, the constant demands to retell the story wore on him—so much so that he couldn't stand to tell it straight. "I'd get up to a certain extent, [then] I'd say, 'Aw, I just can't tell no more. That's as far as I go.'

"I had thought one day we'd get a laugh out of all of it." But it wasn't to be. "I never seen him after that," says Jerry Lee.

The studio was a desert, still. It had been since '73. He cut songs that sounded bad even on the naked page, like "I Can Still Hear the Music in the Restroom," and other songs that seemed like commentary on his increasingly embittered life, like "Thanks for Nothing" and "I Hate You," and even self-pitying songs like "Lord, What's Left for Me to Do?" His voice did not quite sound like him anymore, a bit more faded and hoarse. He was still in demand on television; he still put on his tuxedos of almost every possible color and climbed the piano. But in one appearance on *The Midnight Special*, two weeks before Graceland, he had gone silent after the monologue in "Whole Lotta Shakin' Goin' On" and just stared off into space for a full ten seconds of airtime, as though savoring the moment. It was as if he knew the times were catching up with him. He says he cannot possibly remember every moment onstage, says that people

just try to read too much into things, but it had been a while "since we had a big record."

He was all but done with Mercury, anyway. His contract would be up soon, but in August 1977 he went back into the studio one more time, and this time he found himself cutting a hit. It was a song called "Middle Age Crazy" by a veteran songwriter from Carlsbad, New Mexico, named Sonny Throckmorton. It was a song about a man trying to stay young forever.

> Today, he traded his big ninety-eight Oldsmobile
> He got a heck of a deal
> On a new Porsche car

"That was our last big hit," Jerry Lee says. "No piano at all on that," or not *his* piano, anyway. "That's something Jerry Kennedy wanted to prove he could do." Kennedy gave Jerry Lee an acetate with the complete backing track—strings, rhythm, and a host of guitars he'd overdubbed himself. "The voices and everything, except mine. And I brought it home and played it, and I played it, and I learned it. . . . And I went up there into Nashville, and he set up everything, and I walked up to the microphone, took one take on it, and that was it."

It was not what he remembered recording a song to be.

The relationship with Mercury had grown thankless, each side wary of the other. "Seemed like I was doin' the same thing over and over and over. . . . They tried to get me to quit working the road. They said, 'Stay home, and you'll be making all the money you can make. Take care of your body.' But I said, 'I can't. I just can't.' I couldn't take it, not bein' on the road. I had to be in front of my audience. Besides, no one told me what to do. Bull, trying to tell me what to do."

Still, today he has second thoughts about the whole thing.

"I just got so tired of it, I left Mercury. I just bidded them good-bye. Tired, y'know?" But that was a "bad mistake," he says now, with a

laugh. "I should have never left Jerry Kennedy. I should have never left Mercury Records. 'Cause they were too good to me." It is another rare expression of regret, but he concedes that he would probably make the same choice if he had it to do over, because he's still Jerry Lee Lewis.

He still had the urge to cut quality music. At some point he and Mack Vickery went back to Memphis to collaborate on a kind of tribute to Stephen Foster, whose music he had learned on his old piano at Black River. Foster, who died in 1864, is known as the father of American music, with songs like "Camptown Races," "Oh, Susanna," and "Beautiful Dreamer." His songs were played as the citizens of New York rioted in the streets over conscription for the Civil War, were sung in barrooms in the Old West, and are sung today in grammar schools. Jerry Lee felt a kinship with the man: like him, Foster had forged white and black American music into a new kind of sound, almost a hundred years before rock and roll. Jerry Lee and Mack met Sam Phillips's son, Knox, at the Madison Avenue studio and recorded hours of material, including a version of "Beautiful Dreamer" that opened with a long monologue about the importance of Foster's music.

And no one heard any of it, or at least only a handful of people did.

His cousins, meanwhile, were conquering the charts. Jimmy Swaggart was selling millions of gospel albums while asking people to kneel in their living rooms and pray before the TV, and little cousin Mickey Gilley had used the same rolling, thumping country boogie to blow away the competition on the country charts. In the year 1974 alone, he had three number one country hits, including "Room Full of Roses," "City Lights," and "I Overlooked an Orchid." People said he sounded a lot like Jerry Lee, but then, who else would he sound like? The music was in the dirt they had all walked on. He says now that he was happy for them. "They were family," he says. But at the time, it seemed like they were stealing his act. He would hit a piano lick and shout out, "Think about it, Jimmy!" or "Think about it, Mickey!"

"Neither one of them could touch me," he says.

On August 16, 1977, nine months after he charged the gates of Graceland, three weeks after he cut "Middle Age Crazy," Jerry Lee woke up to find that Elvis Presley had died. The death, by what the coroner called cardiac arrhythmia, had left Elvis on his bathroom floor, his bloodstream polluted by prescription pills and his heart stressed by his weight. He was so beloved that many people would simply refuse to believe he was dead, and the public would invent sightings, till even the dead Elvis took on a celebrity of its own.

The next day, a reporter asked Jerry Lee what he thought when he heard the news.

"I was glad," he reportedly said. "Just another one out of the way. I mean, Elvis this, Elvis that. All we hear is Elvis. What the shit did Elvis do except take dope I couldn't get ahold of?"

He was drunk at the time, and sick, and hurting, and angry.

He did not mean those words.

"I loved Elvis," he says now.

Everybody loved him, didn't they?

He does not believe Elvis is alive; that stuff is for tourists. But he is haunted, a little bit.

"I don't know what was on his mind," he said of that night Elvis called and asked him to come see him, "but he had *something* on his mind. But I hit that gate, boy . . . ," and the police came, and so he will never know. Some would say Jerry Lee wanted to be him, to crash the gates and seize the castle, but that was wrong. They were too different, he says, and wanted different things from their lives. . . . Sometimes it seems like all there ever was, between him and Elvis, is unanswered questions.

"I think of him," he says now, "quite a bit."

But he does not like to think of that night.

In late '77, he made a solemn and sober-seeming appearance on *Nashville Remembers Elvis*, a television special, singing "Me and Bobby McGee" and "You Win Again," which seemed a mournful, rueful tribute to Elvis from his most persistent rival. The year before, he had told a camera crew that Elvis had failed rock and roll, that "he let the Bobbys take it, Bobby Vinton, Bobby Darin, all the Bobbys," and they turned it into treacle. "I think he let us down," he still says now, though with less scorn than sorrow.

Once upon a time, he knows, "Elvis was a rocker. Oh, yeah."

A great singer? Of course. And "a great star."

Jerry Lee? He was a better pure musician than Elvis, truer to the spirit of rock and roll, and both of them knew it.

Where do they rank in the pantheon of the music?

"After me was Elvis," he says, and that will make some people angry, those who followed this music and those who still wait for Elvis to reappear in line at Walmart or behind a newspaper at Waffle House. But if you know how Jerry Lee Lewis looks at the world and his place in it, then you know he has paid his old friend a great compliment.

14

"BABIES IN THE AIR"

.

Memphis and Nashville

1979

"A woman looked at my hands once," he says.

"I'm surprised," she said to him, "they're not bigger."

"No," he told her, "but they're perfect."

People forgave him the braggadocio, the excesses, the indulgences and wickedness, forgave him everything just to hear him use those hands. The oldest and truest fans thought he had earned it; the new ones, seeing him play on television or nostalgia shows or sold-out arenas in far-off lands, some for the first time, were dumbfounded. In an age of machined music, of sound effects, this was what it was supposed to be. Guitar buffs said the same thing when they saw Stevie Ray Vaughan pick his Stratocaster—that it was so much more than music. Jerry Lee's fans did not have to proclaim him to be anything; if they waited long enough, he would do it for them. They knew that the rest of it was just showing off, the way he played with his feet, his elbows—even his be- hind. ("You can do it," Jerry Lee says, "but you have to have a perfect one.")

But as his hands flew across the keys in '79, the corrosion was start-

ing to show. The maintenance he had refused to do on his life—the maintenance mortal people did on their bodies and their money and their future—had long been neglected, and now it was beginning to eat through the indestructible exterior, through the very flesh and personality, of the man.

He was not making much new money, and now he found himself in hock to the United States government. He owed the tax man at least a million dollars, the government said. Internal Revenue came for it the first time in January of '79, raiding the Nesbit ranch as if he was some kind of subversive, then held an auction in Memphis to liquidate his treasure. The United States Treasury had little need for a tractor that once belonged to Jerry Lee Lewis. On the block that day was a 1935 Ford two-door sedan, a '41 Ford convertible, drop-top Cadillacs, other luxury cars, motorcycles, televisions, gold and diamond rings, gold coins, pianos and other musical instruments, and what federal agents described as an arsenal of modern and antique firearms. Agents also found $31,000 in cash in one bathroom, in a brown paper grocery bag. Jerry Lee did not trust banks much and had rarely had a checking account.

"I think they're pretty cruel people, to take your cars," he says.

From the beginning, he said that any allegations of tax fraud were flat untrue. His bookkeeping had been, for decades, less than perfect, "but I paid my taxes," he says. And if he *was* short, over the years, he made it right. "They said I owed something, I paid it, and I wiped the slate clean." But the IRS said he owed more, more than he could pay.

"They was gonna send me up the river."

He needed a big hit now, a moneymaker, more than ever, at least since his breakthrough record. "And Jerry Lee Lewis don't know the meaning of the word *defeat*," he says now. After his tenure at Mercury was done, he signed with another label, Elektra, and went back, for a while

at least, to doing the kind of music he wanted to record, music without a phalanx of violins and a landslide of overproduction. In a few days' worth of sessions in January 1979, he cut his most recent in a growing list of anthems, a Mack Vickery song called "Rockin' My Life Away." While his voice was showing its scars and the words were frequently obscure, Jerry Lee delivered them with commitment, and the beat was pure Louisiana boogie-woogie.

His new producer at Elektra, Bones Howe, had worked on Elvis's celebrated 1968 comeback special, and he was sympathetic to Jerry Lee's mind-set. Together they stripped his band down to something closer to what he used on the road, and the little group romped its way through Bob Dylan's "Rita May" and Sonny Throckmorton's "I Wish I Was Eighteen Again" and Arthur Alexander's "Every Day I Have to Cry," in which he pushed on past the original lyrics and made up some new lyrics of his own about the life he lived and the women he had loved, some longer than others:

> *Once there was Dorothy, and then came Jane*
> *Look out Myra—you look insane*
> *Come on Jaren, you struttin' your stuff*
> *I think I'll take Punkin, 'cause I can't get enough*

(Punkin was a longtime girlfriend)

> *I wanna thank you very much for lis'nin' to me*
> *'Cause brother, let me tell you something—I really need it*
> *Come on, girls, I'm a single man again*
> *I'm really waitin', waitin', waitin' just to hang it in*

That spring, for the first time since he'd started popping little white pills in the Wagon Wheel a quarter century before, his body rebelled

against the chemicals he had fed it. One morning in March, he woke up at home to find he could not catch his breath. The ambulance rushed him to the hospital, in what the doctors would call respiratory distress.

If it was a warning, he ignored it. He continued to party hard, playing at night, traveling in the day. Two months after his short hospital stay, he appeared on the Country Music Awards telecast, throwing the cover off "Rockin' My Life Away," his piano outrunning an overmatched studio orchestra. "Me and Elvis Presley never won an award," he told the audience, "but we know who the kings of rock and roll are." Some who watched the performance said he appeared fairly well drunk, that he treated the entire performance with the boozy disregard of a night at Bad Bob's. He says only that he cannot be expected to recall every show or every night he had a drink of liquor.

In the spring of 1979, he finally filed for divorce from Jaren Pate, pointing out that they had not lived together as husband and wife since October 21, 1971. She countersued, accusing him of years of cruelty and drunkenness, and they awaited a court date to end the marriage that never was.

In the last days of his great country stardom—and of the dwindling wealth it had engendered—he and Elmo raved across the country. His mama and sons had perished, the troubadours he cherished had all gone silent, but Elmo was forever. If ever a man was born to live in the rock-and-roll dream, to eat it with a spoon, it was his ol' daddy. He was not the fierce man he once was, not indestructible; age had stooped him some, till he looked downright kindly. But he would still fight you, and more than one drunk nitwit regretted saying something ugly to him about his boy. He walked the runways of the world with a glass of whiskey in his hand, smiling, ever smiling. He even charmed the pretty girls, in a kindly way, or so it seemed; the old bull still had some horn on him right up until the end. Then he would go home to Ferriday to farm, to walk the dirt that his son's music had bought for him and drive his tractor around in circles, sometimes mildly intoxicated, and when

he grew tired of it, he called his boy, and the next time you saw Elmo, he would again have a glass in his hand, a smile on his face, and one ill-intentioned eye on the women. It pleased Jerry Lee to see his daddy living out this life—a form of payment, somehow, for the snakes he killed and the love he gave his boy.

In summer of '79, Elmo quietly went into the hospital in Memphis with a burning in his own stomach, and while he hoped it was an ulcer, it was not, and the once magnificent man wasted away from the disease that had taken his wife and so many there along the river, where it was said the chemical plants and industry and the agricultural runoff had poisoned the swamps and rivers and backwater and through them had seeped into the people and left them with the disease that so often had no cure.

He died on the twenty-first of July, 1979. His obituary described him as a retired carpenter and a member of the Church of God. He was buried with Mamie in the cemetery in Clayton. The laws of man, of divorces and such, did not count for much when it was all preached and done, and so he joined her in the earth, right beside her, as his son insisted. Their first son, Elmo Kidd Lewis Jr., rests between them, and their second son was more alone than he had ever been. He knows most people remember their daddies by the things they said, but he loves his daddy for a silence, a silence that lasted for decades. When Jerry Lee thinks of his daddy now, he thinks of that long-ago day at the piano when Elmo sat down to show him how to play a song and inadvertently broke his son's heart.

Two months later, Jerry Lee was arrested for possession of pills. At a fitness hearing before the Board of Health, Dr. Nick told his judges that it was better to manage an addict's intake professionally than to have him satisfy his habit on the streets. In 1980 he was indicted for overprescribing medications to Elvis Presley, Jerry Lee Lewis, and nine other patients,

including himself. He was acquitted but later had his license revoked. Jerry Lee always believed it was wrong to blame him for Elvis's death. "Dr. Nick was a good man, a remarkable man," he says now. "If I thought I could get some blues and yellows out of him, I'd call him up right now." Then he grins, to tell you he is just goofing—or maybe he just grins.

In early 1980, the IRS seized Jaren's home. "I am poor and destitute," she told reporters, as she showed up at the Department of Human Services to apply for food stamps. "I can't remember the last time I've been to the beauty shop." The divorce action was still pending when the IRS auctioned off her home for $102,000. "They've sold it all," she said. "There's nothing else they can take."

Jerry Lee was not in the country. He was on another British tour, including a pair of solo piano appearances on the British television shows *Old Grey Whistle Test* and *Blue Peter*, but he was thin and his voice seemed rusted out. It was clear he wasn't feeling well, but again that summer he held off the creeping decay with a new song. In the middle of his grinding tour schedule, he went back into the studio for Elektra and cut a beautiful rendition of "Over the Rainbow." His voice, even charred as it was, and his tremulous piano gave the song a gritty vulnerability it had never enjoyed, and it became an almost instant classic for him. "It had a certain feeling to it," he says now, "like a religious undertone. A something that you very seldom ever can hear." It seemed almost impossible that this one man—the same man who reeled through his life with so little regard for caution or consequence—could create something so purely beautiful. If you ask him how that can be, he merely looks at you with satisfaction and waits for you to figure it out.

In November he appeared in a TV special called *Country Music: A Family Affair*, playing a piano duet with Mickey Gilley that still has stagehands sweeping up the ivory. Playing side by side, the cousins blistered through a version of "I'll Fly Away" that gave the audience a taste of what it must have been like years ago when they battled to beat the old church piano to death. Jerry Lee took the lead and Mickey, smiling,

just tried to catch up. "We got this song in the wrong key," Jerry Lee
announced after a few choruses. "We gonna modulate up to G and do
it." And he sang:

> Just a few more weary days, and then
> I hope to God I'll fly away

"Mickey's a good person, too. He wanted to be just like Jerry Lee
Lewis. He did great, but you can't get by with just one hit record," or
however many he had. "That boy's livin' in a dream world, if he thinks
he's . . ." in the same league as his cousin. But like him, "he knows how
to go to church on a song."

With "Rockin' My Life Away" and "Over the Rainbow," it appeared
as if there was hope for Jerry Lee and Elektra. Sometime in 1980, he
went to the Caribou Ranch recording studio in Colorado to cut a mar-
athon list of songs, more than thirty in all, everything from "Lady of
Spain" to "Tennessee Waltz" to "Autumn Leaves" to "Fever." He did
songs he knew from childhood, like "I'm Throwing Rice" and "Easter
Parade," and a whole passel of gospel numbers, including "On the Jer-
icho Road," "Old-Time Religion," "Blessed Jesus, Hold My Hand," and
"What a Friend We Have in Jesus." There were even a few moving new
ballads, including a soaring performance on "That Was the Way It Was
Then." And once again he did them all for nothing. Deemed subpar by
Elektra executives, the recordings were shelved for decades, available
even today only as bootlegs. Many fans would come to consider the
Caribou recordings one of the best albums that never was—though ac-
tually there was enough material for two or three albums and certainly
one of pure gospel. He thought it was good music and one more exam-
ple of the moneymen messing up an otherwise fine effort.

His relationship with Elektra quickly soured. "I said, 'It's not wor-
kin'. I don't feel it workin', and it's not happenin'.' I didn't want to stay.
I wanted away from all of 'em."

His only solace was on the highway with his road-tested band, including guitarists James Burton and Kenny Lovelace, bassist Bob Moore, and drummer Buddy Harman. "And that's all we needed," he says. "You had yourself a band there nobody could *ever* touch. They followed me. They were such great musicians. It's a one-time-around deal. You'll never have it again."

What happened next has become a legend in the family, though the cousins still disagree on the details. Jerry Lee was doing a show in Dayton, but he was drunk and sick. He had challenged the disgruntled crowd to fight him, and things were going south. Then suddenly Jimmy Swaggart, who was doing a crusade in Ohio at the time, walked onto the stage, told the crowd he was taking his cousin away to take care of him—some cheered at that—and told Jerry Lee he would fight him if he had to, to save his life.

"He didn't let me know he was gonna be there," Jerry Lee recalls now. "I don't recall bein' in that bad a shape. I kinda just went along with it. I couldn't just kick him off the stage. I stood up, we shook hands, and we left."

When they got offstage, there was business to attend to. "You want to take me in your plane, or you want me to have mine come get us?" Jerry asked his cousin.

"Naw, we'll take mine," Jimmy Lee answered.

It was a long way from stealing scrap iron in Concordia Parish.

On the way out, Jerry Lee says, his cousin "invaded my dressing room and flushed all my pills down the commode. It made me mad. I said, 'Jimmy, you didn't have no right to do that.' He said, 'Yeah, I did.'

"I went and stayed at his house for five or six days," he says, down in Baton Rouge. Swaggart administered a cure that seemed to consist mostly of boiled shrimp. "I must have ate a tub," he laughs. "They were real nice to me while I was there. There's no doubt about that."

After a few days, Swaggart told him, "I can't see as how there's really that much wrong with you," and let him go.

Looking back, Jerry Lee has little inclination to second-guess his cousin. "I think he was . . . he was right. He was right in what he was doing and what he thought and what he thinks."

But what was wrong with Jerry Lee could not be cured with a few days of clean living.

On the twenty-eighth of June, 1981, after a show in Chattanooga, he complained that his stomach was on fire. But he felt better by morning, and the next day he was back in Nesbit, lounging at his pool, which had been impossible for the IRS to haul away. He was Jerry Lee Lewis, not some puny man, and a stomachache was nothing to fret about.

On the morning of June 30, he awoke with a pain like nothing he had ever felt before and began spitting up blood.

"I was standin' in front of the mirror in the bathroom. And I had an old gal back there, KK was her name," he says. "I had a *bad* case of indigestion. Heartburn. And I said, 'Man!' I said, 'Give me a glass of water with some bakin' soda in it. That'll knock this heartburn out. And everything will be all right.' And I did that, and when I did, immediately, my stomach—I saw it open up! It just . . . hit me. And I fell to the floor.

"And I . . . I know how it is if you're gonna die. I can feel that, you know?

"And I called KK in there. I couldn't move a finger. And I told her, 'KK, if you could get an ambulance here in the next five to ten minutes, I believe I can get to the hospital and I believe I'll be all right. But if you don't do that, I'm gon' be dead here in the next fifteen minutes.' "

The ambulance made it on time, but the crisis wasn't over. "Headin' out to the freeway," he says, "they had a blowout. And it was rainin' so hard you couldn't see your hand in front of your face. And the nurse in the ambulance said, 'Don't worry, baby, we're gonna get you there all

right. Don't you worry!' So they called another ambulance, and, um . . . it took him quite a while to get there."

He was taken to Methodist Hospital South in Memphis, where he was met by Dr. James Fortune.

"He says, 'I'm gon' operate on you, Jerry Lee, but I'm tellin' you, there's no use in it. 'Cause, you know, you don't have a chance.' "

"I said, 'Well, in that case, could you just give me a pain shot?' " and he laughs.

"He told the nurse, 'Give him whatever he wants. It don't make no difference now, anyway."

The surgery took four hours to repair a ruptured stomach. Something—a lifetime of pharmaceuticals or whiskey, or suppressed worry and anger, or a cocktail of it all—had eaten a hole clean through it.

"I really overshot my runway," he says now.

He lay close to death for a week. Doctors kept him in intensive care into the next. Ten days later, he began running a high fever. An X-ray showed that the eight- to ten-inch incision made in his stomach wall during the surgery was leaking, and fluids and stomach acids were infecting his abdominal cavity.

Dr. Fortune and a team of surgeons rushed him to the operating room. Doctors told members of his family that his chances were fifty-fifty. Dr. Fortune told them his condition was a "minute-to-minute, hour-to-hour proposition."

Fans crammed the hospital lobby that hot summer and sneaked into the waiting rooms to sob and wait and pray for mercy. Some carried flowers. Some held hands and prayed for deliverance in this world or the next. Reporters milled outside. Camera crews set up for the inevitable, sad stand-up when the news finally came. The newspapers touched up his obit; some had had it on standby for years.

Jerry Lee survived the four-hour operation but remained in critical

condition. He lay in the third-floor ICU on a respirator. Myra came, and she and Phoebe were allowed to visit his bedside for fifteen minutes every four hours. Sam Phillips called the hospital and spoke to Jerry Lee's cousin, handsome old Carl McVoy.

"Old Jerry is in pretty bad shape," McVoy told him. "It's in the hands of the Good Lord."

Johnny Cash and June Carter Cash came to the hospital to say goodbye, but they did not tell him that.

"I told Jerry that I didn't come down here to start praying over him," said Johnny, hoping that he was right. "I believe Jerry Lee has a lot more songs to sing."

Kris Kristofferson interrupted a tour to come and sit at his bedside. He considered him one of the greatest singers of all time, comparing him with the legends of opera, and he told him so again. Even Elizabeth Taylor, his old friend from Oscar Davis days, called the hospital to wish him well.

The great threat, doctors feared, would be an onset of pneumonia. They pumped him full of antibiotics to try to ward it off. He spent most days in darkness.

He looked up one day and saw his Aunt Stella standing over the bed.

He winked. She leaned in close.

"You ain't seen nothin' yet," he whispered.

He improved, slowly.

"I's in the hospital ninety-three days," he said.

"It was rough. People wouldn't believe the kind of pain that I was in. A lot of pain, man. They was givin' me pain medicine that would kill an elephant."

But worst of all was the simple fact of lying there, helpless.

"I was frustrated beyond the realms of imagination," he says, and laughs again. "God pulled me through that. And if it hadn't been for Him, I wouldn't have made it at all."

The first thing he did when he got home was sit down at a piano to make sure there was nothing wrong with his hands.

It was fall before he was released from the hospital. He had appeared on NBC's *Tomorrow* show shortly before his emergency, and in September he returned for another appearance to show America he wasn't dead yet. Then in January 1982, he taped a show called *25 Years of Jerry Lee Lewis* in the sold-out Tennessee Performing Arts Center in Nashville. It was a tribute show, with guest stars Kris Kristofferson, Charlie Rich, Dottie West, the Oak Ridge Boys, Mickey Gilley, Carl Perkins, and Johnny Cash. Perkins did "Blue Suede Shoes." Cash did "Get Rhythm," and gave testimonial to the man he once battled for supremacy in the auditoriums of the frozen north, when they lived on saltines and potted meat. He was there, he told the audience, when Jerry Lee, "blond hair flying . . . came onto the scene with such a bang the entire Western world was aware of him."

Jerry Lee, first in a red crushed velvet jacket and then a rust-red tuxedo, looked waxen, ravaged, tired beyond his years. "It was severe," he says of the recovery and the lingering pain.

"You never looked better, buddy," Johnny Cash told him.

Jerry Lee still kicked the bench backward, but it did not go very far. He still banged the keys with his boot, but not more than a time or two. But he seemed genuinely touched by the crowd, which gave him standing ovations, and by the words of his old friends. It was a scripted show, but he knew they meant it. To the tune of "Precious Memories," he summed up his life and his recent ordeal, and said he wished he could go home to his boyhood days in Ferriday, that he would give "five million dollars, if I had it . . . to spend five minutes with my mama again. . . . She'd straighten me out." He reached out to Jimmy Swaggart, telling of their boyhood and the life they lived, "but we went separate ways." He seemed glad to be alive inside that sewed-up body. "My blessings," he testified, "far exceed my woes."

"You know they call me the Killer," he said to the audience. "The only thing I ever killed in my life was possibly myself."

Shawn Stephens was twenty-three, a small, pretty, honey-blond cocktail waitress at the Hyatt Hotel, trapped in the inertia of Dearborn, Michigan. In February 1981, Jerry Lee was playing the Hyatt lounge, part of the truncated road schedule he had been forced into since his surgery and convalescence. There was no record money coming in; he had no record deal, at least not one producing any new songs. But he was glad to be alive, and he picked the vivacious Shawn out of the throng of pretty cocktail waitresses at the hotel lounge. He sang a song to her and smiled; women like a good-lookin' rock-and-roll singer, especially a wounded one.

A girlfriend of Shawn's was keeping company with J. W. Whitten, Jerry Lee's road manager, and that led to a visit by Shawn and the girlfriend to Jerry Lee's ranch, with its piano-shaped pool and sprawling lake. The IRS had taken most of the cars, but it was still an impressive estate. Jerry Lee fell in love with her; it had never taken a whole lot for that to happen, anyway. "I was bad to get married," he says. "But she was a real good woman," one who bounced into a room and lit it up. He needed that. She came to visit him again in Nesbit, and he gave her a gold bracelet and some other expensive presents, and they talked of getting married after his divorce from Jaren was final. His life then seemed glamorous still. In April he jetted off to London to appear at the great Wembley Stadium for the first time since his illness; he told the audience he was "probably not exactly all the way up to full par," but they gave him a hero's welcome, and he sliced through the keyboard with an almost casual defiance.

Shawn's family told her to stay away from the man, that he could be dangerous. She told them he needed her.

His performing life was still almost charmed, in some ways, able to survive long droughts in the studio and even increasingly erratic live shows, but tragedy in his private life seemed to rattle and clank behind it all, the way tin cans do when tied to the bumper of a car.

On June 9, 1982, Jaren Pate was sunbathing at a friend's house in Collierville, Tennessee, outside Memphis. The owner of the house where she was staying, Millie Labrum, looked out the window and did not see her, and sent her son to check on her. He found her floating in the aboveground pool, dead. She was still married to Jerry Lee; they had been scheduled to appear in divorce court later that month. The coroner ruled that her death was an accident. Jerry Lee would never accept her child as his, and no one would ever launch any legal proceeding to prove his parentage. Some people of long memory in Memphis still call it a case of abandonment, the one thing they cannot forgive. But friends of Jerry Lee would say that the marriage had existed mostly on paper, finally ending in a great sadness. And if there was any kindness in it, it was that Jerry Lee would never loudly denounce either the mother or the child.

Two months later, in a haze of new pain from his stitched-together stomach, he stood weakly on the deck of a riverboat as Elmo's long-ago prophecy come true: with Conway Twitty, Loretta Lynn, and assorted other country swells, he sang and played aboard the *Mississippi Queen* for a television special. He played his piano and sang his songs as the big river rolled, as people watched from the banks, but there was no one there, with him, no one who remembered that it was ever said.

His ability to bounce back from almost anything was intact. He left in April for another European tour, and in stops in London and Bristol,

England, put on shows that seemed to defy or ignore all that had happened to him in the last two traumatic years. Gone, or mostly so, were the runaway ego and erratic behavior. He was gaunt, perhaps more introspective onstage, but he smiled with genuine pleasure at the tightness of the band, of Kenny Lovelace's guitar licks, as his own piano went ringing through the Hammersmith Odeon in London. He asked for a drink, and they brought him a Coca-Cola; he looked ruefully at the bottle and then played them "Mona Lisa."

A few days later, in Bristol's historic Colston Hall, lucky fans witnessed a loose and sustained performance from a pure music man, chatting warmly with the crowd and the band. "I thought it was Wednesday! Thought we were off tonight," he said when he took the stage, dressed in a simple red turtleneck. He gave them "Chantilly Lace" and "Little Queenie" and "Trouble in Mind," a roaring "I Don't Want to Be Lonely Tonight," even Jimmie Rodgers's "The One Rose That's Left in My Heart," and more, the whole time seriously intent on his piano, on his craft. "Glad to have a sober audience for a change," he said, sipping from a bottle of Heineken sitting on the piano; later, when he sipped again, it foamed over when he set it back down on the piano lid. He could have nursed one beer all night. He complimented his band again and again. "Them boys are gettin' pretty good," he said, a kind of mantra for him in good times. "I can play guitar just like that—well, I wish I could." But this new, almost modest Jerry Lee still brought them the rock and roll on "Little Queenie," singing about how "I need a little lovin'—won't you get your little . . . self . . . back home? . . . Pick it, Kenny!" He was still hurting then, but it was nothing he could not stand; the show he gave them was satisfying, hopeful, and if it was just a window, a glimpse of what things might have been, well, how lucky those people were to get to see it.

The following month, he played the Memphis Cotton Carnival, a kind of Mid-South Mardi Gras for the river city, and it was a different story. He took the stage in dark glasses and a black sleeveless T shirt, as

if he were a punk rocker, and appeared wired, mumbling some of the lyrics, and not just for effect. At the end of the show, barreling without interruption through "Whole Lotta Shakin' Goin' On" into "Meat Man" and then into "(Hot Damn!) I'm a One-Woman Man," he started pushing the band to go faster, faster, till even he could barely keep up, and wouldn't stop until three girls rushed the stage to distract him with a kiss.

While it's hard to place an exact moment when it happened, it was about this time that a new downward spiral began, a descent into a whole new hell.

He should have toned down his lifestyle, should have slowed his consumption of the chemicals that put him in such shape. He did not. He was in constant pain, and painkillers replaced amphetamines; eventually it was needles.

"When you get those shots and things, you get addicted to 'em," he says of the painkillers he took. "I thought it was helpin' me. I thought I was gettin' pretty high out of it. And I thought it was helpin' me onstage." He laughs, but there is no humor in it. "It *wasn't* helpin' me onstage. It was all in my mind. I got to thinkin' it was very necessary to have, but I was wrong."

Instead, he seemed to withdraw inside himself onstage, breaking off a song midstream, often running off to chase a thing inside his head and leaving his band behind—the band he had been so proud of, for the way they meshed, for the good music they had played across thousands of miles. It was that way in the hotel lounges and bigger venues, too.

"I was—kinda got addicted. I liked them shots. But the shots didn't like me. There's no way you can make it work. *It don't work.* It'll *kill* you."

He was shooting the painkiller directly into his stomach—the only way, some nights, he could climb the steps to the stage.

Now forty-seven, he was starting to miss shows and to be sued by

club owners and promoters when he did. The IRS waited at his concerts to take the receipts to pay off his debt. "They were all after me," says Jerry Lee. "I didn't pay no attention to 'em. I just kept on rockin'."

He was free to marry now, and he did not worry about propriety. Jaren and he had not lived as husband and wife for years before her death, so to him it didn't seem too soon to marry again. On June 7, 1983, he put on a white tuxedo with a ruffled red shirt and a big white bow tie and said "I do" for the fifth time, to Shawn Stephens, now twenty-five. The *National Enquirer* took photographs, covering the event as if it was some kind of royal wedding, as if the editors somehow knew this story would be gold for them, now or at some time in the future.

It was not, of course, a storybook life there in northern Mississippi. It was much less glamorous than it seemed there in the Dearborn Hyatt. The couple argued. Jerry Lee was fully addicted to the painkillers now. His new wife soon began to soften her own reality with her own drugs, barbiturates. "But she done it to herself," he says now. He never asked her to take anything and never forced her to take anything, he says. "I never hurt her."

The maid at the Nesbit ranch found Shawn Stephens Lewis dead in a guest bedroom about noon on August 24, 1983, seventy-seven days after she and Jerry Lee were wed. Jerry Lee, who had slept in his own bedroom, had arisen early that morning and had assumed she was sleeping in.

DeSoto County sheriff Denver Sowell said a preliminary autopsy found that the cause of death was pulmonary edema, or fluid buildup in the lungs, a condition that often accompanies pneumonia or a heart condition. The pathologist who conducted the autopsy concluded that Shawn Lewis had not been the victim of a violent death. But later, a full

autopsy conducted by Dr. Jerry Francisco—who had also performed
the procedure on Elvis Presley, as well as Martin Luther King Jr.—
found the painkiller methadone in her system at ten times the normal
dose.

"Although you never feel like you know everything everybody did,
exactly," said Bill Ballard, the DeSoto County prosecutor, "I think we
made a thorough investigation of this case and nothing has pointed to
homicide."

Francisco told the prosecutor that he found no evidence that the
dosage was forced into her mouth or throat. A DeSoto County grand
jury reviewed the case and found no grounds for indictment.

But Shawn's family in Michigan hired a private attorney to investi-
gate her death, unwilling to accept that it was a self-administered over-
dose. "They feel if Shawn had never met Jerry Lee Lewis, she would
probably be alive today," said Michael Blake, the attorney. Months later,
Rolling Stone magazine published a long, dark, ominous article head-
lined "The Strange and Mysterious Death of Mrs. Jerry Lee Lewis,"
written by Pulitzer Prize–winning reporter Richard Ben Cramer. The
story raised questions about law enforcement's handling of the investi-
gation, suggesting that public officials had been covering for Jerry Lee
for years. Cramer also suggested that investigators did not pursue some
facts in the case, including reports of blood at the scene and questions
about the integrity of the evidence.

Both Cramer and ABC News *20/20* reporter Geraldo Rivera cited
a violent altercation between the couple the night before her death as
evidence suggesting foul play. A bodyguard told *20/20* that he saw Jerry
Lee slap her "a time or two." *Rolling Stone* reported that an ambulance
attendant saw bruises on her arm and scratches on the back of Jerry
Lee's hand. *Rolling Stone* also wrote that Jerry Lee had struck Shawn's
sister, Shelley, and that he had threatened Shawn. The magazine cited
Shelley as the source. They all used his own nickname against him: the
Killer.

None of it prompted charges against Jerry Lee or changed the state prosecutor's conclusions. Police in northern Mississippi and Tennessee had been responding to incidents involving Jerry Lee Lewis for years: fights, cussfights, accidents, gunfire, threats, and untold other infractions. He had been helped into police cars in handcuffs in three counties and judged and fined, usually in absentia, on a regular basis. The notion that they would give him a pass on murder did not make sense, officials here would say. It was not a storybook marriage, obviously; divorce records indicated that none of Jerry Lee's marriages had been harmonious, but investigators would say that the evidence was a long way from proving murder.

Jerry Lee told reporters that he did not believe Shawn meant to kill herself. "We had our usual arguments, but there was no reason for that," he said.

The *Rolling Stone* story was devastating to him, he says now.

"They treated me like a dog."

He has called it ridiculous, a manufactured lie.

"I was innocent, and they never proved nothin'. . . . Never proved I hurt no one. She done it herself. She wasn't beaten at all. There wasn't a touch of circumstantial evidence that I done it. It was a mistake," he says of the overdose. "But I hurt nobody."

The worst of it, he says, was that it made him seem like he had no feelings for the young woman, that people assumed he would not grieve. "That's the 'Killer' part, I guess," he says now. "You don't take something you can't give, when it's a person's life. You can never do that."

But his persona made the tragedy into a story people would hunger for, especially so soon after Jaren's drowning.

"If I had done everything these people think that I've done, I would have been buried in the penitentiary years ago," he says. "I never killed anything in my life."

He believes there was another reason that story spread.

"I ain't never sued nobody," he says, "and everybody knows it."

Shawn was buried in Clayton, with his people.

He retreated behind the gates of his ranch and sealed them with a padlock. But it's hard to be a private man if you are him. In October, two months after Shawn's death, he taped a concert for *Austin City Limits*, playing the show behind a set of dark sunglasses that concealed his emotions. Thin and solemn, he played the boogie-woogie in a sweat, but it would be a lie to say he did not still play it like *him*, did not put on a show, and when he was done, he flew home to wait for the next show and medicate himself in seclusion.

The guilt in it, in the death of his fifth wife, was in the lifestyle he lived, and had lived for so long. He was the unstable rock his blood kin leaned on, and the rock the people who loved him broke themselves against.

Record labels were not courting him. As a last resort, he signed a deal with MCA, but throughout the mid-'80s, the sessions yielded only a few memorable tunes, including yet another signature song, this time by Kenneth Lovelace, called "I Am What I Am":

> *I am what I am, not what you want me to be*

Meanwhile, the tax man was relentless. Jerry Lee had developed a bad habit of ignoring official documents as if they could all be thrown into the Black River, treating court summonses and marriage licenses like throwaway comic books. It had been his experience that most of them just went away with time, that the courts always got tired of waiting. But on February 14, 1984—Valentine's Day, wouldn't you know—he got a piece of paper he could not just discard. He was indicted by a federal grand jury on charges of tax evasion.

Prosecutors charged that he had tried to hide assets under the names of other people to avoid having them seized to pay another million dol-

lars in taxes he owed between 1975 and 1980. When he was no longer able to ignore the charges, prosecutors alleged, he went on the lam.

He left his car at a Nashville hotel, hid behind dark glasses and a massive cowboy hat, and sneaked into the studio to record some more songs. Two days later, as if just to show that he would turn himself in on his own schedule, he surrendered to federal authorities in Memphis. He pleaded not guilty and was released on $100,000 bond, after Kenny "Red" Rogers put his club, Hernando's Hideaway, up for security. The high bond reflected the court's opinion that Jerry Lee Lewis had shown "a defiant attitude toward the court," for as long as anyone could remember. "I was just glad to do it," Rogers told the Associated Press.

When he showed up to be fingerprinted and photographed, he was with a new girlfriend, a twenty-one-year-old singer from Hernando's Hideaway named Kerrie McCarver. "Honey," he told her as he was processed, "this is a breeze."

They were married on April 24, 1984, making her wife number six. They said they were very much in love and wanted children.

Jerry Lee went on trial in October. He was facing a maximum sentence of five years. "Mr. Lewis's job is to play the piano," said his attorney, Bill Clifton. "He doesn't know anything about business." Jerry Lee thought he *was* paying his taxes, he said.

When the jury came in with the verdict, Jerry Lee was sitting in the courtroom with his new wife. "I saw that two or three young women on the jury winked at me and gave me the 'Okay' sign, so I knew I was in."

The jury indeed believed him, that he'd meant to do right by the government, but had allowed others, less righteously inclined, to handle his business; they said the government hadn't proven its case. The courtroom erupted in cheers, and Jerry Lee said he felt the power of God.

Although the charges were dropped, he still owed the government more than $600,000, and federal agents seemed content to follow him to every club date with a briefcase to collect.

He traveled to Europe for another tour in 1985, but he seemed to be running on fumes. Pale, unsteady, he told an audience in Belfast, "I'm doing the best I can tonight, but . . . I'm just sick. I'm out of breath. I can't seem to breathe right, but I'm tryin'." He tried to shrug off what everyone was thinking: "You can call it what you want to. I'm not drinkin'. I'm not takin' any dope, 'cause I can't find any." But the humor was halfhearted, and he left the stage a short time later. The shots he had self-administered for the pain—now he knows he was simply addicted to them—were no longer giving him much relief, so he did more of them. "The dope, it didn't do nothin' for me," he says. "They pushed me into it," he says of doctors who first prescribed it, but he admits he shared the blame: "It takes two to tango."

The best balm, he had always found, was to just drift back in time. Back home in Memphis, he reunited with Johnny Cash, Carl Perkins, and Roy Orbison to record an album called *Class of '55*, a commemoration of their contributions to a whole new kind of American music, and a tribute to the man who could not be there, Elvis. Jerry Lee did the requisite boogie number, "Keep My Motor Runnin'," and a take on "Sixteen Candles," and joined with the others for John Fogerty's "Big Train (from Memphis)" and the Waylon Jennings song "Waymore's Blues," but he was in pain throughout, and looked it. In photographs of the recording sessions, the other men stand; he is sitting down. He looks even more troubled in black and white.

He says he enjoyed seeing his old friends/competitors again, but the best part of that reunion may have been not the music, but rather the on-camera sessions in which the aging rock-and-roll pioneers talked about the raw and beautiful beginning of it all.

In November, he was taken by ambulance back to the hospital. His stomach was perforated again. "I had seven bleeding ulcers in my stomach," he says. "*That* time, it almost killed me."

He did not behave. In the middle of the operating room, he stood up on the hospital bed like it was a piano, raving, out of his mind. He

does not remember much of it. Much of what happened to him in the coming days happened in sunbursts of pain shrouded in a morphine cloud. The doctors had to cut away a third of his stomach in an attempt to save his life.

But there was more damage, as it turned out.

"I used a syringe that hadn't been sterilized," says Jerry Lee, resulting in a massive infection in his thigh that went untreated. "Dr. Fortune . . . he had to cut all that out from my hip, with infection on both sides." Fortune, who had saved his defiant patient more than once before, was incensed. "And to think I pulled you through all that," he told Jerry Lee. "I had six doctors flown in here, man!' "

"Boy, he was mad about it," Jerry Lee remembers.

Again doctors were unsure he would recover.

He looked up through a haze and saw Carl Perkins.

"Hey, Carl," he said weakly, "what are you doin' here?"

Two months later, rock-and-roll royalty gathered in an opulent ballroom in New York to honor the survivors and the fallen. The Waldorf-Astoria had seldom beheld so much hair gel, and had never hosted a gathering such as this. Keith Richards, sunken-cheeked and hollow-eyed, lounged at one elegant, candlelit table with tuxedo-bound Ronnie Wood, separated by a centerpiece of pale pink tulips. Quincy Jones, once Big Maybelle's bandleader, now a legend, dined on smoked Colorado river trout. John Fogerty chatted with Neil Young about a time when their music made politicians sweat and worry, when the radio sang of love *and* Vietnam.

Pups, all of them. The real legends, the ones who showed the way, were past middle age now, those who had survived at all. They were ushered into this opulence, the living and movies of the dead, to be feted as the first class inducted into the Rock and Roll Hall of Fame. It was January 23, 1986, three decades after the great year of Elvis. The

inductees included some of the most influential musicians and person-
alities in music history, and as presenters called their names, they rose
and walked to the stage, some more stiffly than others: Fats Domino,
who would not follow Jerry Lee Lewis onstage in New York; the Everly
Brothers, who would not follow him, either; James Brown, who had
walked in from the wings of the Apollo and kissed his cheek. But it was
a hard business, this rock and roll, and sometimes when they called the
names, there was a second or so of sad silence: For Buddy Holly, who
rocked 'em to the floor and became his true friend. For Sam Cooke,
who sang prettier, perhaps, than any man he ever heard, who called him
"cousin." And, most of all, for Elvis, who had listened to Jerry Lee play
the same song a hundred times, and cried before him and others at Sun.

When the organizers started planning the gala, a year before the
event, they had wondered who would accept the award for Jerry Lee
Lewis, certain that there was no way he could rise one more time. The
musicians in the room had last seen him in hospital beds or too sick to
stand; others had seen the headlines, the death watches. It had seemed
only a matter of time until he joined the ones who fell from the sky or
swallowed down their own destruction.

Keith Richards swayed to the stage and stripped off his black tuxedo
coat to reveal a yellow faux-leopard-skin jacket, to wild applause, look-
ing a little surprised, as if he had just been roused from a good nap. "It's
very difficult for me to talk about Chuck Berry because I lifted every
lick he ever played. . . . This is the gentleman that started it all, as far
as I'm concerned." The house band—Paul Shaffer and his band from
Late Night with David Letterman—ripped into "Johnny B. Goode," and
Berry, still spry, duckwalked onto the stage. Richards, once punched in
the eye by Berry at a rehearsal, hugged him and handed him his statue.

"Dyn-o-mite!" Berry said, and they danced offstage together.

John Fogerty then spoke eloquently of the never-ending cycle of rock
and roll and how a riff from Buddy Holly and the Crickets' "That'll Be
the Day" would echo in the Beatles' "I Want to Hold Your Hand," and

later in his own music. "All of us," Fogerty told the crowd, "are made up of the people we love and we admire. We take those reflections, and hopefully grow from those. I think that's why we're here, in all ten cases tonight." Accepting for Buddy was his widow, Maria Elena, whom Buddy had loved so strongly that one night he called Jerry Lee to ask if he should marry her.

Ray Charles, whose "What I'd Say" had been a hit for Jerry Lee in the lean years, stared into the darkness of the ballroom, and heard nothing but love. Little Richard was unable to accept the award in person, because of a car accident, but he wasn't too far gone to deliver one great "whoooooooooooooooo!" via videotape. The Hall honored Robert Johnson, who shed his soul on Highway 61, the same road that took Jerry Lee to stardom, and the great stylist Jimmie Rodgers, who sang inside Elmo's head in the prison in New Orleans. Sam Phillips, whose induction was a foregone conclusion, whose ear for talent had affected an entire society, received his due, as did the late Alan Freed, who had slumped down on that curb years ago to await word that Elmo Lewis had cut Chuck Berry's throat. Every award, every halting induction speech, every great song the house band played seemed to be mirroring a part of Jerry Lee Lewis's turbulent life, as if he were the frayed, tight, and trembling string that bound all this history together on a cold night in New York City. For almost every story told that night, he had seen another, better one, one they wouldn't have wanted their wives to know.

Hank Williams Jr. waited backstage under a camel-colored Stetson. He, too, had a long, strong thread binding him to Jerry Lee. Years before, when he'd first heard Jerry Lee's recording of his daddy's "You Win Again," Hank Jr. had felt his heart break, and he had called to tell him so. "You know I love my daddy," he said, "but that's the best I'd ever heard it done." Now it was Hank's boy who walked into the spotlight to speak of Jerry Lee.

"He could tear an audience apart," he said, "I'm talkin' tear them out of their frame and throw babies in the air when he got through.

I saw this guy, I said, 'I have got to get some piano lessons.' I respect music and musicians for how good it is, not for the label that it has on it. Jimmie Rodgers is going in. I would imagine that Hank Williams, with his wiggling around in 'Lovesick Blues' in '50 and '51, might be in this Hall of Fame someday." He was, the following year.

"So let's get to the matter at hand. I'd like to bring up and induct into the Rock and Roll Hall of Fame, on all of y'all's behalf, the Killer, Jerry Lee Lewis," and the crowd clapped and whistled and roared as a saxophone howled "Great Balls of Fire."

He walked out in a white tuxedo trimmed in purple, with a ruffled purple shirt. He was wasted away now, perhaps worse than ever—the flesh hung loosely on the bones in his face—but his hair was *still* perfect. He looked like a man who had walked through a fire and been put out just in time. He kissed Hank Jr. on the cheek. "I just don't know what to say, except I thank God that I'm living to be here to get this award. I love you people. I need you. Couldn't do it without you. . . . I don't know what else to say, except may God richly bless each and every one of you. . . . Thank you very much." And he left the stage smiling, to more wild applause.

Paul Shaffer told *Rolling Stone* there was no plan to have Jerry Lee and others play, though "we brought in instruments just in case." But by midnight an all-star band was jamming onstage, led by Jerry Lee, Chuck Berry, Keith Richards, Neil Young, Ron Wood, Billy Joel, Steve Winwood, and others. The crowd roared when John Fogerty hit the first few chords of "Proud Mary," surprising the music-savvy people in the Waldorf ballroom. He had not played the song in public since '72. But this was a historic evening, and it deserved something special.

Fats Domino hit a lick or two on the piano for old time's sake, but it was clearly Jerry Lee's and Chuck's show, even when they were playing Chuck's music. They played "Roll Over Beethoven," and "Johnny B. Goode" and "Little Queenie," and Jerry Lee slowed it down for what the critics called a "delicious" version of Jimmie Rodgers's "Blue

Yodel." But perhaps the jewel of the night was "Reelin' and Rockin'," as almost everybody on the crowded stage—Billy Joel almost sawed an organ in two—got to show off a little bit, none so much as Chuck and Jerry Lee, who seemed to think it was 1957 all over again. Berry, his voice not as clear and strong as it used to be, still shouted the glory of rock and roll like a man who knew.

> *I looked at my watch and it was quarter to four*
> *She said she didn't but she wanted some more*

"I heard that," shouted Jerry Lee.
Chuck pointed at Jerry Lee to take it.
And he sang:

> *I looked at my watch and it was three twenty-five*
> *I said, "Come on, Chuck, are you dead or alive?"*

15

THE FORK IN THE ROAD

....................

New Orleans

1 9 8 6

The Airline Highway in New Orleans is not a place you meander through or go to sightsee. If you have no business there, then you have no business there. Prostitutes work some of the cheap hotels, and much darkness occurs here. In Room 7 at the sad Travel Inn, a variety of men came to visit with the woman there for an hour, a half hour, or so. One of the men was familiar, a tall, elegant man. He spoke from the sky itself and lived on the air. From a parked car nearby, his enemies took his picture to document his sin.

For Jerry Lee and his cousin Jimmy, the road had forked long ago, way back in the gravel and ragweed and flattened bottle caps of Ferriday, as the blues called to them from a propped-open window on Fifth Street. Jerry Lee knew that much even as a little boy, as he tried to drag Jimmy by his overall strap into Haney's Big House to hear it better. Sometimes he says he actually succeeded in getting him inside, for a very little while, but other times he says his cousin held strong, hands clasped in front of

him. Jimmy would see it as a plain choice between heaven and hell, but little Jerry Lee had a different idea, and left Jimmy in the high Johnson grass to pray for his soul. Jimmy would backslide as a teenager, during the great scrap-iron heist of '47, but he kept to his path, mostly, begging forgiveness, then marching onward. Jerry Lee sinned and prayed for forgiveness, too—not so different, when you think about it, except perhaps in the arithmetic—and danced and boogied down his own twisting fork, always hoping that in a faith founded on redemption, the two divergent paths might somehow lead to the same destination.

"I think Jimmy saw me doin' things that he couldn't do," says Jerry Lee.

By the 1980s, Jimmy Swaggart was in a battle with the devil on many fronts. He led a national crusade against sexual immorality. He called rock and roll "the new pornography" and wrote a book called *Religious Rock & Roll: A Wolf in Sheep's Clothing*, to condemn even Christian-themed rock music. He exposed and preached against fellow Assembly of God minister Marvin Gorman, who then admitted committing an immoral act with a woman who was not his wife. He led a purification of the denomination after televangelist Jim Bakker had an affair with a church secretary, Jessica Hahn, then used more than $250,000 of ministry money to cover it up. He called the scandal a "cancer that needed to be excised from the body of Christ." He made himself the guardian of sexual morality, not only within the denomination but among all Christians and everyone else. He was already one of the most visible men in America. His church in Baton Rouge held 7,500 people for services, but his tearful sermons could also be seen in Africa and Central Asia, as satellites beamed his message out of the sky to 143 countries. He filled stadiums, and couldn't walk across a parking lot without being handed a prayer request on a scrap of paper. His ministry sold Bibles with *his* name on the cover, and his untold followers defended him against all questions, all criticism, simply pointing to the multitudes he had helped bring to Christ.

The big fish was still out there. He had preached of his cousin's sin from the hood of a '58 Oldsmobile, at tent revivals and big city cathedrals and finally from the heavens themselves. It seemed, at times, as if his great crusade would be incomplete until he turned this one final soul away from the devil's music toward a place where God rewarded his faithful with everlasting life. His path of righteousness had led to Learjets and a wealth beyond even the standards of rock and roll, which allowed him to do God's will in ever widening circles, but he could never reach quite far enough to bring his cousin to him, on his knees.

"Jimmy called down here one time and got Kerrie," says Jerry Lee, "and he said to her, 'What's this I hear about Jerry Lee having two and three or more women at once? Ain't no way he can handle that.' And Kerrie told him, 'Believe me, he can handle it.' "

His own life continued to sway between accolade and addiction, despite the precipice his drug use had carried him to, twice, three times. In June of that year, he won a Grammy, his first—a spoken-word Grammy, for the interviews he gave in support of *Class of '55*—for telling the story of the very music his cousin had spent a lifetime condemning. In December he checked himself into the Betty Ford Center for treatment of an addiction that would not die. After a week, he walked out. You had to get up too early, and you had to do chores. "Don't nobody tell me what to do," he says.

The choices Jerry Lee and Jimmy Lee had made in life were not so drastically different, he believes. "I never stopped prayin'," he often says, even when it was a long-distance call. "I pray before I go to sleep. I bless my food. I pay my tithes. I think God takes that into account. I guess I have to wait and see."

On January 28, 1987, Jerry Lee Lewis III was born in Baptist Hospital in Memphis, at six pounds three ounces. His mother, Kerrie, was twenty-four. Jerry Lee was fifty-one. He was still battling the federal government, still being picked at by the IRS; he would spend much of his fifties waiting outside courtrooms or standing before judges and

the lawyers for his creditors. But again, that seemed not to be real life to him; it seemed like something other people suffered. In July, a photograph in the *Memphis Commercial Appeal* captured him sitting on a bench beside Kerrie and the baby, whom they called Lee, waiting outside a Shelby County courtroom to testify in a real estate lawsuit. Jerry Lee looks skeletal yet buoyant, as if he had not a care in the world. Kerrie, dressed in a tight leopard-print pantsuit, is striking, her hair big and fluffy. She is feeding the fat, healthy baby from a bottle, and Jerry, beaming, is wiggling his finger in the baby's face to make him smile.

Jimmy Swaggart was rich and powerful; Jerry Lee Lewis was having a good time.

"It just got to Jimmy, I believe."

The scandal broke in '88. Jimmy Swaggart confessed that he went to the Travel Inn on the Airline Highway in New Orleans to consort with a prostitute, not to have sex with her but to watch her perform pornographic acts. He came to see her again and again. His visits might not have come to light if relatives of the preacher Marvin Gorman had not photographed him for revenge. The preacher's son, Randy, and his son-in-law, Garland Bilbo, followed Swaggart around the city and photographed him entering and leaving the hotel room rented by a woman named Deborah Murphree.

"He just weakened and fell," says Jerry Lee. "I guess we all have our weak points."

More than eight thousand people crowded into Jimmy Swaggart's Family Worship Center church in Baton Rouge for the Sunday service that followed the revelation. His response, through tears, has been referred to as the "I Have Sinned" confession. He apologized to his wife, Frances. "I have sinned against *you*," he said, in a whisper. He apologized to his son, Donny, and to the Assemblies of God. "Most of all, to my Lord and my Savior, my Redeemer, the One whom I have served

and I love and I worship . . . I have sinned against You, my Lord. And I would ask that Your precious blood would wash and cleanse every stain until it is in the seas of God's forgetfulness, never to be remembered against me, anymore." Many of the congregation wept before him. "The sin of which I speak is not a present sin," he said, tears rolling like hot coins down his cheeks. "It is a past sin. I know that so many of you would ask, 'Why? Why?' I have asked myself that ten thousand times through ten thousand tears."

"Was I surprised?" said Jerry Lee. "Naw, I was never surprised."

It was never that one of them believed and the other didn't, he said. They both believed.

But there was always that one difference between them. "I never pretended to be nothin'," he says. When he looked up and saw a .45 bullet resting on the lid of his piano, he knew exactly what he had done, though not always with whom, exactly. "But I knew."

But in the end, Jimmy was still family, bound not by paper but by blood.

"Jimmy is a human being, too, and people need to remember that. They need to stop and think about that. He never had any close sex with that woman. He never crossed that fence. I think it was something he had to get out of his mind. But it ain't nothin' God can't forgive you for."

Jimmy Swaggart's following, his flock, not only returned, but swelled and swelled, as he became an independent, nondenominational minister, preaching to untold millions. "They just got in line and followed him," says Jerry Lee.

To rise from ashes, like the music, was also in the blood.

The year of Jimmy's fall and quick resurrection, Jerry Lee sat before a piano at Hank Cochran's landmark studio, dashing off solo renditions of Jolson's "My Mammy" and Stephen Foster's "Beautiful Dreamer," but none of it was for release, and it would languish on the shelf for

decades. That did not help Jerry Lee in the here and now. In 1988, he declared bankruptcy. He was more than $3 million in debt, he said, $2 million of it owed to the United States Treasury in back taxes and penalties. He listed twenty-two separate creditors, including $40,000 owed to one Memphis lawyer. He owed $30,000 to three different Memphis hospitals, hundreds of thousands to clubs for breaches of contract, and more to claimants in lawsuits. He owed payments on a Cadillac and a Corvette, and there was one unpaid hotel bill, of $119, to the Waldorf-Astoria in New York City, from the night he was inducted into the Rock and Roll Hall of Fame.

Meanwhile, the IRS continued to raid his possessions almost as fast as he could procure them. They took more cars, a Jet Ski, and a mechanical bull.

During the worst of it, Jerry Lee went home to Ferriday and walked through the Assembly of God Church on Texas Avenue. He did not kneel and ask for anything, but noticed that the floor where his mother once knelt was caving in; the little church that had stood throughout his life seemed to sag around him. He went home, stuffed seven thousand dollars in an envelope, and sent it to Gay Bradford, who had also grown up in the church, and she and her husband used the money to restore it. Then he bought the church a new piano.

In a moment of great irony, in the summer of '89, the bankrupt Jerry Lee received his own star on the Hollywood Walk of Fame. He posed there with his wife, Kerrie, and with Jerry Lee Lewis III, who was a toddler then, and with the actor Dennis Quaid, who was about to become the face of Jerry Lee on the big screen.

The film, *Great Balls of Fire*, was not a full biopic but the story of his breakout in 1956 and '57, his courtship and marriage to Myra, and the ensuing scandal, all based on a book by the same name written by Myra with coauthor Murray Silver.

The film also made hay of his relationship with Swaggart. One of its most talked-about scenes was in the film's beginning, a shot of two little boys looking down on the debauchery of Haney's. One little dark-haired boy, Jimmy, begs his blond-haired cousin to leave this sinful place.

"Jerry Lee, that's the devil's music!" he yelps.

"Yeaaaaahhhh!" says little Jerry Lee.

It did not happen just like that, but the scene was true in spirit.

The rest of it, Jerry Lee says, was not.

Before filming even began, the filmmakers asked Jerry Lee to relinquish his own music, his own sound, to the actor who would play him. Quaid disliked the notion of lip-synching the lyrics and wanted to record the music himself with his own band.

"I said, 'You can forget it. I'm not giving up the soundtrack. Dennis can never sing and cut these songs the way I did it. You can forget about that, or it ain't gon' work.'"

He took Quaid for a walk down by the Mississippi River.

"Jerry Lee told me that if he didn't do the songs, only one of us was coming back up that bank," Quaid told the *Austin American Statesman*.

"That boy came to his senses," said Jerry Lee.

Executives insisted that he audition his own music for the story of his own life, which insulted him. But the results proved that he could do himself better than anyone. "What you hear is me," he says of the film, and it was worth the trouble: In the songs on that soundtrack, critic Greil Marcus later noted, Jerry Lee sounded "as if decades were minutes."

But the movie itself was weak, from its simplistic script to Quaid's overeager portrait of Jerry Lee. Signed on as an executive producer, Jerry Lee was aghast when he first visited the set. "They wanted me to come up and watch them shoot a scene. I went up and watched them, and I washed my hands of it right there. I said, 'This isn't right.'"

Quaid's comical portrayal made Jerry Lee sound more like Fog-

horn Leghorn—"a mud-dumb bumpkin," wrote the *Washington Post*—
and even casual fans realized how badly it missed the mark. Jerry Lee
Lewis, the real man, was always deeper and more dangerous than the
goofy-eyed hillbilly the film showed. Jerry Lee hadn't expected to see
his story whitewashed, cleansed of its flaws, but he hadn't expected it to
come out looking like *that*, either.

In public, he gritted his teeth and supported the film. "I was hooked
in on the thing. And I'd been paid for it, you know? What can you do?"
But he knew it was a shame. "They really fouled it up, the way they did
it," he says.

The film fizzled at the box office, but it would loop endlessly
on cable television, introducing newer generations to the music, but
also to a portrait of the man that did not fit him. He hates the fact
that a generation of younger people first encountered the image of
Jerry Lee Lewis as such a cartoonish character, though the Inter-
net has since been flooded with images of the young and dangerous
Jerry Lee, the genuine man, playing his music in all his sharp-edged
glory.

The movie also made Myra seem like a pure child, stuffing her
clothes into that dollhouse as she leaves home, reluctant to marry
her cousin, trapped in a situation she couldn't quite control. Jerry
Lee remembers it differently, remembers much more than the film's
few lampoonish details. "If they ever do another movie about me,"
he says now, "I want *all* my wives in it. It would be about piano
playin', and singin', and women. . . . Women, the one thing I might
change."

He wonders sometimes about his wives, especially after Myra's
movie. "It's funny. I never talked about any of them the way they
talked about me. I could have, but I didn't," he says, and grins to let
you know that he does not expect the wider world to ever see him as
anything more than the Killer, where some things are concerned.

"Being the great humanitarian that I am."

The film, which premiered in the early summer of 1989, did have one benefit: it brought renewed interest in the real live Jerry Lee. He did a tour of Scandinavia before its release, then Australia in September, then Paris and London. In Melbourne, looking older but sturdy in a light but somber business suit, Jerry Lee rode a revolving stage into a rolling thunder of applause and put on a clinic in rock-and-roll piano. Scowling with concentration as if determined to outstrip even his usual casual perfection, he banished memories of the wired, manic character who had appeared and reappeared throughout the decade. Even his voice seemed stronger, clearer, as he hollered:

> *Well, give me a fifth of Thunderbird, and write myself a sad*
> *song*
> *Tell me, baby, why you been gone so long?*

He was going on fifty-four and did not climb the piano to survey his kingdom. But at the end of an extended, freewheeling "Great Balls of Fire," he picked up the piano bench, flung it across the stage, and smiled. "You give 'em what they want," he says, and this time he gave them something lasting and fine.

The following year, he returned to 706 Union Avenue to record two versions of a song called "It Was the Whiskey Talkin' (Not Me)," for the soundtrack of the new Warren Beatty movie *Dick Tracy*. Many of the film's original songs were written by Andy Paley, who had written "Whiskey" a decade before with Jerry Lee in mind. The old studio had been resurrected, saved from dereliction and remade as a tourist destination; inside it looked close to how it had in the days when it was the incubator of rock and roll.

The writer Jimmy Guterman would later describe a tiny studio with about a half-dozen people inside, musicians and technicians who were achingly deferential to Jerry Lee. He terrorized one young man, the

studio manager, with questions about religion. The young man had the misfortune to be a Baptist, and Jerry Lee told him the only thing wrong with Baptists was they needed to get saved, and that made the young man stammer and claim he *was* saved, till Jerry Lee told him he was only joking, son. "Baptist folks are good," Jerry Lee said, "they just don't preach the full gospel.

"Well, let me get back to where we started," he went on, "the Book of Acts, second chapter. Read it!" and it is unclear if Jerry Lee is talking about the recording session he is in now or the one he was at some thirty-three years before, when he and Sam Phillips argued faith into the early morning.

"Pentecostal. You are what you are," Jerry Lee told the room. "You're realistic and you're real, or you're not."

Then he turned to the people in the booth, behind the glass. "Now I'm watching you people in there," he said. "I know what you're thinkin'. I know what you're lookin' at. You ain't foolin' Jerry Lee Lewis for a minute."

Elvis stared down from the wall.

Jerry Lee met his gaze.

"Now, if I could just call this dude back here for about fifteen minutes, we could show you a trick. . . . Never be another Elvis Presley. He had that somethin'. Dynamic, you know? Somethin' that would make you want to drive ten thousand miles to see him if you only had fifteen cents in your pocket. You'd get the money somehow to go." He told a story of him and Elvis and the army and how Elvis got upset. Then he recalled the day he first saw him, how he pulled up to Sun in that '56 Lincoln, "I wanted to see what he looked like. He rolled out of that car and he walked in and he looked just exactly like he looked. Dangerous. . . . We had some times. But those days are gone, aren't they?"

Someone in the room said no, there was still Jerry Lee.

Jerry Lee, seeming oddly isolated even in this cramped little room, almost insecure, apologized for being so slow to get the final take on the record. "Well, ol' Jerry Lee is really tryin' to get it

together. I know I haven't quite gotten there yet . . . but I am really workin' on it with everything I've got," and now it is clear he is talking not about the session but something more. "I've had a rough struggle. I got strung out for a couple of years on all kinds of drugs, junk, whiskey, and everything else. And you've just got to back off, man, or you're not gonna make it. Record companies are not gonna buy you, they're not gonna produce you, they're not gonna release a record on you, they're not gonna back you up, if you don't back yourself up. And they can spot you a mile off, if you've got a shot of Demerol or somethin' . . .

"Brother, I don't mean to be gettin' into that. It's just a pleasure talkin' to somebody."

He half-talked his way through some lines from "Damn Good Country Song" to applause from people who may or may not have recognized it as one of his records. Then, as Guterman recounts, he went back to the song at hand and cut it till he was mostly happy. "This is a hit," he said. "I think I can cut a hit with this song." But he became frustrated with one little piece of it, couldn't quite get it right.

"Call Sam," he said, but then immediately, "please don't."

In October 1991, a police officer in Indio, California, saw a man driving on the wrong side of the road in a Jaguar. It was Jimmy Swaggart, and he was with a prostitute, reported the *New York Times* and the *Los Angeles Times*. He was in California for a revival.

This time, he was not contrite. He told his congregation that God told him to return to the pulpit. "The Lord told me it's flat none of your business."

"And they lined up," says Jerry Lee of his cousin's flock.

It was just a power they both had, for being forgiven.

Jerry Lee needed it more often, in smaller doses.

"But I never pretended *nothin'*," he says.

For Jerry Lee, it was the beginning of a period of withdrawal, in which the news he made was mostly in the *National Enquirer*. He did few shows, fewer recordings. Other, lesser performers would have called it retirement, but he was aching to get back in front of an audience, to get back in a studio and cut a new record.

"I don't know where I'd go," he says now, "if I didn't have that stage."

A year passed that way, two, three. In spring of '93, he loaned his name to a short-lived Memphis nightclub called the Jerry Lee Lewis Spot. Then, with the IRS still dogging him, he fled, to become a tax exile in a country that knew how to treat its artists. He and Kerrie and Lee moved to Dublin, where musicians are exempt from taxes under Irish law.

Kerrie, on an Irish television talk show, said they loved Ireland and planned to make it their home, and that the womanizing, hard-living man now wanted to live quietly. "I caught him at the right time," she said. She claimed that Jerry Lee was at peace in Dublin. "He loves the rain," she said. It reminded him of sleeping under a tin roof at home in Black River. "The rain was very soothing . . . the drumming of the rain."

While they were in Dublin, the IRS hired a locksmith to open the gates on the Nesbit house—he had title to the house only through a life-time ownership agreement, so the house itself could not be taken—and started to empty the sprawling brick house of everything but children's toys. Federal agents carried out two grand pianos, a pinball machine, a pool table, a box of Christmas decorations, a riding lawn mower, model cars, including a pink Cadillac, eight swords, a pen-and-ink sketch of Jerry Lee Lewis, a Sun Records clock, a poster signed by Fats Domino, every stick of furniture, two cases of Coke bottles, an empty gun cab-inet, eight ceramic cups (one broken), a toothbrush holder, forty-eight

records, twenty-five pipes, seventeen jackets (some leather), a candela-bra, a Jerry Lee Lewis beer stein, a box of piano-shaped knickknacks, and one warped and buckled Starck upright piano.

Agents would say that the old piano was in "horrible condition" and without value.

The IRS set an auction date, but Kerrie was able to get a restraining order to delay it, and they bought back some of the items that were taken when Jerry Lee declared bankruptcy. The old Starck upright was returned.

After a year in exile, they came home. Jerry Lee missed his people, missed the river, missed it all. After decades of bitter enmity with the IRS, in July 1994 he agreed to pay some $560,000 of a $4.1 million tax bill, fourteen cents on the dollar. To earn the money, he would play music and open the Nesbit ranch to guided tours. "You have to do what you have to do," said Kerrie, as she opened the house to fans.

He had not recorded in years, and his live shows had dwindled, but someone forgot to tell Jerry Lee that he was finished, if anyone had the nerve. He played another European tour in '94, including a show in Arnhem, Holland, where he seemed, again, immune to all that life had thrown at him—that he had encouraged it to throw—and gave the fans their due. He was a little stooped now, and there was gray in his hair. Kenny Lovelace, still playing four feet behind him, helped him off with his jacket; Kenny's ball of curls was graying now, too. But they played "Johnny B. Goode" like it was going out of style; Jerry Lee played all over the piano, and even yodeled a little, as if he was still needling Chuck from an ocean away. He did tell the Arnhem crowd he was glad to be in Amsterdam, but they cheered like crazy anyway.

In Memphis, in December, he was hospitalized after choking on some food.

He was fifty-nine.

"When I can't play no more," he says now, of that time, "*then* it will be over."

Jerry Lee had only one place to go: back into his own fame. The National Academy of Recording Arts and Sciences awarded Jerry Lee Lewis his second Grammy, this time a Lifetime Achievement Award. He went back on tour, no longer leaping onto the piano but still playing the hell out of it sitting down, as most mortal men have been forced to do it.

In 1995, he released a new album called *Young Blood*. It would not reach the charts, would not spark a comeback, though besides the soundtrack it was his most sustained work since the Elektra days. It was a mono album recorded with modern-day methods, and it seemed misplaced amid the country music of the time, the way a slightly dusty bottle of Early Times would be out of place in a bar that served fruit-scented vodkas and designer beer. He did Huey Smith's "High Blood Pressure," and the old country song "Poison Love," and classics from Jimmie Rodgers ("Miss the Mississippi and You") and Mr. Williams ("I'll Never Get Out of This World Alive"), and reviewers said they liked the way his voice had aged, but some of the songs were pieced together mechanically, and the whole seemed to lack his spontaneity, his spirit.

In 1996, on February 24, at the Sports Arena in Goldston, North Carolina, he took the stage, ready to raise hell, and didn't leave it until he had barreled through "Meat Man," "Over the Rainbow," "Memphis, Tennessee," "When I Take My Vacation in Heaven," "Blue Suede Shoes," "Lucille," "Mean Woman Blues," "Mr. Sandman," "What'd I Say," "To Make Love Sweeter for You," Hank Williams's "You Win Again," "Room Full of Roses," a medley of "Sweet Little Sixteen," "Whole Lotta Shakin' Goin' On," and "Blue Moon of Kentucky," "You Belong to Me," "White Christmas," "Rudolph the Red-Nosed Reindeer," a snatch of "Peter Cot-

tontail," "Mexicali Rose," "Seasons of My Heart," "Johnny B. Goode," "Sweet Georgia Brown," "Thirty-Nine and Holding," a few bars of the Everly Brothers' "All I Have to Do Is Dream" and the Beatles' "A Hard Day's Night," Al Jolson's "My Mammy" and "April Showers," "Boogie Woogie Country Man," one verse of Johnny Horton's "Honky Tonk Man," "She Even Woke Me Up to Say Goodbye," a medley of "Will the Circle Be Unbroken," "I'll Meet You in the Morning," and "On the Jericho Road," "Great Balls of Fire," "The Last Letter," "Hi-Heel Sneakers," "Money," "Lady of Spain," "Who's Gonna Play This Old Piano," "Lewis Boogie," "Crazy Arms," "Goodnight Irene," Jimmie Rodgers's "In the Jailhouse Now," Harry Belafonte's "Jamaica Farewell," "Chantilly Lace," a few improvised lyrics ("You're from the center of Alabama/I'm the center of attention"), "In a Shanty in Old Shanty Town," "Bye Bye Love," a medley of "Trouble in Mind" and "Georgia on My Mind," "Me and Bobby McGee," two lines of "The Star-Spangled Banner," "I Wish I Was Eighteen Again," and an encore of "Whole Lotta Shakin' Goin' On" and "Folsom Prison Blues," 160 minutes later.

In 1998, after a long but fractious marriage, Kerrie filed her initial complaint for a divorce, citing irreconcilable differences, alleging that he had been unfaithful—he suspected the same of her—and that he had hidden financial assets from her. It was the most benign complaint he had ever encountered, but the divorce would take years to finalize. Court records were sealed, but the *Commercial Appeal* reported that Kerrie received a $250,000 lump sum, $30,000 a year for five years, and $20,000 for child support for Lee, by then a teenager.

Jerry Lee spent more and more time at the ranch, but it was quieter now; music no longer poured from the place when he came home from a show. "She took my records," he said, in the divorce. The tours of the house ceased, at least. He could roam the dark halls in peace, still in lingering addiction, still hoping for another comeback, and why not? The last time he looked in the mirror, it was still Jerry Lee Lewis he saw looking back.

The pills were no longer as easy to obtain. Dr. Nick had finally been censured and lost his license after a review by the Tennessee Board of Medical Examiners. In the late 1990s he tried for a third time to regain his license, but officials of the Board of Health evoked the ghost of Elvis and the ruin of Jerry Lee as evidence against him, and he was denied.

Jerry Lee had somehow passed into the realm of the old master, and more than ever the younger stars—some of them legends themselves—wanted to be close to him, to reach out and touch history. Some of that attention he welcomed; some, he resented. It depended on the musician. He had seen his life mirrored—though that mirror was sometimes cracked—in every corner of pop culture. He had misbehaved badly, and if he had any regret, it was that some of those who followed him believed that was all there was to it. "I've seen 'em, these new so-called bad boys. They try. They really try. I see it, and it's as phony as can be." He has seen them trash their hotel rooms in celebration, because they can afford to smash as many hotel rooms as they want, at least until the money runs low. "Well, it just don't work that way. You got to *feel* it, boy. Be what you are. If you feel it, you can jump up on that piano, kick the stool back, beat it with a shoe. But you got to *feel* it. The music has to be there. It has to be there, *first*."

Sam Phillips died in the dog days of summer, July 30, 2003, of respiratory failure, two days before the little studio at 706 Union was declared a national historic landmark. He had been a smoker much of his life. Jerry Lee was sad when he heard the news, of course, despite their stormy time together. But it was not only that institutional, historical sadness people feel when someone of importance has passed. Jerry Lee also understood what Sam had done for American music, and so for the music of the world. By taking white music and black music by the hands and joining them together, Sam Phillips not only helped make way for rock and roll but broke down some barriers between

those two peoples, made the world a little better to live in, and certainly more joyful. He would record *anything*, if he felt it, if it moved his soul even a little and made him tap his toes, and he did not give a damn what color the man's skin had; whether it was a towering black man from the Delta, like Howlin' Wolf, or a brooding Arkansas cotton picker, like Johnny Cash. He stamped it all in hot wax and sent it to a pasty-white teenager in Middle America, so he could feel everything they felt—and more, for the distance it traveled. And if that was the so-called danger in rock and roll, then he was a thoroughly dangerous man.

"Sam seen it in me," Jerry Lee says, and he does not care that dollar signs were flashing in Phillips's eyes. He knew Sam was a businessman—all their problems stemmed from that—but also a true believer in the cause, which was why it hurt Jerry Lee when he hesitated over "Whole Lotta Shakin' Goin' On," and seemed to turn away from him when the debacle of London knocked them all out of the clouds. People always talked about the almost religious fervor they saw in Sam Phillips when he heard something he loved, something brand-new or sometimes something very old. Jerry Lee saw that fervor, veiled in tears, when Sam Phillips walked from the room after hearing him play Hank's "You Win Again."

But the sadness Jerry Lee felt pushing down on him that summer was more than that. The old kings were dying, one by one: Roy Orbison in 1988, Charlie Rich in '95, Carl Perkins in '98, Johnny Cash in '03. And the music itself—as much as people remembered, as much as they loved it—seemed to be more and more a thing of museums, of a bygone day.

"We had such a good time," he says.

In 2004, *Rolling Stone*, the magazine that had once all but accused him of murder, placed him on its list of the top one hundred artists of all time. He was about to enter his eighth decade, and he was *still* looking

for a record deal. It was not that he believed he had anything left to prove, he says, or even that he longed for some new validation. It was not even the money, though he knew he had to work, had to earn. It was simpler than any of that: He truly did not know what else to be, other than a rock and roller, a country singer, a piano player, driving his band across the country and around the world, with one eye on the audience the whole time.

"I train my boys to follow me," he says. "I build up a show. I build it up. And I pick my tempo up at certain times, like I want it. And it brings the crowd up."

He takes his thumb and jacks it into the air, once, twice, three times.

"When I do that, it means pick up, *or else*. It means pick it up, or *get off the stage.*"

He knows he has slipped below that perfection, in the harshest times.

But it can be that way again. He knows it.

"I want that show to be right. And I want that *song* to be right, when I play it on the piano and sing it. And I want that band to back me up like they're supposed to."

He says all this, thinking back to that time, as he recovers from a litany of ailments that prevent him from standing still, or even sitting still, for more than a few minutes at a time.

But there is no other place for him.

"Where would I *go*?" he says again. "I wouldn't know where to *go.*"

16

LAST MAN STANDING

· ·

Nesbit

2000s

He had never much cared what other people thought, or at least that was the armor he wore. He probably did care, some, or he would have given up, would have stopped playing his piano and singing songs, but he never did. But you will play hell getting him to concede it. He played from love, the same love "my mama and daddy had. They *loved* music." He had risen from professional and personal ruin, from death itself, and public infamy, so many times; could anybody even keep track of how many? He would be lauded onstage, honored with his industry's highest acclaim, and go home to a house he did not own, which he arranged to be filed under another man's name, so that the government could never take it away. He was seventy-one years old, in wretched health, his body still polluted by the painkillers he had battled across the second half of his life. And as he sat in the gloom of his big house in Nesbit, there beside the tranquil lake, he was not thinking retirement, or even death, though death had begun, naturally, to creep into his thoughts. He was thinking comeback. He just needed a record, needed a hit. Some things, he says, smiling, "don't never change."

He knew it was time to cast off his worldly demon, his addiction, or that comeback was unlikely. He was too far into his life to choke that demon down, and still pour out his songs.

He also knew that if he did not beat it, he would probably die.

He was the last man standing, quite literally, the last of the big Sun boys from the beginning of rock and roll.

Others were still alive, but time had taken either their legs or their will.

Chuck Berry was even older than he, and frail, though still playing.

Little Richard had bad legs, found it hard to walk. He would talk of retirement, but Jerry Lee would dismiss it. "He'll not retire," he said. "Not Richard. As long as they make wheelchairs, he'll be onstage."

Fats Domino had vanished into his house in Louisiana.

"Fats is, is kind of . . . funny about things. I don't know. He's a hard cat to figure out, sometimes. He'd like to do him some more shows, really, but he's—he's too nervous about it. He says, 'I don't think them people really want to see me.' I said, 'I think you're wrong there, Fats. They want to see you. They love you, man.'"

He did not believe in his own passing, his fading, as Fats did.

"I just needed a record," he says.

His daughter, Phoebe, had come to live with him. She has said many times that she has devoted her life to him, even forfeiting her own personal life, even children, to help care for him. She had seen her daddy rise and fall many times across her life, like some yo-yo, so quick, at times, that it seemed almost impossible in a waking world, more like a dream. Kerrie had redecorated the house—the Coca-Cola wallpaper is still there in the kitchen—but had not, despite her very public accounts of Jerry Lee's clean living, cured him.

Phoebe took a hand in her daddy's professional life, searching for a way he could reenter the business beyond the occasional, weary nostalgia show, the tiring European trips, and small events closer to home.

Jerry Lee went searching for a cure of another kind.

He prayed.

He prayed for God to cast off his demon.

"If you're not in the hands of God, you're over," he says, not with the desperation that some men find as old age advances and death stands at the foot of their bed, but with a lifetime of conviction that in the end God would decide his fate in this world and the next. This time, he is certain God gave him another chance to make music, a little more music.

"He calls the shots," he says. "Broke me from my habit. I'm a very hardheaded person. I had to really be proven to."

He laughs. "*I was proven to.*"

Now he calls it one of the hardest things he has ever done. It was not just a rolling addiction, but a lifetime accumulation, sixty years of rattling pills and needles, that he had to relinquish.

"I have myself pretty well straightened out," he says, looking back on that time. "It's been a real uphill climb, I tell you. Never be enough money to make me do that again."

He remembers the usual pain of withdrawal, the shakes and chills that others live through, but he met that with prayer. In the end, he conquered it there in the dark of his bedroom, but not alone.

"*God* did," he says.

He was still frailer than he would have liked. But he was ready to take the stage.

His professional deliverance, when it finally came, seemed almost heaven-sent.

Steve Bing, the businessman, film producer, and philanthropist, had inherited some $600 million from his grandparents when he was a teenager, and by 2008 had most of it left. He had written movies like *Kangaroo Jack*, produced the Stallone remake of *Get Carter*, and invested in the wildly successful animated film *Polar Express*. He had a love for

rock and roll and produced and financed the Rolling Stones concert film *Shine a Light*, which was directed by Martin Scorsese. He put his money to work for causes he believed in, investing millions in congressional races around the country. And one such cause was the music of Jerry Lee Lewis.

In the early 2000s, Bing decided to finance and coproduce a new record featuring Jerry Lee, in duet with—or backed musically by—some of the most legendary performers in rock and roll and country music, as well as some others who just badly wanted to be part of the project.

With Bing's money as a machine and Jerry Lee's reputation as an enticement, the project, coproduced by Jimmy Ripp, drew a host of famous fans: B. B. King, Bruce Springsteen, Mick Jagger, Keith Richards, Ron Wood, Jimmy Page, Merle Haggard, George Jones, Eric Clapton, John Fogerty, Buddy Guy, Don Henley, Kris Kristofferson, Neil Young, Robbie Robertson, Little Richard, and Rod Stewart. It also drew country singer Toby Keith, and the modern-day bad boy Kid Rock. Some of the tracks were laid down using the expedient ways of modern music, with voices spliced and married by machines. But some were done the old-fashioned way, with men looking at each other across a microphone.

It brought live performances and even a made-for-video concert show, joining Jerry Lee with great performers in their own right, like Springsteen on "Pink Cadillac." In one of the most interesting pieces of film from the making of the album, Springsteen sings *backup*, and seems glad to do it. His line at the beginning of the song, "Go on, Killer!" made people smile with a kind of goofy joy. When he and George Jones sang "Don't Be Ashamed of Your Age," he actually yodeled so high that Jones had to warn him not to hurt himself. When he and Willie Nelson sang the sweet "A Couple More Years," it was with a wink and a grin. When he did "Hadacol Boogie" with Buddy Guy, you knew they spanned a time when that song was more than trivia, when broke-down guitar pickers throughout the South had it in their repertoire. Guitar licks from players like Buddy and Jimmy Page meshed with his piano

and voice—which showed its age, surely, but how could it not? It was still Jerry Lee Lewis and all that that implied.

And some of it was music that just stuck in your head. His duet with B. B. King sounded like the two old men were singing on barstools on Beale Street, finally equals, so long after Jerry Lee had to sneak into Haney's to hear the man play. " 'Before the Night Is Over,' you gonna be in love," says Jerry Lee. "That was a song. I liked that." He did "That Kind of Fool" with Keith Richards, "Traveling Band" with John Fogerty, "Sweet Little Sixteen" with Ringo Starr, and "I Saw Her Standing There" with Little Richard.

Recorded mostly at Sun Studio, it was called, of course, *Last Man Standing*.

"Who would have believed it?" said Jerry Lee.

He emerged from the gloom of his Nesbit ranch with, if not renewed vigor, at least a new purpose. Jerry Lee Lewis had not just become relevant again, he was back in the charts. *Last Man Standing* rose to number 26 in Billboard's Top 200, number 8 in country, number 4 in rock, and number 1 among independently produced albums.

"Was I surprised? Naw, I wasn't surprised," he says, slipping back into the confident old Jerry Lee like he was never missing. He is asked if he enjoyed making some of the songs more than others, and he just says "Enjoyed 'em all," that all of his guest artists, some of them in their sixties, were "pretty good boys."

Asked later if he could choose to play music with anyone, anyone in the world—the Rolling Stones, B. B. King, Hank Williams—who would it be, he didn't miss a beat.

"Kenny Lovelace," he answered immediately.

Last Man Standing would have been a fine album to go out on, if he was planning on going out.

He was not.

"Am I satisfied with how it's all gone? I don't think so. I *yearn* to be satisfied. I do a song and I know I can do it better. And so I seek it." He thinks only of the music as he ponders that question, not the life that frames it. By the late 2000s, he knew that his voice was changing, ever changing, but it still sounded like *him*, and his hands were still able to do many of the acrobatic moves of his youth. If it looked a little slower, well, that was his *intent*. As he had moved closer to the Lord, the old R-rated versions of his shows were fading away. He eased up on the word *muthahumper*, though it would creep into a recording here and there, out of habit.

In 2007, after being feted by Kris Kristofferson, Wanda Jackson, Shelby Lynne, and others for the American Music Masters series at the Rock and Roll Hall of Fame in Cleveland, on came a surprise guest: Jimmy Swaggart, who played "Take My Hand, Precious Lord" and told his cousin he loved him. At the end of the program, Jerry Lee took his award and instead of making a speech, walked to the piano, sat down, and played "Over the Rainbow."

Two years after that, he returned to the Hall of Fame for its twenty-fifth anniversary, this time at Madison Square Garden, as its guest of honor. He opened the two-night celebration alone in the spotlight with a solo rendition of "Whole Lotta Shakin' Goin' On." The following night he did the same thing with "Great Balls of Fire," and rose to kick the piano bench away. Then, walking offstage, he picked it up and heaved it farther across the floor. He was seventy-four.

Even well-meaning people believed he was surely done by now; surely he would soon succumb to all that hard living, or at least, growling in disgust, finally retire. Still, when he walked into a hotel room for an interview, reporters seemed surprised somehow that he had actually gotten old. They described his face as wattled, his voice as high and thin; they described a newfound humility when he performed onstage, an increased carefulness with music that now suddenly was not a guarantee. Some reviewers seemed almost let down when he played like a

grown-up and relieved when he slipped back into his occasional indulgences.

But he kept showing up, even as the world enlisted yet one more young pretty face to retell his story, now more than half a century old. In early summer of 2010, the musical *Million Dollar Quartet* opened on Broadway, with the actor and musician Levi Kreis stealing the show in the role of the young upstart piano player.

The show, a fanciful re-creation of that long-ago December day in 1956, was the brainchild of Sun historian Colin Escott, who had written with authority about Jerry Lee for decades, and director and writer Floyd Mutrux. In giving the role to Kreis, the show's creative team selected a Southerner from Oliver Springs, Tennessee, and a piano pounder who had grown up on Jerry Lee's music after his mother handed him a stack of Jerry Lee Lewis 45s when he was still in elementary school. "I cut my teeth . . . on Jerry Lee Lewis music," he told one interviewer. He also played the hymns of Jimmy Swaggart, and was at the time enrolled in ministerial school, as Jerry Lee had been. It was almost like fiction, how his story dovetailed with Jerry Lee's own.

The story of *Million Dollar Quartet* revolved around a few slender subplots—Johnny Cash's departure from Sun, Sam's dream of luring Elvis back from RCA—but all the energy came from the blond-haired figure behind the piano. He had never been an appropriate man, but in old age much had been forgiven, it seemed, and the very idea of Jerry Lee Lewis was enough to carry a show in what they used to call the legitimate theater. And besides, everyone said the music was the true star, just as it had been in 1956.

On a visit with his younger self in New York, Jerry Lee showed none of his characteristic gruffness or ego at the idea that someone else could play him. Wearing slippers on his feet, he merely told the young man he did a splendid job.

Then, in an almost surreal time-machine moment, the real Jerry Lee later joined the actors playing his now-departed friends onstage for an

encore after the final curtain. He played "Shakin'," rewriting the lyrics there, too, as he liked, without telling anyone beforehand. Kreis just sat close by and watched.

"There's no stopping him," he told the interviewer. "I want to be kickin' ass and takin' names at his age, like he is."

In covering the meeting between Lewis and Kreis, the *New York Times* noted that it was made poignant by the older man's "unmistakable frailty." It was true: he was weaker that year, even as a man playing his younger self took home the Tony Award for Best Featured Actor in a Musical.

Last Man Standing had been such a success that there seemed little reason not to do it again, and while the album that followed had fewer blockbuster guests, it was crammed with fine music.

It was his fortieth album, called *Mean Old Man*.

This time the music was mellower but perhaps more meaningful, the artists more soulful.

He sang "Life's Railroad to Heaven" with Solomon Burke, "Release Me" and "I Really Don't Want to Know" with Gillian Welch, and "You Are My Sunshine" with Sheryl Crow and Jon Brion. He did a pair of well-chosen songs from the best corners of the Rolling Stones' catalog: the heartbreaking "Dead Flowers" with Mick Jagger and the spiky, mournful "Sweet Virginia" with Keith Richards.

One of the jewels of the album was its title song, by his old friend Kris Kristofferson:

> *If I look like a voodoo doll, that's what I am*
> *If I look like a voodoo doll*
> *Who takes his licking standing tall*
> *Who'd rather bite you back than crawl*
> *That's what I am*

The album would enter the Top 100 too, peaking at number 72—
and putting Jerry Lee Lewis back in the charts for his seventy-fifth
birthday.

He seemed to be having a good time on the album, with its easy tem-
pos and warm ambience, but perhaps what he enjoyed most was shoot-
ing the cover photo. Dressed in a dark suit, his blond hair completely
silver now, he steps out of a limousine into a waiting bevy of beautiful
young women.

"They changed clothes right in *there*," he says, motioning to a small
room off his bedroom, "and they didn't shut the door."

A man is not meant to be alone.

He would fix that, in time.

He was in demand again, but even as he celebrated this latest triumph,
he knew something was different this time. His phone rang with offers
that year, but he could not take them, or at least not most of them. In
the middle of this latest comeback, his body failed him again, this time
not violently, as it had before, but in a creeping betrayal. Arthritis in
his back all but crippled him, making it nearly impossible to sit on the
piano bench for more than a few songs, a few minutes. Pneumonia hit
him again and again, leaving him weak. Shingles left him in agony. Still
he wasn't convinced that he would not rise one day from his sickbed
in the big house in Nesbit and walk into a studio or climb a stage. "I
would like to record some new songs," he said that summer, "but I
guess that's in God's hands." He had beaten his addictions and walked
cold turkey away from his old friend Calvert Extra just in time to be
beset by the ravages of age, as if he were any other man. The phone
rang, and he promised, weakly, to do it if he could, when he could.

He needed a caregiver.

Judith Ann Coghlan was his ex-brother-in-law Rusty's wife, and Myra's
sister-in-law. She came to Nesbit to cook and help care for him, and to talk

about times better than these. They had much in common. She was the daughter of sharecroppers, too, from the tiny town of Benoit, Mississippi. She was a tall blonde, a star athlete as a young woman who had played basketball for the Memphis Redheads professional team, whose players took the court in satin outfits and jumped for rebounds in big hair.

She was living at the time in Monroe, Georgia, but said she moved to the Lewis house at her husband's urging. She arrived to find the house and the man in need of attention.

"He was lethargic, out of it . . . ," she says, and worse, "Had systemic infections—shingles, pneumonia." But treatment was difficult. "He was scared of needles," she said, afraid of the old demon he had beaten back after a lifetime.

"Yeah," Jerry Lee says now, "it was no bed of roses."

As he lay there between fevers and bouts of pain, they spent long hours talking about where they grew up and how. They talked about old songs, and old ways. "I fell in love," she said. "Well, I probably fell in love before then." They had met more than a quarter century before, in Las Vegas, where he said that if Rusty didn't marry the woman, *he* would. "We went to see him with sawdust on the floor in the Cherokee Plaza, in Atlanta," she said. "I remember the women screaming. . . ."

"And you wanted to be one of them," smirked Jerry Lee.

"Yes," she said, "I did."

She divorced her husband in 2010 and immediately clashed with Phoebe and Myra.

"Phoebe told me, 'You have no right to take him.'"

"She probably thought she was lookin' out for me," said Jerry Lee.

"They told me, 'Well, give her two hundred dollars and the old Buick,'" as incentive to leave, Judith said.

Money was never the reason, she said. There was not much of that, hadn't been for some time.

"I was told he would kill me," Judith said. "I was told he would kick me out after one month. But Jerry stood by me and we made it."

"I got her down here," said Jerry Lee, "and wouldn't let her leave."

At Christmas 2010, he gave her a diamond ring, but did not tell her it was an engagement ring until a few months later. "I want you to know that the ring I gave you for Christmas is a promise that I will marry you," he said, as she later told the *Natchez Democrat*.

"I'd never had a diamond like that," Judith said.

Jerry Lee just lay in his bed and smiled.

She was treating him for various ailments, all over his body. "I figured if she got that close," he said, "we might as well go all the way."

He was still weak and ailing, but he was feeling better.

She traveled with him, to do a show in Budapest.

"That's when it was 'Great Balls of Fire,'" he said, and then, quietly, '*hee, hee.*'"

In those early days with Judith, he would rise from his bed and do a show, then slump exhausted in the car or plane seat for the long ride home. They were all long rides then, even if they were just up the road.

In a concert at Jack White's Third Man Records in Nashville in April 2011, fans lined up by the hundreds to get tickets, to buy posters and T-shirts with the young man's face and the simple legend KILL. They were mostly young people, people who were not alive when he was the hottest thing in rock and roll, not even alive when he was the hottest thing in country music; many of them may not have been alive when he entered the Rock and Roll Hall of Fame. He had been old all of their lives.

"A lot of the old fans are gone," he says now. "But I guess there are new ones to take their place."

In a plain black suit and white starched shirt, he played them some barroom music:

> *Wind is scratchin' at my door, and I can hear that lonesome*
> *wind moan*

Tell me baby, why you been gone so long?

Then he raised his loafer, gave it a final lick, and smiled.

It seemed different, somehow, though it is easy to read so much into such little things. But that day he seemed different from the man of a million self-referential smiles, leering and mugging from the stage, the stage that was his due.

He seemed, simply, happy to be there.

The crowd, with their young voices, roared and roared.

Tragedy continued to dog those in his life, even those on its outer reaches, even those who were bound to him in name only. Lori Leigh Lewis, Jaren's daughter, accidentally smothered her infant son to death in May 2011 when, police said, she passed out on top of the child after ingesting a dose of muscle relaxants. "It was awful," he says. The next year, his longtime bass player, B. B. Cunningham, was killed in a shootout at the Memphis apartment complex where he worked as a security guard. Jerry Lee was not involved, but the tragedy evoked violent memories of the past, a side of him he sometimes refuses even to recall.

"I don't believe in fightin' and carryin' on," he says now. "That's not my game. I sure don't want to shoot nobody." He says this within easy reach of the automatic on his bedside table and three feet from a drawer of firearms, including one that looks like it was made to fell a charging Cape buffalo. But those, he clarifies, are just there in case someone bothers him.

He was hospitalized in January and February 2012 for various old ailments, including the nagging stomach trouble and a new bout of pneumonia. On March 9, when he was seventy-six and Judith was sixty-two, they were married in a small ceremony house on the Natchez Bluff, overlooking the big river, the one that swallowed Jolson when he was a boy.

"They kind of hemmed me in," he jokes now, pretending he was

somehow bushwhacked. "What with that Baptist minister there, and all." The wedding party sang hymns, "but it wouldn't have been shoutin' music," he says, because the Baptists could not have kept up.

The vows were barely said when he struck his leg against a door facing, resulting in a compound fracture of his lower leg. Surgeons repaired the damage with thirteen screws and two metal plates. The pain and stress almost killed him.

"I went out in the parking lot and got down on my knees," Judith says, "and said, 'Please don't, don't take him away, someone I have just found in my sixties.'"

His cousin David Batey drove up from Cleveland, Tennessee, to pray with her. He told Jerry Lee what he had witnessed in the parking lot.

The leg would not heal properly. "The pain was so bad, he was out of his head," she said.

He still refused the needles.

"It was so bad, he had to go to the wound-care center," Judith said. The wound healed—slowly, after three more operations, but it healed.

He did not worry himself with challenges, with the distances others might set as goals: a mile, a half mile, a hundred feet. He wanted to walk across the stage to the piano stool and back, unaided.

That would be enough.

"And it seems okay now," he says. "It's tough. It's hard to do. It's like learning yourself to walk again," as a child. "And you try to cover it up as much as you can. Walk out onstage, walk to the piano, set down, take the microphone and start doin' your thing. And if you can do that, good. If you can't do that, it's best to stay home."

Now, from his bed, he looks at Judith and shakes his head.

"Wasn't much of a honeymoon, was it, baby?"

She is asked now why she would take such a chance on the man they called the Killer. But that man seems, if not gone, at least very well hid.

They go on dates for chili dogs and like to go to a local meat-and-three for vegetables. He still eats the food he loved as a boy, and she cooks it for him.

"It's what a man needs," he says, "good lovin', good cookin'."

In the dark of his bedroom in Nesbit, Judith brings him a Coke float with vanilla ice cream.

"No Diet Coke," he says, and takes a sip. "Real Coke."

Somewhere in this nuptial bliss, an odd thing has happened: the faces of the women on the road have grown less distinct in his mind. It used to be that he could call them all back, or many of them, or things about them. "They run through my mind, and I wonder where *she's* at now or where some other one is. . . . You can't hang on to a ball of fire. That time is over. But it *happened*."

Now, though, things have changed. "I can't even hardly remember. . . . Well, I can remember, but it really didn't amount to nothin'. Not as much as people think."

He wonders if it might be time to do a new record.

"I think now's my time to get it again. It's now or never."

He always liked that Jolson song, "Bye, Bye, Blackbird."

"Been thinkin' about doin' that."

He plays it through in his head.

> *Pack up all my cares and woe*
> *Here I go, singin' low*
> *Bye, bye, blackbird*

He is not worried about his hands.

He looks at them, fingers slightly splayed and crooked, the way they rest on the keys. "It don't matter," he likes to say, "what my head does. They know where to go."

He had to prove so much in his time: that a piano man could lead a band, could be a straight-up star. That a country boy could play the Apollo. That a rock and roller could do big-time, mainstream country. That he was not just a crazy man who wrecked pianos, that he was just living life real loud. A dozen times, that he was not washed up, not done. Now he has to prove, again, that he's not dead yet.

"I'm back on the spot again," he says. "I gotta go back in the studio, and prove it all over again. I gotta come out with somethin' different, that I've stored back in my membranes, back there." In the old days, he recalls, "if somebody wrote a song and it's pretty good, I'd listen to it and play around with it a little bit," then leave it alone till he got to the studio to cut it. "Now, it takes time to really learn the song, and get the band into it, and the singers into it, everybody into it. It ain't just like sittin' down and doin' one take. Those days are gone. But of course you can't *think* in that way. You gotta think you can still do it the same way."

That has always been the trick. If you want to do anything worth a flip, you must live in the past, at least a little bit, because that is where the magic was. That was why he was always so much more exciting live, where his mind could wander free and string together things he loved or half remembered. It was why he went back to the past again and again to find the words, the music. What is wrong with living in the past, he knew as well as anyone alive, if the past was better?

"I've had an interestin' life," he says, "haven't I?"

He had said, at the beginning of interviews for this book, that he "had been lucky at everything, except life." He has had some time to think about that, and he is no longer sure.

His Chihuahua, Topaz Junior, eyes the people who come and go from the room with ill intent. He eyes everyone with ill intent, except Jerry Lee, and he bites anyone who tries to remove him from his place on the soft quilt between his feet.

"But you wouldn't bite Daddy, would you?"
Topaz Junior snuggles deeper.
"A great life," Jerry Lee says.

He has been around so long and lived so hard that almost everyone, it seems, has a story about him, a story of seeing him live, or of a thing that happened while listening to his music, or just a thing they heard, that stuck like fishhooks in their mind all their lives. The memories flash brighter and bang louder, somehow, than others. Gail Francis will always be ninety-eight pounds soaking wet, will always be a looker, every time she hears a Jerry Lee Lewis song. Dr. Bebe Barefoot, who teaches English at the University of Alabama, will always be the young woman who was actually struck by lightning as she drove down the highway listening to "Great Balls of Fire." When she hears his music, she thinks about the world around her charged with blue fire. There are thousands of them, tens of thousands, more, who attach a moment in their lives to his story, his songs. He believes there will be more of it. "I mean," he says, "I can't let 'em down."

Late one afternoon, resting in bed, he suggests that maybe he has been foolish even to think about age. He contradicts himself a little, but then that is his prerogative. "Age never crosses my mind," he suddenly says, and then thinks a minute. "As long as I can sing and play the way I want."

He pauses. " 'And the audience went crazy,' " he says, quoting a piece of some long-ago review, really almost any review, any story.

He looks at his hands, again.

"Just like they always was."

One day last winter, Judith was passing through the electronic gates of the Lewis ranch in a rainstorm when she saw, in the rain over the iron

gate, what seemed to be an apparition. She described it to Jerry Lee. They think maybe it was Elvis. Not his face, not exactly, but somehow she felt it was him.

"I don't know if I believe in all that stuff or not," says Jerry Lee, "but I'm beginning to."

A man who believes in angels should not be surprised by one.

"That's what I think it was, an angel," he says, then thinks a moment. "I don't know what it was. Some kind of warning? 'See what they done to me?' Maybe he was saying to not let 'em do the same to me, and my life. I don't know."

Or maybe it was Elvis coming to answer that old question that haunted them both, that old question about what happens to those who sing and play this music. Maybe again, he has gone and left it unanswered.

"It's strictly in God's hands," he says. "And it makes no difference what they write or what they say, or how they feel, it's . . . right between me and God."

He doesn't believe he can talk his way in.

"You gotta live it. You gotta . . . *believe* it. But you can only believe to a certain extent. You gotta live it, too. You gotta back up what you preach."

He would have liked to have seen this Elvis himself. He wouldn't have been scared of him. But the apparition was gone with the clouds, and with it his answer.

Or maybe not.

If it was an angel, he has the answer now.

17

STONE GARDEN

.

Ferriday

2012

He was going home to see his people. He drove ninety, a hundred some-
times, on the interstate between Memphis and the Natchez turnoff. The
University of Alabama Crimson Tide and Louisiana State University
Bengal Tigers were playing football that evening in a nationally televised
game, the game of the century, people called it. "I wanted to see that
game," he said, and then, after a minute: "I'd have drove that fast if there
wadn't no game." He wanted to get a choice room in the old Eola Hotel
in Natchez, where good-looking Johnny Littlejohn, the one he first heard
sing that "Shakin'" song, used to host his radio show. He stretched out
on the bed, got a butler to bring up some room service, and thought of
Elmo. The next morning, he and Judith took her new Buick across the
big river, across the same old bridge, and he looked down to the barges
and up at the rails overhead where he had dangled, and he smiled and
shook his head. At the halfway point of the bridge, he told Judith, "You in
Louisiana, now, baby," and it made him happy to say it, so he said it again.

They took a hard right turn and followed the river north; in the town
of Vidalia, they stopped at the Sonic and had a cheeseburger and a Coke.

"I am a Sonic man," he says, and ate it with relish. For months he had been mostly flat on his back in that air-conditioned dark in Nesbit, like something put up in storage in a cool, dry place; now he savored the sunshine, the balm of a warm Southern fall. "I've found me a new Rolls-Royce, one like I used to have. . . . Took me forever, but I found it, found it in Los Angeles," of course. They got to Ferriday about noon, past the old fish stall with its long-ago signs for the catch of the day fading to gray, past the lovely-sounding Morning Star Alley, where a broke-down Pontiac rusted at the curb. The marquee on the First Baptist Church warned, GOD OPPOSES THE PROUD BUT GIVES GRACE TO THE HUMBLE, as if they knew he was coming, but then he never thought much of Baptists, anyhow.

For some reason he thought of Elvis.

"Drinkin' champagne and feelin' no pain," he sings. "I hit that gate."

Just a mile outside of the downtown, the green fields stretched out toward the big river out of sight, but you could smell it from here, those ages of mud and rot. "It used to be woods, all this," he said. "Funny, how much it's changed." The dirt has not changed, still not quite brown, not gray, but the color of the front side of a dollar bill. Something else made him think of Sam Cooke. "My thirty-second cousin," he joked. "Man, he was *good*."

They stopped and said hey to his sister Frankie Jean, who talked about Uncle Will floating out of his grave in the great deluge, and then they got back into the Buick and went to see the other kin, there in their stone garden.

He drove north out of Ferriday on US 425, toward Clayton. He took a right on McAdams Road just before the rusted drawbridge over the muddy Tensas River, then another right on Indian Village Road. "There used to be a pretty little farm right here," he said, and he looked for it, but it was gone. He rolled slowly between fallow fields and coasted up to the iron gate of the small cemetery like a man walking softly down a hallway to keep from waking a sleeping child. He stepped out, eased shut the door, and walked without sound through the thick grass. He left the Killer in the car.

His people rest in the third row. He walked past them, one by one, silent, the dead leaves, the first of the year this far south, scudding on the breeze across the ground.

Steve Allen Lewis
Feb. 27, 1959–April 22, 1962

Elmo Kidd Lewis
Jan. 8, 1902–July 21, 1979

Elmo Kidd Lewis, Jr.
Nov. 11, 1929—Aug. 6, 1938

Mamie Herron Lewis
March 17, 1912–April 21, 1971

Jerry Lee Lewis, Jr.
Nov. 2, 1954–Nov. 13, 1973

Shawn Michelle Lewis
(No birth date)–Aug. 24, 1983

Only Jaren was buried elsewhere.

He moved back down the row to stand before Junior.

"I *have* had a good life," he said, "but we do lose our children."

His back gave out as he walked the few steps back to the graves of his mama and daddy, and he sagged against the granite of Elmo's headstone. "Daddy," he said, "you won't mind me resting my back?"

He leaned there for some time.

Later, in the fading light, he pointed the car back toward the big river.

"I's just trying to make a record," he said.

EPILOGUE

KILLER

I had to know. Who, besides the great Kenny Lovelace, would Jerry Lee Lewis want to play his music with in the Great Beyond, assuming he ever actually embraces mortality and goes?

He thought a moment, then named off the great stylists. He would like to see Hank Williams in that cowboy hat, free of the pain of his twisted spine. He would like to hear Jimmie Rodgers sing through clean, strong lungs, the tuberculosis left behind on some worldly plane. He would like to talk a long while with Al Jolson, once called the world's greatest entertainer, who if you believe some historians, actually sang himself to death. In the Beyond, there would be no needles, no reek of raw corn liquor or bathtub gin, no pills, none of those rattling bones. But if you scrubbed them all of their pain, their addictions, their obsession, would they—any of them—be the same?

I thought of that Tom Waits song, the one about how, "If I exorcise my devils, / Well, my angels may leave too. / When they leave, they're so hard to find." Still, Jerry Lee would like to see them all gathered 'round his piano, with Kenny playing lead guitar and some red-hot fiddle, singing their songs, all their songs, on a never-dying rotation: "Sheltering Palms" and "You Win Again" and "Waitin' on a Train" and "Shakin'"—wouldn't "Shakin'" just make Jolson's eyes bug out? And

in the audience would be his people, all his people, everyone he had ever lost.

I think about that, about the four of them together, and it makes me hope that my own mother is right, that there is something out there beyond this.

"Can you just *imagine* it?" Jerry Lee says.

When I was done with this book, I had one line left in my notes that made no sense. It did not fit anything around it, and so I could not use the usual clues to make sense of it. It just read:

he never straightened me out

The thing is, in his story, it could have meant anything, at any moment, in any situation. It could have been anyone. I had long given up on it when it finally hit me. It was Jerry Lee, talking about the piano teacher, the one who slapped him and swore to break him of his boogie-woogie. It had come up, out of the clear blue, in the middle of another thought, a whole other conversation, just a thing on his mind, slicing straight through. But now I know it was perhaps the most important of lines, because, good Lord, what if he had?

When I was done with the interviews, as the long, hot summer faded, I walked over to the bed and shook his hand.

"I will try to write a good book," I told him.

"I know you will, Killer," he said.

ACKNOWLEDGMENTS

From Rick Bragg

Writing about a long life is easy, next to living it. For that reason I have to first thank Jerry Lee Lewis, who day after day walked off through the past and came back, sometimes bloody, with the stories that made this book possible. I hope, at least, it was easier remembering it than living it. I thank him for more than that. He was not, in hot spells in his life, a man to be admired, but I liked him when it was all over, and have seldom enjoyed sitting beside a man so much, hearing his life told out loud. He broke my heart a hundred times, and made me laugh a thousand or more. I do not feel guilty about it. Life is dirty and hard, and he reminded me that even in the middle of that junkyard there is great beauty, if you only listen.

It is hard to write a legend. It is impossible to do it without tremendous help from living souls and new and dusty old books and endless stories told in newspapers, magazines, album notes, newsletters, and more. People almost always say, on a page like this, that there are too many people to thank, but in a legend as large as Jerry Lee Lewis, I believe that to be more true than usual.

For that reason, I want to thank Tyler Jones, my graduate assistant who hung in until this book was done, who helped me make sense of more than a hundred pounds of paper and a billion blips on a computer screen. He also sought out people who remembered Jerry Lee Lewis as more than a rock-and-roll star and boogie-woogie man and country giant. I thank him for every word. I wore him out and moved on to Elizabeth Manning, the next assistant, who helped day after day.

I thank Judith Lewis for the fine iced tea. I thank Cecil for fighting the Giant. I thank Frankie Jean for the story of the graveyard.

There are books on my own shelf that have been almost bibles for the golden age of rock and roll. That writers like Peter Guralnick and Colin Escott would take time to aid in a project like this is a source of unending gratitude.

I need to thank several individuals who provided insight into Ferriday, Louisiana, including Stanley Nelson, Judith Bingham, Hiram Copeland, and Glen McGlothin. I appreciate the music shared by Gray Montgomery, YZ Ealey, and Hezekiah Early, and the glimpse into the history of the little church on Texas Avenue from Gay Bradford, Doris Poole, and Gwen Peterson. Many thanks to David Beatty, Donnie Swaggart, Pearry Green, Graham Knight, and Kenny Lovelace for sharing decades of memories about Jerry Lee. I thank Phoebe Lewis for her early help in getting this whole train running.

I thank the people of the University of Alabama, who have given me a beautiful place to write.

I thank Cal Morgan, my editor, for tolerance and for ignoring the fact that he knows ten thousand times as much about Jerry Lee as I do even now and should have written this damn thing himself. And thanks to him, too, for the music. I just *thought* I liked Jerry Lee Lewis. Then I heard "That Lucky Old Sun." My God.

I thank my agent, Amanda Urban, for not skinning me alive during my constant whining. I am fortunate to be in your company again, and again, I owe so much of my writing life to your guidance.

I thank the pioneers of rock and roll. What a joy.

I thank, again, Dianne, and Jake, for their support and their tolerance, and of course their own contributions to the contents of this book. They are native Memphians and know this geography, its people, its stories, and its soul.

But also I thank the countless writers who came before me and gave me insights and avenues to pursue, and also good stuff to read. They are

listed, as many as I could remember, in the bibliography that follows. Thank you, all of you, for the foundation. I am sure I have left out many people, because there were just so many of them, so many who followed him, loved him, worshipped him, or just listened to him, like me, wishing they could play something besides the radio.

And, as odd as it feels, I thank the alchemy of the World Wide Web, which put so much of Jerry Lee's lifetime of work at my fingertips, and made it possible for generations to see what all the uproar was about. Because of it, people can dial up the past and see him as the young, dangerous man. They can see him age, see him growl, see him climb the piano and hurl the bench and, mostly, hear the music, the wonderful music. I have always been dismayed by the Web, somehow, because of its silliness. Now I finally know what it is really for.

From Jerry Lee Lewis

I want to dedicate this book to Mamie and Elmo, who were the best mama and daddy a boy could ever have, and with God's help made me what I am. Without their love and their gift of music I would still be in Ferriday today . . . and there would be no Jerry Lee. I hope my mama was right and I will see them both again someday.

To my papa and grandma Herron and to my papa and grandma Lewis: I never knew how much I loved them till they were gone. They were my buddies and I miss them very much.

I want to thank my wonderful wife and soul mate, Judith, who came into my life at just the right time. She started out as my caregiver and now she is my everything, and without her and God I would not be here today. Now her love and affection make my life complete.

To my sisters, Frankie Jean and Linda Gail, who have both supported me and my music from the very beginning. Frankie Jean has done a great job telling my life story to everyone who visits Ferriday; and Linda Gail has opened more shows for me than I can count, and there is no one I'd rather have warming up the crowd. I love you both very much.

To my son, Lee (Jerry Lee Lewis III) and his wife, Debbie, thank you

for always caring and loving me, and for giving me a wonderful grandson, Jerry Lee IV. He is my only grandson and he makes my life complete.

To my only daughter, Phoebe . . . all grown up but still my baby girl, I love you.

To my sons in heaven, Jerry Lee Lewis, Jr., and Steve Allen Lewis, I love you both and you are always in my heart.

Next, to Rick Bragg, who besides being a great writer, has more patience than anyone I have ever known. He did a truly amazing job putting my life onto these pages, and he somehow got me to remember things that I hadn't thought about in years. Thank you for never pushing me too hard. I love you, buddy.

To all the Lewises, Gilleys, Swaggarts, Calhouns, and everyone else from Ferriday who helped and supported me. To all my nieces and nephews, I love all of you. Family has always and will always mean everything to me. And to Rev. David Beatty, my cousin and my prayer partner, thank you for all the years of praying with me and for me.

To my new family, my wife's, and now mine, the Coghlans: Pete and Donna, Carolyn and Ronnie, Charles and Marida, Gene and Cathy, James and Julia, and the children, Tiffany, Ronnie, Dakota, and Kolton. I'm so lucky to have such awesome people in my camp, I love you all.

To the great Kenny Lovelace, my lead guitarist for almost fifty years now, and the best sideman an old rock and roller could ever ask for. Thanks for stickin' with me. I wish we could do another fifty years together. And to the rest of my band, Buck Hutchenson, Robert Hall, and Ray Gann, you always make me better onstage.

To Sam Phillips: He gave me a chance when nobody else would. Sam didn't care where you came from or what instrument you played, as long as your music moved him . . . and I always moved him!

I have to thank Steve Allen, the man who put me on television and made "Whole Lotta Shakin' Goin' On" an overnight hit, and made me a nationwide star.

To my friend, Bud Chittom, the owner of Jerry Lee Lewis's Café and Honky Tonk in Memphis. Thanks for making my club a reality and for encouraging me to do this book.

Thanks to J. W. Whitten, who has been my road manager, my side-kick, and my friend for more than forty years. He always believed in me.

To my manager, Greg Ericson, who truly cares for me, and works hard every day to get my business in order and to keep me on the road playing for my thousands of fans around the world. Thank you.

To Cal Morgan, my editor, and Erin Hosier (Pippi Longstocking), my book agent, who got this book deal done and pushed me just hard enough to finish it . . . on time.

To my staff at the ranch, Janet, Michelle, and Seth, thanks for keeping everything running so smoothly, even with my crazy schedule. And to all the animals I have had in my life, thanks for making me smile and for the unconditional love.

To my adopted son, Steve Bing, a man of true character, who came to my aid when I felt like the whole world was against me. Steve cares for me as a person and loves my music as much as I do. He knew I had a few more songs in me and got me back in the studio. He is a great producer and a real friend. Thank you from the bottom of my heart.

I need to thank Hank Williams, Jimmie Rodgers, Moon Mullican, Al Jolson, and all the other great performers who inspired me; and to the hundreds of wonderful songwriters and musicians I have played with, recorded with, and toured with. I wish I had enough time to do it all over again.

And, finally, to all my adoring fans who have stuck with me for all these years, and who keep me on the piano stool. I promise that I will keep rockin' for you as long as I can!

For their generous help in supplying photographs and other materials, special thanks to Jerry Lee Lewis, Judith Coghlan Lewis, the *Concordia Sentinel*, Bill Millar, Colin Escott, Kay Martin, Pierre Pennone, Robert Prokop, Graham Knight, Bob Gruen, Raeanne Rubenstein, Christopher R. Harris, Steve Roberts, Frankie Jean Lewis, Linda Gail Lewis, and the Ericson Group, Inc.

BIBLIOGRAPHY

Armstrong, Kiley. "Rock 'n' Roll Awards: Lot of Shakin' Goin' On." Associated Press, Jan. 24, 1986.

Baird, Woody. "Jerry Lee Lewis Is 'Last Man Standing.'" Associated Press Online, Sept. 13, 2006.

———. "Goodness, Gracious, It's Jerry Lee Lewis." Associated Press, June 27, 1989.

———. "Jerry Lee Lewis Has Stomach Surgery in Memphis." Associated Press, Nov. 12, 1985.

———. "Rock 'n' Roll Singer's Wife Dies of Fluid in Lungs." Associated Press, Aug. 25, 1983.

———. "Rock 'n' Roll Star Acquitted of Tax Evasion." Associated Press, Oct. 18, 1984.

———. "Singer on Trial on Tax Evasion Charges." Associated Press, Oct. 15, 1984.

Blowen, Michael. "Jerry Lee Lewis Says Summer Movie Is Not the Real Story." *Austin American Statesman*, July 4, 1989.

Bonomo, Joe. *Jerry Lee Lewis: Lost and Found*. New York: Continuum, 2009.

Brown, David, and Andy Greene. "Rock and Roll Hall of Fame's Greatest Moments: Three Decades Worth of Classic Jams, Speeches and Reunions." *Rolling Stone*, Mar. 10, 2011.

Brown, J. W., with Rusty Brown. *Whole Lotta Shakin'*. Savannah, GA: Continental Shelf, 2010.

Burdine, Hank. "Gentle Jerry: The Killer's Softer Side." *Delta* 9 (1): July 2011.

Cain, Robert. *Whole Lotta Shakin' Goin' On*. New York: Dial Press, 1981.

Calhoun, Robert Dabney. *A History of Concordia Parish, Louisiana*. Louisiana Historical Quarterly 15, no. 1 (Jan. 1932).

Campbell, Laurel. "Courtroom—IRS to Return Seized Items, Jerry Lee Lewis's Wife Says." *Memphis Commercial Appeal*, Nov. 10, 1993.

———. "IRS Lists 3 Jerry Lee Pianos Awaiting Auction on June 2." *Memphis Commercial Appeal*, May 19, 1993.

———. "IRS Seizes Jerry Lee's Possessions." *Memphis Commercial Appeal*, May 7, 1993.

———. "Jerry Lee Lewis and IRS Come to Tax Agreement—14 Cents a Dollar to Clear His Debt." *Memphis Commercial Appeal*, July 26, 1994.

———. "Jerry Lee Moves to Ireland, Seeks Tax Break." *Memphis Commercial Appeal*, May 9, 1993.

———. "Taxes—Judge Delays Auction of Lewis Items for IRS." *Memphis Commercial Appeal*, June 2, 1993.

Carucci, John. "Jerry Lee Lewis to Perform with 'Quartet' Cast." Associated Press, Aug. 18, 2010.

Cason, Buzz. *Living the Rock 'n' Roll Dream: The Adventure of Buzz Cason*. Milwaukee: Hal Leonard, 2004.

Claverie, Laura, with Barbara Dolan and Richard N. Ostling. "Now It's Jimmy's Turn: The Sins of Swaggart Send Another Shock Through the World of TV Evangelism." *Time* 131 (10): Mar. 3, 1988.

Cramer, Richard Ben. "The Strange and Mysterious Death of Mrs. Jerry Lee Lewis." *Rolling Stone*, no. 416, Mar. 1, 1984.

Davis, Hank, with Colin Escott and Martin Hawkins. *Jerry Lee Lewis: The Killer, November 1956–August 1963*. Sun International, 1982.

Deslatte, Melinda. "Jerry Lee Lewis a No-Show for Museum Induction." Associated Press, Mar. 2, 2002.

"Domestic News," United Press International, June 10, 1982.

Dundy, Elaine. *Ferriday, Louisiana*. New York: Donald I. Fine, 1991.

Edwards, Joe. "Nashville Sound—Jerry Lee Lewis: 'I Am What I Am.'" Associated Press, Mar. 23, 1984.

"Elmo Lewis." *Concordia Sentinel*, July 23, 1979.

"Elvis Doc Loses Bid for License." Associated Press, in *Memphis Commercial Appeal*, Sept. 14, 2000.

"Entertainer's Condition Unchanged." Associated Press, July 15, 1981.

Escott, Colin. *Classic: Jerry Lee Lewis*. Vollersode, Germany: Bear Family Records, 1989.

———. *Jerry Lee Lewis: The Locust Years . . . and the Return to the Promised Land*. Bremen, Germany: Bear Family Records, 1994.

———. *Jerry Lee Lewis: Mercury Smashes . . . and Rockin' Sessions*. Bremen, Germany: Bear Family Records, 2000.

———. *The Killer: The Smash/Mercury Years, 1963–1968, Jerry Lee Lewis*, vols. 1–3. Bremen, Germany: Bear Family Records, 1986–87.

"Ferriday's Jerry Lee Lewis Has a Plaque . . ." *Concordia Sentinel*, Feb. 23, 1972.

Fordyce, J. R. "Following De Soto to His Discovery of Mississippi and Death." *New Orleans Times-Picayune*, June 2, 1929.

Fricke, David, with Brian Hiatt, David Browne, Nicole Frehsée, Andy Greene, and Austin Scaggs. "Higher and Higher." *Rolling Stone*, no. 1092, Nov. 26, 2009.

"Funeral Held for Fifth Wife of Jerry Lee Lewis." Associated Press, Aug. 27, 1983.

Goldstein, Patrick. "Jimmy Swaggart Blasts Rock Porn." *Los Angeles Times*, Aug. 3, 1986.

Guajardo, Rod. "Goodness Gracious: 'Killer' Weds, for 7th Time, in Natchez." *Natchez Democrat*, Mar. 30, 2012.

Guralnick, Peter. "Perfect Imperfection: The Life and Art of Jerry Lee Lewis." *Oxford American*, no. 63, Dec. 2008.

Guterman, Jimmy. *Rockin' My Life Away: Listening to Jerry Lee Lewis*. Nashville: Rutledge Hill Press, 1991.

Hall, Roy. "I Remember Jerry Lee Lewis." *Country Music Inquirer*, July 1983, www.kyleesplin.com/Roy%20Hall%20remembers%20Jerry%20Lee.htm.

Hays, Will S. "Captain J. M. White," in Robert Dabney Calhoun, *A History of Concordia Parish, Louisiana. Louisiana Historical Quarterly* 15, no. 1 (1932).

Hendrick, Kimmis. "A Rock-and-Blues 'Othello.'" *Christian Science Monitor*, Mar. 23, 1968.

"Home of Jerry Lee Lewis Won't Reopen to Public." Associated Press State and Local Wire, in *Desoto Times Today*, Aug. 11, 2005.

Hubbard, Kim, and Mary Shaughnessy. "A Whole Lotta Shakin' Goes on as Rock 'n' Roll's Oldies but Goodies Make It to the New Hall of Fame." *People*, Feb. 10, 1986.

Humphrey, Mark. "Jerry Lee Lewis." *Esquire* 97, no. 6 (June 1982).

"IRS Puts Jerry Lee Lewis' Property on Auction Block." Associated Press, Oct. 23, 1980.

Jerome, Jim. "Fame, Tragedy and Fame Again: Jerry Lee Lewis Has Been Through Great Balls of Fire, Otherwise Known as Hell." *People*, Apr. 24, 1978.

"Jerry Lee Lewis 'All Right' After Stomach Surgery." United Press International, Nov. 13, 1985.

"Jerry Lee Lewis and the Law." *Washington Post*, Nov. 24, 1976.

"Jerry Lee Lewis Files Bankruptcy Petition." Associated Press, Nov. 9, 1988.

"Jerry Lee Lewis Fined." *Delta Democrat-Times*, May 8, 1975.

"Jerry Lee Lewis Has Little Left, Lawyer Says." Associated Press, Dec. 9, 1988.

"Jerry Lee Lewis Undergoes Second Stomach Operation." Associated Press, July 11, 1981.

"Jerry Lee Lewis' Wife Dies." *Washington Post*, Aug. 25, 1983.

"Jerry Lee Lewis Wins Achievement Award." Associated Press Online, Jan. 5, 2005.

"Jerry Lee's Wife Had '10 Times' Usual Methadone Dose." Associated Press, Sept. 17, 1983.

"Johnny Cash Visits Ailing Jerry Lee Lewis at Hospital." Associated Press, July 13, 1981.

Johnson, Robert. "TV News and Views." *Memphis Press-Scimitar*, Dec. 5, 1956.

"Jury Finds No Cause for Charges in Death of Singer's Wife." Associated Press, Sept. 21, 1983.

Kempley, Rita. " 'Great Balls': Tall Tale of Hot Wax." *Washington Post*, June 30, 1989.

King, Wayne. "Swaggart Says He Has Sinned; Will Step Down." *New York Times*, Feb. 22, 1988.

Lewis, Jerry Lee, and Charles White. *Killer!* London: Century, 1995.

Lewis, Linda Gail, with Les Pendleton. *The Devil, Me, and Jerry Lee*. Atlanta: Longstreet, 1998.

Lewis, Myra, with Murray Silver. *Great Balls of Fire: The Uncensored Story of Jerry Lee Lewis*. New York: Morrow, 1982.

Lewis, Randy. Review of *Mean Old Man*, by Jerry Lee Lewis, *Los Angeles Times*, Sept. 7, 2010, http://latimesblogs.latimes.com/music_blog/2010/09/album-review-jerry-lee-lewis-mean-old-man.html.

Loftin, Zeke. "Jerry Lee Lewis." *Twisted South* 1, no. 2 (Winter 2011).

Lollar, Michael. "Jerry Lee Lewis Opens His Home for Tours, Cash." *Memphis Commercial Appeal*, Aug. 3, 1994.

"Magazine, ABC Question Jerry Lee's Role in Wife's Death." Associated Press, Feb. 3, 1984.

"Methadone Linked to Death of Entertainer's Wife." Associated Press, Sept. 14, 1983.

Murphy, Leona Sumrall. *A Teenager Who Dared to Obey God*. South Bend, IN: LeSEA Publishing, 1985.

Nelson, Stanley. "A Century." *Concordia Sentinel*, Feb. 25, 2004.

———. "Haney's Big House—a Legendary Place—Down the Street from Morris' Shop." *Concordia Sentinel*, Nov. 26, 2007.

"No More Nightclubs." *Washington Post*, Dec. 11, 1970, p. C6.

Palmer, Robert. "Waldorf Rocks 'n' Rolls with Hall of Fame Stars." *New York Times*, Jan. 25, 1986.

———. *Jerry Lee Lewis Rocks!* New York: Delilah Books, 1981.

Pareles, Jon. "Rock Hall of Fame Adds Members." *New York Times*, Jan. 22, 1987.

"People in the News." Associated Press, Sept. 13, 1980.

"People in the News." Associated Press, Feb. 20, 1981.

"Presley's Doctor Acquitted on All Prescription Charges." *New York Times*, Nov. 5, 1981.

Ryan, James. "Rocker Jerry Lee Lewis Honored with Star on Walk of Fame." United Press International, June 14, 1989.

Sanderson, Jane. "In the Wake of His Fifth Wife's Death, Jerry Lee Lewis Takes Bride No. 6, Kerrie McCarver." *People* 21, no. 19 (May 14, 1984).

Sandlin, Lee. *Wicked River: The Mississippi When It Last Ran Wild.* New York: Vintage, 2011.

Sayre, Alan. "Evangelist Stepping Down Pending Investigation into Sex Scandal." Associated Press, Feb. 22, 1988.

"Scandals: No Apologies This Time." *Time*, Oct. 28, 1991.

Seago, Les. "Entertainer Released After Pleading, Posting Bond." Associated Press, Feb. 16, 1984.

————. "Entertainer Fights for Life." Associated Press, July 11, 1981.

"Singer Taken off Critical List, Serious but Stable." Associated Press, July 20, 1981.

"Singer Undergoes Further Surgery." Associated Press, July 10, 1981.

Smith, Cecil. " 'Catch My Soul' Rocks the Ahmanson Theatre." *Los Angeles Times*, Mar. 7, 1968.

Sullivan, Jim. "Jerry Lee Lewis: 'The Killer' Says the Wild Times Are Behind Him." *Chicago Tribune*, July 28, 1985.

Swaggart, Jimmy, with Robert Paul Lamb. *To Cross a River.* Baton Rouge: Jimmy Swaggart Ministries, 1984.

"Tennessee Singer Is Ordered Arrested After Ignoring Court." *New York Times*, Nov. 25, 1976.

"The Sudden Death of Wife No. 5 Confronts Jerry Lee Lewis with Tragedy—and Troubling Questions." *People*, Sept. 12, 1983.

Tosches, Nick. *Hellfire: The Jerry Lee Lewis Story.* New York: Delacorte Press, 1982.

————. *Country: The Twisted Roots of Rock 'n' Roll.* Cambridge, MA: Da Capo Press, 1996.

"When Elvis and Jerry Lee Were Rock's Naked Bikers." *Miami Herald*, June 28, 1989.

Willet, Edward. *Janis Joplin: Take Another Little Piece of My Heart.* Berkeley Heights, NJ: Enslow Publishers, 2008.

Williams, Bayne C. "Jerry Lee Lewis's Wife Seeks Divorce." *Memphis Commercial Appeal*, Apr. 24, 2002.

"Woman Riding in Swaggart Car Says She's a Prostitute." Associated Press, in *Los Angeles Times*, Oct. 12, 1991.

INDEX

Grateful acknowledgment is made to reprint the material on the following pages:

Page 70: "Hong Kong Blues" by Hoagy Carmichael copyright © 1939 by Songs of Peer, Ltd., copyright renewed, used by permission.

Page 71: "Drinkin' Wine Spo-Dee-O-Dee" © Universal Music Group, used by permission.

Page 79: "Cherry Red," written by Barry Alan Gibb. Used by permission of Warner/Chappell Music, Inc.

Page 111: "Hadacol Boogie" ©1938 Bill Nettles/Flat Town Music, Nettles Publishing.

Page 144: "End of the Road" by Jerry Lee Lewis © Lost Square Music. Used by permission of Warner/Chappell Music, Inc.

Page 148: "Whole Lot of Shakin' Goin' On" © NIMANI Entertainment, Co.

Page 161: "Crazy Arms." Music and Lyrics by Ralph Eugene Mooney and Chuck Seals. All rights reserved.

Page 174: "I Shall Not Be Moved," written by John S. Hurt © 1998 EMI Longitude Music. All rights administered by Sony/ATV Music Publishing LLC, 424 Church Street, Nashville, TN 37219. All rights reserved. Used by permission.

Page 218: "Great Balls of Fire," written by Otis Blackwell and Jack Hammer. Used by permission of Warner/Chappell Music, Inc.

Page 246: "Breathless," written by Otis Blackwell. Used by permission of Warner/Chappell Music, Inc.

Page 287: "You Win Again," written by Hank Williams Sr. © 1952 Sony/ATV Acuff Rose Music. All rights administered by Sony/ATV Music Publishing LLC, 424 Church Street, Nashville, TN 37219. All rights reserved. Used by permission.

Page 333: "Another Place Another Time," written by Jerry Chesnut © 1968 Sony/ATV Tree Publishing. All rights administered by Sony/ATV Music Publishing LLC, 424 Church Street, Nashville, TN 37219. All rights reserved. Used by permission.

Page 336: "Lust of the Blood," written by Jack Good, Ray Pohlman. Used by permission of Range Road Music, Inc.

Page 345: "She Even Woke Me Up to Say Goodbye," written by Douglas Gilmore and Mickey Newbury © 1969 Sony/ATV Acuff Rose Music. All rights administered by Sony/ATV Music Publishing LLC, 424 Church Street, Nashville, TN 37219. All rights reserved. Used by permission.

Page 345: "She Still Comes Around." Music and lyrics by Glenn Sutton © EMI Music Publishing.

Page 362: "Mother, the Queen of My Heart" by Hoyt Brant and Jimmie Rod-

gers, copyright © 1933 by Peer International Corporation, copyright renewed, used by permission.

Page 390: "A Damn Good Country Song," written by Donnie Fritts © 1975 Combine Music Corp. All rights administered by Sony/ATV Music Publishing LLC, 424 Church Street, Nashville, TN 37219. All rights reserved. Used by permission.

Page 401: "Middle Age Crazy," written by Sonny Throckmorton © 1977 Sony/ATV Tree Publishing. All rights administered by Sony/ATV Music Publishing LLC, 424 Church Street, Nashville, TN 37219. All rights reserved. Used by permission.

Page 440: "Why You Been Gone So Long," written by Mickey Newbury © 1969 Sony/ATV Acuff Rose Music. All rights administered by Sony/ATV Music Publishing LLC, 424 Church Street, Nashville, TN 37219. All rights reserved. Used by permission.

Page 457: "Mean Old Man," written by Kris Kristofferson. Jody Ray Publishing (BMI). All rights reserved. Used by permission.

Page 463, "Bye, Bye, Blackbird," written by Mort Dixon and Ray Hederson. Used by permission of Bienstock Publishing Company on behalf of Redwood Music Ltd.

OCT 2 4 2014

princeton

Princeton Public Library
Princeton, New Jersey
www.princetonlibrary.org
609.924.9529